Pre-Columbian ART HISTORY

Selected Readings

Alana Cordy-Collins

University of San Diego
San Diego Museum of Man

Peek Publications • P.O. Box 50123 • Palo Alto, California 94303

Library of Congress Catalog Card Number 81-82638

ISBN 0-917962-71-0

Manufactured in the United States of America

Contents

Introduction

Pre-Columbian art signifies the art of a particular place, time, and people. The place is the New World—the Americas. The time extends from the fourth millenium B.C. through the early sixteenth century A.D. The people—the artists and craftsmen who created the art—were the indigenous inhabitants of the New World, representative of myriad cultures on both continents. Some of these cultures influenced others artistically. Others developed autonomously.

Pre-Columbian art ceased, not with the landing of Columbus in 1492 as the term pre-Columbian implies, but with the arrival of the Spanish on the mainland some years later. Although Cortez conquered Mexico in 1521 and Pizarro conquered Peru in 1532, many areas of the New World were untouched by Spanish influence for years thereafter. Therefore, the term "pre-Hispanic" is actually more accurate than "pre-Columbian." For this reason many researchers prefer the term pre-Hispanic Art to pre-Columbian Art. However, "pre-Columbian" is the more widely used of the two terms; and it is, therefore, for the sake of consistency that the term "pre-Columbian" has been used.

Within the pre-Columbian world, two main cultural areas are recognized. The more northerly is Mesoamerica, an area which encompasses Mexico, Guatemala, Honduras, Belize, and El Salvador. The Andean Area is the more southerly and includes southern Ecuador, Peru, western Bolivia, and the northern part of Chile and Argentina. Between these two main culture zones lies another which is usually termed the "Intermediate Area," formed by Costa Rica, Nicaragua, Panama, Colombia, and northern Ecuador.

In arranging the articles in this volume a southward progression has been followed, beginning with Mesoamerica, followed by the Intermediate Area, and ending with the Andean Area. Within the three areas a general

chronologic order has been followed, beginning with the oldest cultures in a specific area and moving forward in time.

This book of readings has been compiled with two main criteria in mind. The first is that the articles be basically art historical; i.e., that they deal with form and meaning as subject matter, as well as exhibiting sound art historical methods and theories.

The second criterion was that the articles be timely, representing the latest research and scholarship in the history of pre-Columbian art. Over the past several years, the field of pre-Columbian studies has expanded tremendously and an ever-increasing number of pre-Columbian art courses are being offered in colleges and universities. An unfortunate side effect of this burgeoning field and expanding research is that it is extremely difficult for instructional material to be kept current. The problem in writing survey books in pre-Columbian art is the same as in any rapidly developing field: by the time a comprehensive survey is finally published, much of the material is outdated. By contrast, this book of readings contains all new and previously unpublished research and essays. It is designed to provide a selection that is suitable for students gaining a first grasp of this field and to encourage an up-to-date dialogue among advanced students and scholars.

With these two criteria satisfied, it is hoped that this second edition of *Pre-Columbian Art History: Selected Readings* will provide students of art and archaeology a valuable resource of new and stimulating information about the ancient cultures of the New World.

The editor extends her sincere gratitude to the authors for allowing their articles to be included in this volume. Special appreciation is also extended to Jack L. Riesland for his substantial editorial assistance in the preparation of these articles for publication.

Alana Cordy-Collins

The Relation of Mesoamerican Art History to Archaeology in the United States

Cecelia F. Klein
Department of Art, Design and Art History
University of California, Los Angeles

This article charts the development of the field of pre-Columbian Mesoamerican art history in the United States while correlating and contrasting it with its counterpart, pre-Columbian Mesoamerican archaeology. The growth of the art historical field is seen to result in part from a narrowing of the archaeological one. Moreover, this article suggests that Mesoamerican art history's and archaeology's relationship may be more than historical; art historians may find future benefits in applying "new" archaeological methodology to their own research.

THE ACADEMIC DISCIPLINE of pre-Columbian art history, which from the beginning has preoccupied itself with Mesoamerica, was not officially baptized in the United States until 1956, when Yale University awarded Donald Robertson the first doctorate that involved extensive research on the subject. The award was made 106 years after the publication of John Stephens and Frederick Catherwood's path-breaking *Incidents of Travel in Central America, Chiapas, and Yucatan*, and roughly 150 years after the initial exploration of the Maya site of Palenque by Guillermo Dupaix. Thus U.S. Mesoamerican art history as a pedigreed, officially sanctioned discipline long postdates the initial surge of western interest in the region's artifacts and monuments. Since its outset, however, the young discipline has faced increasing criticism from Mesoamerican archaeologists, with whom its relations are sometimes very tense. Since both archaeologists and art historians are now calling for an abatement of this tension, it is worth investigating the origin and nature of their disagreement. Understanding of the historical basis of the problem in this country should help us in turn to formulate a potential local resolution.[1]

1. I am deliberately confining this paper to the problems faced by art historians and archaeologists in the United States, and hence to the history of their relationship. While there is no doubt that pre-Columbian art history and archaeology in the U.S. have been profoundly affected by comparable developments in Mexico in particular, the nature of the problem in Latin American countries is naturally somewhat different. The relation of Mesoamerican art history to archaeology in Mexico remains to be charted, but Ignacio Bernal's *History of Mexican Archaeology* (1980) represents an invaluable first step in this direction.

Mesoamerican archaeology as practiced in the U.S. grew out of the nineteenth century passion of men, many of whom were non-Mexicans like Dupaix and Stephens, for exploring and recording, both verbally and visually, the ancient ruins and most accomplished artworks of first Mayan, later Mexican, societies. Since such ruins as could be detected in the overgrowth were typically large and durable, those societies were usually what we call "complex." They reflect a level of development commensurate with what European archaeology has labelled "civilization," replete with evidence of high technical skill and other massive expenditures of wealth and labor; some form of writing; and indications of so-called "advanced" and "scientific" forms of knowledge. That most non-Mexican nineteenth century scholars, themselves typically of "cultured" backgrounds, were specifically interested in signs of native intellectual accomplishment is demonstrated by the many linguistic, mytho-religious, and calendrical and astronomical studies of the period. The Maya hieroglyphic investigations of Ernst Förstemann, Charles Bowditch, and Daniel Brinton, for example, were matched by the German Eduard Seler's investigations of the meaning of Mexican carved and painted images. It is clear, therefore, that the period in American archaeology from 1840 to 1914, while labeled by Gordon Willey and Jeremy Sabloff (1980:34) as essentially "descriptive," also saw much, particularly "foreign," interest in Mesoamerican iconography and hieroglyphics. Many of the men who contributed to these descriptive and symbolic studies were not, in fact, true archaeologists (ibid.:58-60; Bernal 1980:116, 118, 145). Some of them, like Brinton, for example, nonetheless helped to found that discipline in the U.S. (Willey and Sabloff op. cit.:79).

The earliest Euroamerican analytic studies of Mesoamerican art therefore focused on qualitatively selected products of a few "civilized" societies in a manner either descriptive or iconographic. These studies, however, tended to be ahistorical as well. The indefatigable William Prescott had to depend largely on ethnohistoric documents for the compilation of his famous history; those available studies that we today describe as "archaeological" were of little service (Bernal op. cit.: 114, 129, 155). This situation began to be rectified by trained archaeologists during the Porfiriato,* but the main concern of the time was the determination of strictly local chronologies by means of typology and seriation. Such archaeological goals were largely shaped by the thinking of the expatriate German anthropologist Franz Boas, well known for his conviction that history comprises innumerable chains of essentially unique events. Boas's now so-called "particularistic" approach was fully adopted by Mexico's leading archaeologist of the post-Revolutionary period, Manuel Gamio, who had studied with Boas in New York. Gamio's preference for regionally specific "histories" and the unique in general was easily adapted to a field already dominated by students of the unique aspects of "unique" cultures. Their mutual compatibility is well documented; Boas had worked under Seler in Berlin, for example, and it was Seler who helped Gamio convince Boas to fund his excavation of Atzcapotzalco (Willey and Sabloff op. cit.:85) The early decades of Mesoamerican archaeology proper thus carried forward a theoretical set of premises initially laid down by humanists.

This is important because the late establishment of pre-Columbian art history followed hard on the heels of the initial moves of American archaeology toward repudiation of its particularistic tenets. Willey and Sabloff (ibid.:131) date the first such move in the U.S. to the mid-1930s, when William Duncan Strong called for archaeology to begin to try to understand the processes of cultural development and change.

*During the regime of President Porfirio Diaz (1876-1880; 1884-1911).—A.C.-C.

2

The banner of criticism was taken up in 1938 by Julian Steward and F.M. Setzler in their stand against particularism, and passed on to Clyde Kluckhohn in 1940. A theoretical reformulation of the entire discipline in the U.S. was produced by Steward in the next two decades. Stripped to its barest essentials, it called for a comparative, cross-societal approach that can reveal developmental regularities and, hence, principles or "laws." The regularities, moreover, were deemed explainable on the basis of environmental or, more properly, ecological factors. These assumptions deliberately recalled, although they by no means directly emulated, the unilinear cultural evolutionism and Marxian materialism that had been laid aside by archaeologists as "discredited" since the late nineteenth century. Their political implications escaped few scholars. Willey and Sabloff (ibid.:184) suggest that eventual acceptance of the so-called "new archaeology" was abetted by the waning of the U.S. "red scare" of the '50s.

The implications of the "new archaeology" for the old, traditional humanistic study of art in the U.S. were, therefore, profound. The comparative approach of the new social scientists rejected the primary value of the unique and elitist. Its materialist premise denied the autonomy of ideas, forms, and symbolic systems. New archaeologists, moreover, were preoccupied with the landscape, modes of production and reproduction, and habitation patterns and crude artifacts of the most common, humble sort of people. They neither dealt with, nor apparently recognized as significant, the "fine" art masterpieces of the Indian—and by implication *all*—upper classes. New archaeology's enthronement of objective science thus placed the "old" archaeology first on the defensive and, finally, in partial exile. Study of the precious and symbolic aspects of Mesoamerican culture in particular were ripe for relocation in another, more congenial discipline.

The first pre-Columbian art history lectures presented by a pedigreed art historian in a U.S. art history department at a major national university accordingly were offered at Yale in 1938,[2] the year of Steward and Setzler's important salvo. The instructor was George Kubler, today still recognized as the "dean" and major theoretician of the field. His degree had been earned in "western" art history but he had studied Mesoamerican archaeology with the "old school" anthropologist Herbert Spinden at N.Y.U. Spinden's own courses were offered through the Department of the History of Art there, no doubt because he had written his dissertation on Maya art. His work clearly both provided the inspiration for, and served as a foil to, Kubler's own comprehensive volume on pre-Columbian art and architecture (Kubler 1962:14; 1975:760). Although not published until 1962, Kubler's book was an outgrowth of his teaching in the '40s, the decade that witnessed the strong challenge by Kluckhohn within archaeology (Kubler 1962:14). It was Kubler, moreover, who produced Donald Robertson as the first U.S. art historian to receive a doctorate in conquest period studies. The award followed by a year the publication of Julian Steward's 1955 classic *Theory of Culture Change* which, according to Willey and Sabloff (op. cit.:151), was particularly influential in directing archaeologists away from Boasian particularism and the ideational. Five U.S. doctorates in pre-Columbian art history were subsequently awarded in the 1960s, the decade influenced by the theoretical writings of Leslie White and Lewis Binford (Klein n.d.1). Twenty-one have been issued since 1970, by which time William Sanders, Kent Flannery, and Jeffrey Parsons, to name but three of the best known North American new archaeologists, had begun in earnest to apply the new tenets directly to Mesoamerica (Klein *ibid.*).

2. This is to be inferred from Kubler 1962, p. xxv.

Obviously, the foundation of a discipline is ultimately attributable to a number of sometimes independent factors. In an earlier paper (Klein *ibid.*), I attempted to show how the fledgling discipline of pre-Columbian art history was fostered by the particular nature of U.S. political and economic relations with, and interests in, Latin America during this period. From the foregoing, however, it seems fair to suggest that pre-Columbian art history came into being in this country in part specifically to carry on what archaeology had ceased to do. This is amply borne out by examination of the dissertation topics of matriculated U.S. pre-Columbian art historians which, almost without exception, have involved either descriptive stylistic, or iconographic analyses of select classes of objects—or both (Klein, *ibid.*). The former continue the nineteenth century tradition of describing objects, albeit with an eye now to "aesthetic quality." The latter are often the direct legacy of Eduard Seler. Symbolic studies, moreover, are still notably restricted to the ideological sphere. Images are typically "explained" by pre-Columbian art historians in terms of mythic, astronomical, and/or religious concepts.[3] In recent days, linguistic study, once favored by humanist archaeologists like Förstemann and Brinton, has been incorporated by those iconographers. And while there is some sparring within the discipline as to whether stylistic analysis or iconography is more informative, there traditionally has been general agreement on both sides that history as such is at best a secondary goal.[4] When historical reconstructions do surface, they are as particularistic, as preoccupied with the unique, as were those of Boas, and are usually confined to the narrow typologies and seriations that absorbed the attention of archaeologists prior to 1940. This practice conforms to Kubler's dictum (1975:758) that art operates according to its own principles, independent of "history" on a grander scale, a dictum still accepted by most art historians in the field.

Since U.S. pre-Columbian art history defined itself from the outset, then, as an alternative to the new archaeology in particular, it is no wonder that most Meso-american archaeologists and art historians have been unhappy bedfellows. At the most fundamental, philosophic level, the two have been from the start in almost total disagreement. The real question for us today, however, is whether this situation must or should continue. Many U.S. Mesoamerican art historians, in response to shrinking job opportunities and archaeology's increased disrespect for their premises and methods, argue that strict maintenance of the bundling board that separates the two disciplines is the surest guarantee of art history's integrity and well-being. Meso-american art historians must continue, in other words, to focus on the subjective rather than the objective, on the unique rather than the predictable, on the ideational rather than its relation to the material.[5] Materialism and evolutionism—indeed the very concept and goals of objective science—are dismissed, despite their long and respectable role in European intellectual history (including, I might add, art history), as irrelevant manifestations of a current "vogue" or "trend." Mesoamerican art historians, in the face of criticism and lessening academic interest in their activities and products, are being advised to keep the faith and guard tradition.

3. This has been the case as much for me as for any Mesoamerican historian; by no means am I implying that I am exempt from my own criticism.

4. See Robertson 1978 and Coggins 1979 for theoretical support for this position. Examination of completed U.S. dissertations on Mesoamerican art history confirms its entrenchment. One of the most 'historical' of these was written by Coggins herself; it serves as inspiration to a number of art historians interested in a more historical approach to Mesoamerican art (see Klein n.d.1).

5. The most recent published defense of this position is Coggins 1979. From conversations with numerous colleagues and graduate students in the field, however, I can add with fair certainty that this is the prevailing opinion.

4

But Mesoamerican art history, as we have noted, has not been really concerned with history in the broad sense of the word. At best historical issues are to be addressed only to facilitate what have been decreed as "the preeminently art historical questions of style and iconography" (Coggins 1979:317). This creates a curious situation, for stylistic and iconographic analyses, at least as they have been practiced by virtually all Mesoamerican art historians to date, are academic *methods*, not subjects or goals. Pre-Columbian art history, in other words, unlike nearly all other well-established academic disciplines, has set itself apart on the basis of specific methodologies rather than the subject of its inquiry. Use of these methods, the discipline maintains, are what determine whether one is or is not practicing "real" pre-Columbian art history. This stands in direct opposition to the definitions of, for example, both history and anthropology, and even European art history, which recognize and incorporate a wide variety of focuses and methods.

Why pre-Columbian art history alone must define its province in terms of a limited set of methodologies has never, to my knowledge, been explained. To perceive one's profession and duties primarily in terms of specific and immutable approaches is surely to entrench conservatism and ensure a lack of progress. Methods are in the end nothing but adaptive strategies that, like all human strategies, must be periodically reassessed and, not infrequently, adjusted or replaced as knowledge and human needs themselves change through time. Linguistics could not have made the tremendous strides it did during the 1950s and '60s if it had refused to entertain new methodologies, new ways of learning; the medical profession could not continue to increase our average life-expectancy if biochemistry and neurophysics were forbidden to try out new approaches to the problem. Pre-Columbian art history's best response to prognoses of troubled times should be a redefinition of the discipline in terms of its contribution to our common fund of knowledge about human behavior in general. The answer cannot lie with mere defense of an old self-definition confined to one or two methodologies in need of reevaluation and, no doubt, updating.

U.S. Mesoamerican art historians actually can gain inspiration from the new archaeology, particularly regarding the relation of artistic form and meaning to the material and social circumstances of production. There is no reason to go on insisting that art is "explained" by religion or ideas and that the struggle for subsistence and advantage bears no direct relation to the images men make. Avoidance of the social and material basis of the concepts expressed by an artwork can seriously distort our understanding of the object's ultimate function, if not its meaning. Examination of the economic basis of the rise to prominence of the Mexica-Aztec cult of the "earth" goddess Cihuacoatl, for example, revealed that state-commissioned images of the goddess served a primarily political, not "religious," purpose. Their "meaning" for the urban populace had become increasingly negative: Cihuacoatl came to connote political oppression and the misery of the masses rather than just agricultural and human fertility, as she had at first (Klein n.d.2). Mesoamerican art historians, moreover, need not fear that such redirection would cause them ultimately to be 'consumed' by history or the social sciences; the province of art history is not this or that methodology, but art. Most historians and social scientists are and would be quite willing to let specialists deal with most of the special problems that art poses for their disciplines. The trouble is that art historians traditionally have defined their own goals as unrelated to those problems. Contrary to what most Mesoamerican art historians believe, moreover, the new materialism in the social sciences has not repudiated the value of understanding the relation of the ideational to the material. "Nothing," writes Marvin Harris, the leading North American theoretician of the so-

called 'cultural materialism,' ". . . warrants the inference that structure or super-structure are insignificant, epiphenomenal reflexes of infrastructural [that is, material] factors . . . indeed, it would be irrational to assert that ideological or political struggle could not enhance or diminish the probability of systemic changes involving all three sectors" (Harris 1979:72). If Harris concludes that the most fundamental changes nonetheless come from these infrastructural, material factors and not from the ideational and, therefore, art, there is no real reason why art historians should feel hurt or threatened. Cultural materialists, including the new archaeologists, give priority to understanding how the material infrastructure affects both human socio-economic, and human symbolic, concepts and actions. There is no way any of us can establish this for the artistic realm if someone does not determine what those changing arts and ideas were.

Ultimately, however, if there is ever to be an understanding of human behavior, specialists in all areas must learn to work together and to pool their findings. Those findings will not mesh neatly to form the final, comprehensive picture if they are not derived from a common, fundamental premise and ambition. *All* Mesoamerican art historians and archaeologists need to sit down together and decide what they seek in common, not continue to declare the separateness and inviolability of their respective operations. In the end, our goals should be essentially the same. Who knows, the two disciplines may find that removal of the bundling board will bring increased productivity and even pleasure, and that they can maintain their own identities at the same time. It should at least be worth a try.

Bibliography

Bernal, Ignacio
 1980 *A History of Mexican Archaeology: The Vanished Civilizations of Middle America*. London: Thames and Hudson.

Coggins, Clemency
 1979 "A Role for the Art Historian in an Era of New Archaeology." *Actes du XLIIe Congrès International des Américanistes, Congrès de Centenaire, Paris, 2-9 Septembre 1976* (7) 315-320.

Harris, Marvin
 1979 *Cultural Materialism: The Struggle for a Science of Culture*. New York: Vintage Books.

Klein, Cecelia F.
 n.d.1 "The Effect of the Social Sciences on Precolumbian Art History in the United States." M.S. in author's possession.
 n.d.2 "Rethinking Cihuacoatl: Aztec Political Imagery of the Conquered Woman." M.S. in author's possession.

Kubler, George
 1962 *The Art and Architecture of Ancient America: The Mexican, Maya, and Andean Peoples*. Baltimore: Penguin Books.
 1975 "History—or Anthropology—of Art?" *Critical Inquiry* 1: 757-767.

Robertson, Donald
 1978 "Anthropology, Archaeology, and the History of Art." *In* Marco Giardino, et al, eds. *Codex Wauchope: A Tribute Roll. Human Mosaic*, New Orleans: Tulane University. Pp. 73-80.

Willey, Gordon R., and Jeremy A. Sabloff
 1980 *A History of American Archaeology*. Second edition. San Francisco: W.H. Freeman and Company.

N.B. This is a slightly modified version of a paper delivered at the session on "Archaeology and Art History: Interdisciplinary Approaches for the 1980s," chaired by Fred Lange and Mark Graham at the 79th Annual Meeting of the American Anthropological Association, Washington, D.C., 1980.

2

Antecedents of Olmec Sculpture at Abaj Takalik

John A. Graham
Department of Anthropology
University of California, Berkeley

Since 1976 archaeological investigations at Abaj Takalik, southwestern Guatemala, have yielded a major corpus of sculpture reflecting various important early art styles of southern Mesoamerica. Included is the largest number of Olmec style monuments yet to be discovered outside the Olmec "heartland" sites of southern Veracruz-western Tabasco in Mexico. The ruins, apparently occupied at least as early as the third millennium B.C., shed important light upon the origins of Olmec style in a lengthy sequence of antecedent boulder sculptures. The discoveries re-open fundamental questions relating to the locus of origins and the early history of Olmec style.

THE GREATEST QUANTITY of impressive Olmec sculptural art found to date derives from a relatively small area of southern Veracruz and western Tabasco of southern Mexico, a district often termed the Olmec "heartland." The corpus of heartland monuments consists of close to 200 known examples, ranging from some truly colossal multi-ton carvings to works smaller than life size and extending from true sculpture in the round to a large body of relief work of diverse kinds. Almost half of the known corpus derives from only two archaeological ruins, La Venta and San Lorenzo, the only Olmec sites of the heartland to have received some excavation beyond that of a pre-liminary, exploratory character. The chronology of this sculptural tradition has been the subject of the most divergent interpretation over the years, although at present most students agree in placing much of the work within the first millennium B.C. Unfortunately, precise calendar ages such as one frequently encounters confidently put forth in both scholarly texts and popular literature rest upon subjective evaluation of often quite ambiguous evidence and a variety of conjecture and traditional assumptions. Not only does the time of the first appearance of a clearly recognizably Olmec monumental sculptural style remain to be demonstrated satisfactorily, but so also its duration through time and its final demise remain questions for which satisfactory solutions have yet to be obtained.[1]

Additionally, the origins of this great and fascinating sculptural art of ancient

7

Mesoamerica have been the subject of only limited speculation, sometimes of a rather fantastic nature, and even less substantial investigation. Some considerations of Olmec style have placed more stylistically developed exemplars of the heartland at the very beginnings of hypothetical schemes of development, thus even more dramatically emphasizing the absence of apparent antecedents and origins. Since quarries and sources for the stones most commonly employed for Olmec sculptures at such important heartland sites as La Venta and San Lorenzo are lacking, the miniature highlands of southern Veracruz, the Tuxtlas, demonstrably the source of much stone employed by Olmec carvers, has been suggested as a possible locus of origin by some writers. However, only more extensive and intensive investigation of that little-studied region can provide a reasonable basis for evaluation of this interpretation.

It is well known, however, that Olmec stone sculptural art has been found in solitary examples or in small quantities at a number of localities beyond the Veracruz-Tabasco district, and such intriguing discoveries increase in number with the passage of years. Considerations of these occurrences have sometimes been formulated in the context of trading factories (especially for raw materials), imperialistic expansion, and even cult or religious evangelization. Occurrences of Olmec related materials south of the Valley of Mexico, in Guerrero-Morelos, have been interpreted by a few as re-

1. This count of the "heartland" monumental corpus omits "plain" monuments, "blanks," drain stones, unmodified natural basalt columns, and similar objects which at times have been accorded monument numbers. By definition, figurines, celts, and similar miniature carvings are naturally excluded; and as in any individual assessment, my count includes pieces some colleagues would consider non-Olmec while excluding others that some might consider to be within Olmec style. Illustrating the confusions with which students must contend, there are three La Venta sculptures which have each received no less than four separate catalogue designations while certain other "La Venta" monuments do not derive from the La Venta site. The invaluable and admirable guide to Olmec sculpture of the heartland by Beatriz de la Fuente (1973) is an indispensable index, but even de la Fuente and her associates were unable to sort out all the duplicating and misleading references and terminology to a number of monuments.

 The general problems of archaeological methodologies in the dating of sculptures in Mesoamerica is considered in detail in a paper in preparation. I would here note only that the problems, in part, involve distinguishing dating of creation, and sometimes re-carving, from the dating of subsequent uses, the possibilities of more recent sculptures being found in seemingly older contexts versus the very common occurrence of ancient sculptures in more recent contexts. Bearing upon the question of the dating of the first appearance of a developed Olmec sculptural style, Coe and Diehl (1980) assert their belief that at San Lorenzo, in striking contrast to La Venta, a number of major Olmec sculptures were not only not re-used during the subsequent three millennia of the site's history (in which various later occupations have been documented, including a Villa Alta phase of terminal first millennium A.D. age which equalled or exceeded the San Lorenzo phase in its magnitude) but were, in fact, permanently "buried" by about 900 B.C. The still earlier genesis or emergence of a clearly definable Olmec style required by the Coe and Diehl interpretation raises serious problems of interpretation and credibility. For instance, since there are substantial reasons to believe that Olmec-style sculpture and Olmec influenced or related art were being produced at much later dates within currently accepted chronologies, the relatively small present corpus of Olmec work exhibiting little profound evidence of substantial, long-term change and evolution through time, requires a stylistic duration difficult to believe, but perhaps not impossible to accept.

 Among the many instructive comparisons to be examined between Olmec art of the "heartland" and sculptural art occurring elsewhere is the case of La Venta Monument 19 and Kaminaljuyu Stela 11. While the Kaminaljuyu carving has often, and astonishingly, been termed "Izapan," its formal properties, despite its fundamentally Maya conception, are so clearly tied to La Venta Monument 19 that a significant historical relationship cannot be doubted. La Venta Monument 19 is most probably later than the earliest examples of Olmec style and Kaminaljuyu Stela 11 may well be earlier than its final repositioning in the Miraflores context within which it was discovered; this would allow narrowing of temporal separation in terms of conventional chronologies. The Olmec relief (termed "Izapan" by Clewlow 1974:134) of Abaj Takalik Monument 1 parallels Cerro de las Mesas Stela 9 and illustrates a more perplexing tie for traditionally held chronological schemes. The parallels between many early, and even later, Maya works and Olmec carvings further points to significant chronological and stylistic overlaps.

8

flecting a "proto-homeland." In discussions of these far-flung discoveries of Olmec-style monuments and other remains, Pacific Guatemala has received relatively little attention, in part simply because not much of the material has been well known or adequately published.[2] Major sculptural discoveries in recent years at Abaj Takalik in southwestern Guatemala necessarily reopen the question of the significance of "beyond the heartland" or "colonial" Olmec carvings as well as the matter of antecedents and origins.[3]

While it is not the aim of the present essay to analyze and describe the formal properties of Olmec style, a digression here to note in brief some of these aspects of Olmec sculpture may be in order, considering the numerous erroneous and misleading generalizations which have been made and continue to be slavishly repeated in so much of the literature. At fault here is the conspicuous failure of many New World archaeologists to distinguish between formal properties—those basic aspects of any art style which reveal so much about the "vision" or apprehension of form unique to its creators—and iconographic or thematic elements which can be and repeatedly are passed not merely from one style to another but from one culture to another, often with minimal modification. To clarify these points most succinctly, it is probably simplest pedagogically to cite the oppositions and contrasts of Izapan and early Maya sculptures in relation to which Olmec art is most frequently discussed.

In contrast to both Izapan and early Maya art, the Olmec style is above all characterized by a preoccupation with volume, that is, a feeling for full, swelling masses, which together with consistent application of a highly refined system of proportion accounts for the overall impression of grand, inherent monumentality which distinguishes even the smallest of fine Olmec objects.

Izapan art, on the other hand, with only a very few exceptions, displays almost no feeling for volume, systematic proportion, or monumentality, but concerns itself instead almost entirely with the sometimes amazingly sophisticated creation of notional or depicted space, a natural predisposition for artists whose chief purpose seems to have been the depiction of narrative scenes often depending to a great extent on movement and dramatic action for their clarity and effect.

The early Maya reveal yet a third and quite different mode of apprehension, a

2. On the other hand, three of the four important Olmec carvings in the round from Sin Cabezas, Escuintla, were published thirty years ago (Shook 1950). These carvings are all fine examples of Olmec sculpture while the better preserved Sculpture 1 (Figure 15) is an exceptionally outstanding work; had it been un-covered at La Venta, one can be certain it would have been illustrated frequently as one of the master-pieces of Olmec carving in the round. Nevertheless, neither of the two articles treating Olmec sculpture and its style in the *Handbook of Middle American Indians* (Volume 3) mentions the Sin Cabezas sculp-tures although the less impressive Olmec reliefs from Las Victorias, Chalchuapa, El Salvador, and San Isidro Piedra Parada (Abaj Takalik Monument 1), Retalhuleu, Guatemala, situated to either side of Sin Cabezas are both cited. Considering the importance of the Sin Cabezas carvings, I might note that two rather similar pieces now in the Popol Vuh Museum, Guatemala, are, in my opinion, of most dubious authenticity while a third example, in a private collection and *con cabeza*, is not directly comparable stylistically (cf. Parsons 1981:270-271, Figure 12).

The designation of "Pacific Guatemala" is employed broadly and without strict restriction to current political frontiers.

3. Preliminary accounts of recent work at Abaj Takalik and a plan of a small section of the ruins, largely deriving from the first season's exploratory investigations (1976), may be found in Graham 1977, 1979, and Graham, Heizer, and Shook 1978. Work at Abaj Takalik by the University of California, Berkeley, has been faithfully supported by the National Geographic Society together with the generosity and keen interest of John Clark, of Marriottsville, Maryland; William Parady, of Farmington, Connecticut; and Francesca Wiig, of Antigua, Guatemala. The requisite authorizations, valued cooperation, and intel-lectual stimulation of Guatemalan authorities, colleagues, and friends are most warmly acknowledged.

For a selection of some additional Olmec material recently published from the area and from neigh-boring Chiapas, see Shook and Heizer 1976; Milbraith 1979; Navarrete 1974; McDonald 1977.

mode which parallels, or perhaps more accurately presages, later "Classic Maya" traditions. The subjects, predictably, tend toward elite portraiture of rather static nature whose unmistakable identifying characteristic is the typical Maya predisposition toward conceptions based upon elaborate two-dimensional surface pattern. There is no attempt at, indeed there is a conscious suppression of, indications of depicted space, a deliberate flattening for decorative effect. Similarly, volume and monumentality held little interest for the early Maya though they were willing, as at Abaj Takalik, to go to great lengths to achieve impressive, grandiose effects—this, however, through colossal scale.

In the case of Olmec art it is often surprisingly claimed by writers on the subject that the style is characterized by a naturalistic depiction of human anatomy, even such elements as musculature and indications of bone structure being often, consciously or unconsciously, injected into drawings of Olmec figures by modern draftsmen. Comparison with clear photographs will usually make this almost shockingly apparent. One finds it difficult not to suspect in this approach a projection of the mindset prevalent with so many students of the subject—a determination to equate the "classic" styles of Western European art with what this theory perceives to be the parallel position of Olmec art as the "classic" art of the New World.

It should come as no surprise that a figural art emphasizing simplicity of forms and an often almost "inflated" quality (devices used to emphasize the predominate objective of full, spatially assertive masses), would naturally minimize or even ignore many of the elements of naturalistic anatomy. Even appendages such as hands and feet are typically not treated in detail but are instead usually portrayed in a stylized and sometimes even crude manner. The full, swelling quality of the Olmec ideal recalls not so much the "classic" art of Europe as it does the voluptuousness of much of the art of ancient India, though lacking its beauty of movement and offering instead a somewhat inert monumentality which projects most impressively in the more successful works. Large scale Olmec sculpture is not only lacking in dynamic movement (cf. Covarrubias, Stirling, *et al*.) but is instead solid, stationary, and "fixed" in aspect.[4]

* * *

The ruins of Abaj Takalik are situated upon the lower Pacific piedmont of Guatemala a short distance northwest of the modern departmental capital city of Retalhuleu. This is a fertile zone where natural boulders of all shapes and sizes occur in great abundance. The extensive archaeological remains include numerous constructions of earth, at times utilizing adobe brick and facings of cobbles as well as a distinctive local material of varicolored appearance for floorings. Edifices were arranged upon great terraces which successively step up the sloping piedmont gradient. Several hundred sculptured and plain stone monuments, stelae, altars, and other carvings have been found in the ruins despite the extreme difficulties of exploration resulting from the burial of the remains beneath modern volcanic ash deposits and coverage of the surface with economically valuable crops which cannot be stripped to facilitate investigations or permit substantial exposures of archaeological features. Although sculptured stone monuments from the ancient ruins have been noted in the literature since at least the nineteenth century, it was not until modern explorations of the site commenced in 1976 that Abaj Takalik has been recognized as

4. *E.g.* "Olmec figures are especially notable for their dynamic quality, almost invariably striding, crouching, kneeling, leaping" (Stirling 1965:721).

one of the most important sculptural centers of pre-Columbian Mesoamerica now known to archaeology. In fact, upon the basis of present knowledge, Abaj Takalik is quite unique when the number of its stone monuments, their frequently great size or monumentality, and the diversity of sculptural styles present are all taken into consideration. The site's cultural and historical significance is further emphasized by the fact that a sequence of sculptural development is present which strongly appears to reach back to the very beginnings of monumental stone sculpture. The ruins, on the present evidence, appear to have been occupied at least as early as the third millennium B.C., and it is interesting to note that present day inhabitants of the site, as well as pilgrims from afar, continue to venerate both sculptured and plain monuments of the ruins while local legend holds that it is here that the world began.

In considering a sculptural sequence, among the preliminary and fundamental archaeological problems to be resolved, or at least to be considered in detail prior to more extended interpretation of the sculptures discovered in an archaeological site, is the issue of whether the works in question are in fact of local manufacture, commissions from other metropolitan centers of sculptural production, or antiques or booty imported from elsewhere. Fortunately, at Abaj Takalik there can be no question that some of the sculptures were in fact executed at the site, and this establishes that at least during certain periods of the ruin's history (including the Olmec epoch) there were resident sculptural workshops. The fact that with a single important exception, all major Abaj Takalik sculptures known at present are carved from locally abundant andesite boulders, some even in their natural geological context, together with a number of other considerations, reinforces the case for Abaj Takalik being one of the primary great centers of ancient sculptural art in Mesoamerica.

The collection of Olmec style monuments at Abaj Takalik now known, which certainly represents only a portion of the sculptures still to be unearthed there, includes a remarkably full range of Olmec sculptural types, extending from sculpture in the full round through high and low relief. One of the most interesting discoveries is a colossal head, Monument 23 (Figures 1, 2), since in the popular conception of Olmec art the type is almost a hallmark of Olmec sculpture. Because nearly a score of these remarkable sculptures is known at present from Veracruz-Tabasco, its location at Abaj Takalik, at present a unique occurrence outside of the heartland, is particularly noteworthy. While colossal carvings of the human head are known from other sites in Pacific Guatemala (the largest collection at present being known from Monte Alto, Escuintla), Abaj Takalik Monument 23 is entirely distinct from these, and it is clearly closely related stylistically to the Veracruz-Tabasco examples: the shape of the head, the treatment of the ears, their size, placement, and adornment, all relate Monument 23 to the Olmec Gulf coast examples and contrast strongly to known Pacific Guatemala carvings. The great interest in this sculpture is further enhanced by the fact that it illustrates sequent phases of carving: the facial features of the colossal head were re-worked by later Olmec artists to convert the nose and lips into a human figure, seated cross-legged fashion within a niche, yet another classic Olmec theme.

Another impressive and particularly powerful example of Olmec-style art at Abaj Takalik is the Monument 14 relief carving (Figure 3). The carving ranges from highly rounded relief to quite flat and even incised passages, accentuating the fullness of the human form that is so typical of the emphasis on volume in Olmec sculpture; the subject is a squatting figure presented within a stylized open mouth. A small animal is held in the crook of each arm, a small feline and a hooved creature, the theme recalling the archetype of the master or, considering the squatting posture and possible suggestion of breasts, the mistress of the forest and animals. It is instructive

11

to compare this sculpture in its handling of various depths of relief as well as the "kenning" effect of the headress-upper lip to Stela 2 of La Venta (see Stirling 1965: Figure 14, b)

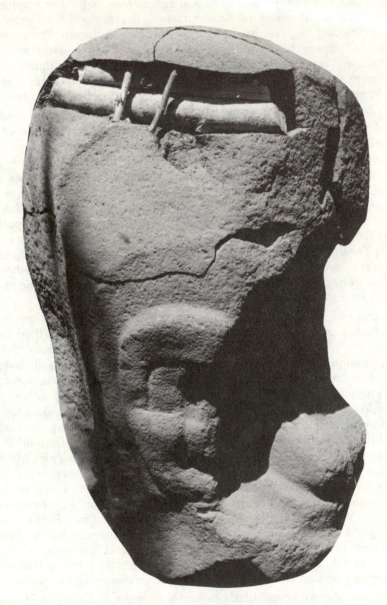

Figure 1. Abaj Takalik Monument 23, side view.

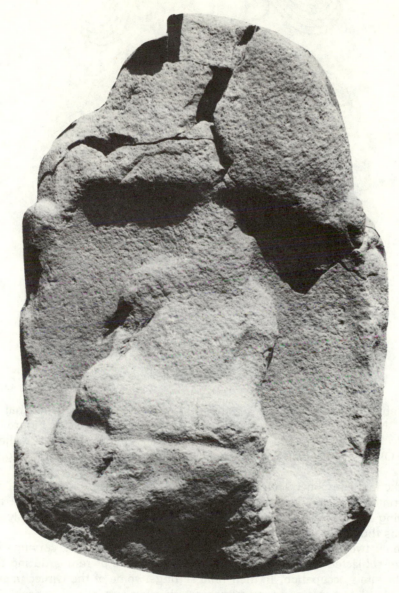

Figure 2. Abaj Takalik Monument 23, front.

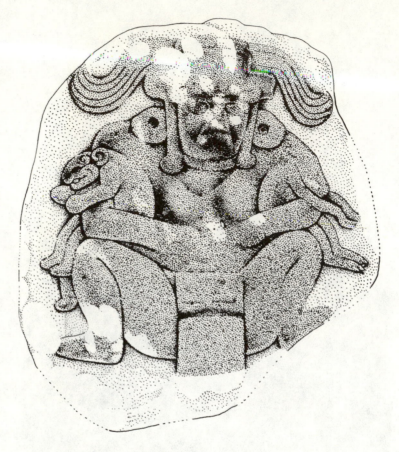

Figure 3. Abaj Takalik Monument 14. Drawing by James Porter.

Also definitely Olmec are the features of one of the most recent Abaj Takalik discoveries, Monument 55, a detached human head of heroic size (Figure 4). The dramatically "snarling" mouth and masterful arrangement of forms make it unmistakably Olmec, while the "closed" quality of its conception perhaps suggests an early date.

Even the familiar Olmec sculptural category of rectangular "altars," so limited in their occurrence even in the heartland, is probably to be included in the array of Olmec carving at Abaj Takalik in the presence of Monument 57, of which only a corner fragment has thus far been recovered.

With only two exceptions known at present, the Olmec-style carvings of Abaj Takalik were subjected to the common, worldwide practice of re-use during the long history of the site's occupation. In their final settings, some of the Olmec monuments were placed in alignments and arrangements with other carvings of entirely different styles and periods of creation. In effect, later inhabitants of Abaj Takalik were creating some of the most ancient "museum displays" of the New World.

An obvious question of crucial importance with respect to the Olmec sculptural art of Abaj Takalik is its source and its place within the site's complex sculptural history. Since almost all of the Olmec sculpture of Abaj Takalik thus far excavated has been found to have been last reset quite late in the site's history, the archaeological dating of placement, as so often is the case, does not provide very useful information

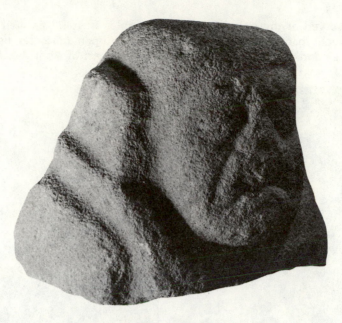

Figure 4. Abaj Takalik Monument 55.

bearing upon the age of creation. And, of course, the Olmec sculptures lack the usual inscribed hieroglyphic dates which are found on a number of the Maya sculptures of Abaj Takalik and which relate those works to the late centuries B.C. and early centuries A.D.[5] Dating and relative placement must therefore proceed on other bases.

Since it does not seem likely that radically different styles of sculptures, each represented by a number of major works, which utilize quite different technical methods and which represent considerably differing conceptions, aims, and degrees of sophistication would be contemporaneous products of the same pre-industrial center, it follows that time is a logical basis upon which to explain such differing works. If a readily observable and plausible sequence of development, even if entirely hypothetical, can be seen in the corpus of carvings, then an arrangement of the sculptures in a temporal-developmental history is encouraged. Further speculation is encouraged when it is noted that the sequence conforms to such generally accepted broad formulations as "the usual course of development in style in all periods [is] from solid and simple to more open and complicated" (Canaday 1980:40). Finally, extremely important clues to sequence may be discovered in a sculptural corpus where some pieces exhibit evidence of recarving, yielding a form of sculptural stratigraphy somewhat reminiscent of palimpsests; the dramatic example of recarving in Abaj Takalik Monument 23 has been cited previously and is only one of several such

5. Whether or not the commonly employed "11.16.0.0.0" correlation of Maya and Gregorian calendars is correct, there seems no reason at present to suspect that the calendrical dates inscribed on the Maya-style monuments of Abaj Takalik belong to a different calendrical reckoning from that found in the Maya lowlands to the north during the first millennium A.D. The Abaj Takalik hieroglyphic dates satisfactorily relate these Maya sculptures vis-à-vis the earliest hieroglyphically dated Maya sculptures now known in the lowlands to the north and to which the Abaj Takalik carvings are clearly antecedent.

Of course, a number of objects in Olmec style, particularly jades, possess Maya hieroglyphic texts; these have usually been interpreted as subsequent additions. The famous Olmec relief Stela C of Tres Zapotes with its Maya-style Initial Series date and Maya glyphic text is paralleled at Abaj Takalik in Stela 50, a badly mutilated Olmec niche sculpture with a Maya-style bar and dot Initial Series on the reverse and presumably added in later times.

examples preserved at the site. With such principles in mind as well as other considerations which space does not allow elaboration upon here, let us consider the possible sources and antecedents of the classic Olmec art of Abaj Takalik.

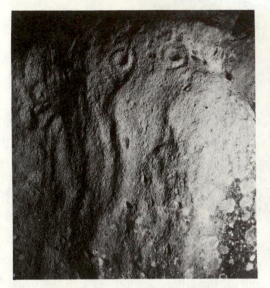

Figure 5. *Abaj Takalik Monument 1-A.*

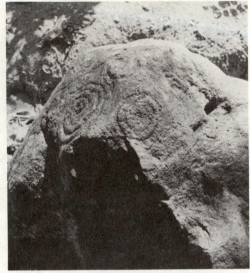

Figure 6. *Abaj Takalik Monument 38.*

A large number of sculptures at Abaj Takalik may be referred to as boulder sculptures. By this term I refer to the use of large stones in which the natural contours remain substantially recognizable or distinguishable. The natural form of the boulder may be entirely unmodified (in which instance it is only the incising, grinding, or grooving of features that makes the boulder a sculpture), slightly altered, or considerably modified; the essence of the definition rests upon the recognition of the original volume and contours of the boulder. Boulder sculpture at Abaj Takalik occurs in both basic types, relief and sculpture in the round. Relief boulder sculpture is the modification of a surface or various surfaces of the boulder without the volume of the boulder constituting a basic component of the sculptural conception; such work is sometimes referred to as a petroglyph by archeologists. Boulder sculpture in the round, on the other hand, utilizes the natural shape and volume of the stone, unmodified or modified to varying degrees, to constitute a basic quality of the conception. Although boulder sculpture was produced during many different periods in varied cultural contexts, its great importance lies in providing the sources of some of the early advanced sculptural developments of Pacific Guatemala.

At Abaj Takalik some of the simplest boulder sculptures known at present were created by the addition of two round, staring eyes, ground and/or incised into the stone, simple in conception but powerful in the haunting fixity of their gaze (Figure 5). In some instances there is no immediate, at least to our sense, suggestion of a life form in the natural contours of the boulder; in other instances, the eyes enhance a purely naturally shaped stone which was clearly selected for its implicit recollection of a human or animal form. In the former instance, Abaj Takalik Monument 38 (Figure 6) is of the greatest interest in representing a possible initial stage of the "potbelly" boulder sculpture tradition. These rotund sculptures, commonly representing human subjects, are known from many sites in Pacific Guatemala and beyond. At present the

16

largest corpus of these sculptures on the Pacific piedmont derives from Abaj Takalik where they range from extremely primitive boulder sculptures through true sculptures in the round, works of increasingly naturalistic conception and technical execution. In Monument 38 concentrically incised ovoid lines represent the eyes of a now greatly damaged boulder which crudely suggests the potbelly theme. Modification of the fortuitous natural shape of the boulder appears to have been minimal, or nil.

In contrast to Monument 38, Monument 41 (Figure 7) illustrates rough shaping and modification of the boulder form through coarse hammer dressing of much of the surface. The head of the figure is indicated here by simple facial features as well as eyes, with no indication of a neck to differentiate the head from the body and with no attempt at the development of a naturalistic torso, the body being suggested only by primitive ''belly clasping'' arms.

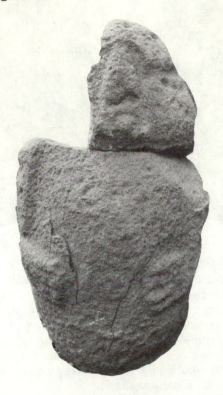

Figure 7. Abaj Takalik Monument 41.

The early boulder sculptures represent zoomorphic as well as anthropomorphic themes, both of which follow similar developmental and stylistic histories. One of the better preserved and elaborated examples of the former is Abaj Takalik Monument 6, the upper portion of which was exposed in the bed of a road cutting through the archaeological ruins (Miles 1965:Figure 10b). This boulder, of substantial size, was removed to the National Museum in Guatemala City a dozen years ago where it may be seen today. The late S. W. Miles, responsible for the rescue of the monument, stated ''the small sample of pottery from fill over and around the head is early to middle Preclassic'' (*ibid.*:247), and while this does not constitute sufficient evidence to place the sculpture in an early stratigraphic level, the suggestion that the sculpture may have occurred in an early context is enhanced by the fact that the road level from

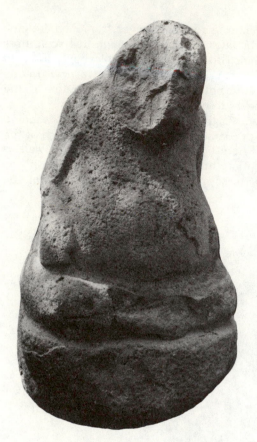

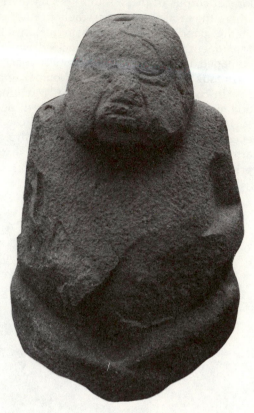

Figure 8. Abaj Takalik Monument 2. Figure 9. Abaj Takalik Monument 40.

which the carving derives cuts very deeply into the archaeological deposits of the ruin in this area. While Monument 6 shows no modification of the boulder's form, reliance being placed upon incising and grooving to suggest an amphibian head (with additional features), other zoomorphic boulder sculptures such as Monument 47 have partly dressed surfaces, some shaping, and rudimentary indications of limbs. This sculpture, a much more advanced conception, represents a toad or frog, an important sculptural theme in Pacific Guatemala, and reflects a careful search for a boulder form of an appropriately suggestive natural shape.

Other carvings in the potbelly tradition display increasingly well executed dressing of the stone with the head becoming increasingly differentiated from the body by a neck, with shoulders and chest becoming ever more distinguishable from the belly although arms continue to be primitive, "belly clasping" appendages (Figures 8, 9, and 10). Legs now appear, sometimes simply wrapped around, sometimes crossed, and gradually moving beneath the body in a more anatomically feasible conception of supporting the seated figure. Finishing and anatomy become ever more accomplished, the limbs in increasingly high relief, legs and buttocks in some cases even being finished on the underside. The developmental series grades into typically Olmec conceptions of the cross-legged, seated figure. Clearly in this respect it is well to recall the Sin Cabezas sculptures, masterful works of indisputable classic Olmec style of which Sculpture 3 is a strikingly unmistakable potbelly (Figure 11).

While it is not claimed that this is necessarily an unalterable sequence of devel-

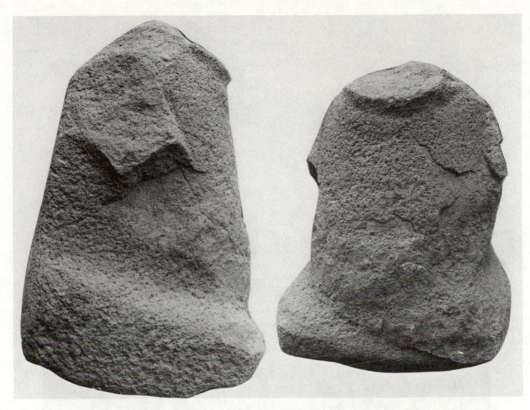

Figure 10. Abaj Takalik Monument 46, side and front views.

opment which proceeded along identical and precise lines everywhere in Pacific Guatemala where boulder sculpture and early Olmec carvings are found, it is argued that a general and overall sequence of development is represented which accounts at the very least in part for the emergence of some typically Olmec sculptural forms.[6]

One example of "sculptural stratigraphy" from Abaj Takalik providing independent support to the developmental schema discussed above is Monument 40 (Figures 9 and 12). This is a potbelly sculpture of an advanced type in the sense that very little of the original boulder form has survived. What has survived, however, in this otherwise carefully dressed carving is an old, unprepared surface on the back of the potbelly head. Here the distinctive "staring eyes" of the simple, earliest type of Abaj Takalik boulder sculpture may be easily discerned. These antique features obviously were valued, perhaps even revered by those who later so thoroughly and finely dressed the stone, and thus were carefully preserved.

To conclude this necessarily brief and highly compressed survey, it is reiterated that Pacific Guatemala and its immediate neighbors constitute a primary cultural region of Mesoamerica whose complex and crucially significant history is only beginning to be perceived in some of its broader outlines. The enormous corpus of

6. The interpretation of some boulder sculpture as antecedent to Olmec style was advanced by the late S. W. Miles (1965) in the first and to date only broad attempt to synthesize the sculptural history of Pacific and highland Guatemala and Chiapas. Her study was extremely insightful in many respects, deserving far more serious attention than it was accorded in its time. It is now necessary, of course, to revise substantially much of Miles' sequence as the increasingly complex history of the area is gradually coming to light.

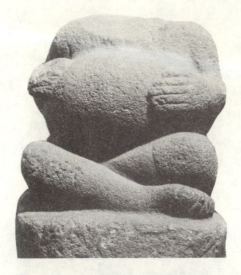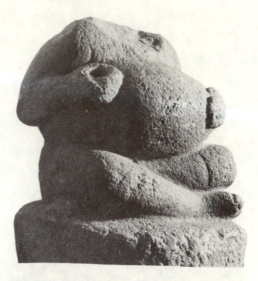

Figure 11. Sin Cabezas Sculpture 3.

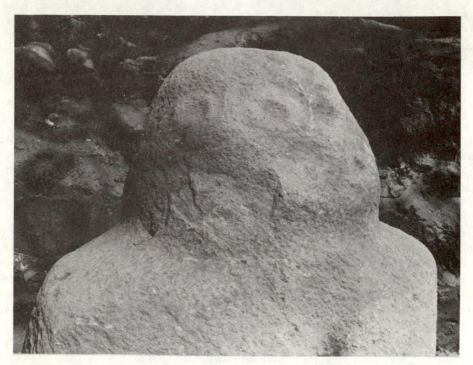

Figure 12. Abaj Takalik Monument 40, showing surviving details of earlier carving.

Although potbelly boulder sculptures were still being reset in very late pre-Columbian times, no student today familiar with the archaeology of Pacific Guatemala disputes the carving of these monuments as early as the middle to late centuries of the first millennium B.C. Some students, however, have believed the sculptures to be derivative and provincial to Olmec style, holding that their age of creation was synchronous with the age of placements in the archaeological contexts of this period at certain sites. These views can no longer be considered plausible in the context of the archaeological remains at Abaj Takalik.

20

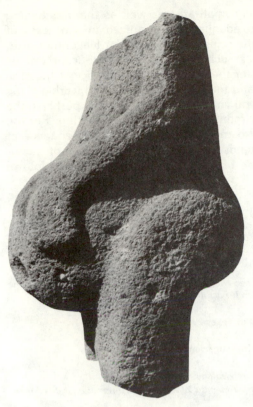

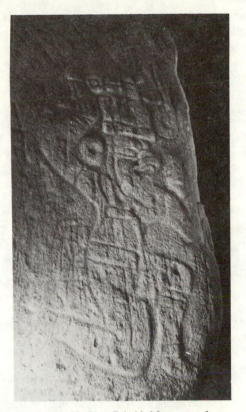

Figure 13. Abaj Takalik Monument 33.

Figure 14. Abaj Takalik Monument 1.

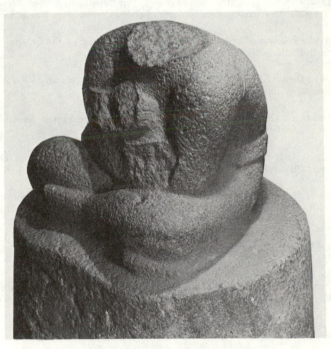

Figure 15. Sin Cabezas Sculpture 1.

21

sculptural art to be found within this relatively small area as well as the outstanding quality of many of the works has not been adequately recognized in syntheses of Mesoamerican culture history. In addition, the region is unique in at least one sense: no other major sculptural province possesses such a diversity of significant artistic styles. Among the factors partly accounting for the sculptural significance of the area are the abundance of local stone readily at hand for experimentation and working, the apparently very lengthy history of sculptural art in the region, and perhaps the strategic cultural crossroads location and environmentally rich natural setting. For the present at least, it is the first region of Mesoamerica in which a likely sequence of sculptural development is present which extends from the very beginnings of monumental stone carving through the emergence of one of the most famous sculptural styles, the Olmec.

Bibliography

Canaday, John
 1980 *What is Art?* New York: Alfred A. Knopf.

Clewlow, C. William, Jr.
 1974 "A Stylistic and Chronological Study of Olmec Monumental Sculpture." *Contributions of the University of California Archaeological Research Facility,* No. 9.

Coe, Michael D. and Richard A. Diehl
 1980 *In the Land of the Olmec.* Austin: University of Texas Press.

de la Fuente, Beatriz
 1973 *Escultura Monumental Olmeca.* Instituto de Investigaciones Esteticas, Mexico.

Graham, John
 1977 "Discoveries at Abaj Takalik, Guatemala." *Archaeology,* vol. 30:196-7.
 1979 "Maya, Olmecs, and Izapans at Abaj Takalik." *Actes du XLII Congrès International des Américanistes.* Paris, 1976. Vol. VIII:179-188.

Graham, John, Robert F. Heizer, and Edwin M. Shook
 1978 "Abaj Takalik 1976: Exploratory Investigations." In *Studies in Ancient Mesoamerica, III:* University of California Archaeological Research Facility Contribution No. 36:85-114.

McDonald, A. J.
 1977 "Two Middle Preclassic Engraved Monuments at Tzutzuculi on the Chiapas Coast of Mexico." *American Antiquity,* vol. 42:560-566.

Milbraith, Susan
 1979 "A Study of Olmec Sculptural Chronology." *Studies in Pre-Columbian Art & Archaeology.* No. 23. Washington: Dumbarton Oaks.

Miles, Susanna W.
 1965 "Sculpture of the Guatemala-Chiapas Highlands and Pacific Slopes, Associated Hieroglyphs." *Handbook of Middle American Indians,* vol. 2:237-275.

Navarrette, Carlos
 1974 "The Olmec Rock Carvings at Pijijiapan, Chiapas, Mexico, and other Olmec Pieces from Chiapas and Guatemala." *New World Archaeological Foundation; Papers,* No. 35.

Parsons, Lee A.
 1981 "Post-Olmec Stone Sculpture: The Olmec-Izapan Transition on the Southern Pacific Coast and Highlands." *In* E. P. Benson, ed. *The Olmec and Their Neighbors.* Washington: Dumbarton Oaks.

Shook, Edwin M.
 1950 "Tiquisate Ufers Scoop Archaeological World, Find Ruined City on Farm." *Unifruitco,* August, pp. 62-63.

Shook, Edwin M. and Robert F. Heizer
 1976 "An Olmec Sculpture from the South (Pacific) Coast of Guatemala." *Journal of New World Archaeology,* Vol. I, No. 3.

Stirling, Mathew W.
 1965 "Monumental Sculpture of Southern Veracruz and Tabasco." *In* Robert Wauchope and Gordon R. Willey, eds. *Handbook of Middle American Indians,* vol. 3:716-738. Austin: University of Texas Press.

A Possible Cycle 7 Monument
From Polol, El Petén, Guatemala

Gary W. Pahl
Anthropology Department
San Francisco State University

The developmental locus for Maya iconography and writing is a subject of some conjecture and debate in Mesoamerican studies. The present reevaluation of a very early Maya altar from the site of Polol in the Petén region of Guatemala hints that this lowland area, so artistically and intellectually advanced during the Classic period, may have figured in a seminal capacity during a much earlier epoch.

THIS REPORT TOUCHES on an aspect of a fascinating and, as yet, unresolved issue in Mesoamerican studies, the locality or localities that gave rise to Mesoamerican hieroglyphic art: the calendric and writing systems. Six recently published reports emphasize the Veracruz and central Chiapas regions as promising candidates, each having examples of monuments which their Long Count inscriptions date quite early (Coe 1976: 107-122). Alternatively, Abaj Takalik on the Pacific Coast of Guatemala has most recently been addressed as a promising area for early examples of the Mesoamerican Long Count calendar system (Graham 1978: 90-91). However, the present paper draws attention to the southern Guatemalan lowlands of the Petén as an early contributor to, or at least participant in, calendric development.

In the summer of 1979, discussions with Edwin Shook in Antigua, Guatemala, led to a reexamination of the carved monuments of Polol, El Petén, Guatemala. Shook had studied and recorded these monuments for Sylvannus Morley during the latter's study of the inscriptions from the Maya area, a study that culminated in the voluminous *Inscriptions of the Petén* (1937-1938). Shook related that many of the monuments had not been adequately recorded even though C. Lundell (1934), the first European discoverer of the site, as well as Morley (1938) and Tatiana Proskouriakoff (1950) had published and illustrated several Polol monuments. One monument in particular was indicated by Shook as requiring serious study: Altar 1. Lundell (*op. cit.*: 181) referred to Altar 1 as "Stela 6," assuming it to be the upper portion of the (fragmentary) stela. But Shook reclassified the monument as an altar (Morley *op. cit.*: 402).

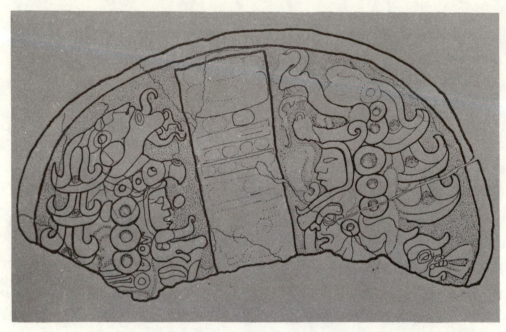

Figure 1a. Composite drawing of Altar 1 from Polol with raking light assist.

Representations of Altar 1 have likewise been of varying degrees of fidelity. Lundell did not include an illustration of Altar 1 in his work on Polol, whereas Morley published a rough sketch (1938, Figure 132), from a photograph supplied him by Shook. Morley had, purportedly, never seen the monument or visited the site. Proskouriakoff published Shook's photograph of the altar (1950: Figure 36d).

Morley made note that he assigned the monument to the "Early Period," but offered no reading of the date on it, which is, admittedly, in a poor state of preservation (*loc. cit.*). Nevertheless, Proskouriakoff was interested in Altar 1 as a potentially early monument (*op. cit.*: 110). She noted the faults in Morley's drawing, but indicated that the date could nevertheless be pushed back possibly as early as Cycle 8,* based on the stylistic elements it shares with other monuments known to be of the eighth cycle.

* The ancient Lowland Maya employed a calendric dating system we call the Long Count. In effect, it is a tally of years just as is 1982 in our dating system. That date means that one thousand, nine hundred, eighty, and two years have elapsed since our zero date—the birth of Christ. The Maya used a similar method of counting, but one which involved a different year series and a different zero point (presently dated at 3114 B.C.). To determine the year in a Maya inscription one reads the glyphs from left to right, and top to bottom. The greatest period in the Maya Count is the Baktun, a period of 144,000 days. It is followed by the Katun which is made up of 7,000 days. Next is the Tun of 360 days—an approximate solar year. After the Tun is the Uinal, a 20-day "month." Last is the Kin, a single day. Each of the Long Count glyphic periods is accompanied by either a numerical coefficient or a zero sign. A numerical coefficient of eight beside the Baktun glyph indicates that 144,000 is to be multiplied by eight to arrive at the proper Baktun reading. Each succeeding period is multiplied by eight to arrive at the proper Baktun reading. Each succeeding period is multipied by its coefficient and all the resulting days totaled. These are then divided by the number of days in a solar year to produce a year date in the Maya system.

For our convenience, we record Maya dates using decimal points. For instance, a period of 8 Baktuns, 16 Katuns, 5 Tuns, 6 Uinals, and 2 Kins is written 8.16.5.6.2, which refers to a specific date in the Maya calendar. Very often, we refer to Maya monuments by the Baktun coefficient only. For historical and mathematical reasons, all Maya monuments fall within Baktuns 7, 8, 9, or, rarely, 10. When we do refer to Maya dates by the Baktun only, the term "Cycle" is usually preferred to "Baktun."—A.C.-C.

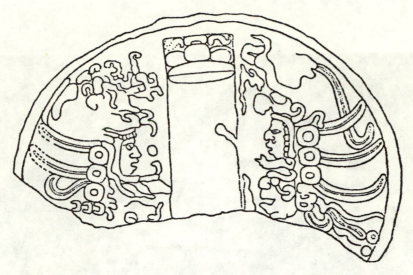

Figure 1b. (After S. G. Morley 1938, Figure 132) Morley's rendition of the surface of Altar 1 of Polol, El Petén, Guatemala.

The author's examination of the altar in July 1979 and summer 1980 was undertaken with a variety of lighting conditions for optimal detail during photography. A series of black and white photographs was taken both in daylight and with raking light at night. Additional photos were made with the stone doused with water in hope of revealing more detail. The same series was taken with color film. The detail revealed in the photos and subsequent observations allowed the author to develop a line drawing which displays more detail than Morley was able to extract in his drawing. During the 1980 season a latex mold of the altar was made so that a cast of the monument could be studied under more controlled light situations. Again, newly revealed details were checked with the composite drawing of the piece. Even with these efforts to reveal details of the iconography and of the calendric text running down the center of the monument, a clear reading of the calendric data remains difficult. A comparison of Morley's drawing and a 1980 composite drawing shows the increase in detail that was achieved (Figure 1a *vs.* Figure 1b). Photographs of the altar along with a photo of the rubbing made from the cast taken of the monument are included for comparison (Figures 2 and 3).

The central column of calendric material on the face of the monument separates two standing figures in profile facing each other. The altar is broken in half, roughly at chest level of the profiled figures. Nonetheless, it is clear that both individuals are in ornate costume. The fragmentary monument measures 66 cm across its diameter, 25 cm at its thickest point, and its greatest height from break line to the top is 28 cm, as cited by Morley (*loc. cit.*). Morley felt that there was enough detail available in the upper portion of the central column to identify an Initial Series Introductory Glyph, but it is equally possible that the cartouche form, faintly visible under raking light, may be a month patron headform. The Baktun position and the remaining calendric text are well worn, but a portion of a large dot just to the right of center in the column is positioned over the faint bar so that a reading of Cycle 7 might be suggested. The dot is not centrally located and thus the number cannot be a six or an eight. A nine reading seems out of the question because the dot is too large to allow room for the other three dots necessary for a nine notation. This does push the

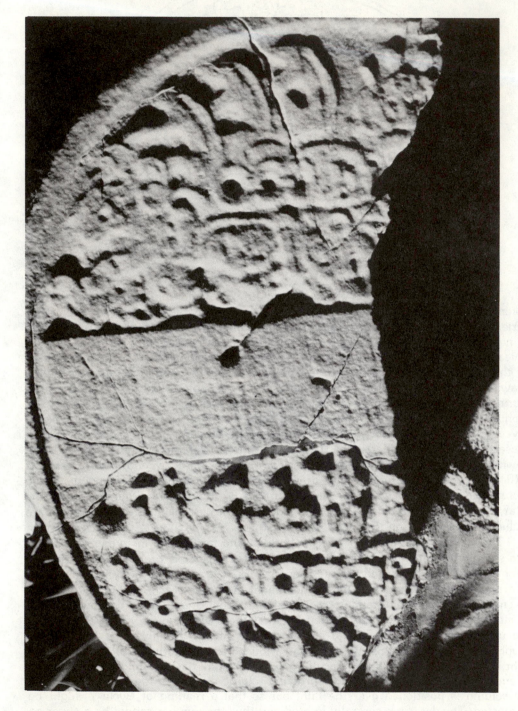

Figure 2a. Photograph of the face of Altar 1 from Polol.

Figure 2b. Detail of the central calendric column of Long Count information from Altar 1 at Polol.

proposed age of the monument back a position from the Cycle 8 offered by Pros-kouriakoff. (Details of the iconography on the monument are enumerated in Table 1.) To avoid reading bias into the already vague text, a second reading of the text was requested of John Graham from the University of California at Berkeley. The author did not reveal his opinions, so as not to prejudice the second reading. Graham cor-roborated the author's interpretation by observing that the best reading might be Cycle 7 (personal communication, 1980).

Interestingly, it was Graham who, in his earlier analysis of the Altar de Sacrificios inscriptions, had proposed the Polol altar be used as a potential piece of evidence to suggest the Lowland Maya region itself as one of the places of origin of the Maya sript, calendrics, and art style. Now, with the author's additional possibility of Cycle 7 reading for Polol Altar 1, that observation is further strengthened.

Michael Coe has devoted considerable attention to the question of the locale or locales of origin for Maya writing and calendrics with a cited predilection for the Veracruz and Central Chiapas area (1957:597-611; 1976:107-122). However, his com-pilation of early dates suggests an ever broader geographic region for early calendric development (Table 2). Now with the addition of Altar 1 from Polol as a possible Cycle 7 monument, the area encompassed by known Cycle 7 monuments must be enlarged. Unless the altar from Polol was imported from as far off as Chiapas, Veracruz, the Pacific littoral, or highland Guatemala, the Lowland Maya area should be considered again as a contributor to the developing system of Mesoamerican writing, calendrics, and iconography.

This in no way resolves the issue revolving around the practice of writing and calendric notation, but it adds another perspective. A model for development of the system which might be entertained more attentively is one in which all of the major regions with Cycle 7 and Cycle 8 monuments and iconography are considered rela-tively coequal in terms of their input into the evolution of such a system. The Gulf Coast, the Pacific littoral, the Maya Lowlands, and the Chiapa de Corzo vicinity were all operating under an umbrella of a fairly common *Kultur-Kreis* which Coe (1976:121)

Table 1: Inventory of Details in Altar 1

Details shared by both figures -

1. drilled and carved ring earspools hanging as a chain from the headdress.
2. numerous centrally drilled rings and elements in the context of the headdress.
3. omega-form flaps probably representing cloth flaps in tiers appended to the headdress.
4. punning with line resulting in double and triple entendre headforms of zoomorphic creatures. Olmec culture revelled in such iconographic line play to blend traits of deities, but this is also typical of early Maya iconography associated with texts.
5. Each figure has a characteristic nose-bead although the figure on the right has an eroded area which might indicate the form of a mask floating in front of its face. The nose-bead appears on the earliest known text-accompanied monuments from the Pacific Coast (Abaj Takalik Stela 2) and in the Guatemala Highlands at Kaminaljuyu (Stela 10). It is a part of the Leyden Plaque figure's costume, which dates to Cycle 8 and the Early Classic Period.
6. Pendant heads hanging from the waist level in the form of a bustle attachment may be present on both the right and left figure but the bustle on the left-hand figure is not visible as that part of the monument is broken off. The right-hand figure has a bustle pendant-head which is in the shape of a skull with two bands coming from its mouth (speech symbols?). The figure on the right also has a large head hanging as a chest or neck ornament. The figure on the left has an eroded tri-lobed neck ornament. The bustle head-form appears clearly on Stela 10 at Kaminaljuyu (Coe, M. 1976, fig. 10) and on the Leyden Plaque figure. This ornament, however, becomes a popular motif during the Classic Period.

Table 2: Sites with Cycle 7 monuments and Cycle 8 monuments within Mesoamerica

Chiapas	Long Count Date	Christian Correlation
Chiapa de Corzo Stela 2	(7.16) 3.2.13 6 Ben	37 B.C.
Veracruz		
Tres Zapotes Stela C	7.16.6.16.18 6 Etznab	33 B.C.
Tuxtla Statuette	8.6.2.4.17 8 Caban	A.D. 162
Pacific Coast of Guatemala		
El Baul Stela 1	7.19.15.7.12 12 Eb	A.D. 37
Abaj Takalik Stela 2 (M. Coe 1976) (J. Graham 1978)	7. ? 7.16.19.17.19.1.19.17.19	? 18 B.C.-235 B.C.
Highlands of Guatemala		
Kaminaljuyu Stela 10	7. ?	?
Lowlands of Guatemala		
Tikal Stela 29	8.12.14.8.15 (1st EG)	A.D. 292
Leyden Plaque	8.14.3.1.12 1 Eb	A.D. 320
Uaxactún Stela 18	8.16.0.0.0 (1st lunar ser.)	A.D. 357
Balakbal Stela 5	8.18.10.0.0	A.D. 406
Polol Altar 1	7.9? (19?).9?(14?).?	A.D. 22-

observes shared a Maya language base. This cultural commonality undoubtedly promoted a high enough information exchange level to accommodate a "leap frog" evolution of the calendric and writing systems over time as they were transmitted and modified from region to region within the greater cultural system of Mesoamerica. The difficult task with which Coe wrestles, apart from a continuous search for the earliest example of the writing, is the accurate tracing of its evolution as it mushroomed at different rates in distinct regions. Joyce Marcus (1976:29) probably best touches on logical antecedents of the Long Count system with her discussion of Monte Alban in the Valley of Oaxaca with its stelae (12 and 13) bearing bar-dot notations and other glyphic data which may date to as early as 450 B.C.

An interesting question that must be posed when considering the broad contributive area, which gave rise to Maya and other Mesoamerican writing, concerns the source of the Polol Altar 1 inscription.

It is quite possible that the monument may not have been carved at Polol or by the local scribes. As an alternative supposition to local carving of the monument, Graham (personal communication, 1980) has suggested that it may have been pirated from an outside site during a raid or imported as an antique from an earlier Petén site or some distant locale. It is remotely possible that an artist was commissioned to perform the carving at Polol during the Cycle 7 period. The latter seems highly unlikely, however, considering the type of data recovered from the Polol excavations.

Three months of field excavation at Polol, in search of Preclassic material to corroborate the proposed Cycle 7 date for Altar 1 and to produce answers to a series of related questions about the site, yielded no satisfactory proof of Preclassic occupation. In fact, to date, it appears that even the Early Classic occupation is quite sparse at Polol. The site is predominantly Late Classic. Seibal, a larger neighboring site to the south, and Lubaatun to the east, similarly experienced great population density during the Late Classic and sparse occupation during the Early Classic (Norman Hammond, personal communication). Weak, if any, indications of the Preclassic are present at Lubaantun, while Seibal experiences a limited Xe-Real* occupation. Unfortunately, these finds are not conclusive support for a similar situation at Polol. Further testing and the processing of Carbon 14 and obsidian hydration samples from Polol may alter this situation.

Considering the lack of Preclassic material at Polol, the best interpretation for the presence of Altar 1 with such an early date is that the monument was carried to the site during the Late Classic Period as a result of the exploits of a local Maya noble.

In order to establish the altar's provenience, a study of the limestone in the altar, in other Polol monuments, and limestone from the site in natural outcrops is being pursued. If limnological testing can indicate the source of the Polol material, at least a portion of the question can be answered.

Descriptions of the Altar

The monument is most accurately described as an altar rather than a stela fragment. The shape formed by the top or face of the extant portions of the monument encompasses more than 180 degrees and thus is greater than a half-circle. This suggested circular shape precludes the monument's interpretation as a stela. The face of the monument is well worn and has evidently suffered from "milpa" burning because the surface detail is broken by heavy cracks and crazing. The limestone from the monument is good homogenous quality and is of sufficient hardness so that it has withstood total obliteration. Fortunately, no portions of the surface have exfoliated.

The style of the monument falls within the parameters of known Early Classic and Preclassic monuments. Like Abaj Takalik Stela 2, the scene on the face of the altar depicts two ornately clad individuals facing each other across a central column of Long Count information. The suggested reading of the Baktun position as Cycle 7 does comfortably parallel the reading and scene depicted on Abaj Takalik Stela 2. The Polol ISIG** position and form are vaguely visible with raking light both on the monument and on a plaster cast of the monument made from a latex mold in 1980.

The headdress of the left figure on Altar 1 incorporates a deer's head at the uppermost level, while a saurian monster below borrows the deer's round cheek as its eye. A beaked avian or saurian creature forms the lower stage of the headdress and its maw opens to envelop the emerging head of the human wearer. The headdress of the figure on the right is greatly eroded; nonetheless, an interpretation of its component parts can be suggested with some certainty. A dragon head with curling snout forms the upper tier of the headdress while the gaping jaws of another monstrous head open to envelop the human face of the wearer. This latter might be a jaguar.

Conclusion

The discovery of a possible Cycle 7 monumental inscription in the southern Maya Lowlands at Polol, El Petén, Guatemala, rekindles the controversy concerning the

*Xe-Real is a pottery type dating to the Preclassic Period at Seibal. — A.C.-C.

**ISIG is a standard abbreviation for "Initial Series Introducing Glyph." — A.C.-C.

origin and spread of the Maya writing and calendar systems. Although the Cycle 7 date for Polol Altar 1 remains somewhat tenuous due to the monument's uneven preservation, the iconography indeed supports such an early reading. In fact, the iconography alone places Altar 1 among the earliest known Maya carvings in the Petén. Therefore, it seems that the Petén is a strong contender as a generative locus for one of the ancient Mesoamerica's highest achievements: written communication.

Bibliography

Coe, Michael
1957 "Cycle 7 Monuments in Middle America: A Reconsideration." *American Anthropologist* 59: 597-611.

1976 "Early Steps in the Evolution of Maya Writing." *In* H.B. Nicholson, ed. *Origins of Religious Art and Iconography in Preclassic Mesoamerica*. UCLA Latin American Center Publications. Pp. 107-122.

Graham, John
1972 *The Hieroglyphic Inscriptions and Monumental Art of Altar de Sacrificios*. Papers of the Peabody Museum of Archaeology and Ethnology, vol. 64, No. 2. Harvard University.

Lundell, C.
1934 *Ruins of Polol and Other Archaeological Discoveries in the Department of Petén, Guatemala*. Washington, D.C.: Carnegie Institution of Washington, Publication 436, Contribution 8.

Marcus, Joyce
1976 *Emblem and State in the Classic Maya Lowlands: An Epigraph Approach to Territorial Organization*. Washington, D.C.: Dumbarton Oaks, Trustees for Harvard University.

Morley, Sylvannus
1937- *The Inscriptions of the Petén*. Washington, D.C.: Carnegie Institution of Washington, Publica-
1938 tion 437. 5 vols.

Proskouriakoff, Tatiana
1950 *A Study of Classic Maya Sculpture*. Washington, D.C.: Carnegie Institution of Washington, Publication 593.

Acknowledgments

The writer would like to acknowledge the support of EARTHWATCH in financing the major portion of the 1980 field season in Polol. Additional support was gratefully received from a faculty research grant given by San Francisco State University, Mr. Sam Young, and other donors. A particular note of thanks is extended to TAP Plastics for their donation of latex and moulding materials and to a most cordial Guatemalan host, Señor Enrique Peña who helped the writer and the project through practically every phase of its conduct. He offered housing in Guatemala and the Petén, the use of a Landrover, and the benefit of his contacts in Guatemala City and the Petén. Lic. Polo Sifontes, Director of the Instituto Nacional de Antropología e Historia de Guatemala, facilitated the issue of the contract for work at Polol and gave every extra consideration to the needs of the project and its research goals.

The Maya Cauac Monster's Formal Development and Dynastic Contexts

Carolyn Tate

Maya iconography is perhaps the richest in all of pre-Columbian art. Motifs are complex and meaning is multi-faceted. As an agrarian society, the ancient Maya believed the earth to be especially venerable. It was a transformational zone for energy of many sorts, including vegetal, mineral, and human. A special motif, known as the Cauac Monster, appears to have been an animated concept of the devouring and regenerative earth. This jaguarian anthropomorph became symbolic of the Maya aristocracy, standing as both an intercessor between secular and divine beings, and as an emblem of legitimacy of rulership. Herein, the evolution of the Cauac Monster iconography is explored.

THE KEY TO UNDERSTANDING the symbolism of Maya art lies in the comprehension of the contexts in which particular elements are portrayed. Therefore, this study of the Cauac Monster (CM) began with a compilation of fifty CMs from stelae, pottery, architectural sculpture, jade, and carved bone, and a tabulation of all the associated figures and glyphic statements that occurred with the CM. It was apparent that the CM was used between the Maya dates 9.2.0.0.0 and 9.19.10.0.0 (A.D. 475 and A.D. 820)[1] in scenes of dynastic succession or legitimacy, in Underworld scenes of sacrifice, or in scenes of the reception of a ruler into the Underworld.

CM imagery was used in several compositional functions (Taylor 1979). On altars, stelae, and pottery, it formed a pedestal for a ruler. On architectural façades and roof-combs, the CM mask animated a zone of the building, its upper teeth framing the doorway so that entrance into the temple was accomplished by passing into the mouth of the CM. In the Late Classic period, 9.13.0.0.0-10.1.0.0.0 (A.D. 600-900), the Cauac Monster mask was sometimes used in stacks to border or enclose a scene as an indicator or place.

1. Maya dating is used throughout this paper to retain the inherent calendrical rhythms in the development of sculptural style and iconography. Correlations with Christian dates use the Goodman-Thompson-Martínez correlation.

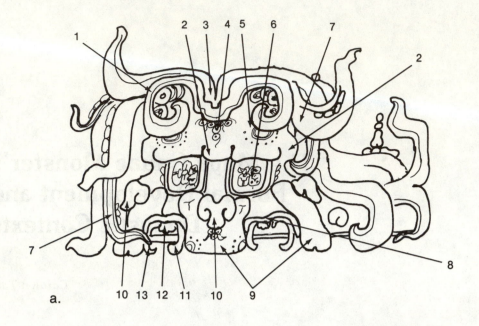

a.

Key to Figures 1a and 1b:
 1. Step-curl
 2. Lobed forehead
 3. Cleft
 4. "Bunch of grapes"
 5. Dotted crescent
 6. Eye
 7. Vegetation
 8. Upper lip
 9. Snout or puffy upper lip
10. Nostril
11. Fang
12. Molar
13. Curling "fish barble"
14. Ear or curling horn
15. Oval earplug
16. La pendant
17. Triad of circlets

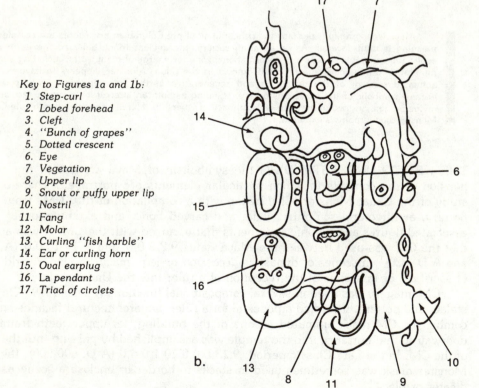

b.

Figure 1. Element identification of the Late Classic Cauac Monster.
 a. Temple of the Foliated Cross Panel, Palenque CM detail, ca. 9.13.0.0.0 (A.D. 692). After Schele, 1976:54. b. Copan Stela B, side detail showing CM. Dated 9.15.0.0.0 (A.D. 731). After Maudslay, 1902. c. Bonampak Stela 1, base detail. 9.13.0.0.0 (A.D. 692).

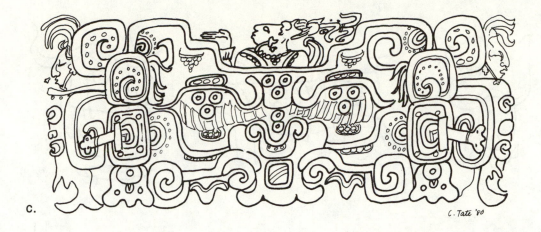

c.

C. Tate '80

The CM is a wider than high, two-dimensional portrayal of a being that a twentieth-century observer can only term imaginary. Thus the word "monster" is used for this image composed of animal, human, and some abstracted features. It is called "Cauac" because of the presence of the T528* or *Cauac*[2] day sign glyphic components that appear on various areas of its visage.

What is the relation of the Cauac Monster or composite animal mask to the accession of Maya rulers and to the Maya Underworld? This paper addresses these questions by means of a chronological summary of the formal development of the CM and the contexts in which it was employed.

Several types of bodiless composite heads are found in Maya art. However, I have considered as a CM only those heads which exhibit the T528 elements or a step-curl forehead (Figure 1a,b,c). In addition to this unique forehead, the CM is endowed with one of six varieties of eyes—each an iconographical unit. The *Ix* eye incorporates the day sign *Ix*, a reference to the jaguar.[3] Eye form T606 may refer to female ancestry (Schele 1978:commentary of the Palenque Temple of the Foliated Cross Panel at 0 12).[4] The other eyes are vegetation, darkness or water symbols (Figures 2a-f).

The frontal Cauac nose is simply a curling line describing the nostrils and septum, which droops well below the lower edge of the nostrils. This elongated snout hints at the profile monster's lengthy, puffy upper lip. The CM's face is seldom completed by a lower jaw. Its upper jaw is frequently interrupted in the frontal image by an extension of the snout. Otherwise, a broad central tooth and fangs proceed from the upper jaw, and a spiral element emanates from the corners of the mouth. Exceptions to the agnathic visage are mostly on Middle Classic images, before the standardization of the Cauac vocabulary of forms.

* J. Eric S. Thompson's 1962 *A Catalogue of Maya Hieroglyphs* organizes the glyphs numerically for standard reference (the "T" prefix is for Thompson)—A.C.-C.

2. Yucatec *Cauac* has cognates in other Maya languages (Taylor 1979:79). It is translated as thunder and lightning, and sometimes rain (Thompson 1971:87).

3. On the day *Ix*: "The fierce jaguar. Bloody is his mouth, bloody his claws. A slayer as well, devourer of flesh. Killer of men " (Barrera-Vasquez 1943, First Kaua List).

4. Maya glyphic texts are designated with letters and numbers. The letters label vertical columns and the numbers indicate the horizontal rows. The reading order proceeds horizontally across two columns (e.g. Row 1, A & B) then transfers down to Row 2, A & B, Row 3 A & B, etc. When the vertical columns A and B are exhausted, reading continues downward in pairs in columns C & D, then E & F, etc. There are occasionally exceptions to this rule.

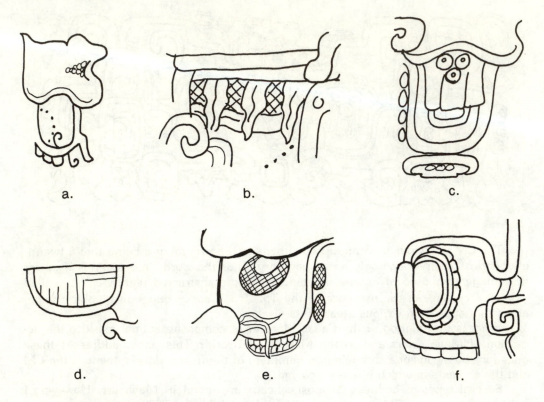

Figure 2. Cauac Monster eye variants.

a. Spiral eye (*Black Background Vase*); **b.** Vegetative Eye (*Tzakol Tripod*); **c.** Ix eye (*Copan Stela B, side*); **d.** Perforator eye (*Copan Jade, Early Classic*); **e.** Cross-hatched eye (*Palenque Intaglio Relief*); **f.** Dotted arc eye (*Piedras Negras Altar 4*).

In the Pacific coastal region of Guatemala and southern Mexico the sculptures of Izapan art are formal precedents for Early Classic Maya art (Quirarte 1977). Long-lipped supernaturals appear on Izapa Stelae 3 and 50 (Norman 1973:Plate 50) among others. This long-lipped trait was identified as an image of water suppliers (Parsons 1972) and later developed into the Maya rain god or Cauac Monster, and the Post Classic Chac (Quirarte *op. cit.*). Abaj Takalik Stela 4, which dates to the Early Proto-classic, contains a supernatural creature clearly antecedent to the CM. The lower third of the stela is carved into two profile images of a creature whose gaping mouth is filled with water (Parsons *op. cit.*). Their heads are described by a thick line that creates a lobed, sloping forehead terminating at the back of the head in a curl. This form is used to depict profile CM foreheads into the terminal Classic period (Coe 1978:11, Figure 10f. On Abaj Takalik Stela 4, a serpent is shown emerging from its source — a U element in a cartouche — and writhing upward to emit a face-upward human head from its mouth. I feel this is an example of the pre-Maya version of the generation of elite human life, a predecessor to the double-headed serpent that travels between sky and underworld. Quirarte defined these composite creatures as representations of the earth and sky (Quirarte *op. cit.*). He sees the double-headed serpent as a power-conferring entity rather than a symbol of regeneration. I agree that the serpent is a royal emblem, such as the ceremonial bar or manikin sceptre, and is power conferring; but I believe that it is associated as well with death and royal lineage (Schele 1974:59).

Izapa Stela 50 visually explains the process of revitalization via the serpent. A skeletal long-lipped profile figure is cradled into the stone form of the stela. From its midsection emerges an object like an umbilical cord. It spirals, then metamorphizes into a serpent, and is grasped by another, smaller figure who is depicted in action, full of vitality. The identity of the decaying skeleton is probably indicated by the Kan Cross in its headdress. The Kan Cross was used later as a title of the Maya God K, the deity of ancestry and royal lineage (Schele 1978:44).

These and other pre-Classic monuments such as Monte Alto Monument 1 (see Hunter 1974:28), indicate that precedents for the CM existed in the art styles and cultures antecedent to the classical Maya civilization. The long-lipped earth monster image spread to the limits of southern Maya civilization, from Uaxactún to the Pacific Coast, prior to the Classic Period. The puffy-lipped supernatural mask appeared on the earliest architectural creations of the Maya, as basal panels on pyramids at Tikal and Cerros (Friedel 1979:Figure 7), and as multi-level masks at Uaxactún (Figure 3a). Symmetrically arranged around the stairways, these supernaturals appeared on these early burial constructions. They do not bear the T528 elements that later identify the CM, but are similar in proportion and form to the CM and Olmec G I (see Joralemon 1976). They are bilterally symmetrical, have feline downturned mouths, a protruding upper lip, and flamelike eyebrows. On the mask facades of Tikal 5-D Sub and Cerros Structure 6B (Figures 3b, c), groups of the triple circlets which represented rain or water as seen on Chalcatzingo Relief 1 (ibid.: Figure 9b) appear on the central forehead crest of the long-lipped face. Elements of these early masks that occur subsequently on CMs are the volute below the eyes, an elongated upper lip or snout, large round or quincunx earplugs with a la dangle or knot (Schele 1979a:24), the curling horn elements, and, of course, the triad of circlets. These architectural masks are much more recognizably human in appearance than the later CM images. They resemble the long-lipped profile deity that appears on Tikal Stela 1 (cf. Coe 1967:92) and images of God K that can be found on Early Classic pottery during the reign of Jaguar Paw of Tikal, ca. 9.14.0.0.0-8.17.1.4.2 (A.D. 327-357; L. Crocker and D. Hales, personal communication 1979). So it was from long-lipped, earth-dynastic, deity images that the CM developed.

Prior to the appearance of the CM, the Maya represented at least two types of long-lipped deities, God K as a declaration of royalty, and an underworld, water-vegetation deity. The objects that bear God K iconography are luxury pieces such as jade and fine ceramic wares. A comparison of God K and CMs appears in Figures 4a-k. An example of Early Classic God K iconography is the well-known Leyden Plaque, a jade pendant celt inscribed with the date 8.14.1.3.12 1 Eb, seating of Yaxkin (ca. A.D. 320; Morley 1956: Plate 15). It displayed the contemporary ruling class iconography that transcended local boundaries. This tiny plaque is a summary of Maya monumental iconography during the Early Classic Period. It includes the symbols of dynastic authority: idols of the ancesters worn as pendant masks, the identification of the ruler as the living God K, a prone prisoner, a serpent staff, and a Long Count inscription, but it does not bear a single trace of the CM. Neither does a parentage statement appear in the inscription. The hieroglyphs record the birth of the figure that the celt immortalized, identify him as God K, and associate him with the territory of Tikal (Schele 1979:25).

Because the appearance of the CM is tied to Classic-style parentage statements at Tikal, a brief review of the dynastic history of that site during the Early Classic is in order. The ruler named on the Leyden Plaque is not named on any known monument from Tikal. The first ruler about whom information has been retrieved from glyphic

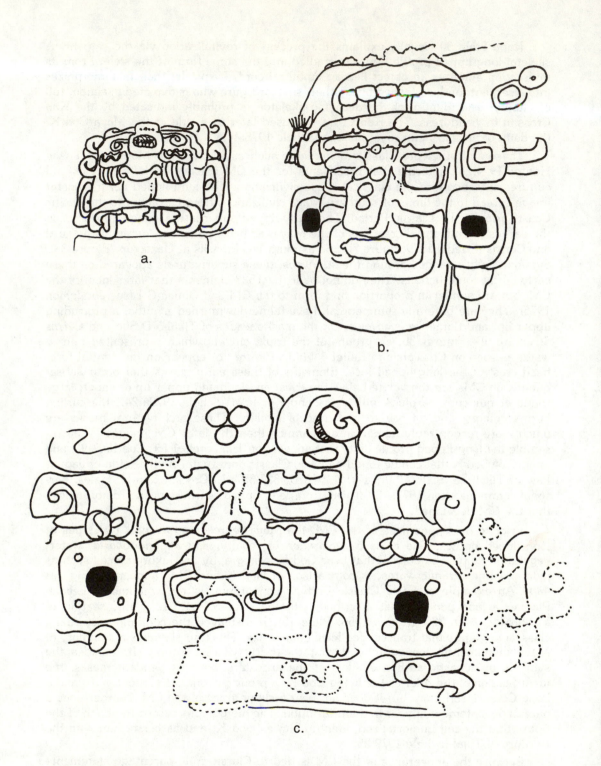

Figure 3. Pre-Classic Maya precedents for the frontal Cauac Monster mask panels from architectural façades.

 a. Uaxactún E-VII Sub(after Proskouriakoff 1963:5); **b.** Tikal 5 D-Sub (after Hunter 1974:48); **c.** Cerros Str. 6B (after Friedel 1971:46, photo).

statements on monuments and/or ceramics is called Jaguar Paw. Among the objects attributable temporally to the reign of Jaguar Paw are the Leyden Plaque and the Plate of Jaguar Paw Smoking (illustrated backwards by Robicek 1978: Plate 103). Both include early Lowland Maya images of God K. On the Plate of Jaguar Paw Smoking, the ruler is depicted with a skeletal lower jaw, probably indicating that the plate is a posthumous reference. The T281 Kan Cross glyph present under his image either indicates the ruler's identity as God K or that he is in the realm of God K—the ancestral Underworld. Thus the use of a specific ancestral long-lipped deity image, God K, began with the Early Classic, prior to the use of an iconographically complete CM.

During the reign of Curl Nose,[5] who succeeded Jaguar Paw on 8.17.2.16.17 (ca. A.D. 379; cf. Tikal Stela 4:E 7-F 11), the monument manufactured show strong influence from Teotihuacan (Coe 1967:101; Coggins 1979:48). Perhaps an unsettled social and political atmosphere caused by the influx of foreigners to the developing Maya center prompted the Maya rulers to begin to publicly declare their descent from a local ruler. Curl Nose's successor, Cleft Sky, 8.19.10.0.0—ca. 9.1.10.0.0 (A.D. 426-455; cf. Tikal Stela 31:H 6-G 9; L. Crocker and D. Hales, personal communication 1979) was the first known Tikal ruler to include a Classic-style parentage statement on his accession monument, Tikal Stela 31 (at B21-B26; cf. Coggins 1979:Figure 3-1). Somehow the Cauac concept was being formulated during his reign, for T528 variants appear as nouns, verbs, and titles throughout the clauses of Stela 31. Though Cleft Sky apparently did his utmost to establish his identity as a member of the Maya royal lineage on this monument, portraying himself in the traditional regalia with an image of his ancestor appearing above his head from a sky serpent, Teotihuacan political force must have been powerful enough to warrant the presence of two Teotihuacan-attired warriors on the flanking sides of the stela (Coggins 1979).

Cleft Sky's successor is not named on any of the known monuments dated to this period (Stelae 7, 13, 32). The pressure exerted by Teotihuacan around 9.1.5.0.0. — 9.2.0.0.0 (A.D. 460-475) may have prevented a local Maya member of the royal lineage from taking power or erecting monuments, or perhaps a dual role was in effect (Coggins 1980). Whichever the case, an incised blackware tripod vessel, now in a European collection, bears a glyphic parentage statement naming the son of Cleft Sky with ancestral recall to Curl Nose (Figure 5a).[6] This Tzakol phase vessel is incised with two images of the earliest known complete CM. The image relies on the frontal composite animal masks and ancestor image façades from Tikal and Uaxactún. The use of the elements of the Cauac day sign and Cauac-Shield title of Curl Nose as seen on Tikal Stela 31 as decoratively meaningful infixes identify this image as a CM.

The feature that most differentiates this CM from earlier ancestor images is its frontal step-curl forehead, which combines two profile views of the type of head shape found in the earth-water deity images of Izapan art with a typical Olmec cleft head. The ''corncob'' texture of the curling forehead appeared on a mask from Uaxactún, Mascarón #9, E-VII Sub. (Figure 3a). The vegetative eyes might be characteristic of the traits used in portraiture of Cleft Sky's successor, the protagonist named on the tripod vessel. A ceramic two-part effigy from this time period (Coe 1967:60), now in the Tikal Museum, has the same type of three-tendril eyes and could be an image of the unnamed Tikal ruler. Another aspect of the mask on the blackware tripod that

5. The names given to the ancient Maya rulers by modern scholars are nicknames based on the appearances of their hieroglyphic names and titles. Curl Nose is also known as Curl Snout (Coggins 1975) and Cleft Sky is also known as Stormy Sky, though his name glyph is a cleft T561, or sky, variant.

6. Dorsinfang-Smets 1977: Cat. #194.

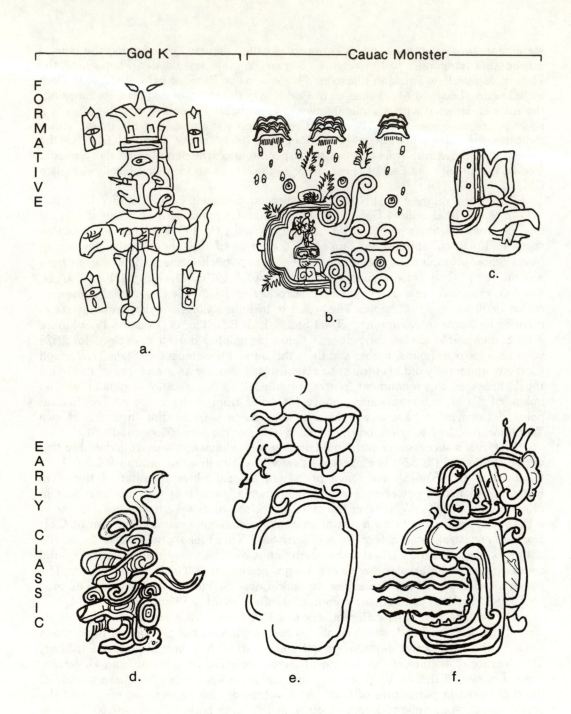

Figure 4. Chronological Comparison of Profile God K and Cauac Monster images.

a. Olmec incised jade celt from Arroyo Pesquero, now in the Museo de Antropología, Jalapa (after Joralemon, 1976: Fig. 8f) b. Olmec, Chalcatzingo Relief I (after Bernal, 1968:139); c. Olmec, image incised on the Las Limas Figure's right shoulder (after Joralemon, 1976: Figure 36); d. Tikal incised bowl depicting Jaguar Paw, ca. 8.17.0.0.0 (A.D. 386) (after Lin Crocker, private collection); e. Tikal Altar 4. One of four CMs, each of which has a quatrefoil infixed in his open mouth. Ca. 9.4.0.0.0 (A.D. 514); f. Abaj Takalik Stela 4. One of two similar profile heads placed

L
A
T
E

C
L
A
S
S
I
C

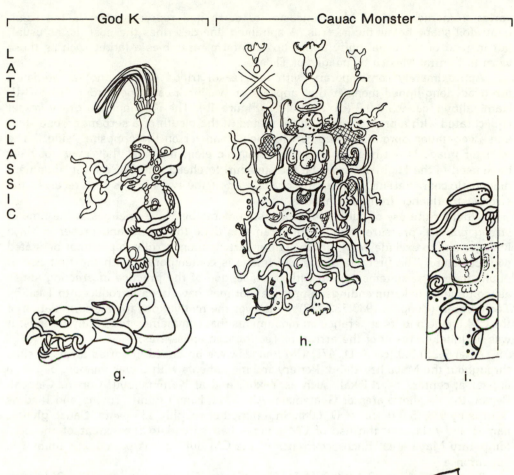

g.

h.

i.

P
O
S
T

C
L
A
S
S
I
C

j.

k.

*at the base of the stela. Formative period. (After Quirarte, 1977: Figure 10e); **g.** Quirigua Zoo-morph P. Manikin sceptre held by the ruler enclosed by a CM. 9.19.0.0.0 (A.D. 800) (After Robicek, 1978: Figure 109); **h.** Palenque Intaglio Relief, ca. 9.16.13.0.0 (A.D. 764) (After Robertson, 1974: Figure 23); **i.** Palenque Temple of the Cross interior door jamb. This drawing is a composite of the lower masks on the left and right panels. Ca. 9.13.0.0.0 (A.D. 692) (after Schele, 1976); **j.** Dresden Codex: God K (after Villacorta, 1977:62); **k.** Dresden Codex: God B or Chac (after Villacorta 1977:148).*

varies from the norm of Maya ancestor or earth god representation is the semi-quatrefoil shape below the nostrils. A spiralling line describes the nostrils, as usual, but instead of the usual puffy upper lip, this form resembles a labret such as those worn in Central Mexico by images of Tlaloc.

Approximately contemporary with the Tzakol tripod CM is another step-curl forehead, long-lipped monster that appears on a cylindrical tripod from Tomb B-II, Kaminaljuyu, ca. 9.3.0.0.0 (ca. A.D. 475) (Figure 4b). The Kaminaljuyu grave vessel is decorated with a profile supernatural seated in the mouth of a serpent on one side, and a vegetation sprouting, step-curl forehead monster on the opposite "side." The monster image is not marked with Cauac glyphic elements, and they may not have been used in the Highland area. So the step-curl forehead, the CM's most prominent diagnostic characteristic, apparently crystallized at the two centers that received the strongest influence from Teotihuacan.

Whether the use of public parentage statements by Maya lineages at the time of strong political pressure from Teotihuacan was done to protect and preserve Maya lineages and to exclude Teotihuacanos from participation in rulership cannot be stated with certainty. The first use of the CM image is contemporary with the first use of public parentage statements and with the inception of the practice of erecting stelae as monuments to katun endings, a practice that may have been introduced to Tikal by Teotihuacan (Coggins 1980:732-737). Whatever the motivations for the formulation of the CM image and its apperance on monuments that commemorated katun endings, it was definitely a result of the arrival of Teotihuacan emissaries.

After 9.2.0.0.0 (ca. A.D. 475) CM images were produced in varied forms at sites throughout the Maya heartland. Pottery and monuments with Cauac imagery began to appear at centers near Tikal, such as Yaxhá, and at Kaminaljuyu, Copan, Caracol, Becan, the Esquintla area of Guatemala, Altun Há, Nimili Punit, Toniná and Piedras Negras by 9.8.15.0.0 (ca. A.D. 608). In a period of roughly 135 years, Cauac glyphic names and titles and the use of CM images had spread to the extent of the contemporary Maya area. Each occurrence of the CM during this period was unique in appearance.

Tikal Altar 4, ca. 9.4.0.0.0 (A.D. 514) (Figure 5d), combines profile CMs with Teotihuacanoid figures. On the sides of this circular altar are four profile, gaping-jawed, vegetative-eyed CMs. Enclosed in each quatrefoil-shaped CM mouth sits an aged male, holding a shallow bowl in his outstretched hand. Repetition of motifs, the quatrefoil opening, and the simple, graceless manner in which the emergent ancestor figures are rendered are characteristic of the Teotihuacan style.

Caracol was a center about 75 km southeast of Tikal. At Caracol, now in Belize, CM monuments spanned the three hundred years from 9.5.0.0.0 to 9.19.10.0.0 (A.D. 534-820). The several Caracol CMs present a unique view of the CM's development and fusion with traditional Maya sacrificial and ancestral imagery. Stela 14, dated 9.6.0.0.0 (A.D. 554) shows a ruler and two other figures, probably his parents, in an accession ritual (Figure 6a). The acceding ruler is seated cross-legged, frontally, on a prone figure that also functions as the step-curl of the CM head. The prone figure previously appeared behind the feet of the ruler in monumental statements such as the Leyden Plaque and Tikal Stela 8 as a reference to sacrifice as part of the accession ritual. Of special interest is the tri-figure scene that occurs in front of the CM throne. Two profile figures, seated on low thrones, face the central figure, whose frontal posture indicates that he is the protagonist of the monument. Schele has shown that similar tri-figure panels from Palenque were scenes of genealogical documentation, created to indicate the posthumous conferral of power to a ruler by his deceased parents (Schele 1979b).

a.

b.

c.

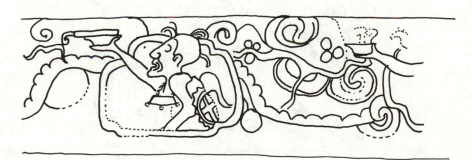

d.

Figure 5. Early Classic Cauac Monsters, ca. 9.2.0.0.0-9.4.0.0.0 (A.D. 475-514).

 a. *Tzakol tripod (after Dorsinfang-Smets, 1977, Cat. #194, ca. 9.2.0.0.0 (A.D. 475);* **b.** *Tripod cylinder from Kaminaljuyu (after Kidder, et al. 1946, Figure 204 B, detail), ca. 9.2.0.-0.0. (A.D. 495);* **c.** *Detail of Tequisate region tripod in Denver Art Museum (after photo in Hellmuth 1975:19), ca. 9.3.0.0.0? (A.D. 495);* **d.** *Tikal Altar 4 (after drawing by Taylor, n.d., detail), ca. 9.4.0.0.0 (A.D. 514).*

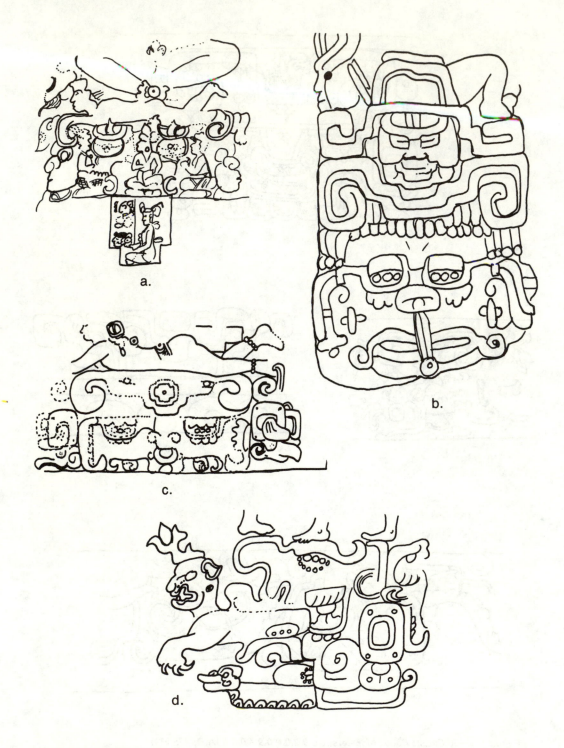

Figure 6. Middle Classic Cauac Monsters

a. *Caracol Stela 14, Front, detail, 9.6.0.0.0 (A.D. 554);* **b.** *Altun Há Jade Plaque (after drawing courtesy of David Findlay, R. O. M.), dated 9.7.11.2.17 (A.D. 584, December 13);* **c.** *Stela 6 Caracol (?), detail. Ca. 9.6.0.0.0 (A.D. 554);* **d.** *Nimili Punit Stela 2 base (after Illustrated London News, 1972), ca. 9.8.0.0.0 (A.D. 593).*

Additional ancestral recall may be recorded by the profile seated female figure enclosed in an abbreviated quatrefoil cartouche below the CM; a three-glyph phrase accompanies her. The first glyph is T757, which can function at the beginning of a phrase as an auxiliary verb (Schele 1979a:29). Though the glyph in second position is eroded, it suggests additional verbal information (*Ibid.*). The third glyph is a female nominal introducing glyph, T1000 variant (Schele 1979a:23) that prefixes a T511 *Mol glyph*, referring to Lady Jade or Lady Grandmother (Tate ms:95). Therefore, the short text indicates that a female ancestor positioned underneath the tri-figure scene was related to the main action of the stela, the accession.

A jade plaque from Altun Há, dated 9.7.11.2.17.7 Caban 5 Kankin (A.D. 584, December 13), was buried nearly 100 years later in the lavish tomb of an Altun Há ruler, along with 110 other jade objects, ceremonial flints, pottery, shells, and codex fragments (Pendergast 1969:86). The plaque is one of the few carved jades inscribed with a date, and one of the larger known pieces, measuring 20.2 cm x 6.7 cm x 1.9 cm. When uncovered in Altun Há Tomb B-4/6, it was located face up on the chest of the deceased. The front of the plaque or pendant shows a right profile ruler seated on a frontal CM throne (Figure 6b). The Altun Há plaque's throne is composed of the mirrored image of the CM's step-fret forehead. Contained in the quatrefoil formed by the negative space of the two step-frets is a frontal human image, probably ancestral. The obverse is inscribed with 20 glyphs that record an "axe event" on the first date at A1-A3, and an accession on the later date at A4-A7. The third clause gives the female parentage of the protagonist at B7-B9, and probably the male parentage at A10-B10. The mother's Emblem Glyph or site identifier compares closely with one on the aforementioned Caracol Stela 14, dated 9.6.0.0.0 (A.D. 554).

A fragmentary limestone panel from Toniná, designated as Monument 106 (unpublished) by the French Mission, includes a nearly whole, frontal CM that functions as a throne. Enough of the sculpture remains to determine that the monument represented a seated ruler in right profile, wearing a belt decorated with jade masks and triple jade pendants, similar in form to the Altun Há plaque and the Leyden plaque. In Proskouriakoff's analysis of posture, this type of pose was not used later than 9.8.0.0.0 (A.D. 593) (Proskouriakoff 1950:19, Figure 7). The fragmentary glyphic text of the Toniná panel has been analyzed by Peter Mathews and yields the corroborative date 9.8.0.0.0 5 Ahau Ch'en (P. Mathews, personal communication 1980). According to his research, this CM panel is the earliest extant monument from Tonina. It is a precisely executed sculpture with elegant figural detail.

One other feature of the Toniná CM deserves mention. Below the curl-horn element in the position where a central stepped cleft usually occurs is a small infix of a very long nosed supernatural, in profile. It is similar in form to a hieroglyph appearing at the upper right front portion of the panel tentatively identified by Mathews as the name of Ruler 1 of Toniná (personal communication 1980). The ruler could be showing his own name glyph in a position usually reserved for the mention of ancestors, or the glyph could be the name of his father.

By 9.13.0.0.0 (A.D. 692), after a general hiatus at most sites since 9.8.0.0.0 (A.D. 593), the artists working at Palenque and their royal patrons continued the use of the CM in the context of proclaiming dynastic legitimacy.

The famous Sarcophagus Lid of Pacal from the Temple of the Inscriptions at Palenque suggests rather than depicts the CM in a unique manner: as gaping lower jaws that received Pacal on his axial journal into the Underworld (see Green 1967: Plate 15). Other Cauac-related imagery on the Sarcophagus Lid are the ancestral heads infixed in semi-quatrefoils that appear on the two short borders of the Lid (Schele

1976:29). These have precedents in the Tzakol tripod, the Altun Há jade, the Toniná panel, Tikal Altar 4, and elsewhere.

Each of the three major monuments of Pacal's son and successor, Chan Bahlum, includes a CM in its symbolic scheme. On the Temple of the Foliated Cross Panel (TFC) which deals with the Cauac complex of ancestry, vegetation, and sacrifice (Schele 1976; cf. Figure 10), Chan Bahlum stands majestically on the four-directional Cauac mask, as though he is the living human sprout that the Cauac head generated.

The TFC CM is rendered in Palenque's refined Late Classic style (Figure 1a). Its proportions are narrower than the previous monster images because, instead of earplugs on each side of the mask, profile CM images emerge from beneath the frontal step-curl and share the frontal CM's glyph-filled eyes. The CM faces three directions with a fourth implied. For the first time it is possible to compare the lines that describe frontal projecting forms with their profile shapes as rendered by the same artist. The curvilinear shapes over the eyes on the frontal image correspond with the projecting lobed forehead. The broad area around and below the frontal nostril is translatable into the profile's elongated, puffy upper lip.

In the Temple of the Sun at Palenque the CMs are used as borders for the panels that were situated on the door jambs of the interior room of the temple. They are in profile, stacked vertically, and are marked alternately with mirror (God K) symbols and T529 (Cauac) symbols (cf. Schele 1976:Figure 12). This type of border stacking of profile earth-ancestor images is a variant of the emergent busts seen on Caracol Stela 5 (unpublished), Tikal Stela 1, and other Early Classic compositions.

From the lowest in the stack of monsters on the Temple of the Sun projects a long, Cauac-marked tooth resembling a flint knife. When T528 markings appear on sacrificial blades or spear points, they are considered to designate either flint or obsidian (Schele 1978:8). In modern Tzotzil, teeth are called *tanal eil*, literally, "stones of the mouth." Perhaps on the Temple of the Sun CM as well as those from Toniná and Caracol and the Tzakol tripod, the CM is shown as a devouring entity—the earth—whose teeth are the stones used by man in sacrifices (flint and obsidian blades).

Unlike the panels secluded within the temples of the Sun and the Foliated Cross, the roofcomb of the Temple of the Cross was visible to visitors of Palenque. On the roofcomb, as reconstructed by Merle Greene Robertson, a CM forms a throne for a seated ruler who holds a double-headed serpent bar (Robertson 1979:168). This CM contains the set of elements that became standard in the Late Classic representation of the CM. It is practically identical to a monster on Bonampak Stela 1 (Figure 1c), which, like the Palenque Temple of the Cross was dated 9.13.0.0.0 (A.D. 692).

The CM image that was used around 9.13.0.0.0 no longer included the varied elements seen on monsters during the period 9.2.0.0.0-9.8.0.0.0 (A.D. 475-593). The forehead no longer incorporated a prone figure, but utilized either a step-curl or central curling crest such as the one seen on Machaquila Stela 13 (Figure 7a). Neither did large noseplates appear again; instead tubular jade noseplugs were occasionally represented. Figures were still associated with the monster image, but rather than being seated in front of the CM mask or emerging from double-headed serpents on both sides of the mask, the Late Classic style showed youthful images, usually busts, enclosed in the semi-quatrefoil shape of the forehead cleft or emerging from the monster's eyes. Examples of Late Classic monuments upon which a CM served as an enclosure for a figure are Copan Stela B, front and rear, (Figure 7b) Piedras Negras Throne 1 (unpublished), Tikal Temple 4 Lintels 2 and 3 (cf. Jones 1977:Figures 11, 12), Quirigua Zoomorphs O and P (latter, cf. Maudslay 1889-1902:II:Plates 54-58), and

46

the throne in the collection of Dr. and Mrs. José Saenz, Mexico City (Easby and Scott 1970:#174).

For five katuns CM representations retained the basic vocabulary displayed in the 9.13.0.0.0 examples, despite stylistic differences and innovations. Between 9.13.0 - 0.0 and 9.16.0.0.0 (A.D. 692-751) the CM continued to perform an important role in monumental compositions, but after 9.16.0.0.0 its size was diminished in relation to the figures, and it became a geometricized abstraction in some instances.

The most aberrant of the 9.13.0.0.0-9.16.0.0.0 group is the CM on Machaquilá Stela 13 (Figure 7a). It is a ''Giant Ahau Glyph'' stela, dedicated 9.14.0.0.0 6 Ahau 13 Muan (December 5, A.D. 711), a katun ending. An irregular projection of stone from the top of the monument is carved with what may be a God K head, an interpretation based on the forehead mirror infix. The CM is frontal, with cross-hatched eyes that may have had dotted arcs or circlets infixed (Graham 1967:88 photo and Figure 66 and 67). Cauac glyphs appear on the two sides of the mouth, separated by an elongated snout. The elevated central crest is split and curls to the outside, like a profile forehead. Stela 13 is the earliest dated monument at this site to be published by Graham in his survey. It stood alone, centrally placed before a building in the northeast corner of the site, near the Río Machaquilá.

Copan Stela B (Figure 7b) also celebrates a katun ending, 9.15.0.0.0 (A.D. 751). A Cauac Monster convention seems to be in progress—the monsters appear on the top front; they stack up on the sides of the stela, and a huge mask occupies the entire elongated surface of the rear of the stela. The style in which Stela B's rear monster is rendered and the complex composition of the stela are unique among the corpus of CM monuments, yet the elements of the mask are limited to those seen on the Palenque monsters and do not include forms from the Middle Classic group.

Though the front and sides of Stela B are carved in Copan's characteristic high relief, the rear of the stela is much lower in relief and shows several forms invented by the artist, which express Cauac concepts in unique ways. First, in the forehead of the rear mask is embedded a niche that contains a crosslegged, seated figure. It was contrived to give the impression that the substance of the CM had grown upward to form a throne for this figure, terminating its energies in split volutes. This split continuation of the CM's central crest is similar in appearance to the Machaquilá Stela 13 forehead. Second, Stela B's rear CM mouth varies from the norm by having been given a lower jaw, stylized into the Maya statement for opening—a semi-quatrefoil. The mouth opening contains glyphs. Third, tubular noseplugs complete the CM's set of jade jewelry.

The CM retained its standardized formal elements until 9.18.0.0.0 (A.D. 800, November 11), when, on monuments such as Aguateca Stela 7 and Quirigua Zoo-morph O (Figures 8a,b), Cauac markings were carved into forms that approximated the traditional CM in compositional placement. On Aguateca Stela 7, a horizontal band was composed of Cauac elements enclosed in rectangles of varying sizes, arranged symmetrically around a central rectangle containing an agnathic visage. The remainder of the stela is traditional in iconography—the ruler stands above the Cauac band and a bound, prone prisoner peers up from below (latter not illustrated in Figure 8a).

Quirigua Zoomorph O is a huge monolith of red sandstone. One half of the broad, flat altar is composed of a glyphic text formed around a rectilinear semi-quatrefoil in which are inscribed Cauac symbols (Figure 8b). Inside the semi-quatre-foil is the Long Count date 9.18.0.0.0 (A.D. 790). From the interior of the quatrefoil emerges a supernatural figure with a humanlike body and his dancing partner, a

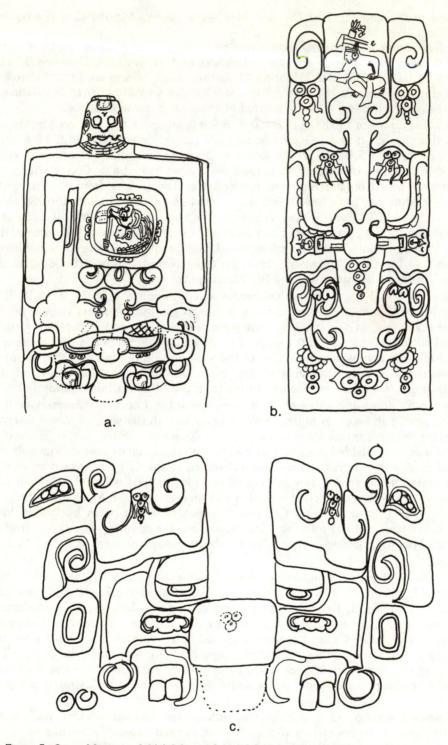

Figure 7. Cauac Monsters, 9.14.0.0.0 and 9.15.0.0.0 (A.D. 711 and 731).
a. *Machaquila Stela 14 (after Graham 1967:88). Dated 9.14.0.0.0 (A.D. 711);* **b.** *Stela B. Copan, rear (after Covarrubias 1957, Figure 100), dated 9.15.0.0.0 (A.D. 731);* **c.** *Copan, Temple 22, corner, detail (after photograph). Ca. 9.15.0.0.0 (A.D. 731).*

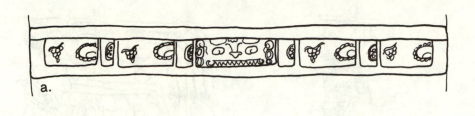

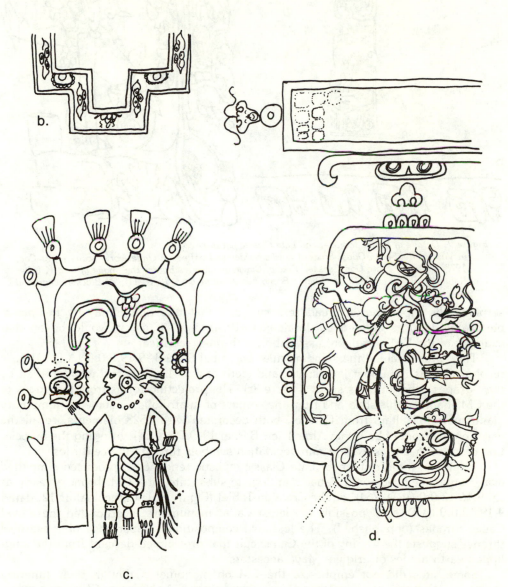

Figure 8. Terminal Classic Stylization of Cauac Monsters.

a. Aguateca Stela 7 (after Graham, 1967:24). Below CM panel is belly-down captive. Dated 9.18.0.0.0 (A.D. 790); b. Quirigua Zoomorph O. Penis perforator deity and serpent dance on opposite side. 9.18.0.0.0 (A.D. 790); c. Seibal Stela 3, central area (glyphs omitted) (after rubbing by Greene 1972:Plate 103), 9.19.0.0.0 (A.D. 810); d. Palenque "Creation Tablet": quatrefoil forms mouth of stylized CM (glyphs omitted), 9.16.13.0.0 (A.D. 764).

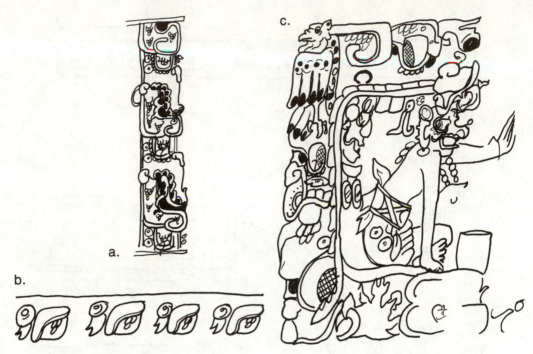

Figure 9. Details of Cauac Monsters on Late Classic pottery.
a. *Vase of the Seven Gods. Stacked masks border and define an Underworld scene (after Coe, 1973: #49);* **b.** *"Flare God" vessel. Row of Cauac glyph titles border the image of God K (after Robicek, 1978: Plate 236);* **c.** *Enema Scene vessel (after Coe, 1978:#11);* **d.** *Black Background*

serpent. His triple knotted headdress suggests that this figure may be the penis-perforator deity as defined by Joralemon (1974), and, if so, it would be another example of the CM's frequent association with royal sacrifice.

The "arch" behind the standing ruler on Seibal Stela 3, 9.19.0.0.0 (A.D. 810), is recognizable as the upper jaw, snout, and teeth of a CM and is further identified by the "grapes" that infix its snout (Figure 8c). The projecting forms from the edges of the CM shape on this stela and from the corners of quatrefoils on some contemporary giant quatrefoil altars from Caracol, both decorated with T528 elements, recall the vases on the front of La Venta Altar 1 (cf. Bernal 1969:Plate 14), bringing the association of monster-enclosure and rain-vegetation symbols through the centuries.

Palenque, a forerunner for Late Classic stylistic tendencies, produced simplified oval, humanlike heads with Cauac markings to substitute for a CM throne as early as ca. 9.16.13.0.0 (A.D. 764), on the Creation Tablet (Figure 8d). Caracol Altar 12, dated 9.19.10.0.0 (A.D. 820), possibly the latest Cauac monument, incorporated these oval Cauac thrones (unpublished). The lessened compositional importance of these oval thrones suggests the waning of the Cauac cult that proclaimed descent from the long-lipped earth deities or original Maya ancestors.

Some sites did not emphasize the CM on monuments though their funerary ceramics include highly developed Cauac compositions. At Naranjo, CMs were rarely represented on stelae, while on ceramic vases the CM is illustrated in a full range of functions. The "Vase of the Seven Gods" includes a stack of profile CMs framing an Underworld scene (Figure 9a). On two vases entitled "Young Lords Dancing with Dwarves," CMs appear on the backrack ornaments of the rulers (the young lords) where they support animal deities and representations of God K (Coe 1978:#14, #15).

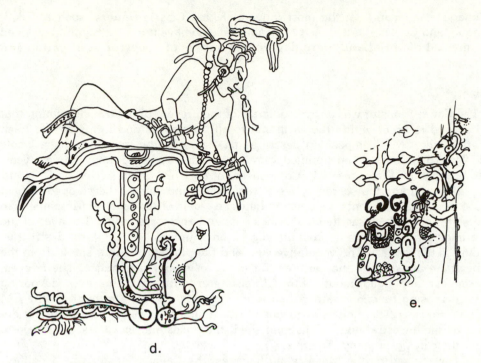

d.

e.

Vase. Cauac's long upper lip carries deceased lord into Underworld (after Quirarte, 1979, drawing by O. Lemelle); e. Bloomington Vase. This drawing modifies that of the reconstruction (after Robicek, 1978, Figure 167).

Naranjo's "Vase of the Underwater Sacrifice" is poorly restored in areas, but it is possible to see that the CMs were used as thrones for the Underworld deities (Coe 1978:#12).

The use of CMs occurred at many, but not all major sites. Not all frontal supernatural masks below the feet of rulers on stelae are marked with Cauac elements. Some monuments show the substitution of other earth symbols for the CM in the typical position of the rulers' support. The Machaquilá corpus of stelae includes several representations of what I consider to be CM substitutes or variants of the same theme. Stela 10, 9.15.0.0.0? (A.D. 721) (Graham 1967:67; Figure 61) is carved with a representation of a ruler standing on a large quatrefoil that encloses a long-nosed head, probably an ancestor image. Machaquilá stelae 4, 8 and 7, dated 9.19.-10.0.0 , 9.19.15.0.0 , and 10.0.0.0.0 (A.D. 820, 825, 830) (Graham 1967), show a substitution of a semi-quatrefoil enclosing an Imix or earth glyph marked with dotted spirals. Like a CM, these semi-quatrefoils sprout vegetation and appear below the feet of the ruler.

Yaxchilán, a center relatively close to Palenque, Bonampak, and Piedras Negras, all locales where CMs appeared, developed elaborate sacrificial and ancestral imagery but not the CM. At Yaxchilán, sculptures do show renowned warrior rulers capturing prisoners and bloodletting to ancestral deities. While CMs did not appear at Yaxchilán, occasionally Cauac glyphic symbols decorated the containers for sacrificial blood, as on Lintel 25 (cf. Graham 1977).

The lack of Cauac iconography at particular sites may indicate socio-political strife stemming from long-standing clan disagreements. Politics and family power struggles probably played an important role in the dissemination of the aristocratic

CM image. It appears that the most influential Late Classic centers, such as Tikal, Palenque, and Copan, did use the CM image and also have the most highly-developed monumental pictorial and hieroglyphic statements of ancestor verification and veneration.

Summary

The Cauac Monster was a representation of the process of the transformation that was believed to occur within the earth and to all substances and forms of life. Each element of the CM's composition described an aspect of the meaning of the whole mask. The T528 Cauac glyph signified sacred, repetitive cycles of time: the day, year, katun, and baktun (Tate, ms:103). Components of the #528 glyph infixed on CMs are multiple referents to the sacred cycles of time, rain, and stone. The stepped cleft of the CM forehead represents the opening between levels of the layered Mesoamerican universe through which sacrificial offerings pass and ancestors travel. The eyes of the CM are either generative (sprouting vegetation, humans, or rain) or destructive (alluding to the jaguar). The vegetative eyes and the plant forms that sprout from the CM head are allusions to the earth as the source of man's sustenance. The Ix eyes, jaguarian ear, and jaguar mouth of the CM also refer to the earth, but to its devouring and decomposing functions rather than to its generative ones. The teeth of the CM are flints, the sacrificial knives by means of which vitality is taken from man and devoured by the ancestral gods. Thus nourished, the ancestors, as Chacs, send rain to sustain their living progeny (Tate ms:97).

As it was used by the Maya ruling lineages, the Cauac Monster was a political statement symbolizing the descent of their dynasties from the early elite. The Cauac Monster seen on public monuments declared that a ruler was one of the multiple incarnations of God K, the first ancestor, through the cycles of time.

Bibliography

Barrera-Vasquez, Alfredo
 1943 "Horóscopas Mayas ó el prognostico de los signos del Tzolkin según los Libros de Chilam Balam de Kaua y de Mani." *Registro de Cultura Yucateca,* Mexico. 1(6):4-33.
Bernal, Ignacio
 1969 *The Olmec World.* Berkeley and Los Angeles: University of California Press.
Coe, Michael D.
 1976 *The Maya Scribe and His World.* New York: The Grolier Club.
 1978 *Lords of the Underworld.* Princeton: Princeton University Press.
Coe, William R.
 1967 *Tikal: A Handbook of the Ancient Maya Ruins.* 9th Edition. Philadelphia: University Museum of the University of Pennsylvania.
Coggins, Clemency
 1979 "A New Order and the Role of the Calendar: Some Characteristics of the Middle Classic Period at Tikal." In Norman Hammond and Gordon Willey, eds., *Maya Archaeology and Ethnohistory.* Austin: University of Texas Press.
 1980 "The Shape of Time: Some Political Implications of a Four-Part Figure." *American Antiquity,* 45 (4): 727-739.
Dorsinfang-Smets, A.
 1977 *Art de Mesoamerique.* Bruxelles: Société Générale de Banque.
Easby, Elizabeth and John F. Scott
 1970 *Before Cortez: Sculpture of Middle America.* New York: Metropolitan Museum of Art.
Friedel, David A.
 1979 "Culture Areas and Interaction Spheres: Contrasting Approaches to the Emergence of Civilization in the Maya Lowlands." *American Antiquity,* 44 (1): 36-54.

Graham, Ian
 1967 *Archaeological Explorations in El Petén, Guatemala.* Publication 33. Middle American Research Institute. New Orleans: Tulane University.

 1977 *Corpus of Maya Hieroglyphic Inscriptions.* vol. 3, Part I. Peabody Museum of Archaeology and Ethnology, Harvard University. Cambridge: Harvard University Press.

Greene, Merle, Robert L. Rands and John A. Graham
 1967 *Maya Relief Sculpture from the Southern Lowlands, the Highlands and the Pacific Piedmont.* Berkeley: Lederer, Street and Zeus.

Hellmuth, Nicholas
 1975 "The Esquintla Hoards: Teotihuacan Art in Guatemala." *FLAAR Progress Report,* Guatemala City, 1 (2).

Hunter, Bruce
 1974 *A Guide to Ancient Maya Ruins.* Norman: University of Oklahoma Press.

Jones, Christopher
 1977 "Inaugural Dates of Three Late Classic Rulers of Tikal, Guatemala." *American Antiquity, Vol. 40, No. 4:* 28-60.

Joralemon, Peter David
 1974 "Ritual Blood Sacrifice among the Ancient Maya, Part I." In Merle Green Robertson, ed., *Primera Mesa Redonda de Palenque, Part I.* Pebble Beach: Robert Louis Stevenson School. 59-76.

 1976 "The Olmec Dragon: A Study in Pre-Columbian Iconography." In H.B. Nicholson, ed., *Origins of Art and Iconography in Pre-Classic Middle America.* Berkeley and Los Angeles: University of California Press. Pp. 29-71.

Kelley, David H.
 1976 *Deciphering the Maya Script.* Austin: University of Texas Press.

Kidder, Alfred
 1946 *Excavations at Kaminaljuyu, Guatemala.* University Park: Pennsylvania State University Press.

Maudslay, Alfred P.
 1889- *Biologia Centrali-Americani: or Contributions to the Knowledge of the Fauna and the Flora of*
 1902 *Mexico and Central America: Archaeology.* 5 vols. London.

Morley, Sylvannus G.
 1956 *The Ancient Maya.* Stanford: Stanford University Press.

Parsons, Lee
 1972 "Iconographic Notes on a New Stela from Abaj Takalik, Guatemala." *Atti del XL Congresso Internazionale degli Americanisti,* Rome and Genoa.

Norman, V. Garth
 1973 *Izapa Sculpture, Part I.* Papers, New World Archaeology Foundation, #30. Provo, Utah: Brigham Young University.

Pendergast, David M.
 1969 "An Inscribed Jade Plaque from Altun Há." *Archaeology,* 85-92.

Proskouriakoff, Tatiana
 1950 *A Study of Classic Maya Sculpture.* Washington, D.C.: Carnegie Institute of Washington. Publication 593.

Quirarte, Jacinto
 1977 "Early Art Styles of Mesoamerica and Early Classic Maya Art." *In* Richard E. W. Adams, ed., *The Origins of Maya Civilization.* Albuquerque: University of New Mexico, Pp. 249-283.

 1979 "The Representation of Place, Location and Direction on a Classic Maya Vase." *In* Merle Green Robertson, ed., *Proceedings, Tercera Mesa Redonda de Palenque.* Pebble Beach: Robert Louis Stevenson School. 5:99-110.

Robertson, Merle Green
 1974 "The Quadripartite Badge: A Badge of Rulership." *In* Merle Green Robertson, ed., *Proceedings, Primera Mesa Redonda de Palenque.* Pebble Beach: Robert Louis Stevenson School. Pp. 77-94.

 1979 "A Sequence for Palenque Painting Techniques." *In* Norman Hammond, ed., *Maya Archaeology and Ethnohistory.* Austin: University of Texas Press.

Robicek, Frances
 1978 *The Smoking Gods.* New York: Museum of the American Indian, Heye Foundation.

Schele, Linda
 1974 "Observations on the Cross Motif at Palenque." *In* Merle Green Robertson, ed., *Proceedings,*

Primera Mesa Redonda de Palenque. Pebble Beach: Robert Louis Stevenson School. Pp. 41-62.

1976 "Accession Iconography of Chan Bahlum in the Group of the Cross, Palenque." *In* Merle Green Robertson, ed., *Proceedings, Segunda Mesa Redonda de Palenque.* Pebble Beach: Robert Louis Stevenson School. Pp. 9-34.

1978 *Notebook for the Maya Hieroglyphic Workshop*, March 10-11, 1978. Austin: Institute of Latin American Studies, University of Texas.

1979a *Notebook for the Maya Hieroglyphic Workshop*, March 24-25, 1978. Austin: Institute of Latin American Studies, University of Texas.

1979b "Genealogical Documentation on the Tri-Figure Panels at Palenque." *In* Merle Green Robertson, ed., *Proceedings, Tercera Mesa Redonda de Palenque.* Pebble Beach: Robert Louis Stevenson School. Pp. 41-70.

Tate, Carolyn
1980 "The Maya Cauac Monster: Visual Evidence for Ancestor Veneration Among the Ancient Maya." M.A. Thesis, University of Texas, Austin.

Taylor, D.
1979 "The Cauac Monster." *In* Merle Green Robertson, ed., *Proceedings, Tercera Mesa Redonda de Palenque.* Pebble Beach: Robert Louis Stevenson School. Pp. 79-90.

Thompson, J. Eric S.
1962 *A Catalog of Maya Hieroglyphs.* Norman: University of Oklahoma Press.

1971 *Maya Hieroglyphic Writing.* 3rd Edition. Norman: University of Oklahoma Press.

Villacorta, J. Antonio and Carlos A.
1977 *Codices Maya. Reproducidos y Desarrollados.* Segundo Edición. Guatemala, C.A.

The Serpent At Cotzumalhuapa

Barbara Braun

Ritual permeated every aspect of Mesoamerican life, even those areas which by today's criteria would seem secular. One such is the ballgame. Although the Spanish chroniclers made note of the Aztec ritual sport, and even though a variety of ballcourts are known archaeologically, many aspects of the ballgame remain elusive. Here, serpent imagery at Cotzumalhuapa is used to present an interpretation of both an enigmatic symbol and to suggest the meaning and function of the game.

THE INTENTION OF THIS PAPER is to describe and interpret serpent imagery in the art of Santa Lucia Cotzumalhuapa, Guatemala, dated ca. A.D. 400-900, because its extent and importance have not been previously demonstrated. The first part of the paper describes the range of these images, including their manifestation in three-dimensional form as tenoned heads, *hachas*, and monumental staircases, and their realistic and emblematic representation on various reliefs. In the course of this discussion, I will link serpent imagery with the ballgame at Cotzumalhuapa; draw comparisons and contrasts between representations of serpents on tenoned heads and *hachas*; and tentatively identify a previously enigmatic Cotzumalhuapa glyph as a serpent symbol. In the second part of the paper, I will explore the meaning of serpent motifs at Cotzumalhuapa, and offer an hypothesis about the nature of the ballgame at Cotzumalhuapa. I conclude that serpent representations appear to have functioned as images of transformation in the ballgame ceremonial, and also suggest that there is a similarity between Cotzumalhuapa and Petén Maya serpent conceptions that has heretofore been overlooked in favor of Mexican correspondences.

Three-Dimensional Serpent Images

In Cotzumalhuapa art, the characteristic serpent image resembles a stylized crocodile or cayman, sometimes combined with iguana or snake attributes. Most images are restricted to the head of a serpent; full-bodied representations of serpents are rare. The serpent representation most typically associated with the Cotzumalhuapa tradition is the tenoned serpent head. At least a dozen are known from Cotzumalhuapa Pacific slope and

Figures 1, 2, 3. Cotzumalhuapa-style horizontally tenoned serpent heads. 1. Unknown provenience; 2. Pasaco, Jutiapa. Collection Museo Nacional de Antropología, Guatemala; 3. Unknown provenience. Photographs by the author.

Antigua basin sites. The serpent head is represented with open jaws, exposed fangs, bifurcated tongue, elaborated scrolls around the eyes, and sometimes with a ruff around the neck. Frequently a human head is enclosed within the maw (Figures 1, 2, and 3). Some serpent heads from the south coast and highlands that are stylistically related to Cotzumalhuapa heads have an upsweeping snout that extends over the brow (Parsons 1969: Plate 57j), or an extension at the tip of the nose (*ibid.*: Plate 56i).

The eye and mouth are clearly the principal elements of the serpent-head image at Cotzumalhuapa. The overall shape of the head is either curvilinear or rectilinear, and the shape of the orbits of the eyes follows accordingly. Usually, the sub- or supra-orbital lids are joined in front of the eye and swing to enclose it and form balanced scrolls, one curving upward, the other downward, and sometimes there are also trefoil elements above or below the orb. Known as the Reptile Eye (RE) glyph, the serpent eye with trefoil attachment is one of the most prevalent Cotzumalhuapa glyphs, and consists of a central element surmounted by an inverted U-shaped or supra-orbital scroll, which is in turn topped by three long triangular peaks (*ibid.*: 145). Mouths of serpents receive special treatment when they are wide open or contain human heads. In this event, the ridge pattern of the upper palate is articulated and framed by fangs and teeth, as on Monument 3 from El Castillo (Figures 4a and 4b).[1]

In the Cotzumalhuapa region, tenoned heads are associated with ball courts as paired centerline markers on range walls (as at Palo Gordo), and with stairway balustrades (as at El Baul), but in most cases they have been found without a context.

1. Tenoned serpent heads with human faces in their jaws that are stylistically related to El Castillo Monument 3 include examples from the highlands at Kaminaljuyu (Miles 1965:269), Xalapan, Jalapa (Parsons 1969:Plate 57a, b), and Patzun, near Chimaltenango (Villacorta and Villacorta 1927: ill., p. 110). The latter is noteworthy for its colossal size and fine carving. It also has a trefoil motif appended to its suborbital lid and a bifurcated tongue. In the Middle Motagua region, Altar V from Quirigua seems closely related to El Castillo Monument 3 in style, and other Quirigua monoliths, such as Zoomorph P, seem linked to Cotzumalhuapa conceptually.

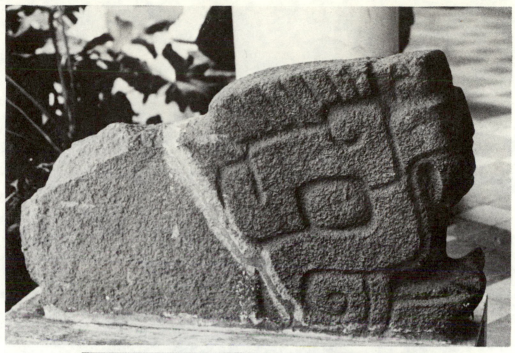

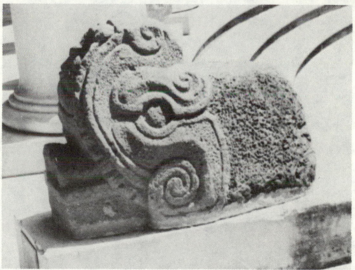

Another possibility, suggested by a representation on a Tiquisate relief vessel,[2] is that tenoned heads at Cotzumalhuapa were arranged in composite, hieratic, altarlike sculptures set back to back flanking a central circular form, such as a stone ball or a tenoned disk. In summary, tenoned serpent heads are common Cotzumalhuapa representations. The eyes and mouth of the serpent are its most important features, and serpent mouths often enclose human heads.

2. The relief on a tripod cylinder vessel in the Denver Museum shows two ball players, wearing hip protectors and yokes, flanking an image consisting of two back-to-back tenoned serpent heads supporting between them a tenoned disk decorated with a grinning skull, and topped with a tied bundle, bow or cylinder (see Stroessner 1974; Hellmuth 1975: ill., p. 19).

Figures 4a, b. El Castillo Monument 3. Horizontally tenoned serpent head with a human head in its open maw. a. Front; b. Rear. Jorge Castillo collection, Guatemala. Photographs by the author.

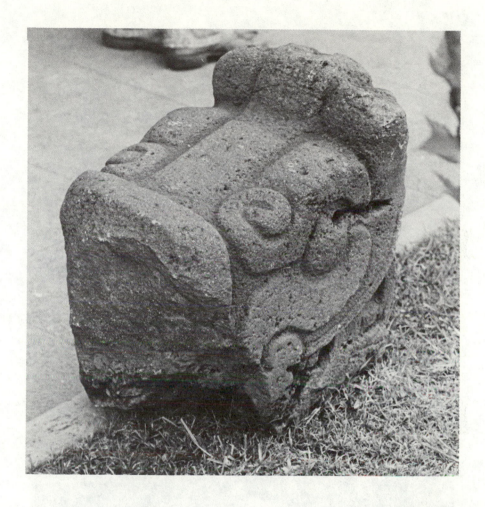

The serpent is the most common animal image on Cotzumalhuapa-style *hachas*. Like tenoned heads, *hachas* have traditionally been associated with the ballgame, and are considered to have been used as paraphernalia in the athletic contest or as ceremonial props in the ritual. Unlike tenoned serpent-head representations, serpent effigy *hachas* are often ambiguous images. It is frequently difficult to distinguish between serpent and jaguar heads, and there is also a deliberate fusion or blurring of human and jaguar or serpent identities. This is best illustrated by comparing a "serpent" head effigy in the Philadelphia Museum (Figure 5) with two "jaguar" heads in private collections (Figures 6 and 7). The contour of the heads, form of the jaws, placement and shape of the eyes, as well as the vertical tenons, are all comparable. There are slight differences: the nostrils, and especially the jutting lower jaws of the two "jaguars" are distinct from the "serpents," which also have more widely gaping maws. None of these images has ears, although the placement of the perforations on these heads conveys the impression of earholes.

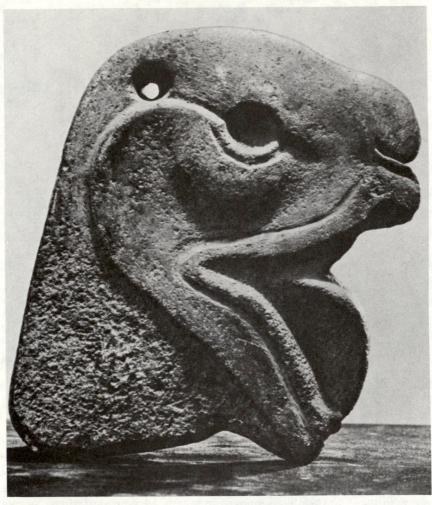

Figures 5, 6, 7. Cotzumalhuapa-style serpent-head hachas of unknown provenience. 5. Philadelphia Museum collection, after Kidder and Samayoa 1959, Figure 92; 6. Private collection, Guatamala, after Arts Maya du Guatemala 1968, Figure 233; 7. Private Collection, Santa Barbara, California.

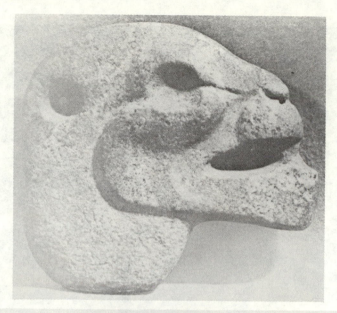

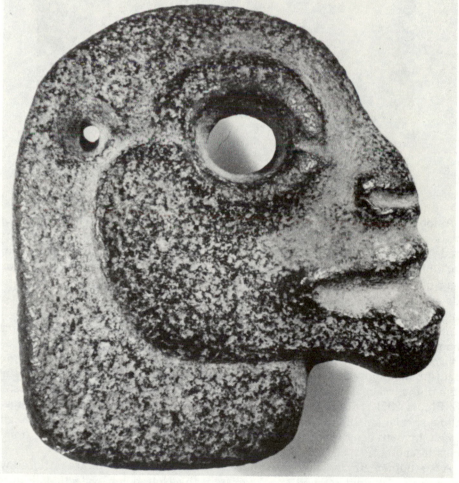

61

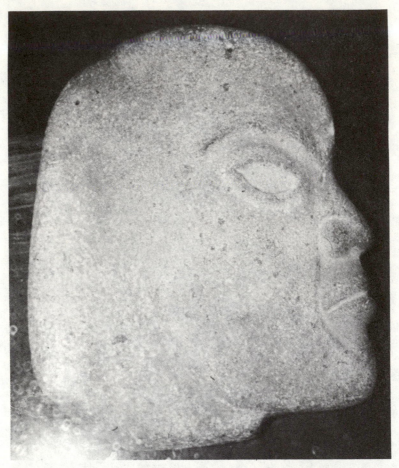

Figure 8. Human effigy-head hacha, Aldea Río Santiago. Muñoz collection,
Las Illusiones, Guatemala. Photograph by the author.

Among the anthropomorphic heads whose identities appear to fuse with those of animals are two youthful human heads, one from Aldea Río Santiago (Figure 8), located between El Baul and Bilbao (Muñoz collection), and another from the Philadelphia Museum collection (Figure 9). They are conspicuously unadorned, lacking not only headdresses, but also ears and hair. Moreover, the shape of their heads and features is distorted, so that they bear a peculiar resemblance to certain jaguar or serpent effigy-head *hachas* (cf. Figures 5, 6, 7, and also Thompson 1948: Figure 19d, left, and j). The S-curve scrolls over the surface of a unique miniature *hacha* representing an anthropomorphic head also suggest a second identity as a curling serpent for this object (Figure 10). It can be compared with a similar *hacha* from El Baul (*ibid.*: Figure 19j) and a full-figure serpent effigy *hacha*, with its head at the bottom of the image and body formed by an S-curve above (Arts Mayas du Guatemala 1968: Figure 235). This deliberate shifting between a human and serpent image may signify a special kinship between these species, involving a circulation of vital energy between human beings and animals, or the concept of transformation from one species to another.

A few human effigy-head *hachas* have serpent headdresses or are enclosed within serpent maws. A finely carved specimen from the Nottebohm collection (Figure 11)

62

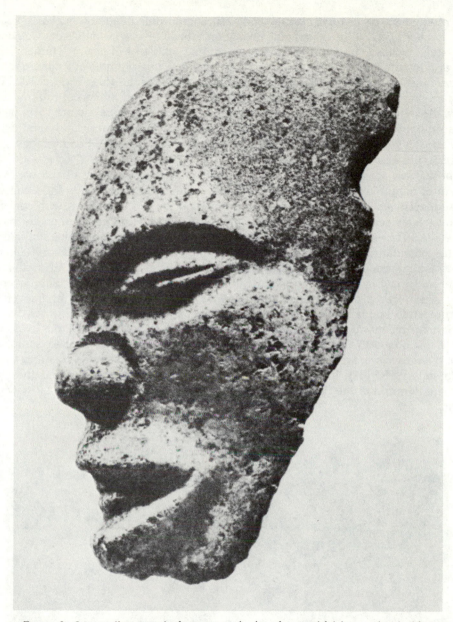

Figure 9. Cotzumalhuapa-style fragmentary hacha of a youthful human head. After Kidder and Samayoa 1959, Figure 93.

displays a typical Cotzumalhuapa male face, with query-mark shaped ears lacking ornaments, which is enclosed within a fangless and toothless serpent maw. The absence of teeth is stressed by the representation of gums with a serrated pattern that suggests gaping holes left by extracted teeth (cf. Figure 7 and Thompson *op. cit.*: Figure 19b and d, left). The nostril of the serpent has a tassel hanging through it, which may either be a part of the serpent or a crested human headdress emerging from the nasal aperture. To review, serpent heads, sometimes enclosing human faces, are common effigies on Cotzumalhuapa-style *hachas*. Representations of serpent

heads often seem to fuse with jaguar and anthropomorphic heads on *hachas.*

It is characteristic of all animal and human heads—even skulls—on Cotzumal-huapa-style *hachas* to be uniformly deprived of their emblems of power. Human effigy heads are denuded of their ear ornaments and teeth, while animals are defanged and have no masticators. A few exceptions are fanged supernaturals (Figure 10). This consistent stripping of power attributes from both animal and human effigy heads on *hachas* distinguishes them from tenoned head representations, which are nearly always equipped with ear ornaments, headdresses (where appropriate), and teeth. *Hacha* effigies thus appear to be dead or powerless, while tenoned-head images seem to embody life or status and power.

The largest scale three-dimensional serpent image at Cotzumalhuapa occurs in the form of monumental Stairway F-4 at Bilbao, which Parsons (1969: 48-9) convincingly suggests was intended to symbolize the gaping jaws of a serpent, with cones on the balustrades representing fangs, and the steps representing ridges on its palate (Figure 12a). This stairway leads directly to the Monument Plaza and the sunken ball court (as postulated by Parsons), where the ball player stelae and other ballgame related monuments were displayed at Bilbao (*ibid.*: 55-57). The conceit of a staircase as a serpent maw is unique neither to Bilbao, nor to Cotzumalhuapa. Similar cone-shaped sculptures also associated with a major stairway were found at one of the westernmost Cotzumalhuapa sites, Palo Gordo (Termer 1973: 218; Figures 98-99). Although no reconstruction of this stairway at Palo Gordo has been made, it was possibly analogous to the Bilbao F-4 Stairway. Comparable cone-shaped sculptures adorning stairways are also known from such distant sites as Chichén Itzá and Copan (see Parsons 1968: 131). In addition, the Copan Hieroglyphic Stairway and the stairway of the Pyramid of the Niches at Tajín probably also symbolize the open maw of a serpent.

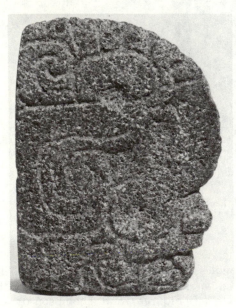

Figure 10. Miniature hacha. Escuintla. Anthropomorphic head with large eyes, fangs, and curled mustache. Photograph courtesy Museum of the American Indian, Heye Foundation.

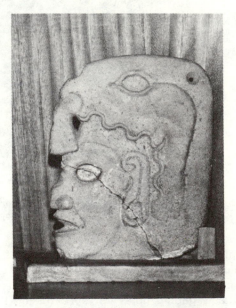

Figure 11. Cotzumalhuapa-style hacha of unknown provenience. Human head within serpent maw. Nottebohm collection, Guatemala. Photograph by the author.

Figures 12a, b, c. Cotzumalhuapa stylized serpent maw representation. a. Stairway F-4, Bilbao Monument Plaza; b. Bilbao Monument 7; c. El Castillo Monument 1. Drawings by the author after Parsons 1969, Figure 11 and Plate 34b.

Thus far, I have shown that three-dimensional representations of serpents at Cotzumalhuapa focus on images of heads, and include tenoned heads, *huchas*, and monumental stairways.

Relief Representations of Serpents

Serpent motifs on Cotzumalhuapa reliefs are largely confined to serpent heads and maws, as they are on three-dimensional sculptures. These representations vary in scale from miniature to monumental and in form from naturalistic to abstract. Stylized serpent maw images conceptually similar to the one on Stairway F-4 occur in profile on El Castillo Monument 1 and in frontal view on Bilbao Monuments 3 and 7. The serpent maws on Bilbao Monument 7 and El Castillo Monument 1 (Figures 12b, 12c, 13, and 14) are rendered in a highly stylized, rectilinear manner. On Monument 7 the

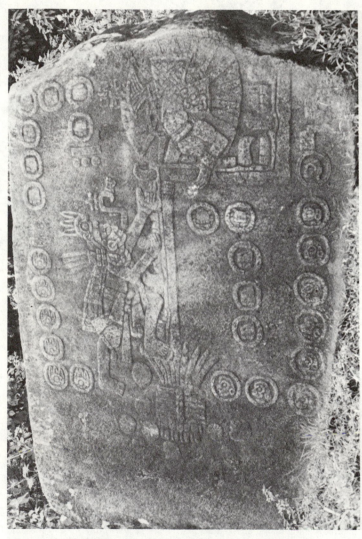

Figure 13. *El Castillo Monument 1. Human figure climbing serpent maw stairway, stela. Photograph by the author.*

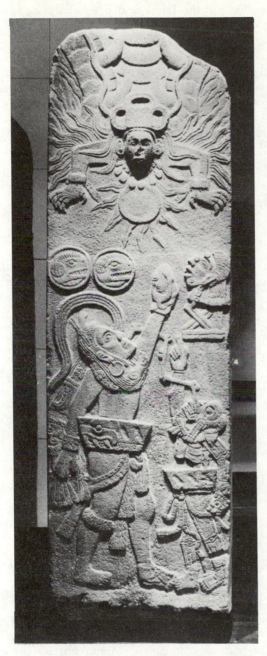

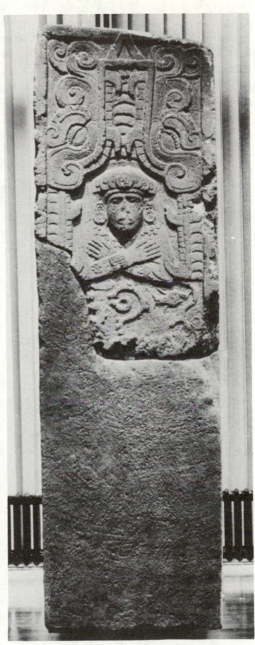

Figure 14. Bilbao Monument 7. Ball player stela. Photograph courtesy Museum für Völkerkunde, Berlin.

Figure 15. Bilbao Monument 3. Ball player stela. Photograph courtesy Museum für Völkerkunde, Berlin.

widest horizontal lines delineate the ridges of the upper palate, a more closely set and evenly spaced strip of horizontal lines indicate a row of teeth, interrupted by occasional fangs, a narrow strip outside the fangs indicates the gums, and yet another slightly wider row of lines, most clearly seen beyond the fangs that bracket the deity figure, may be the fleshy lips of the reptile's mouth. Bilbao Monument 3 (Figure 15), probably slightly later in date than Monument 7 (because of its opened-up and frameless composition), is a more naturalistic and organically rounded rendition of a gaping crocodile maw. Both maws enclose "diving" deity heads. Where the upper portion of the maw and thus an upward direction is stressed on Monument 7, the lower portion of the jaw and a downward direction is emphasized on Monument 3. The deity wearing a solar disk on the upper register of Monument 3 is also closely comparable to the figure surrounded by a solar disk at the top of El Castillo Monument 1 (Figure 13), but seen from a different perspective.[3]

Figure 16. Front and side of Bilbao Monument 33 (drawing). Shaft carved on three sides with Reptile Eye glyphs and serpent maw markings. After Thompson 1948, Figure 2h.

Motifs on Bilbao Monuments 33 (Figure 16) and 84a, b, c (Figures 17 and 18), are far more abstract, but essentially resemble the realistically recognizable serpent maws on Bilbao Monuments 7 and 3 (Figures 14 and 15). In Bilbao Monument 33 the original point of departure for the representation is difficult to detect: the serpent

3. At dawn, an actual figure climbing the F-4 Stairway, located on the western side of Platform 1 at Bilbao, would have been facing the sun in much the same manner as the figure on El Castillo Monument 1. Counting the platform top, there were nine steps on the F-4 Stairway, suggesting a symbolic ascent.

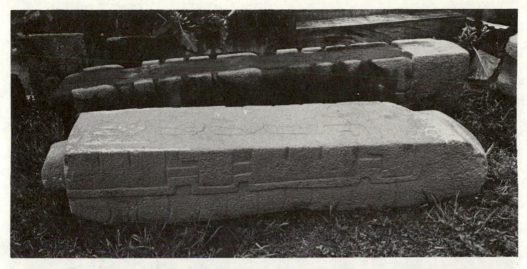

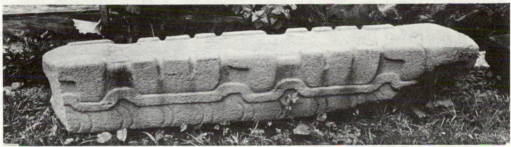

Figures 17, 18. Bilbao Monuments 84a, b, c. Shafts carved on three sides with Reptile Eye glyphs and serpent maw markings, recently unearthed. 17. Bilbao Monuments 84a and c. Low relief, with three and four Reptile Eye glyphs; 18. Monument 84b. High relief, with three Reptile Eye glyphs, side view.
Photographs by the author.

maw has become an abstract emblem. All four sculptures of Monuments 33 and 84a, b, and c are basalt shafts, rectangular in cross-section, with relief decoration on three sides (Figures 16 and 17). The front of each column is carved with either three, four, or six trefoil Reptile Eye glyphs, and a bifurcated double scroll motif that represents a cleft serpent tongue flowing from the base of the lowest glyph.[4] The sides of each shaft are carved with a complex geometric decoration of modular widths (Figure 18), which Parsons has tentatively identified as serpent ventral scales and dorsal patterns (1969: 112), but appears instead to replicate the layered pattern of the serpent maws on Bilbao Monuments 3 and 7 and El Castillo Monument 1. On Monuments 84a and b this pattern forms a notched ladder made up of deeply undercut fangs and teeth, with the trefoil Reptile Eye glyph possibly mapping the stages of ascent on the front of the shaft. Thus, the four columns appear to symbolize gaping serpent maws.

4. Monuments 84a and b were found recently in an area just beyond the F-4 Monumental Stairway on the north side of the Monument Plaza. These two columns are of nearly identical dimensions and style; each is adorned with three trefoil Reptile Eye glyphs and has deeply undercut carving on the sides of the shaft. They were set on either side of Monument 85, a lintel. Monument 84c, with slightly different dimensions, decoration, and carving style, was found some distance behind. It resembles Bilbao Monument 33, which was uncovered some years ago from a non-specific location at the site, more closely than Monuments 84a and 84b. Monument 33 has six Reptile Eye glyphs on its front surface, whereas Monument 84c has only four.

Figures 19a, b, c, d. Ornamental rectangular devices at Bilbao. a. Back element worn by ball players, as on Monument 2; b. Headdress element worn by ball players, as on Monument 38; c. The "Serpent Maw" glyph, for example, on top of Monument 1; d. An emblematic device on Monument 21. Drawings by the author.

An open-ended rectangle, embellished with horizontal striped lines, can be seen in several locations (Figures 19a, b, c, d). I believe this motif to be an even more abstract or ideographic version of the serpent maw motif at Cotzumalhuapa. It can be seen most clearly as a stylized back and head ornament worn by ball players.[5] These ornaments are roughly uniform in size, bordered on two sides by a narrow and a wider row of evenly spaced horizontal lines, and have a tasseled crest attached either to their bottom (Figure 19a) or top (Figure 19b). Figures with yokes and calloused knees on Bilbao Monuments 2, 4, 6, 8, and 10-11 (Parsons 1969: Plates 32c; 33a, b, c; 41a, b) wear this rectangular ornament attached to the back of their waists. Similar devices frame the heads on Bilbao relief Monuments 82 and 83 (Figures 20 and 21) and 38, and the head of the central figure on El Baul Monument 4 (ibid.: 1969: Plate 29b and cover; Plate 58d). They also appear on three-dimensional "portrait busts," including El Baul Monument 12 (Figure 22), Pantaleon Monument 1, two tenoned heads from Fincas Los Pastores and Pompeya, near Antigua, and two others from the south coast (ibid.: Plates 60d, 63a, b, c). The device is now up-ended so that the crest and tassel are at the top, projecting over the face of the personage,

5. Figures on Cotzumalhuapa reliefs wearing yokes, kilts, neck ornaments (usually shell gorgets), ear plugs or pendants, and also frequently having gloves, garters, sandals, and calloused knees, are considered to be ball players. Busts or heads with the same headdress and body ornaments as full figures with complete costumes are also identified as ball players.

70

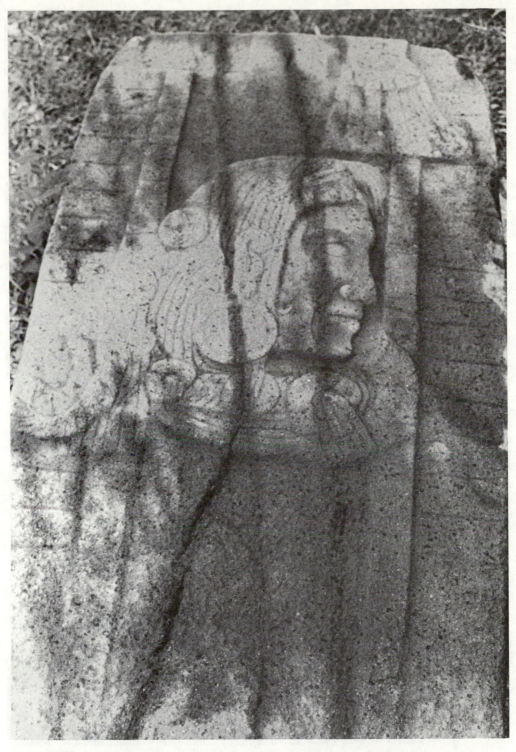

Figure 20. Bilbao Monument 82. Human "portrait" head within ornamental rectangular device, relief on a rectangular block, recently unearthed. Photograph by the author.

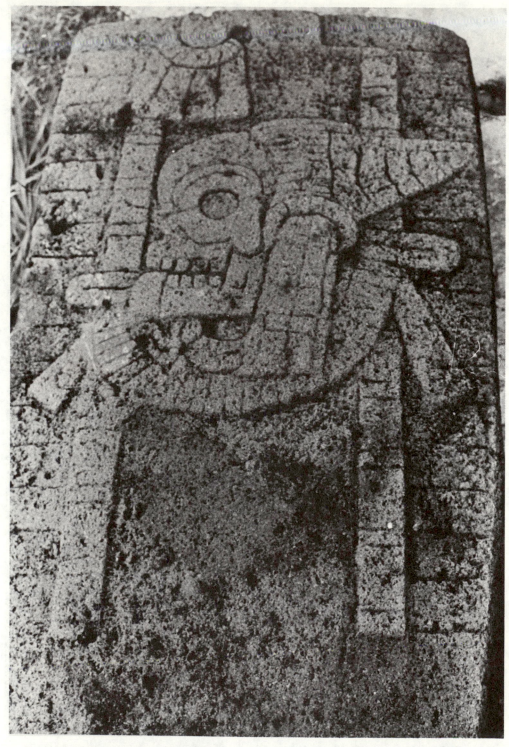

Figure 21. Bilbao Monument 83. Skeletal head within ornamental rectangular device, relief on a rectangular block, recently unearthed. Photograph by the author.

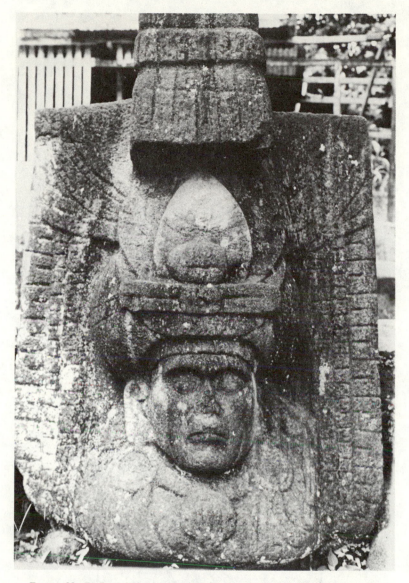

Figure 22. El Baul Monument 12. Horizontally tenoned human "portrait" bust. Photograph by the author.

rather than hanging from the bottom. Whereas only youthful ball players wear back ornaments, rectangular head ornaments are worn by youthful, more mature, and death figures. Yet another difference involves the distinctive hairdressing of these heads; instead of being worn in a long queue down the back, hair is now wound around the neck, as on Bilbao Monument 82 (Figure 20). That the rectangular ornament is an emblematic representation of a serpent maw is supported by comparing it to representations of clear-cut serpent maws on Bilbao Monuments 3 and 7 and El Castillo Monument 1 (Figures 12b, 12c). On the latter relief, a profile serpent maw is divided into distinct parallel strips marked by evenly spaced horizontal lines. The serpent maw element *per se* is symbolized by either one or two narrow strips with horizontal lines. The outer, wider strip probably represents a feather border.

Figure 23. Bilbao Monument 1 (drawing). Ball player stela. Collection Museum für Völkerkunde, Berlin. After Museum handout 004.

A glyphic form, surrounded by a cartouche, that is essentially identical to the stylized rectangular ornament I call the Serpent Maw glyph appears at the top of Bilbao Monument 1 (Figures 23 and 19c) and on Bilbao Monument 55a, a carved riser of the F-14 Stairway on the north side of the Monument Plaza (Figure 24).[6]

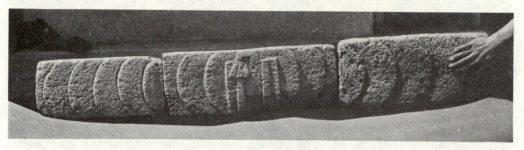

Figure 24. Bilbao Monument 55a. Block carved with glyph and semicircles from Stairway F-14, Monument Plaza. After Parsons 1969, Plate 6c.

To review briefly, we have seen realistic and stylized relief representations of serpent maws on Bilbao Monuments 3 and 7 and El Castillo Monument 1. More abstract images of serpent maws occur on four carved shafts from Bilbao, Monuments 33 and 84a, b, c. An emblematic version of the serpent maw motif appears as a stylized rectangular back and head ornament worn by ball players on various Cotzumalhuapa monuments. Finally, a glyphic version of this rectangular device is seen on Bilbao Monuments 1 and 55a. This mixture of realistic and abstract representations of serpents observable at Cotzumalhuapa recalls a similar phenomenon in lowland Maya art, where elements that appear on reliefs in realistic form are abstracted and combined into hieroglyphs. It does not occur in the art of Teotihuacan, which is consistently emblematic in character—everything is a sign or symbol—nor in the predominantly naturalistic art of Veracruz.

The Meaning of Serpent Motifs at Cotzumalhuapa

The meaning of serpent imagery at Cotzumalhuapa is closely bound up with the ballgame, which is the central metaphor of Cotzumalhuapa art. I believe that the ballgame was probably a great state festival incorporating agricultural, civic, and religious concerns, all focused on an athletic contest, culminating in sacrificial rites. The proliferation of architecture, monumental sculpture, and stone paraphernalia associated with the ballgame in the Middle Classic period at Cotzumalhuapa marks the institutionalization of the cult in the society. Elsewhere (Braun 1977) I have hypothesized that this development was a response to profound socio-economic changes brought about by the demand for cacao, particularly as a medium of exchange, and the introduction of specialized labor and trade. In social terms, the ballgame ceremonial may have provided altered forms of activity and association. These may have been reflected in new status relationships between members of the community.

6. A variation of this glyph may be seen on the lower right of Bilbao Monument 21 (Figure 19d) (Parsons 1969: Frontispiece).

 The earliest appearance of an emblematic serpent maw motif on the south coast of Guatemala may be at Monte Alto in the Late Pre-Classic period. Monument 6 is decorated with "an interesting medallion on the breast which may be a serpent-jaw motif" (Parsons and Jenson 1965:137-38; Figure 12, left). Consisting of two curved brackets with curled ends, decorated with diagonal stripes, enclosing a row of evenly spaced horizontal lines, this pectoral resembles the stylized serpent maw on Bilbao Monuments 7 and 21 and glyphic versions of this motif on Bilbao Monuments 1 and 55a.

The game probably legitimized new Cotzumalhuapan merchant rulers and enshrined a new social order based on the production and mercantile trading of cacao. Under this regime, the game may also have been a means of channeling social energy and sanctifying new competitive values in Cotzumalhuapa society. Through rigorous competition in the athletic contest, participants secured a high civic-religious status. Spectators of the cult had a cathartic experience in witnessing the enactment of social conflicts and their harmonious resolution in sublimated form. A power struggle between the old and new orders might also have been symbolized in this way.

If the ballgame were regarded as a cultic performance based on initiation rites, then the problem of who was sacrificed at the culmination of the game—the loser or the winner—might be resolved. The imagery of Cotzumalhuapa reliefs suggests that a mythic underworld battle between the lords of the night and ancestral culture heroes was dramatized in the ballgame ritual. The former appear to be represented by earth and underworld motifs, the latter by sky and celestial motifs; the one by vine plants, the other by cacao. The sacrifice of the ball player who transcends worldly experience by ascending to the sky as a god may be a reconciliation of these polarities. The *Popol Vuh* narrative of the adventures of twin ball players in the underworld conforms to such a scenario. In the myth, two pairs of ball player twins play ball against the rulers of the underworld. Dismembered by their adversaries, the second set of twins is resurrected, and manages to defeat the enemy on the ball court. Finally, the twins rise up victoriously as the sun and the evening star. Although this is a Quiche myth dating to the Late Post-Classic period, it is generally considered to reflect a very widespread pre-Columbian religious conception with a considerable time depth. The game itself might also be regarded as a species of initiation rite, with the ordeal being an athletic contest on the playing field. By successfully undergoing heroic trials on the ball court, players reached a higher grade and became heroes. When such heroes finally lost the game, they were sacrificed and became gods or supernaturals. Viewed in this light, the sacrificial victim at the climax of the game is both the winner and loser of the game. He is a reigning hero who has been challenged and overthrown by a younger and stronger man; previously victorious, he is now superseded by a new hero. It is further conceivable that the tenure of the victor was restricted, perhaps to the duration of an agricultural cycle or a year, as was the case among Aztec deity impersonators and rotational priests.[7]

An iconographic interpretation of several Cotzumalhuapa reliefs supports the reconstruction of such a sequence of ballgame rites. Bilbao Monument 9 (Figure 25), a seated figure with a yoke, calloused knee, elaborate headdress, and staff, and a similar unnumbered relief (Parsons 1969: Plate 29a), represent the enthronement of a ball player hero. There are a number of reliefs showing the defeat and sacrifice of a ball player, including El Baul Monuments 4 and 27 (Figure 26), Bilbao Monuments 1 (Figure 23), 10 and 11. A large number of reliefs represent a dialogue between two ball players, including El Baul Monuments 27 and 30 (Figure 27), Bilbao Monuments 10, 11, and 20, and El Castillo Monument 2 (Parsons 1969: Plates 40a; 41a, b; Thompson 1948: Figure 7a). What is recorded here is a ritual transfer of power from

7. At the Aztec feast of Toxcatl, dedicated to Tezcatlipoca, there was an annual sacrifice of a young man impersonating Tezcatlipoca, who had lived like a god for one year (Nicholson 1971:432). Among the Aztecs, in addition to a fulltime priesthood, there were also rotational priests who served successive *veintena* shifts as well as votive penitents from the upper class who vowed to serve a particular temple for specific periods of time. "Typical were . . . groups of young men and women who served exactly one year in the Huitzilopochtli temple in Mexico" (*ibid.*:436).

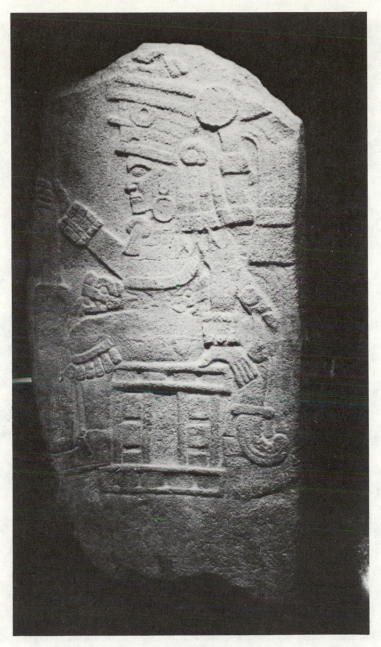

Figure 25. Bilbao Monument 9. Enthroned human figure, stela. Photograph courtesy Museum für Völkerkunde, Berlin.

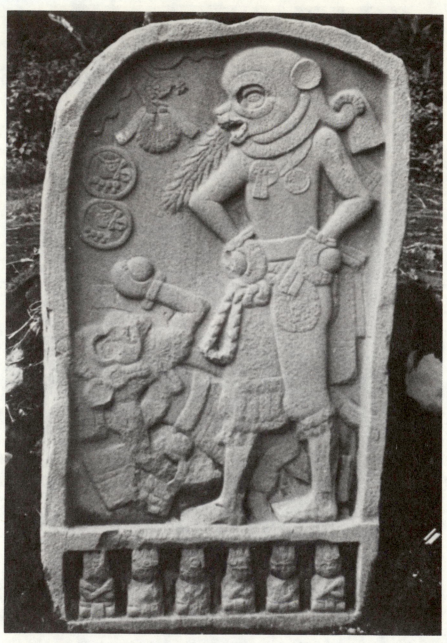

Figure 26. El Baul Monument 27. Two grappling ball players, stela. Photograph courtesy Milwaukee Public Museum.

Figure 27. El Baul Monument 30. Two confronting human heads. Relief on rectangular block. Photograph by the author.

one ball player hero to his successor in office.[8] Finally, El Castillo Monument 1 (Figure 13) and Bilbao Monument 15 (Parsons 1969: Plate 36c) depict a ball player ascending a staircase towards a celestial deity surrounded by a disk, and signify the apotheosis of the ball player.

The representation of an ornamental rectangular device on many Cotzumalhuapa monuments also suggests a sequence from ball player to divine hero. There is an explanation for the observed shift in orientation of these devices on certain figures and the accompanying hairdress modification. Prior to the game the player wears the ornament attached to the back of his waist, while after the contest and possibly in conjunction with his sacrifice it is transferred to the back of his head and turned upside down. Evidence from burials in Veracruz indicates that yokes may have undergone a similar transposition during the course of the ballgame ceremonial in that region.[9] Ceremonial objects are treated similarly in initiation rites in many ethnographic cultures.[10]

8. Ethnohistoric and ethnographic parallels suggest this idea of a ritual transfer of office ceremonial in the ballgame context. Examples include the fellow-feeling and kinship expressed between an Aztec sacrificer and his victim (Soustelle 1971:99); and the cargo festival rituals in many contemporary Mexican communities, such as Zinacantan, Chiapas, in which old and new leaders face each other obliquely and shout out their speech simultaneously during the highly ritualized transfer ceremonials (Mendelson 1967:401).

9. First worn around the waist of living ball players, yokes were later placed around the head of a ball player as a funerary crown or container for his body. At Omealca, Genin (1928) uncovered an undecorated yoke placed around the skull of a buried man; at Santa Luisa, near Tajín, Wilkerson (1970) found the body of a young man of athletic build flexed on top of a carved yoke and partially contained within it; Medellín Zenil (1960) found the pulverized bones of an individual mixed with cinnabar placed within the arch of the yoke.

10. For example, in the early stages of the Asmat initiation rite in New Guinea, the youthful initiate undergoes an ordeal in the men's house. Immediately thereafter he is elaborately decorated, and bamboo plates called *owan* are placed on his back. After a subsequent ordeal involving a canoe trip and a ritual reenactment of death and rebirth, the initiate is once again decorated from head to foot, and the bamboo plates are shifted from his back to his breast. He is thenceforth considered to be a man (Zegwaard 1959:1025).

Worn by the ball player as a back ornament at one point in the ceremonial game, the device was transposed to his head when he had achieved a certain status. Ball players may have been ranked hierarchically at Cotzumalhuapa: there are ethnohistoric[11] and mythical[12] parallels to support such an hypothesis. The serpent maw symbolizes the ultimate status elevation, awarded posthumously after the sacrifice of the hero, and signifying his apotheosis.[13] Moreover, the crowning of the hero with this device identified him with a serpent deity. Thus, serpent maws were associated with heroic ball players who successfully emerged from the ordeal of the athletic contest, and passed through several ranked levels to become heroes, or perhaps hero-rulers, and finally divine culture heroes.

Following this interpretation, the glyph in a raised cartouche at the top of Bilbao Monument 1, and on Monument 55a (Figures 23 and 24) suggest two meanings: a serpent maw headdress, and an empty frame, which might have been filled by the (sacrificed) head of the ball player hero. The raised format and the position of the glyph on the top of the stela are analogous to the high-relief representations of divine deity heads on the tops of the seven other Bilbao ball player stelae, Monuments 2-8. This suggests a correspondence in the meaning of these forms, which supports these speculations.

The investiture of the ballgame hero with a serpent maw headdress that identified him with a serpent deity can be seen to be analogous to Maya rulers who identified themselves with the serpent deity, Itzamna. Viewed in this light, the serpent maw motif at Cotzumalhuapa may be likened to the Maya deity Itzamna, as has been suggested by Thompson (1970; 1973), and thus have less correspondence to Mexican serpent imagery.[14] According to Thompson, the Maya serpent monster is Itzamna or Iguana house, a reptile combining crocodile, iguana, and snake attributes, embodying a group of deities who were earth and sky, with four aspects that together comprise the roof, walls, and surface of a huge world-enclosing house or frame (1970: 214). Maya temples or houses with serpent maw facades confirm this interpretation, as do representations of Itzamna beings forming a frame in which a ruler is seated on his throne, as on Piedras Negras Stela 25 (*ibid.*: Figure 4d). Thompson concludes that the constant identification between the ruler and a serpent in Maya art was an effort on the part of rulers to identify themselves with the supreme power, and an assertion of the divine right of the Maya rulers (1973: 69). He further suggests that the image of the human head within a serpent maw represents one of four deified aspects of Itzamna, with the serpent standing for Itzamna and the head, for a particular version of the god, depending on the secondary characteristics, usually either God D, a sky creator, or God K, an earth fertility god (Thompson 1973: 65ff).

11. Both the Aztec priesthood and military were organized hierarchically. Each major grade of the priesthood, from student acolyte to high priest, had a rank and title. Individuals who chose the priesthood as a fulltime profession seem to have moved up this ladder about every five years (Nicholson 1971: 436). The military ranking system included a long series of grades based on heroism displayed on the battlefield, judged according to how many enemies were taken or killed. The supreme rank awarded to war heroes was membership in the highest military orders, jaguar or eagle knighthood (Soustelle 1971: 43).

12. The structure of the *Popol Vuh* myth, narrating the progressive adventures of two sets of twins undergoing ordeals in the underworld, shows the first set of twins preparing the way for the eventual triumph and deification of the second set.

13. The serpent is the perfect embodiment of the idea of resurrection by the natural fact of its periodic sloughing of old and regeneration of new skin. There are also certain Cotzumalhuapa representations that explicitly appear to relate serpents to the concept of rebirth or renewal (Thompson 1948: Figures 9f and 28a).

14. Seler (1902-23), Nicholson (1961), Klein (1975), and Pasztory (1976) have interpreted the image of the human head enclosed within a serpent maw as primarily associated with earth, underworld, death, and fertility.

At Cotzumalhuapa, we have seen that the serpent maw appears as a framing device in monumental scale on the F-4 Staircase, according to Parsons' reconstruction (Figure 12), and around the heads on Bilbao Monuments 38, 82, and 83, El Baul Monuments 4 and 12, and Pantaleon Monument 1, as well as other sculptures from south coast and Antiguan sites. It also appears as a glyph and an empty frame at the top of Bilbao Monument 1 and on Bilbao Monument 55a. The crest and tassel prominently displayed on the stylized back and head ornaments worn by many ball player figures (Figures 19a, b) and on a serpent effigy-head *hacha* (Figure 11) further suggest an analogy between Cotzumalhuapa serpent images and Maya God K. This earth-fertility aspect of Itzamna is characteristically endowed with a crest and tassel (see Thompson 1970: 226). The alternating orientation of this crest on Cotzumalhuapa representations suggests that the Cotzumalhuapa serpent represents a deity embracing both earth and sky associations or the descending and ascending aspects of a deity. The predominance of the ascending direction in the iconography emphasizes ideas of birth, ascension, and transition to a higher state at Cotzumalhuapa, and associates the serpent head primarily with these conceptions.

As a feature of the serpent's head, both the Reptile Eye glyph and the Serpent Maw glyph also appear to be closely associated with ideas of elevation. The meaning of the trefoil Reptile Eye glyph at Cotzumalhuapa is disputed. Thompson identified it as a celestial symbol, and Parsons as an earth-related symbol whose three peaks are symbolic of leafy vegetation (1969:145). My analysis shows that the Reptile Eye glyph at Cotzumalhuapa is linked with earth and vegetation, and restricted to one upward direction. But it also occupies a position between earth and sky, and in fact bridges the gap between these two spheres in the Cotzumalhuapa universe.[15] The Serpent Maw glyph seems to operate more flexibly in both up and down directions, while favoring the former. The distinctive meaning of both these glyphs involves process, becoming, emerging, and transition between two spheres or states of being.

In conclusion, Cotzumalhuapa serpent head representations appear to have functioned as images of transformation and change. As tenoned heads, *hachas*, monumental stairways, shafts, relief images, and glyphs, they are mediating emblems of passage from one state of experience to another in the ballgame ritual. As realistic and emblematic headdress ornaments, they signify the periodic temporal and spiritual renewal of men and heroes (or hero-rulers) in the context of the ballgame ceremonial. Thus, rather than images related to the earth and underworld, Cotzumalhuapa serpents appear to be emblems of transformation and transition to an upperworld. If my interpretation is correct, then serpents at Cotzumalhuapa correspond more closely to Petén Maya than to Mexican representations.

15. The Reptile Eye glyph is usually represented in a vertical series which traces an upward course from a lower to an upper level, as on Bilbao Monuments 10 and 11, 33, 84a, b, c, and El Castillo Monument 1.

Bibliography

Arts Mayas du Guatemala
 1968 Exhibition. Paris: Grand Palais, Ministère d'Etat Culturelles.
Braun, Barbara
 1977 "The Monumental Sculpture of Santa Lucia Cotzumalhuapa, Guatemala." Ph.D. Dissertation, Columbia University.
Genin, A.M.A.
 1926 "Note sur les objets précorteziens nommés indûment, jugos ou yougs." *Proceedings of the XXII International Congress of Americanists*, 1: 521-28. Rome.

Hellmuth, Nicholas M.
 1975 "The Escuintla Hoards." Teotihuacan Art in Guatemala. *F.L.A.A.R. Progress Reports*, 1 (2).

Kidder, A.V. and C. Samayoa Chinchilla
 1959 *The Art of the Ancient Maya.* New York: Thomas Y. Crowell Company.

Klein, Cecilia F.
 1975 "Post-Classic Mexican Death Imagery as a Sign of Cyclic Completion." In *Dumbarton Oaks Conference on Death and the Afterlife in Pre-Columbian American.* Washington, D.C. Dumbarton Oaks Research Library and Collection. Pp. 69-85.

Medellín Zenil, A.
 1960 *Ceramicas del Totoncapan.* Jalapa, Veracruz.

Mendelson, Michael E.
 1967 "Ritual and Mythology." In *Handbook of Middle American Indians*, M. Nash, Ed., 6: 392-415. Austin: University of Texas Press.

Miles, Suzanna W.
 1965 "Sculpture of the Guatemala-Chiapas Highlands and Pacific Slopes, and Associated Hieroglyphs." In *Handbook of Middle American Indians*, R. Wauchope and G. Willey, eds., 2: 237-75. Austin: University of Texas Press.

Nicholson, H.B.
 1961 "An Outstanding Aztec Sculpture of a Water Goddess." *The Masterkey*, 35: 44-55. Los Angeles: Southwest Museum.

 1971 "Religion in Pre-Hispanic Central Mexico." *In* R. Wauchope, ed., *Handbook of Middle American Indians*, 10: 395-446. Austin: University of Texas Press.

Parsons, Lee A.
 1969 Bilbao, Guatemala. An Archaeological Study of the Pacific Coast Cotzumalhuapa Region, vol. 2. *Milwaukee Public Museum Publications in Anthropology*, No. 12.

 _____ and Peter Jenson
 1965 "Boulder Sculpture on the Pacific Coast of Guatemala." *Archaeology*, 18 (2): 132-44.

Pasztory, Esther
 1976 "The Xochicalco Stelae and a Middle Classic Deity Triad in Mesoamerica." *23rd International Congress of the History of Art, Granada, 1973*, 1: 185-215. Granada.

Seler, Eduard
 1902- *Gesammelte Abhandlungen zur Amerikanischen Sprach-und Alterthumskunde.* 5 vols. Berlin.
 23 (Reprint 1960-61: Akademische Druck-und Verlagsanstalt, Graz.)

Soustelle, Jacques
 1971 *The Daily Life of the Aztecs.* Stanford: Stanford University Press.

Stroessner, Robert J.
 1974 "Free-Standing Portable Sculpture Related to Teotihuacan During the Early Classic Period." Unpublished paper, Denver, Colorado.

Termer, Franz
 1973 Palo Gordo. Ein Beitrag zur Archäologie des pazifischen Guatemala. *Monographien zur Völkerkunde Heramsgegeben vom Hamburgischen Museum für Völkerkunde.* Munich. (Published posthumously. With an English summary by H. von Winning.)

Thompson, J. Eric S.
 1948 An Archaeological Reconnaissance in the Cotzumalhuapa Region, Escuintlá, Guatemala. *Carnegie Institution of Washington, Pub. 574.* Washington.

 1970 *Maya History and Religion.* Norman: University of Oklahoma Press.

 1973 Maya Rulers of the Classic Period and the Divine Right of Kings. In *The Iconography of Middle American Sculpture.* New York: The Metropolitan Museum of Art. Pp. 52-71.

Villacorta, J.A. and C.A. Villacorta
 1927 *Arqueologia Guatemalteca.* Guatemala.

Wilkerson, S. Jeffrey K.
 1970 "Un yugo ' in situ ' de la region del Tajín." *INAH Boletin*, No. 41, Pp. 41-4. Mexico.

von Winning, Hasso
 1961 "Teotihuacan Symbols: The Reptile's Eye Glyph." *Ethnos*, vol. 26, No. 3, Stockholm.

Zegwaard, Rev. Gerard A.
 1959 Headhunting Practices of the Asmat of Netherlands New Guinea." *American Anthropologist*, vol. 61, No. 6, pp. 1020-41. Washington.

Artistic Specialization at Teotihuacan: The Ceramic Incense Burner

Janet Catherine Berlo
Art Department
University of Missouri at St. Louis

A very special class within the Teotihuacan pottery inventory is that of incense burners, or *incensarios*. In ancient Mexico incense was employed for ritual purposes and, therefore, the containers in which it was burned were specifically designed for that function. Items of special function, especially religious ones, are usually constrained by prescribed sets of special design features. This article analyzes the incense burners from urban Teotihuacan and the specialty workshops which produced them. Ritual, through constant repetition, can become prefunctory and/or highly mechanized. In the case of Teotihuacan incense burners, mechanization led to surprising diversity and individualization.

Introduction

THE ARCHAEOLOGICAL SITE OF TEOTIHUACAN is located 50 km north of modern Mexico City. Because of its proximity to the modern capital, and the grand scale of its two major pyramids, Teotihuacan has always been one of the major archaeological landmarks of the Valley of Mexico. Long abandoned by the time the Aztecs gained ascendancy in the Valley, Teotihuacan was to them a place of mystery, a site where in former times "humans became divine."

From 100 B.C. to A.D. 700, Teotihuacan prospered. A thriving metropolis of over 100,000 people, the city maintained a network of trade and diplomatic relations throughout Mesoamerica. Teotihuacan was the pre-eminent commercial and economic capital of its time. It was also a center of the arts. The massive Sun and Moon pyramids, characteristic talud-tablero architectural profile, planned avenues, and numerous apartment complexes attest to the primacy of the architecture among the arts (Figure 1). Architectural space was defined by fresco painting; polychrome murals covered stuccoed façades and interior walls (Figure 2).

In addition to these large-scale arts, small-scale objects were created in numerous craft workshops. The cylindrical tripod urn, painted or incised with figural and emblematic designs, is a hallmark of Teotihuacan civilization, found not only at the metropolitan center but at places distant from Teotihuacan as well. Figurines,

Figure 1. *Pyramid of the Moon, Teotihuacan.*

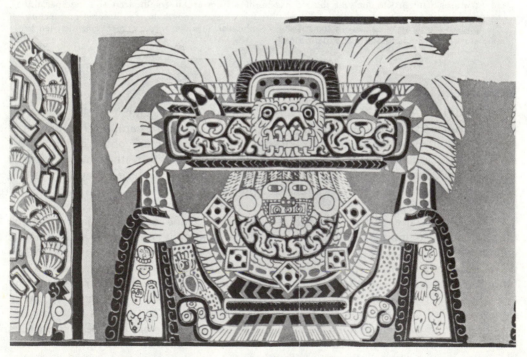

Figure 2. *Teotihuacan Mural, Tetitla Residence Compound.*

obsidian and stone items, and ceramic incense burners were among the other arts produced in quantity at Teotihuacan.

Although archaeologists have been excavating for nearly a century at this vast city, which covers nearly 22 square miles, a great deal remains to be discovered about Teotihuacan and its inhabitants. In addition to archaeological excavation, our knowledge of this ancient central Mexican culture has been advanced by art historical analysis of murals (Pasztory 1976; Miller 1973), architecture (Kubler 1973), and iconography (Kubler 1967; C. Millon 1973; Pasztory 1973, 1974; von Winning 1947, 1949, 1961, 1968, 1977, 1979). An art object is an individual expressive statement, disclosing information about artist, craft, and workshop. It is also a cultural artifact, which can aid in defining larger social issues such as religious practices, social organization, and world view.

In this essay, I shall examine one particular class of art objects, pottery incense burners, in order to elicit information about Teotihuacan artistic practices and craft organization. As such, this essay is an exercise in one aspect of art historical methodology.

Teotihuacan Incense Burners

Pre-Columbian vessels used to burn *copal* or other offerings to the gods are generally known by the Spanish term *incensario*. Ritual vessels for the burning of incense have been recovered from almost all periods and all areas of ancient Meso-america, indicating that this was a pre-Hispanic ritual of great ceremonial importance. As general homage to deities, incense was burned in front of their effigies. Incense offerings were also made in New Year rituals, in architectural renewal of temples and pyramids, and in offerings to sacred bodies of water such as the Chichén Itzá cenote and Lake Amatitlan. In the *Chilam Balam of Chumayel*, copal smoke is called "the super-odor of the center of heaven " (Roys 1931:278). It functioned as a link between mortals and their gods; a means of homage, a prayer. Traces of ancient incensario ritual survive among modern Indians, many of whom burn incense as household offerings as well as in front of ancient stone monuments and Catholic churches (Ritzenthaler 1963).

Throughout Mesoamerica, various vessel forms were standardized as suitable containers for this offering. Teotihuacanos developed a highly distinctive and elaborate anthropomorphic incensario made of a number of component clay parts, each one formed, and sometimes fired, separately (Figure 3). Minimal requirements for an incensario consist of: (1) a *base*, which may be a high-sided dish, or an hour-glass shaped vessel. Within this base incense was burned. (2) a *conical lid,* sometimes with handles on the sides, and (3) a *chimney* or long tube which is attached at the back of the lid. The chimney allows for the escape of smoke from the burnt offering. In addition to this bare minimum, an incensario usually has (4) an *armature* of clay slabs attached to the lid in front of the chimney, providing the backdrop to which (5) *adornos,* or small badges and symbols, are affixed. In the center of this armature, a space is generally left for (6) a *face,* which is the focal point of the composition, surrounded by a wealth of badges and insignia.

The total effect of such a construction ranges from relatively austere (Figure 4) to very elaborate (Figure 5). Artistic individuality is evident both in the manipulation of the plastic mass (in such details as method of construction, relative depth, fineness of execution) and in the selection of symbols used to construct an incensario. The artist, choosing from a number of adornos, built up the incensario like a prayer, focusing on specific symbols for certain needs or occasions. George Kubler's linguistic

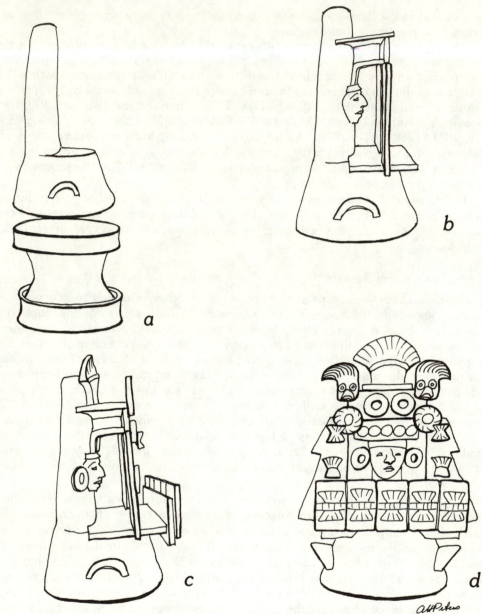

Figure 3. Steps in the construction of an incensario. Drawing by Ann H. Peters.

metaphor for Teotihuacan art (1967) is particularly appropriate here, where the use and repetition of certain motifs denotes a particular ritual emphasis.

A number of formal principles are characteristic of most incensarios. Foremost among them is an emphasis on frontality. Although all incensarios are three-dimensional composite pieces of sculpture, almost all are meant to be viewed from one angle only: a straight-on frontal view. Profile and back views (Figure 6) reveal the architectonic layering of the structure, but are generally free of ornamentation.

This aesthetic preference for two-dimensionality of composition may reflect the influence of mural painting, the major art form of Teotihuacan. Sculpture in the round

86

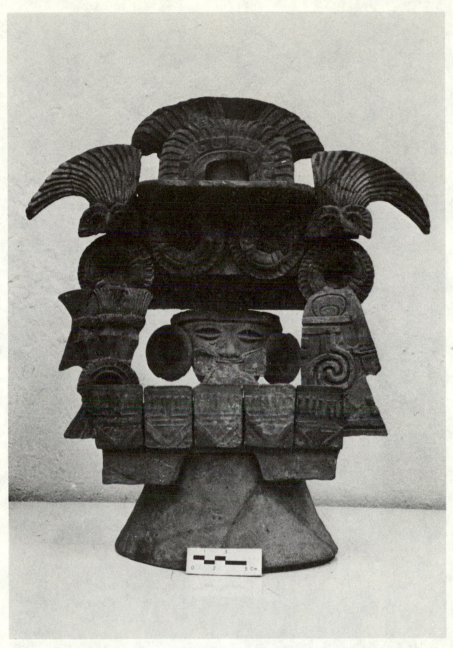

Figure 4. Incensario from La Ventilla, Teotihuacan. National Museum of Anthropology, Mexico City.

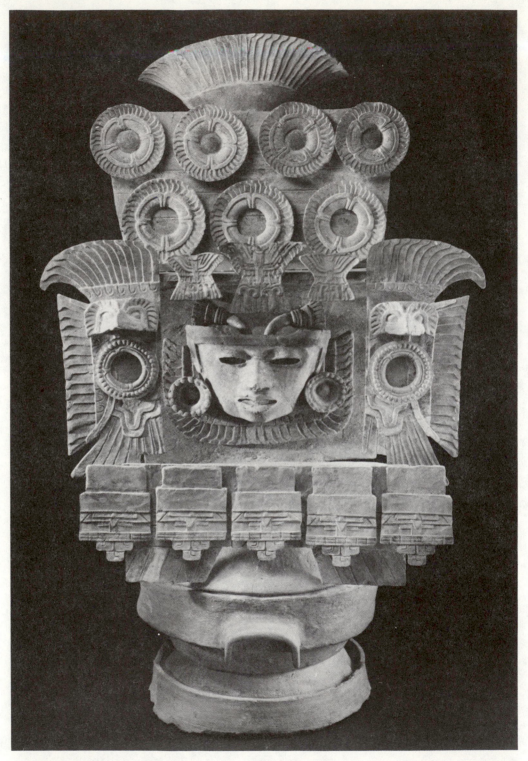

Figure 5. Teotihuacan incensario. St. Louis Art Museum. Photograph courtesy of the St. Louis Art Museum (Gift of Morton D. Day).

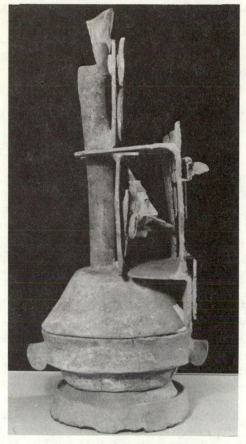

Figure 6. *Profile view, Teotihuacan incensario.*
St. Louis Art Museum (Gift of Morton D. Day).

Figure 7. *Pyramid of the Moon and Cerro Gordo, Teotihuacan.*

is rare at Teotihuacan. Although modeled and moldmade figurines were widely distributed in the city, most of them are frontal, static compositions as well, in which three-dimensionality is suggested by the curve of an arm, or headdress, but never carried farther. The backs are always flat and unadorned. A frontally conceived two-dimensionality seems to be a dominant feature of Teotihuacan art. In the case of incensarios, their two-dimensionality may also reflect their use on altars as frontally displayed icons.

In 1922, Manuel Gamio astutely observed that incensario lids seem to be miniature temples (1922:199). The recessed head suggests the icon within the temple shrine, standing on a decorated base. The side flanges are the painted walls of the temple enclosure. Above, adornos mimic the large stone and clay architectural decorations known from the Quetzalpapalotl Palace and elsewhere.

Architectural miniaturization and scale-modeling of architectural elements was common at Teotihuacan, where the characteristic talud-tablero profile is echoed in vessel feet and ceramic nose-plaques, thus transmitting aspects of conventional meaning of the architectural profile into other media.[1] In certain cases, architecture itself miniaturizes the natural order: the Pyramid of the Moon scales down and humanizes the bulky majesty of Cerro Gordo behind it[2] (Figure 7).

Archaeological Contexts

At Teotihuacan, incensarios were discovered in burials, in caches and offerings, and in one instance on a stone altar. These contexts provide clues to the ritual functions of these objects. Zacuala Burial 10 and Tlamimilolpa Burial 1 provide two examples of the mortuary context of incensarios.[3] The Zacuala grave contained cremated bones of one or more persons. The incensario was found in association with bones of deer, eagle, coyote, and white pelican (Séjourné 1959:667). Another incensario came from the sumptuous Tlamimilolpa Burial I, which contained over 200 ceramic vessels, 1,000 other small objects of clay, obsidian, mica, pyrite, bone, shell, and more than 30 censer fragments (Linné 1942:125-32). The incensario itself had been broken into pieces.

It was standard Teotihuacano practice either to break or carefully disassemble an incensario before placing it in a burial or cache. In cache 1 at Tlamimilolpa, Sigvald Linné found an incensario composed of two bowls, one inverted upon the other. Within the bowls were the remaining pieces of the incensario which had been taken apart but not destroyed. Arranged in a circle around the incensario offering were two tripod vessels, four bowls, an obsidian ring, a bone needle and tube, and various shells (1942:42).

The ritual nature of some of these incensario offerings is demonstrated by the following description of a find at Tlamimilolpa:

Below the undermost floor of room 1, four incensarios were discovered in hollows in the filling. Bowls and tubes were absent, and all other parts—not including the masks—were badly damaged. They had evidently been de-

1. The conventional meaning of the spatial order of Teotihuacan architecture has been discussed by Kubler (1973).

2. Such scale-modeling of natural phenomena as the basis for art and ritual has been discussed by Claude Lévi-Strauss in *The Savage Mind* (1966:23-4) and by Vincent Scully in *The Earth, the Temple and the Gods* (1962).

3. No thorough investigation has yet been carried out of Teotihuacan burial practices, so there are little reliable data on the range of items found in a Teotihuacan grave, other than what one can piece together from excavation reports. For the most complete information on grave furniture, see Linné 1934, 1942.

posited immediately before the moulding on the floor. They were embedded in ashes and surrounded by considerable quantities of yellowish clay. In some cases were found bits of charcoal and remains of charred textiles. Three of them had been placed together in east-to-west orientation. The predominant colors of the decoration of the masks were, counted from the east, red, green, white. North of them lay the fourth one, which was decorated in white and green.

<div align="right">(Linné 1942:172)</div>

Offerings of vessels during architectural construction formed a common practice in Mesoamerica. The most interesting feature of the Tlamimilolpa offering is the association of different color masks with different directional orientations. Association of colors with world directions is a pan-Mesoamerican concept, found in Mexican manuscripts, Maya divination books, colonial ethnography, and vestigally among modern Indians.

In Teotihuacan apartment compounds, a central patio or court is usually the core around which the inner rooms of the compound are arranged. These patios have central stone altars, which were the focal point for apartment group ritual (Figure 8). At Xolalpan, Linné found adorno fragments from at least two incensarios in the central altar of the patio as well as pieces of a volcanic stone fire god brazier (1934:48). This suggests that, as well as being used for personal and household religious practices (as evidenced by the numerous caches in residential areas), incensarios functioned as icons for the larger gatherings within the apartment compound. These were probably religious practices involving members of a common lineage, clan, or cult group. Once again the concept of miniaturization comes into

Figure 8. Patio 13, with central altar, Tetitla Residence Compound, Teotihuacan.

play: the residents gathered around a small-scale platform, upon which rested a miniature clay temple model which contained an iconic image. Within the confines of their extended family group, the Teotihuacanos were enacting on a lesser scale the religious rituals that took place in the ceremonial heart of the city at the monumental pyramids and temple platforms. William Sanders reports that ritual paraphernalia like that found at Teotihuacan, including incensario fragments, were found in household refuse at rural Teotihuacano communities elsewhere in the Valley. These objects were imports from the metropolitan center (Sanders 1966:138), and presumably would have served in rituals imitating urban ceremonial practice.

Caches of disassembled or broken incensarios, as well as the ubiquitous presence of incensario sherds in the house compounds (Linné 1934:113), leads one to conclude that these icons were used for a specific occasion, or a specific period of time, and then dismantled and interred. This, too, was a pan-Mesoamerican practice, usually taking place at the end of a calendrical period, when one was obliged to destroy household icons in preparation for the new year. Because many incensarios were deliberately taken apart by their users, their correct reassembly by archaeologists is a matter of some concern. In some cases the reconstruction may be open to question. In rebuilding a censer from Tlamimilolpa, Linné was careful to piece it together according to the clues provided:

> To guide us in the reassembling work, we had the marks from the cementing substance. The entire objects had further been coated with thinly fluid white paint, and as that had been applied in its fully assembled state, unpainted surfaces indicated the position of certain details (1942:172).

Craft Specialization and Workshop Practices

There are two methods of assembling an incensario. The differences between them may shed light on practices on craft specialization and on ritual activity. In both cases, wet clay forms the component parts of an incensario skeleton (base, lid, chimney, and armature). These are luted together while in a leather-hard air-dried state. It is after this point that the two techniques diverge. Examination of some censers reveals that air-dried adornos were then attached by soft clay pellets, and finally the entire assemblage was fired in a kiln. In this method, all components are fired at the same time, for it is not possible to affix pre-fired pieces to wet clay and bake the whole assemblage to attach them.

In the second method, the incensario skeleton was assembled and fired, individual mold-made adornos were fired, and then the adornos were affixed to the incensario framework by means of a lime-stucco "glue." Hundreds of loose adornos in storage at the *Museo Nacional de Antropología* in Mexico City retain vestiges of this white lime compound[4] (Figure 9).

These two methods of construction may reflect two differing levels of specialization in the manufacture of an incensario. A Teotihuacano could purchase a ready-made incensario from a craft workshop, where artisans had facilities to attach adornos with clay and fire the entire object. The individual would then be purchasing a standard incensario with iconography corresponding to fixed patterns used by the artists.

To judge from the sheer number of adorno fragments found throughout the city, there was also an active trade in the component parts of incensarios. A customer could

4. Linné reports one instance in which both clay and some perishable glue were used to affix different adornos (1942:171-2).

Figure 9. Back of censer adorno with white lime glue. National Museum of Anthropology, Mexico City.

buy a mass-produced, plain incensario body (base and lid with armature already fired on). From other craft specialists, one could purchase mold-made adornos, singly or in quantity, in order to ornament an incensario according to the particular ritual requirements of a specific occasion. The non-ceramicist, with no access to a kiln to fire unbaked components, would attach pre-fired adornos with lime-stucco glue. Examination of adornos in the *Museo Nacional* storerooms proves that this was the method used for the majority of censers. It allows ritual specialists rather than ceramic specialists to choose appropriate insignia for specific occasions. Perhaps a priest would advise an individual that a particular symbol or symbol cluster would have the greatest efficacy for healing or fertility, or whatever the need at hand. The individual could then construct a highly personal incensario to fit the occasion. After the proper ceremonies, this censer would be dismantled and buried. Linné reports instances in which only parts of incensarios were buried, while the bowls and chimneys were salvaged, apparently for new constructions (1942:174). This, too, argues for the temporary nature of these assemblages, which were set up for specific occasions and then destroyed.

The use of pieces mass-produced from a standard inventory of molds in order to assemble one's own censer accounts for the different clay types sometimes found in the same incensario. Linné noticed two kinds of clay used in the censer from Tlamimilolpa Burial 1: "The bowls, the tube, and the mask are of comparatively good material, but plaques and ornamental details are exceedingly brittle (1942:172)." This, too, could be evidence for the "throw away" nature of the ornaments—purchased and applied for a special occasion and then buried. Linné also found that at Tlamimilolpa the masks were often of better quality material and manufacture than

the rest of the pieces (1942:174). The use of highly distinctive clays for different incensario components may indicate extreme craft specialization. One would not simply be an incensario maker, but have an even more specialized role as mask maker, adorno maker, specialist in molding technology, or lid and armature maker, perhaps in entirely separate workshops with varying production standards. Examination of censers and adornos reveals a great diversity of quality in clay types as well as a range of technical proficiency in the production of incensario elements. Clays vary from fine, smooth types with small particles to coarse, heavy wares. Adornos range from thin, well-made pieces with crisp, sharp features to those evidently made in worn-out molds causing blurred, muddy outlines in the finished pieces.

Many incensarios were coated with a thin wash of white lime paint after final assembly and after firing. Individual adornos were painted in a variety of bright colors comprising the same color range found in murals. Most of these shades are highly fugitive, having been applied after firing, and little remains to indicate the striking polychromy of these vessels. One exception is the La Ventilla incensario upon which the once-bright yellows, reds, and blues are only slightly faded (Figure 10).

The manufacture of composite censers involved problems different from those in the production of figurines, cylindrical tripods, or murals. It is likely that censers, made in quantity, were the principal type of cult icon available to the general populace. It was probably in the manufacture of censers that Teotihuacan artists first applied principles of mass-production to art objects. Prior to this, such techniques were developed in the obsidian industry, and other technical pursuits. As the metropolitan population passed 100,000, the demand for ritual objects necessitated the application of mass production and time-saving techniques to these crafts as well. As adapted to incensario production, such principles included: (1) assembly line construction, (2) use of interchangeable component parts, (3) use of molds for repeating details, and (4) specialization of both routine and skilled jobs for greater volume of production. These principles were later applied to other arts. In figurine technology, molds were used first for heads. Based on stratigraphic evidence, Warren Barbour believes that molds were not widely used in figurine manufacture until after A.D. 450, in the Xolalpan phase (1976:90-1). After their introduction for the heads of portrait-type figurines, molds were used for puppet figures, and late in the city's history, molds supplanted hand modeling entirely to supply the demand for large numbers of figurines. Countless examples of mold-made mass-produced figurines are known from Metepec phase Teotihuacan and Azcapotzalco (Figure 11).

In contrast, censer artisans were using molds to make adornos in the early Tlamimilolpa phase (A.D. 250-375). The finest molds, for faces and delicate adornos, were probably made by the master artists of the workshop. Such molds were often used until their edges developed indistinct and tired outlines. Apprentices could quickly press out scores of adornos, to be air-dried until final assembly. It is likely that the censer framework was mass-produced by apprentices as well: clay would be rolled into slabs, chimneys formed, conical lids shaped around a form, armatures cut and applied to lids, and outlines of feathers scored with a knife into the slabs. In some cases, templates may have been used for these processes. In other cases, there is enough variation to indicate that the artist is working simply from practiced familiarity with the forms.

A number of censers excavated at Tetitla, La Ventilla, and other residence compounds resemble the censer in Figure 4. These were probably products of true assembly-line techniques, put together with only the slightest of individual variations. Usually the whole object was assembled and fired in one piece. Incensario production

became an increasingly expressive craft by Xolalpan times; individuality and variation were prized. It is from this period and later that the greatest range of adorno types are known. Master artisans were creating new and unique assemblages, and private individuals were constructing their own censers also, to fit the needs of certain ritual occasions. The hundreds of adornos with lime-stucco compound probably date from this period. These were individually fired emblems, that were later affixed to a pre-fired frame.

While the trend in figurine production led from individually adorned figures to mass-produced mold-made types, the trend in censer production went from

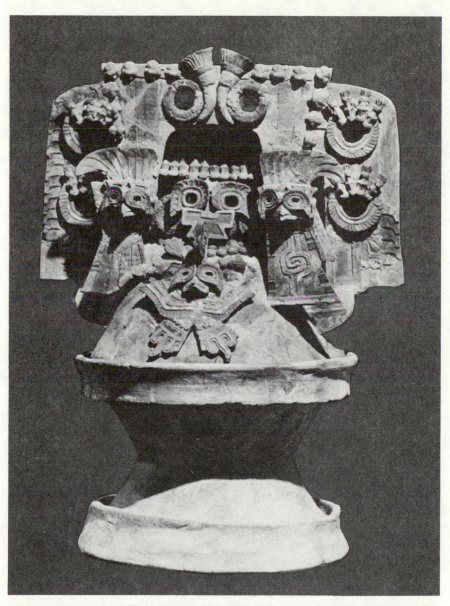

Figure 10. Incensario from La Ventilla, Teotihuacan, retaining traces of post-fired polychrome paint. National Museum of Anthropology, Mexico City.

mass-produced mold-made types to more individual constructions, still with mold-made components. It is worth noting that the same means of mass-production in two different crafts led to different results. The use of the mold for figurines brought about a highly systematized genre of types: warrior, enthroned figure, and so forth, with little stylistic or iconographic variation (Figure 11). In censer production, use of molds over several centuries led to individuality and self-expression because of the composite nature of the censer. Component parts were always standardized, but total construction became more individual by the Xolalpan period. Each person could build a unique construction out of mold-made units, indicating that mass production does not necessarily foster monotony and repetition.

Figure 11. Mold-made figurines, Teotihuacan, Mexico.

Incensario Iconography

In his study of Teotihuacan iconography, Kubler lists 97 "signs" used in Teotihuacan art (1967). Almost half of these are recognizably human or animal. Few are true glyphs. The Teotihuacanos lacked the kind of glyphic system that allowed the Maya to write in sentences and record historical events. They did, however, have a number of conventional signs that functioned as emblems in their iconographic system. Some of these are purely representational images such as stars, footprints, shields, and knives. They may, in some instances, be parts standing for wholes, as in the case of shields and spear ends which are military emblems, or shells which can represent watery places. The few signs that may actually be glyphs are at least partly abstract, and refer to something other than themselves. The reptile-eye glyph and the trapeze-and-ray sign are examples of Teotihuacan glyphs.

Some 60 different signs are found on Teotihuacan censers. Common emblems include earplugs, noseplaques, butterflies, feathers, flowers, decorative spear tops, shields and bird heads. Less often are seen reptile-eye glyphs, tri-mountains, shells, and crossed bands. The Teotihuacan symbol system is a fluid one, not a system of static equivalences. The conventional meaning of certain symbols seems to be modified and amplified by context and associated symbols. Alternation and repeated conjoining of insignia give clues to meaning. Many symbols surely have positional denotation, their meanings shifting with context. Thus, individuality of message is assured in a censer built up, like a prayer or a ritual chant, of different emblems and badges.

It was stated previously that Teotihuacan incense burners were miniaturized versions of large-scale temple icons, and were used in rituals taking place within the residential compounds. These small pottery icons were decorated and venerated in a manner similar to larger deity images. Later Aztec chronicles describe images made of various materials, hung with flowers, popcorn garlands, paper, feathers, and other perishable materials. Similar adornments are miniaturized in censer emblems made of fired clay, a less perishable substance. These censers, as we have seen, were dismantled and placed in underground offerings, making the assemblage an ephemeral one, constructed for a particular ritual occasion.

Censers most often display an anthropomorphic image as the central feature of the pottery assemblage. Most often the effect is of a human face recessed within a shrine. These faces are adorned in the same manner as human images in Teotihuacan murals and vase painting. Elaborate headgear, large round ear plugs, and noseplaques are carefully delineated. The faces themselves are mold-made, and sometimes have inset mica eyes. Although the faces do vary in contour, shape, and detail, they are, like most faces in Teotihuacan art, relatively inexpressive. Individuality and identity are found in the surrounding attributes.

Fugitive hues were used on censers, but occasionally traces of face paint can be discerned on the masks. Linné found a number of censer masks bearing a variety of painted designs (Figure 12). The eyes are outlined or circled with color. The bottom half of the face is painted with circles, stripes, or jagged lines in red, green, black, gold, and white. Similar styles of facial adornment among later inhabitants of the Valley of Mexico are described by Diego Durán. The Aztecs painted their own faces and those of their deity images with blood, soot, tar, chalk, and other pigments for ritual events (Durán 1972:72,91). To the Teotihuacanos, the various facial designs on censers and murals doubtless had emblematic significance.

Other insigna used on censers delimit the meaning of the incensario offering, or define the circumstance or deity to whom it is offered. Butterflies are among the most

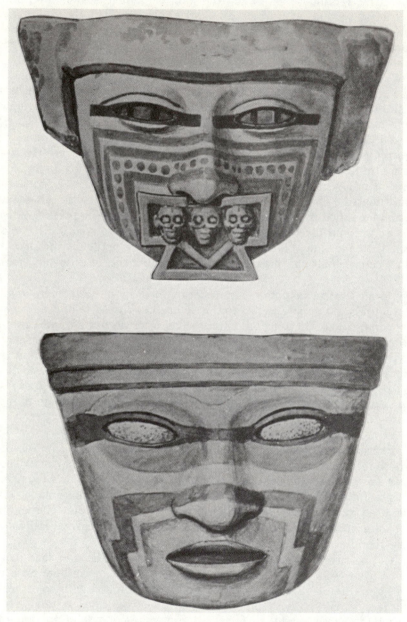

Figure 12. Polychromed face masks from incensarios. After Linné 1942: Plate 4.

common incensario emblems, occurring as wing adornos, proboscises, antennae and abstract noseplaques, as well as adornos imprinted with a whole butterfly outline. Butterflies combine with most other insignia on censers, from aquatic symbols to warrior implements. In the Aztec symbol system, the butterfly had several meanings. Observation of nature shows butterflies to be closely associated with flowers; indeed butterflies adorned the faces or headgear of Aztec deities with *Xochitl* (flower) in their names, such as Xochiquetzal and Xochipilli. The Aztecs often depicted flames in the shape of a butterfly, and the souls of dead warriors were represented by butterflies. These last two aspects of butterfly iconography share a common theme: transformation. Butterflies transmute into flames, and the souls of slain warriors transform into butterflies. The butterfly is a natural choice for a transformational symbol. During its life, it changes from caterpillar to pupa wrapped in hard chrysalis, to butterfly: a process of birth, apparent death, and resurrection as an elegant airborn creature. Fire, too, is a transforming process: fire feeds on natural materials, turning them to ash. In Mesoamerica's traditional system of slash and burn agriculture, fire transforms wild forest into workable *milpa*. Butterfly symbolism on incensarios relates directly to the fire offering within the censer. The burning of offerings is a concrete manifestation of natural powers of transformation, the butterfly symbolism a metaphorical one. To the Teotihuacano, the butterfly surely was an emblem of the soul, as it was for the later Aztecs.

Flowers, too, are common symbols on Teotihuacan censers. In the Aztec writing system, the flower was an ideograph for sacrificial blood (Dibble 1971:324). R. Laughlin has found similar associations of flowers with blood and sacrifice among modern Tzotzil Maya (1962). At Teotihuacan, flowers and blood sacrifice may have been linked, yet it is also possible that flowers and feathers simply indicate richness and preciousness, rather than having a more specific semantic reference.

In summary, Teotihuacan censers offer varied images and iconographic configurations. They were household icons, depicting emblems and symbols that, for the most part, restate the imagery found in other arts at the city. Although many display emblems associated with death, transformation, and militarism, their semantic categories are broad, and often general in message. Often non-specific themes such as fertility and abundance seem to be implicit in the generous use of butterflies, flowers, shells, and aquatic motifs. The use of badge-like insignia in changing configurations illustrates the flexibility of the Teotihuacan iconographic system, recombining ritual symbols to fit the needs of the occasion.

A similar flexibility has been suggested here for workshop practices at Teotihuacan. Time-saving methods of assembly line production and specialization in the manufacture of component parts were used to make large numbers of censers for a growing urban populace as well as to meet the needs of rural Teotihuacanos living elsewhere in the valley. Analysis of the workmanship and construction of a number of censers suggests that concurrent with this method of workshop assembly, there existed a large trade in incensario parts, giving rise to an "assemble-it-at-home" censer that could be built by a private individual for particular ritual events.

Bibliography

Barbour, Warren
 1976 "The Figurines and Figurine Chronology of Ancient Teotihuacan, Mexico." Ph.D. dissertation, Department of Anthropology, University of Rochester.

Berlo, Janet Catherine
 1980 "Teotihuacan Art Abroad: A Study of Metropolitan Style and Provincial Transformation in Incensario Workshops." Ph.D. dissertation, Department of History of Art, Yale University.

Dibble, Charles E.
 1971 "Writing in Central Mexico." In Robert Wauchope, et al., eds., *Handbook of Middle American Indians*. Austin: University of Texas Press, 10:322-32.

Durán, Diego
 1971 *Book of the Gods and Rites and the Ancient Calendar*. F. Horcasitas and D. Heyden, trans. and eds. Norman: University of Oklahoma Press.

Gamio, Manuel
 1922 *La población del valle de Teotihuacan*. 3 vols., Mexico.

Kubler, George
 1967 "The Iconography of the Art of Teotihuacan." *Dumbarton Oaks Studies in Pre-Columbian Art and Archaeology 4.* Washington, D.C.: Dumbarton Oaks Library and Research Facility.

 1973 "Iconographic Aspects of Architectural Profiles at Teotihuacan and in Mesoamerica." *The Iconography of Middle American Sculpture*. New York: Metropolitan Museum of Art, pp. 163-7.

Laughlin, R.
 1962 El símbolo de la flor en la religión de Zinacantan. *Estudios de Cultura Maya*, 2:123-39.

Lévi-Strauss, Claude
 1966 *The Savage Mind*. Chicago: University of Chicago Press.

Linné, Sigvald
 1934 "Archaeological Researches at Teotihuacan, Mexico." *Ethnographic Museum of Sweden Publication* 1, Stockholm.

 1942 "Mexican Highland Cultures." *Ethnographic Museum of Sweden Publication* 7, Stockholm.

Miller, Arthur
 1973 *The Mural Painting of Teotihuacan*. Washington, D.C.: Dumbarton Oaks Library and Research Facility.

Millon, Clara
 1973 "Painting, Writing, and Polity at Teotihuacan, Mexico." *American Antiquity*, 38:294-314.

Pasztory, Esther
 1973 "The Gods of Teotihuacan: A Synthetic Approach in Teotihuacan Iconography." *XL International Congress of Americanists*, 1:147-159, Rome.

 1974 "The Iconography of the Teotihuacan Tlaloc." *Dumbarton Oaks Studies in Pre-Columbian Art and Archaeology*, 15. Washington, D.C.: Dumbarton Oaks Library and Research Facility.

Ritzenthaler, R.
 1963 "Recent Monument Worship in Lowland Guatemala." *Middle American Research Institute*, 28: 107-116. New Orleans: Tulane University.

Roys, Ralph L.
 1931 The Ethno-Botany of the Maya. *Middle American Research Series, Publication* 2. New Orleans: Department of Middle American Research, Tulane University.

Sanders, William T.
 1966 "Life in a Classic Village." In *Teotihuacan, Onceava Mesa Redonda*, 1:123-48. Sociedad Mexicana de Antropología.

Scully, Vincent
 1962 *The Earth, the Temple, and the Gods*. New Haven: Yale University Press.

Séjourné, Laurette
 1959 *Un palacio en la ciudad de los dioses, Teotihuacan, 1955-58*. Mexico: I.N.A.H.

von Winning, Hasso
 1947 "A symbol for dripping water in Teotihuacan culture." *El Mexico Antiguo*, 6:333-340.

 1949 "Shell designs on Teotihuacan pottery." *El Mexico Antiguo*, 7:126-53.

 1961 "Teotihuacan symbols: the reptile's eye glyphy." *Ethnos*, 26:121-66.

 1968 "Der Netzjaguar in Teotihuacan, Mexico: Eine Ikonographische Untersuchung." *Baessler Archiv* (n.f.), 16:31-46.

 1977 "The Old Fire God and His Symbolism at Teotihuacan." *Indiana*, 4:7-61, Berlin.

 1979 "The Binding of the Years and the New Fire at Teotihuacan." *Indiana*, 5:15-32, Berlin.

The Cult of Death
at El Zapotal, Veracruz

Robert Thomas Pirazzini

Looted archaeological sites are both the bane of archaeologists and an unfortunate fact. Occasionally, however, cultural interpretations can still be drawn by iconographic analysis of looted material, supplemented with salvage archaeology, and these two data tested against ethnohistoric information. Such an approach has allowed for the present interpretation that the site of El Zapotal in Veracruz was the focus of a cult of the dead.

EVERY STUDENT OF ANCIENT New World cultures is familiar with the Olmec civilization of the Gulf Coast, the *cultura madre* of Mesoamerica. Most are also acquainted with the Totonac culture which occupied the same area at the time of the Spanish Conquest. Between the Pre-Classic Olmec and the Post-Classic Totonac, however, little is known of Gulf Coast cultures. The picture of the pivotal Classic Period is almost blank here, while elsewhere—particularly in the Maya area and the Valley of Mexico—studies of Classic Maya and Teotihuacan civilizations have flourished. The reason for the paucity of information on Classic Gulf Coast Veracruz culture seems to have been a situation of benign neglect. There have been too few trained archaeologists, too little money, and too many other sites in Mexico.

One can drive on the roads of Veracruz and see literally hundreds of unexcavated mounds. Even the ubiquitious looters have only scratched the surface. One mound among the many of El Zapotal, the subject of this commentary, yielded hundreds of pottery figures, many in perfect condition.

Discoveries in the state of Veracruz in the last few years, though not well published, have revealed some of the most important and beautiful artifacts in Mesoamerican art. In addition to the Zapotal ceramics, the murals of Las Higueras on the north-central coast and the breathtaking Olmec sculpture "El Señor de las Limas" from the southern border area attest to the richness of Gulf Coast archaeology.

The Gulf Coast of Mexico, along with the Pacific Coast of Guatemala, has been termed the "Peripheral Coastal Lowlands" (Parsons in Pasztory 1978:12), lying as it does between the two major cultural areas of Mesoamerica: the Valley of Mexico and

the Maya region. This periphery has long been neglected by archaeologists. The very term "peripheral" seems to connote a prejudice against the coastal lowlands. However, there is a growing awareness of the Gulf Coast's importance in Classic times (*loc. cit.*).

The western sector of the Peripheral Coastal Lowlands is only now beginning to feel the impact of archaeology. John Graham of the University of California, Berkeley, has been working at Abaj Takalik on the Guatemalan piedmont. North, across the border, The New World Archaeological Foundation of Brigham Young University has been focusing on Izapan sites. Yet Veracruz is still neglected.

Veracruz, because of its important commercial products such as rubber and cacao, very likely became the commercial rival of Teotihuacan during the Classic Period. Rubber was used in making the ball for the ritual ball game; in fact, the game was probably invented in the Gulf Coast and thence spread to other parts of Mesoamerica. Of even more importance in trade was cacao, for not only was it used as a beverage, but it served as a form of currency as well. Such trade can be seen as a legacy of the Olmecs who had a substantial influence in Guatemala's Pacific Coast, no doubt resulting from their jade trade network which extended all the way down to Costa Rica.

Veracruz-style artifacts have been found from Querétaro in the northeast of Mexico, south to Costa Rica. Also, Veracruz artistic influences are stronger in Teotihuacan art than are either the better known Oaxacan or Mayan. The usual explanation for this is that Veracruz influences were spread by Teotihuacan merchants.

However, I completely agree with Esther Pasztory (*ibid.*) that the strong influences of the Veracruz art style in Teotihuacan sculptures, mural painting, and pottery between A.D. 300-500 are more a measure of the prestige of the Veracruz centers than a sign of the Teotihuacanos' aesthetic appreciation of Veracruz styles. Aside from the site of El Tajín (about nine-tenths of which is still unexcavated), little archaeological work has been done and, therefore, it is not surprising that we are ignorant of the part played by Veracruz in Mesoamerica during the Classic Period. However, there are hints of the area's importance. As Pasztory has stated,

> The wide spread of Veracruz art style and of Veracruz ball game paraphernalia suggest that some Veracruz centers may have been nearly as important commercially as Teotihuacan.

> (Pasztory 1978:12)

Also, it is likely that the ball-game cult was spread from Veracruz by the Veracruzanos themselves rather than by Teotihuacan groups who, though thoroughly exposed to the cult, never emphasized it. Nevertheless, there is promise of greater research in the Gulf Coast zone. Salvage operations carried on at the looted site of El Zapotal, south of the Port of Veracruz, have yielded a wealth of fascinating information and material culture.

El Zapotal lies off the main highway in the *municipio* of Ignacio de la Llave. The site is in the archaeological zone known as *La Mextequilla*, a very flat area which contrasts markedly with the ancient mounds there. The most prominent ones are *Cerro de la Gallina* and *Cerro del Gallo*. Immediately south of *La Gallina* there is an artificial platform which measures 76 m in length by 35 m in width by 4 m in height. The base was formed of compacted earth with some surfaces burned in order to harden and strengthen them. The same type of compacted and burned clay construction has been found at nearby *Cerro de las Mesas* (Drucker in Torres Guzmán *et al.* 1975:323) and Nopiloa (Medellín Zenil 1975). That technique was undoubtedly used because of the scarcity of stone in the region. The platform's construction

followed a north-south orientation. And right in the center, resting on a pyramidal base, is the most important discovery made to date at El Zapotal.

Facing north, wherein lies his realm, is an imposing shrine to the God of Death and the Lord of the Underworld, *Mictlantecuhtli* (see Torres Guzmán 1972: Fotos 7, 8). Within the shrine is the seated figure of the deity (Figure 1). Made of unfired clay, with much of the original yellow, red, blue, green, and white paint remaining, the figure measures 1.6 m in height. Appropriately, *Mictlantecuhtli's* final body is that of a skeleton (Figures 2 and 3). Adorning his prominent ribcage is a large pectoral, while his groin area is shielded by a loincloth in the form of what is possibly an earth symbol. In addition, he wears a tall headdress surmounted by the head of an animal—possibly a bat (Figure 4). On the god's sides are modeled skulls painted red and yellow (Figure 5). Flanking the deity are two mural-painted walls of unbaked clay in an L-form. The shrine and its contents are dated to the Late Classic Period (A.D. 600-900). There is iconographic evidence of influences from Teotihuacan Phases III and IV, from Monte Alban Phases III-A and III-B, and affiliations with Los Cerros, Nopiloa, and Dicha Tuerta which all belong to the same sub-area of *La Mextequilla.*

To the north of the shrine is located a building with nine steps, perhaps representing the nine lower heavens of Mesoamerican cosmography that led to the realm of

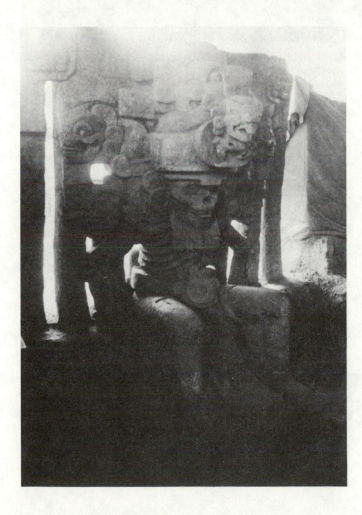

Figure 1. Full-size (1.6 m) modeled clay Mictlantecuhtli figure inside shrine at El Zapotal. Photograph by the author.

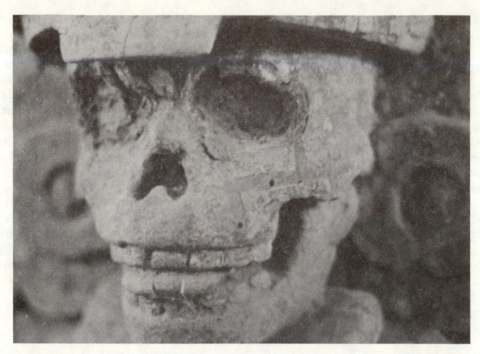

Figure 2. Facial detail of Mictlantecuhtli *from shrine at El Zapotal. Note tongue protruding through skeletal jaw. Photograph by the author.*

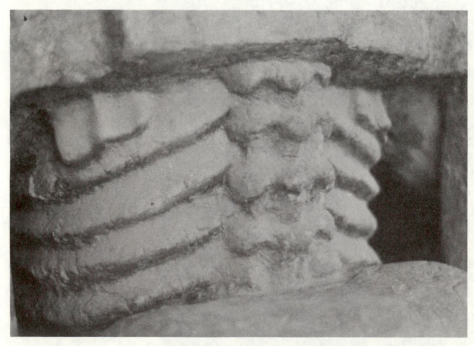

Figure 3. Torso detail of Mictlantecuhtli *from El Zapotal shrine showing ribcage and spinal column. Photograph by the author.*

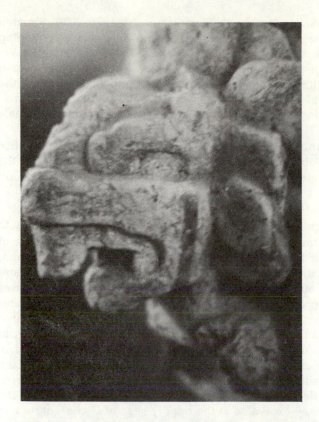

Figure 4. Bat (?) frontal ador-no of Mictlantecuhtli's *head-dress which bears traces of red and blue pigment. Photograph by the author.*

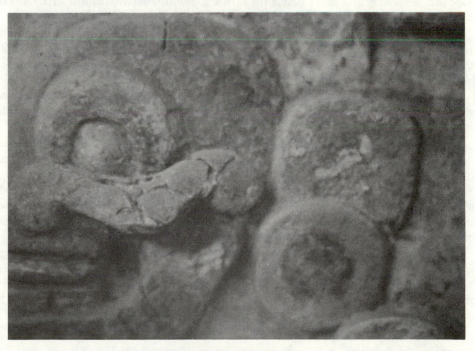

Figure 5. Detail of Mictlantecuhtli's *headdress of a profile human skull. Painted in red and yellow. Photograph by the author.*

Mictlantecuhtli, the Lord of Darkness (see Torres Guzmán *et. al.* 1975: 329). Situated between the shrine and the nine-stepped building was found an ossuary containing eighty-two human skulls (detail in Figure 6). Many of these had been intentionally deformed. However, the technique used differs from the usual frontal (tabular erecta) deformation and was instead achieved by compression of the lamboidea region of the cranium which caused the frontal area to project forward. Dental mutilation was also practiced at El Zapotal. Interestingly, it appears most frequently in the deformed male crania.

The complex formed by the *Mictlantecuhtli* shrine, the nine-stepped edifice indicative of the Underworld, and the ossuary of human skulls leads one to the inevitable conclusion that El Zapotal was host to a dramatic and well-developed Cult of the Dead.

Yet the most extraordinary offerings were found in the extreme northwest section where the first salvage excavations were made. Locals, apparently digging for clay to make bricks, found two "monumental type"[1] fired clay figures, representations of women who had died in childbirth or, more likely, their patron goddess *Cihuateteo*. Looters surreptitiously removed these figures to the capital of Veracruz where they were eventually smuggled out of Mexico. Tragically, most data on these figures are therefore lost. One of these sculptures, or another very like them, did appear later in the catalogue of a New York art dealer.[2] Fortunately, further looting was prevented when the guardian of the surrounding archaeological zone notified archaeologists at the Regional Institute and Museum in Jalapa. Salvage excavations were initiated in 1971 and thirteen more monumental *Cihuateteo* clay figures were unearthed. Each varies somewhat from the others in size and detail, but all conform to basic *Cihuateteo* iconography. Of the thirteen only five were complete. Similar representations of the goddess have been archaeologically excavated at the nearby sites of Dicha Tuerta and El Cocuite. Probably the most beautiful of the *Cihuateteos* was found at El Cocuite and is now on exhibit in the Jalapa Regional Museum (Figure 7).

The *Cihuateteo* ceramics are frequently classified as either pertaining to the Upper Remojadas II culture or to Late Classic Totonac times (Medellín Zenil 1975). These designations, both inappropriate (especially the latter), demonstrate the paucity of knowledge concerning the Veracruz cultures, especially during Classic times. Until an accurate cultural classification system can be established, a binomial taxonomy composed of provenience and date would be most useful (e.g. El Zapotal/Middle Classic Veracruz).

These Classic Period Veracruz ceramics are all very intriguing; some are virtually life-size (up to 145 cm tall) and many have traces of white, red, and blue paint. Some figures are seated, others are standing; but, typically, they have their eyes closed, as in death. A common attribute is a censer held in the left hand adorned with the modeled visage of *Mictlantecuhtli*. Frequently, the neck and wrists are adorned with clay representations of shells, and some figures have a belt in the form of a twisted serpent. Usually a long skirt is worn which reaches almost to the toes.

One *Cihuateteo* from El Cocuite wears the sign *Ce Mazatl* which, according to ethnohistoric sources, was an important date in the cult of this goddess. Fray Bernardo de Sahagún, the foremost Spanish chronicler in the New World, reported that the five aspects of *Cihuateteo* were said to descend to earth on only five occasions: on the calendar days *Mazatl, Quiahuitl, Ozomatli, Calli,* and *Quauhtli.* On

1. See *Ancient Art of Veracruz*, p. 27 for examples of the "monumental style."
2. Kerr 1971:Figure 9.

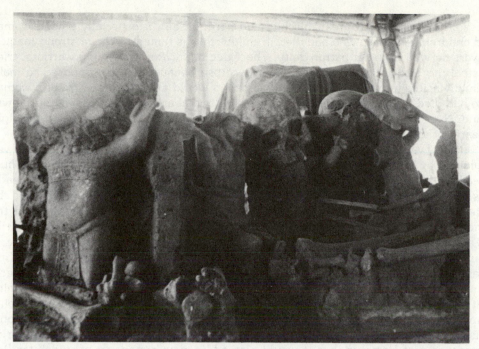

Figure 6. Ossuary at El Zapotal with Nopiloa Mayoid and Nopiloa Smiling figurines among the human bone. All in situ. Photograph by the author.

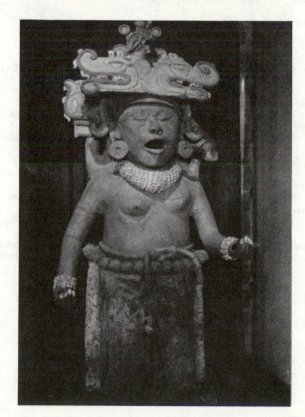

Figure 7. Full-size (1.3 m) Cihuateteo figure from El Cocuite. Open mouth and closed eyes symbolize death. Note the double saurian creature at the front of the headdress. Photograph by the author.

these days they created great mischief and harm on earth, especially among women and children. A woman who had died in childbirth was thought to have strong magical powers derived from her patron deity. The Aztec *telpochtin*, the young warriors, tried to steal the right arm of such a woman's corpse because it was supposed to make them invincible in battle. Witches and sorcerers would also steal the arm of a woman who had died in childbirth. Significantly, at El Zapotal an important female burial was found. Near it were pottery fragments of several *Cihuateteo* clay figures, and the right forearm of the skeleton was missing.

It is always an exciting moment when the archaeological data can be so well explained by the ethnohistoric record as here at El Zapotal in the case of the *Cihuateteo* belief and reality. Coupled with the earlier evidence for a general Cult of Death, this complex of *Cihuateteo* figures and the female burial with missing forearm, the latter unquestionably linked with the cult of *Cihuateteo*, strongly suggests that the veneration of the dead was specifically directed toward women who died in childbirth.

Veracruz is one of the richest archaeological zones in Mesoamerica. Therefore, it would seem fitting if a mere fraction of the revenue resulting from the sale of Gulf Coast oil and gas should be devoted to Gulf Coast archaeology. The Mexican government needs to create new jobs and new industry. Thus, the archaeological goldmine that already exists in this area and the potential tourism that it would generate would employ untold numbers of Mexican citizens of the State of Veracruz for generations. This utilization of an existing national archaeological resource would not only enrich the economy of Veracruz, but it would also add a new dimension of understanding between the fascinating past of Mesoamerica and the growing appreciation of that past by other world cultures.

Bibliography

Ancient Art of Veracruz: An Exhibit Sponsored by the Ethnic Arts Council of Los Angeles at the Los Angeles County Museum of Natural History, February 23-June 13, 1971
 1971 Los Angeles: the Ethnic Arts Council of Los Angeles.
Caso, Alfonso
 1958 *The Aztecs: People of the Sun.* Norman: University of Oklahoma Press.
Kerr, Justin, researcher and photographer
 1971 *Works of Art From Pre-Columbian Mexico and Guatemala.* New York: Edward H. Merrin Gallery.
Medellín Zenil, Alfonso
 1975 *Guía Oficial del Museo de Antropología de la Universidad Veracruzana.* Xalapa [Jalapa].
Pasztory, Esther, ed.
 1978 *Middle Classic Mesoamerica: A.D. 400-700.* New York: Columbia University Press.
Torres Guzmán, Manuel
 1972 "Hallazgos en el Zapotal, Veracruz." *Boletín* (Julio-Septiembre, 1972). México, D.F.: Instituto Nacional de Antropología e Historia.
 ——————————————————, Marco Antonio Reyes, y Jaime Ortega G.
 1975 "Proyecto Zapotal Veracruz." *In Sociedad Mexicana de Antropología XIII Mesa Redonda, Xalapa Septiembre 9-15, 1973.* México, D.F.

A Procession of God-bearers: Notes on the Iconography of Classic Veracruz Mold-impressed Pottery

Hasso von Winning
Southwest Museum, Los Angeles

Rio Blanco, an eclectic pottery style produced in Veracruz during the Classic period, exhibits a cluster of important iconographic themes. One in particular which illustrates a procession of figures carrying deity images is analyzed herein. This analytic study suggests that Rio Blanco ceramics were disseminated by a merchant group from Teotihuacan and central Veracruz between A.D. 600 and A.D. 900.

IN THE PAST TWO DECADES I have been able to assemble data on some 40 relief-decorated bowls from south-central Veracruz which portray narrative scenes of rituals and historical events in a manner that is comparable to coeval Mayan painted vases. The designs are skillfully detailed and cover the entire outer surface, and frequently the base as well. Each vessel was made from a two-piece mold; in many instances two vertical ridges show where both halves were joined. The use of molding techniques in the manufacture of this type of pottery is not only a chronological indicator to which I shall later refer, but accounts also for the existence of two, or even three, bowls with identical decoration. The molds themselves have, however, to my knowledge, not turned up so far. There is no indication that the bowls were painted except for the plain red rim border.[1]

The relief decoration represents a variety of animated scenes involving, on the average, six to nine full-figure images of persons, frequently accompanied by animal heads. They are arranged in continuous order or as processions advancing from left to right. Scenes that involve persons attired as ball players predominate.[2] These are subdivided into groups of two or three individuals, one of whom confronts his kneeling

1. Von Winning 1965; 1971a; 1971b; 1978.

2. A posthumously published monograph by Borhegyi (1980, Figure 10), who has been particularly interested in the study of the Mesoamerican ballgame, contains photographs of a moldmade (not plano-relief, as stated) relief-decorated bowl with a procession of seven ball players, similar to that in von Winning 1971b, Figure 2.

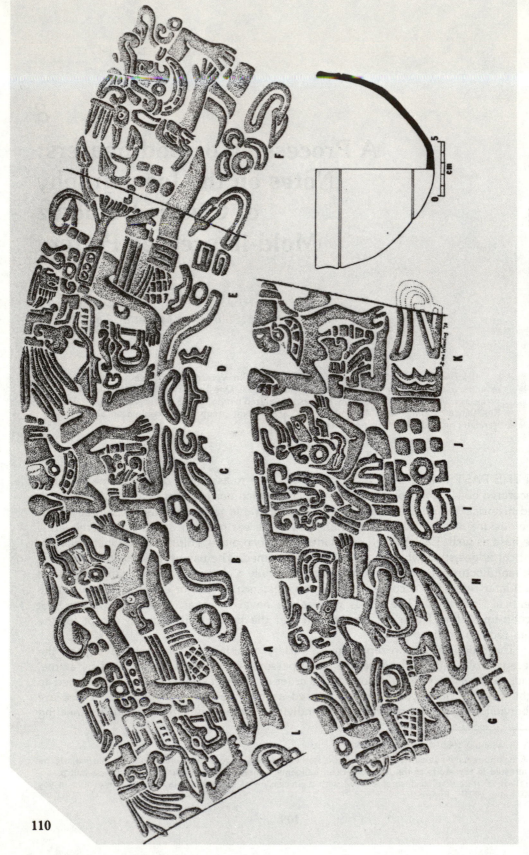

110

Figure 1. Decapitated and other ball players on a Rio Blanco mold-impressed bowl (von Winning 1978 in press).

opponents with a gesture of command. Decapitation rituals associated with the ballgame ceremonies are shown on several bowls where the same individuals occur repeatedly in varying sequential order (Figure 1).

Other themes include historical events, such as the submission of chieftains to a high authority, an investiture ceremony, and very complex assemblages of persons, large animals, calendar signs and other symbols.[3] A ring-eyed lord or god-impersonator occurs frequently with a monster head in profile on his hipcloth, and the same monster head is shown on the base of the bowl and probably represents a toponymic (place-name) emblem. Deities or god-impersonators with a buccal mask occur in groups of four or as opposite pairs.

It is remarkable how many features with minute details were accommodated in the available space. This circumstance can be appreciated better in the photographs than in roll-out drawings which, due to the semi-globular shape of the bowls, require some spatial adjustments when curved surfaces are rendered flat. On round-sided bowls the head and torso are emphasized; reduced space toward the base accounts for disproportionate legs and feet. Arms and hands are carefully modeled, and their position, as well as an open or closed mouth, are outstanding features that highlight the anecdotal character of the configurations.

At this point, and before dealing with the subjects of style, origin, and diffusion of mold-impressed (so-called "Rio Blanco") pottery, a previously unpublished bowl shall be discussed which displays a theme not encountered so far on any of the other vessels of this type. It is a molded, round-sided, buff-colored bowl with a plain everted rim border and shows thirteen full and half-figure individuals (Figures 2a,b).

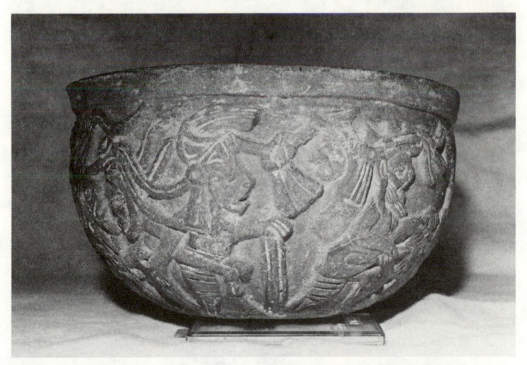

Figure 2,a. God-bearers and fan-holders on a mold-impressed bowl; 9.3 cm. high, 16 cm. diameter; height of relief 3-5 mm.; buff clay. Coll. Southwest Museum, Los Angeles (2079-G-1).

3. Von Winning 1971b.

111

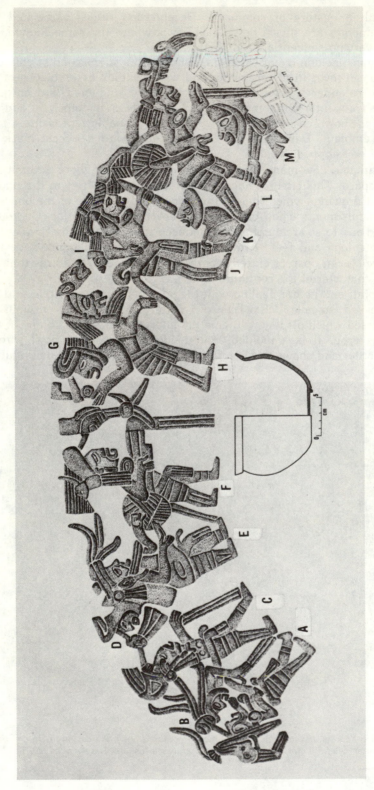

Figure 2.b. Roll-out drawing of bowl Figure 2.a. Drawing by the author.

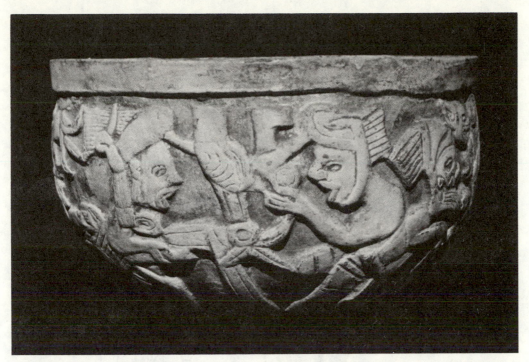

Figure 2,c. The same scene as Figure 2,b but with minor variations in detail, on a cream-colored bowl in a private collection.

A second bowl depicts virtually the same design with slight variations in detail (Figure 2c).

Description of Bowl Figure 2

Seven standing persons are advancing from left to right, but the procession has apparently come to a halt because of two seated individuals (K,M), who face to the left. One sits on the foot of J, the other grabs the leg of person L in front of him. Although there are no vertical divisions to indicate who is first in the linear progression, one can observe that the two persons on the right and the three on the left side are connected.

Features in common. The seven standing persons share the following attributes:
— A hipcloth with horizontal stripes and a frontal loincloth flap. This particular garment occurs only with cross-hatched pattern on other Rio Blanco bowls and on Tajín sculptures.
— The left foot is placed before the right foot and indicates that the persons are walking.
— The right leg has two vertical grooves and is therefore skeletonized (cf. the decapitated disjointed figures in von Winning 1971b, Figure 4); the left leg with anklet is that of a living person.

The four god-bearers. Attached to the backs of Persons C, E, and H is a human head, equal in size to that of the bearer, and an arm with an extended hand (B,G); Person J has only a small head (I) above the arm. The first bearer carries the head with a tumpline; the second bearer carries the body in a bundle; the third bearer is bending forward to balance the load; the fourth bearer also leans forward but his load is reduced to a small head, probably because of lack of space.

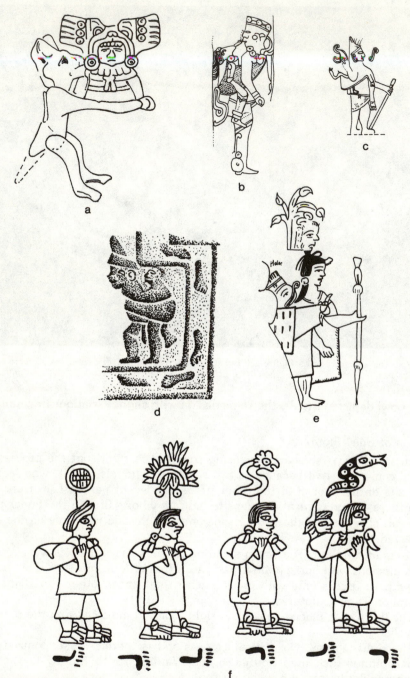

Figure 3. God-bearers.

 a. Teotihuacan figurine of jaguar disguised bearer with deity icon (after Séjourné 1959, Figure 84).

 b. Person carrying a small individual in a bag, El Tajín, Sculpture 3, (after Kampen 1972, detail of Figure 17,d).

 c. El Tajín, Sculpture 4 (after Kampen 1972, detail of Figure 33,b).

 d. Piedra del Palacio (detail), Xochicalco (after Caso 1976: 166, Figure 1).

 e. God-bearer carrying Tlaloc, Codex Azcatitlan, Plate 3.

 f. Three bearers with sacred bundles and one carrying Huitzilopochtli, Codex Boturini, Plate 2.

(Drawings by the author.)

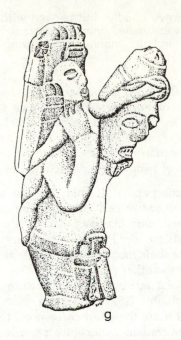

g

Figure 3,g. Aztec sculpture of a male carrying a stone image of a fertility deity. (After von Winning 1974: figure 4.)

There are very few Classic Period representations of this custom. A Teotihuacan figure (probably Late Xolalpan or Metepec phase) of a person in jaguar disguise holding a deity icon is related to this concept (Séjourné 1959, Figure 84) (Figure 3a). Two examples from El Tajín show individuals of smaller size carried in a bag or bundle: Sculpture 3 from the Pyramid of the Niches shows the small figure with skeletonized limbs and head falling back to indicate that he is dead (Kampen 1972, Figure 17d) (Figure 3b). On another sculpture, from the Mound of the Building Columns, a different individual (incomplete) is being carried in a bag (Figure 3c). On the "Piedra del Palacio,"[4] from Xochicalco, a male carries a small person in a cloth on his back (Figure 3d). He is surrounded by calendar glyphs and by footprints. The latter, although separated by a line, imply a journey. An Aztec sculpture of a male carrying a fertility deity with a tumpline is shown in Figure 3g.

Post-Conquest pictorials represent the god-bearer concept more explicitly and in the context of migrations. Four god-bearers are taking part in the Aztec migration recorded in *Codex Boturini* (= Tira de la peregrinación Mexica), an early post-Conquest manuscript, and in *Codex Azcatitlan*, probably a 17th or 18th century copy of an earlier manuscript. Three of these men carry sacred bundles (*tlaquimilolli*) that contain the deified bones; the fourth carries Tlaloc (*Azcatitlan*) and the tribal god Huitzilopochtli (*Boturini*) respectively (Figures 3e,f). Among the commentaries of this event in the major sources, that of Torquemada should be cited; he refers to the god-bearers as *teomama* (Náhuatl, pl. *teomamaque*):

> . . . *ya no seguían su Jornada a ciegas, sino llevaban Dios, que los guiaba, a cuyos ministros llamaron Theotlamacatzin, y a la silla en que iba, Teoicpalli, y el acto de llevarlo a cuestas pusieron theomama.*
>
> (Torquemada 1975, I, Bk. 2, ch. 1, p. 78.)

4. The "Piedra del Palacio," so designated by Alfonso Caso (1967:166-167, Figure 1), is a carved slab from Xochicalco with a detailed "codex-like historical (?) scene with many dates" (Nicholson 1971:105, photograph Figure 21), now in the Palacio de Cortés, Cuernavaca. Caso (p. 167) intended to describe the scene but failed to do so.

115

(. . . they no longer continued their journey blindly, but carried with them a god who guided them, whose priests were called *theotlamacatzin*, and the chair in which he traveled, *teoicpalli*, and the manner of carrying him on somebody's back was called *theomama*.)

The occurrence of god-bearers on the relief bowl is the earliest evidence so far of a group of four such individuals (or three, if one interprets Person I as a severed head resulting from a decapitation ritual, which in this context seems unlikely). Four is a basic concept: as noted above, four bearers occur in Aztec migration history, related also to later territorial subdivisions.[5] The question remains whether the procession on the bowl records the wanderings of a group of people or a particular ritual.

The three fan-holders (F, J, L). Only one person (J) holds the fan upright (it is partially covered by a bird headdress); the other two carry it under the arm. That is, they are not displaying it. Apparently Person J, with his open mouth, is talking to the small individual at his feet who also opens his mouth. The next fan-bearer (L) and his companion (M) who grabs his leg, both have their mouths shut. All three fan-holders wear an oval shell (?) pectoral, not worn by the other persons.[6]

A fan is usually considered an identifying attribute of the traveling merchants and ambassadors. A recent study by Kurbjuhn (1977) indicates that among 157 Mesoamerican depictions of fans, somewhat more than half correspond to the Mayan area. She states that "although Mayan post-conquest literature recorded Precolumbian uses of fans, such information is not available for other areas," and concludes that "contrary to interpretations that have been made to the present time, neither social organization nor status are illuminated by fan-holding" (Kurbjuhn 1977:146). Nevertheless, the fan, together with the shell pectoral, are distinctive attributes of the three personages on the bowl. The connection between fan, death, and the Underworld in Mayan iconography is consistent with the life-death dichotomy expressed by the skeletal legs on the bowl.

Gestures. These are very expressive and therefore significant. An open hand with extended figures above a vertical triple bar element clearly indicates that Persons B, C and L are not holding but dispensing this element. Reminiscent of the water-dispensing priests in Teotihuacan murals, it is emanating from an object, also of rectangular shape, held by fan-bearer F who seems to be pouring a liquid. The gesture of god-bearer E is enigmatic: his left hand is clenched, the thumb points down. His right hand holds the handle (?) of the object on his waist. In the center of the entire configuration a solitary clenched hand reaches down from the rim (the sky?) and holds an ornament with three feathers and a jade disk in the middle (note the same motif on the duplicate bowl, Figure 2c).

Grouping of the scenes. Although no divisions are delineated between the

5. In the Postclassic Selden Roll, of probably western Oaxaca affiliation, three migrating personages are led by a god-bearer with the sacred bundle of Ehecatl-Quetzalcoatl on his back (Nicholson 1978:79, Figure 7). Women carrying a deity in a cloth on their backs occur in the Maya codices (Dresden 16b; 17c-10; Madrid 94d). Tozzer (1941:164, Note 865) quotes Cogolludo's (4,VIII) reference to four war captains who carry an idol of Ah cuy (or chuy) kak. Motul dictionary translates *chuy*, llevan pendiente y colgando ("they carry [it] suspended and hanging"); San Francisco dictionary: alzar, llevar colgando ("to raise, to carry [it] hanging"). Several Aztec period stone sculptures of *teomama* representations are in the National Museum of Anthropology in Mexico City.

6. The shell pectoral appears to be a significant, perhaps determinative, attribute of Maya priestly soothsayers who, on Jaina (Campeche) figurines, are distinguished by elaborate scarification covering the entire face (von Winning 1980 in press).

participants in the procession, an attempt to link some of them is noticeable. For instance, Persons A through E are connected by bands between their foreheads. In the center, the water-pouring fan-holder F, the descending hand, and the god-bearer H appear to be separate units, but fan-holders J and L have the connecting band between their bird headgear. However, one cannot be certain which group or individual is the leader.

Origin, Chronology and Diffusion of Rio Blanco Relief Pottery

Only three mold-impressed bowls have a documented provenance. Best known among these is the "Calpulalpan bowl," excavated by Linné (1942:82-88, figures 128, 171-174) from a mound at Las Colinas, Tlaxcala. This is the only vessel that displays almost exclusively Teotihuacan symbolism. A straight-sided bowl was excavated at El Faisán, north of the town of Huachín, in south-central Veracruz, and is now in the Museum of Anthropology in Jalapa (Hangert 1958).[7] A third bowl, acquired by the National Museum of Anthropology in Mexico City, is illustrated by Aveleyra (1964, unpaginated) with a stated provenance from Santa Ana Tlaxicoya, near Huachín.

All the other bowls published so far are in private collections (except Figures 2a, b) and were reportedly found in the vicinity of Huachín, in the Rio Blanco Region. This river roughly parallels the course of the Papaloapan River farther south; both empty into the Laguna de Alvarado on the Gulf of Mexico.

According to Rattray (1977), mold-impressed pottery, similar to the Calpulalpan bowl and decorated with Teotihuacan and "Veracruz" motifs, has been excavated from Metepec phase deposits, or derived from surface finds at Teotihuacan. Therefore a date between A.D. 600-700 marks the beginning of Rio Blanco relief pottery. The designs include elements from El Tajín, Cerro de las Mesas, Teotihuacan and, to a lesser degree, Monte Albán and the Maya Lowlands (von Winning 1965:127-133; 1971a:51). These were amalgamated into an eclectic style applied exclusively to moldmade bowls that were manufactured in the Rio Blanco region, centering near the modern town of Huachín.

Huachín, and for that matter Calpulalpan, are situated on the trade routes that linked the central highlands with the Gulf Coast trading posts established by *teotihuacanos*. Most likely, the Rio Blanco pottery was distributed by merchants of Teotihuacan and central Veracruz origin during the last phase of Teotihuacan and also after its demise, between the 7th and 10th centuries.

7. Subsequent to my earlier description (von Winning 1965: 122-127, Figure 7), it can now be stated that the Faisán bowl portrays a ballgame decapitation. The scene occurs also on three other bowls in the same order, though the number of protagonists varies (von Winning 1978 in press).

Bibliography

Aveleyra, Luis Arroyo de Anda
 1964 *Obras selectas del arte prehispánico (adquisiciones recientes)*. Mexico City: Consejo para la Planeación e Instalación del Museo National de Antropología.

Borhegyi, Stephan F. de
 1980 "The Pre-Columbian Ballgames—a Pan-Mesoamerican Tradition." Milwaukee Public Museum, *Contributions in Anthropology and History*, Number 1.

Caso, Alfonso
 1967 *Los calendarios prehispánicos*. Mexico City: Universidad Nacional Autónoma de México.

Codex Dresdensis
 1962 *Die Maya-Handschrift der sächsischen Staatsbibliothek Dresden* (Facsimile edition). Berlin: Akademie Verlag.

Codex Tro-Cortesianos (Codex Madrid)
 1967 Facsimile edition. Graz: Akademische Druck-u. Verlagsanstalt.

Códice Azcatitlan
 1949 Facsimile edition. *Journal de la Société des Américanistes* (accompanies Vol. 38). Paris.

Códice Boturini
 See Echániz.

Echániz, G. M.
 1944 *Tira de la Peregrinación Mexica* (Códice Boturini). Facsimile edition. Mexico City.

Hangert, Waltraut
 1958 "Informe sobre el edificio número 1 de 'El Faisán'." *Jalapa: La Palabra y el Hombre*, no. 7, Pp. 267-274.

Kampen, Michael E.
 1972 *The Sculptures of El Tajín, Veracruz, Mexico.* Gainesville: University of Florida Press.

Kurbjuhn, Kornelia
 1977 "Fans in Maya Art." *The Masterkey*, 51:4. Pp. 140-146. Los Angeles.

Linné, Sigvald
 1942 *Mexican Highland Cultures; Archaeological Researches at Teotihuacan, Calpulalpan and Chalchicomula in 1934/35.* Ethnographic Museum of Sweden. Publication 7. Stockholm.

Nicholson, Henry B.
 1971 "Major Sculpture in Pre-Hispanic Central Mexico." *In* R. Wauchope et al. eds., *Handbook of Middle American Indians*, Vol. 10. Pp. 92-134. Austin: University of Texas Press.
 1978 "The Deity 9 Wind 'Ehecatl-Quetzalcoatl' in the Mixteca Pictorials." *Journal of Latin American Lore*, 4:1, Pp. 61-92.

Rattray, Evelyn C.
 1977 "Los contactos entre Teotihuacan y Veracruz." *XV Mesa Redonda, Guanajuato.* Mexico: Sociedad Mexicana de Antropología. Vol. 2: 301-311.

Séjourné, Laurette
 1959 *Un palacio en la ciudad de los dioses* (Teotihuacan). Mexico: Instituto Nacional de Antropología e Historia.

Torquemada, Fray Juan de
 1975 *Monarquía indiana.* Mexico City: Editorial Porrúa.

Tozzer, Alfred M.
 1941 *Landa's Relación de las Cosas de Yucatán; a Translation.* Peabody Museum of American Archaeology and Ethnology, Harvard University. Papers, Vol. 18, pp. 394. Cambridge.

von Winning, Hasso
 1965 "Relief-decorated Pottery from Central Veracruz, Mexico." *Ethnos*, 30:105-135. Stockholm.
 1971a "Relief-decorated Pottery from Central Veracruz, Mexico: Addenda." *Ethnos*, 36:38-51. Stockholm.
 1971b "Rituals Depicted on Veracruz Pottery." In *Ancient Art of Veracruz.* An Exhibit Sponsored by the Ethnic Arts Council of Los Angeles at the Los Angeles County Museum of Natural History, Feb. 23, 1971 - June 13, 1971, Pp. 31-36.
 (1978) "Los decapitados en la cerámica moldeada de Veracruz." To be published in *Indiana*, 6, Berlin.
 (1980) "Las escarificaciones en las figurillas de Campeche." To be published in *Libro-Homenaje en honor de Raphael Girard.*

Studying Style in the Mixtec Codices: An Analysis of Variations in the Codex Colombino-Becker

Nancy P. Troike
Institute of Latin American Studies
University of Texas at Austin

The ancient Mixtecs of the present-day Mexican state of Oaxaca recorded sacred histories and geneaologies in a pictorial form within screen-fold books called codices. In order to be able to read these manuscripts effectively, the painted images must be studied detail by detail. This article presents an analysis of the pictography in a single book wherein the hands of several artists may be seen. Their work is evaluated to determine those pictographic elements with which they could take liberties (exercise artistic license) and those with which they could not. Only in such a manner can the informational *intent* of the Mixtec scribes be ascertained and, thereby, the reading of these unique documents be facilited.

THE WESTERN PART of the modern Mexican state of Oaxaca is a rugged mountainous area that reaches from the Pacific coast on the south to the high peaks of the Sierra Madre on the north. The Mixtec people had inhabited this region for centuries before the Spanish arrived in the New World, and they continue today to make their homes among these narrow valleys and steep hills. This Mixtec region, referred to as the Mixteca, is shown in Figure 1.

Prior to the Spanish Conquest, the Mixtecs for many years had been creating manuscripts in which they recorded, by means of a pictorial system, those events worthy of being remembered. These documents were made of long strips of animal skin glued together and folded to form a continuous set of pages, as illustrated in Figure 2; this type of manuscript is now called a codex (plural: codices). Mixtec scribal artists filled these pages with texts composed of long sequences of pictorial scenes. Of the many codices the Mixtecs must have created in the pre-Hispanic years, only four are now known to exist: the Bodley, Zouche-Nuttall, Vindobonensis, and Colombino-Becker.[1] The tradition of creating these documents, however, continued

1. The repositories for the original manuscripts are: Bodley (inventory number 2858), Bodleian Library, Oxford; Zouche-Nuttall (Add. MS. 39671), also called Codex Zouche or Codex Nuttall, British Museum, London; Vindobonensis (Bibl. Pal. Vind. Cod. Mexic. I), Österreichische Nationalbibliothek, Vienna. The Colombino and Becker are the separated parts of a single manuscript: Colombino (inventory number 35-30), Museo Nacional de Antropología, México; Becker (inventory number 60306), Museum für Völkerkunde, Vienna.

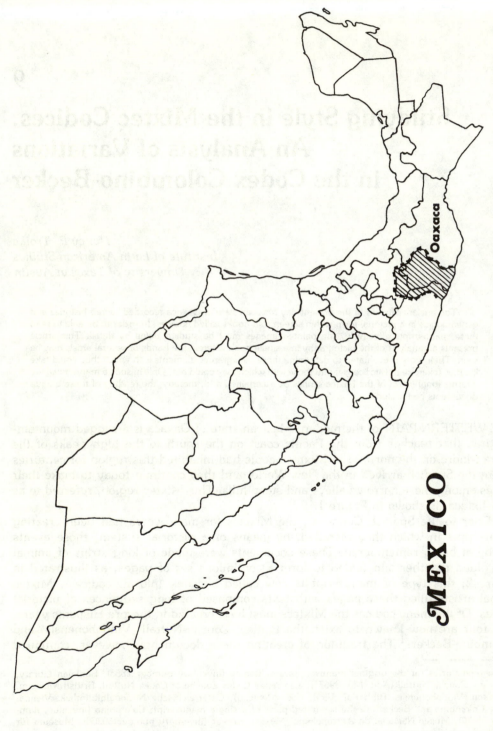

Figure 1. The area of modern Mexico occupied by the Mixtec people is called the Mixteca and lies primarily in the western part of the state of Oaxaca, with small portions in adjacent states to the west and north. On this map the Mixteca region is marked with diagonal lines.

Figure 2. The typical folding form of a Mixtec codex is illustrated here by the Codex Colombino-Becker. Such manuscripts were composed of long strips of animal skins glued together and folded in alternate directions to create a continuous series of page areas. Lines drawn across these pages formed sets of narrow bands within which scenes were painted by the Mixtec scribal artists. The ends of each band opened into the immediately preceding and succeeding bands so that the pictorial text could be followed in a continuous sequence by reading back and forth across the pages, adjacent bands on a page being read in opposite directions. (After Troike 1971:183.)

among the Mixtecs for much of the sixteenth century, particularly during the early Colonial period.

The Mixtec artist-scribes painted these manuscripts in order to record the events and explanations of the past so that this important information could be preserved and transmitted accurately to future generations. Within the pages of the pre-Hispanic codices their scenes summarized historical events extending back to approximately the year A.D. 1000. They recorded the births, marriages, and deaths in the ruling families of many important towns, such texts now being the longest and most detailed genealogical sequences that have survived for the entire pre-Columbian Western Hemisphere. For important political figures they depicted the major rites of status and wars of conquest, and also showed the plots and treachery that could lead to overthrow and violent death. From a rich and complex background of religious beliefs they painted scenes of the creation of the Mixteca, the origin of the Mixtec rulers, and the formation of special relationships with the many deities.

All these events were recorded by means of a complex pictorial system in which accuracy of communication was the primary aim, with the painters fulfilling the role of scribes, or "writers," in symbolizing the details of Mixtec history and culture. Beauty of composition and execution was prized, but was judged on the basis of the contributions made to the communication goal, for the drawings were never intended to be a mere realistic copying of the external world. Realism is of only limited use in achieving accuracy in a pictorial communication system, because all those elements crucial to the meaning of a scene must be depicted in a size and form that would be seen and understood by the readers, regardless of their actual size relative to the other objects being shown, while features of lesser importance in communication could be eliminated entirely. Thus "distortions" or "omissions" in the drawings actually reflect the method of making the message clear to the readers, and not an inability on the part of the scribal artists to produce a faithful copy of the real world. The elements in the scenes that deviate most markedly from realism (which have led some poorly informed persons to call this Mixtec codex painting style "primitive") are actually those that reflect most clearly the sophisticated pictorial communication system within which the painter-scribes were working.

Designs that represented the appropriate words in the Mixtec language were always used by these scribal artists for recording the names of geographical locations (Smith 1973) and the personal names of individuals. This direct representation of the language in the drawings occurs in Mixtec codices of both pre- and post-Hispanic origin and is the fundamental trait that identifies these manuscripts as being Mixtec.

121

Codices lacking this basic linguistic evidence are not Mixtec, even though they may be drawn in a style similar to that of the Mixtec manuscripts. It is well to remember that, in the Late Post-Classic period, many peoples across a broad area of Mesoamerica utilized an art style similar to that of the Mixtecs.

Despite the limited number of these codices that are now available, for no other people in the New World have there survived such detailed pre-Hispanic depictions of their own history and beliefs as are found in these long Mixtec documents. But if the great amount of knowledge in these manuscripts is to become meaningful, the pictures must be accurately interpreted. Just as the primary purpose of the artist-scribes in creating these texts was to communicate information concerning events of importance to Mixtec life, so too the principal goal of modern students of these documents is the recovery of this information. Mixtec pictorial studies are appropriately concentrated upon the four pre-Contact documents, for post-Hispanic manuscripts may be influenced by European culture or art and so not reflect an accurate statement of Mixtec traditions.

In particular it is essential that stylistic studies be focused on these texts if the original Mixtec practices are to be recovered, because the pictorial communication system in which these codices were composed is an intricate one. The scenes often contain a great variety of detail, such as the clothing and ornaments worn by individuals, the paraphernalia they carry or are shown utilizing, and the geographical or architectural environments within which they are portrayed. Such elaborations in the drawings raise a crucial question for the student of these texts: were all these details equally essential to a correct understanding of the events, or were some of them of greater, and some of lesser, relevance?

Three different types of pictorial information might potentially be present in these painted scenes: those details that were necessary to ensure the primary goal of accurate communication; those that characterized the general Mixtec artistic style in use in these manuscripts; and those that resulted from the personal preferences and painting practices of the individual artist-scribes. Material in each of the three categories would obviously be of different value to modern scholars making interpretations of the codex scenes. For such purposes the most important elements would be those that actually carried the main burden of communication—the details that had to be shown in order for a Mixtec reader to understand fully the message of a scene. Interpretations that relied too heavily on features that were simply the personal idiosyncrasies of a scribal painter, or were more broadly characteristic of Mixtec art in general, could be seriously flawed. Without a method of discriminating among these painted details, however, the modern interpreter must consider virtually all elements in the scenes as being at least potentially informative. If even a few features in each of these three categories could be identified, it would help to isolate the elements of prime importance from those that were perhaps less meaningful and so provide better clues to the methods by which the pictures actually communicated.

Stylistic analyses provide the most suitable and unbiased method for approaching this problem. A systematic examination of the elements in the many complex scenes of the four pre-Hispanic codices requires analytic criteria that are precise, clearly formulated, readily observed, and broadly applicable, if they are to be appropriate for use in all four texts. Impressionistic, vague, or ambiguous distinctions based upon presumed or undemonstrated differences in the drawings must be avoided. The greatest precision and replicability will probably be found in the analysis of those features in the drawings for which the shapes or spatial arrangements can be directly observed or physically measured. This paper will explore some of the possibilities

inherent in such stylistic analyses to study the insights that result from this methodology.

The term *style*, as it will be used here, refers to the repeated co-occurrence of particular features of set form, and involves the preponderate usage of some forms and the lesser use of others. It is this preference for certain clusters of elements that characterizes a style and distinguishes it from all other styles. The manner in which these elements are manipulated and their distribution within a text establish the range of each style and enable its examples to be located. In this approach a style is functionally the sum of its specific traits, and consequently the analyses of the individual characteristics of the drawings are of fundamental importance.

Because of the differing backgrounds to the creation of each of the four pre-Cortesian Mixtec codices—they are thought to have been painted by different scribal artists at different times and in different places—each must be studied separately to search for its characteristic sets of stylistic usages. Among these four the Colombino-Becker is a particularly good subject for analysis, for even a cursory examination of its pages reveals the presence of drawings that vary markedly in appearance, suggesting the possibility of different hands. The pictorial text of this codex details the political history of the rise to power, and eventual murder, of the greatest of the pre-Hispanic rulers, Lord 8 Deer. Several reproductions of the Colombino or the Becker have been published, but the most useful and readily available photographic editions are those listed in the Bibliography.[2]

The Colombino-Becker is not a simple manuscript to work with, however. Its forty surviving pages are now fragmented into seven parts, and some portions are still missing. In addition, the scenes of the text were deliberately and extensively damaged several centuries ago to obliterate the drawings of animal and non-human heads, elements that functioned in the names of many persons and places; and the Mixtec names of sites were written on the pages. Few of its scenes are now totally complete, and the vicissitudes of use during the five centuries or more since it was created have in many cases eroded the drawings near the outer edges of the pages. Because of these problems I have made detailed examinations and measurements of the original fragments in Mexico and Vienna and have closely scrutinized all the details in the many scenes, using a binocular microscope where necessary.

It is critical that the parts of this manuscript be placed in their correct order before it is analyzed because the painted scenes must be studied in their original sequence if the political history obtained, and the search for stylistic clues to aid the understanding of that history, are to be valid. Through a study of the physical structure and functioning of the codex segments I have been able to rejoin these seven fragments to form the three long strips shown in Figure 3; four additional sections of text are still lost (Troike 1969, 1970a, 1971, 1974).[3] The individual features in the scenes must also be carefully examined, especially if partially damaged, to ascertain the original form or size. In an earlier study I made of stylistic variations among the badly destroyed animal-head helmets depicted on many persons in this manuscript, I

2. The 1961 Becker facsimile is precisely accurate in size and virtually indistinguishable in appearance from the original manuscript, but the 1966 Colombino reproduction is some 4% larger than the original and the printed colors are often badly distorted. Each manuscript was paginated separately and without reference to the other, but for consistency here all pages are specified with Arabic numbers and all bands with Roman numerals; bands on a page are numbered from the top down, regardless of the sequence in which they are actually read.

3. The reconstructed form of the Colombino-Becker proposed by Caso (1966) is inaccurate, most of his connections or relationships being physically impossible.

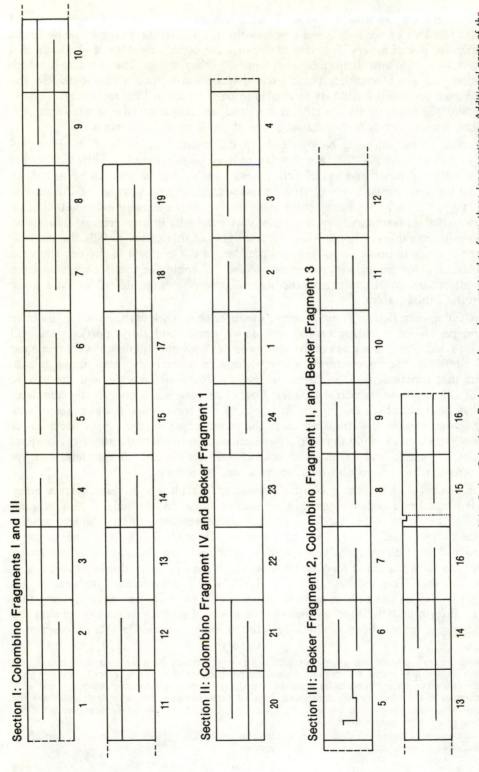

Section I: Colombino Fragments I and III

Section II: Colombino Fragment IV and Becker Fragment 1

Section III: Becker Fragment 2, Colombino Fragment II, and Becker Fragment 3

Figure 3. The seven surviving fragments of the Codex Colombino-Becker are shown here rejoined to form three long sections. Additional parts of the original text are still missing at the beginning and end of the manuscript, and between the sections. Page numbers, assigned separately to the Colombino and the Becker in the nineteenth century, are given below each page, with incomplete pages being indicated by broken lines. Band line patterns are depicted for all pages having them. (After Troike 1974:88.)

discovered regular patterns of design that enabled me to establish the probable identities of most individuals (Troike 1980). This concrete example of the usefulness of stylistic analysis, resulting in the recovery of information that could not have been obtained in any other manner, suggested that the examination of other features in this codex might also prove valuable.

In the political history of Lord 8 Deer's life as recorded in the Colombino-Becker, the pictorial events are shown basically through the use of figures of named individuals and drawings specifying the names of geographical localities. The stylistic aspects to be studied here are confined to those figures in human form, which in this codex includes both humans and supernaturals. Despite my close examinations of the Colombino-Becker original, there are often many instances in which the color, shape, or size of a particular feature can no longer be determined. Discussions in this paper are confined to only those elements that can still be defined with security.

In an earlier preliminary study of artistic styles in the Colombino-Becker (Troike 1970b) I was able to distinguish three different styles within the codex. In each case, however, the pages I specified for a particular style also included figures and scenes in other styles, and some pages were not assigned to any of the three styles. The page assignments given at that time were: Style I, Colombino 3-10; Style II, Colombino 11-15 and 17-19; and Style III, Becker 1-16. The pages left without stylistic assignments were all in the Colombino and included pages 1-2, 16, and 20-24. This brief but pioneering article was the first to grapple with the problem of attempting to distinguish among the works of different contemporary artist-scribes who were painting in the same manuscript at the same time and in the same local tradition.

The term *Style Area* is now a more appropriate name for these large segments of the codex in which the hand of one individual dominates but is not exclusive, while the term *Style* can best be reserved to define the work of single artist-scribes. On this basis, these three earlier "Styles" will be referred to here as Style Areas I, II, and III. The exact beginning and end of each of these three style areas in the Colombino-Becker is not always clear, for between those figures that can be readily assigned to different style areas there are sometimes others whose stylistic affiliations are not so straightforward. In addition, several pages and scattered bands in the manuscript are wholly or partially filled with the place signs that give the names of geographical locations. These parts of the codex cannot be assigned to a style or style area until studies are undertaken to determine the characteristics by which to classify such drawings. Colombino 7-8, 20, and most of 21 contain only such place signs and are consequently omitted from the present study of the human-shaped figures.

Subsequent to the identification of the three major style areas in the Colombino-Becker, I noted several sets of figures that appeared to be done by other painter-scribes (Troike 1974:104-105), and since each set was the work of a single individual, these are here called Styles. Style IV is found on Colombino 15-III and 17-III, in the middle of Style Area II, an example of the work of one scribal painter within a style area dominated by another. Style V, on Colombino 22-24, occupies several of the pages between Style Areas II and III that were previously unassigned. Style VI is found in Colombino 1-III, another area that had not been stylistically classified earlier.

In the present paper I will utilize and build upon the foundation created by my prior research and stylistic analyses of the Codex Colombino-Becker. The focus here will be upon the study of individual features of design in this manuscript to determine which of the three categories of pictorial information they represent: those that were essential to the communication process, those characteristic of the general Mixtec art style, or those reflecting the personal preferences of the individual scribal painters.

Section I: Colombino Fragments I and III

```
| 11 12 13 14 | X    15   16    X | X   17        X | X          18  X | 39   40      |
|       10 9  | 8 7            6  |    23   22      | 21  20  19       |          38 37|
| X 1   2   3 |          4  5     | 24 25 26    27  | 28  29           |              |
       1               2                 3                 4                 5
```

Section II: Colombino Fragment IV and Becker Fragment 1

```
|                      123 X | X          X | 125 |     | 127   128   |
|                      124   |              |     | 126 | 130   129   |
|                            |              |     |     | 131  132 X X|
         20            21              22          23          24
```

Section III: Becker Fragment 2, Colombino Fragment II, and Becker Fragment 3

```
|          | 159 X  160 |          172 | 173 174 175 176 | 177  178     |
|   156    | 162  161   | 171      170 |                 |            X |
| 157  158 | 163 X 164 165 | 166 167 168 169 | 179 180   | 181          |
     5            6               7                8            9
```

Figure 4. On this drawing of the pages of the Codex Colombino-Becker are the numbers representing the 228 figures still sufficiently well preserved to be of use in the present research. The figures were numbered in the sequence in which the scenes are to be read, their placement reflecting the back-and-forth reading pattern typical of Mixtec codices. Badly damaged figures,

After a careful inspection of the Colombino-Becker text, I determined that 228 of its figures were still sufficiently well preserved that relevant information could be obtained from them. I numbered each of these figures in sequence, beginning with what is now the first band of the surviving text (Colombino 1-III) and continuing through the extant manuscript to its present end (Becker 16-III). For ease of reference, Figure 4 shows these numbers placed on an outline of the codex pages at the location occupied by each figure. Those figures that were too badly obliterated to be of use, or were largely concealed by other objects in the scenes, were excluded from the numbering sequence, but their presence is indicated by an X.

A large number of elements connected with the human figures could profitably be tested in any stylistic study of the Colombino-Becker. In the present paper several general areas will be explored: the shapes of various body parts; the clothing, ornaments, and body paint being worn; the amount of the available space occupied by figures; the placement of the body extremities relative to the torso; and the objects the figures are shown holding, carrying, or employing. From among each of these areas I selected one or more specific characteristics for investigation: the shapes of facial profiles, hands, feet, mouths, and eyes; the colors and form of the jackets worn by males, the shapes of ear decorations, and the colors of facial paint; the height of vertically standing figures compared to the amount of available vertical space; the overlapping of the torso by one arm; and the size of the shield being carried in comparison to the size of the figure.

In the following discussions and analyses of these elements, all measurements are expressed as percentages or proportions to facilitate comparisons among the scenes of the Colombino-Becker and to make this information available for comparative purposes when similar research is carried out for other Mixtec codices. All direct measurements were made in metric units. Percentage figures were originally carried to two decimal places, but have been rounded here to the nearest whole

6	7	8	9	10
41 42			55 56 X 57 58 59	60 61 62
36 35 34 33 32			54 53 52 51	50 49 48 X
30 31			43 44	45 46 47

1	2	3	4
135 136 137 138	X	149 150 151	152 153 154 155
134 X	141 140 139	148 147	
X 133	X 142 143 144	145 146	

10	11	12	13	14
194 X	195 196	198 200	201	212 213
X 193	192	197 199		211 210
	191			
182 183 184 185 186	187 188 189 190		X	X 202 203

and those hidden by other objects in the scenes, were not numbered but their presence in the pictorial text is indicated by an X. All three strips are to be read continuously; see Figure 3 for overall appearance. Pages of the Colombino-Becker are continued on the following two pages.

number and, therefore, may in some cases total to slightly more or less than 100%. The number of colors used in the Colombino-Becker is quite limited, as is typical of Mixtec codices, consisting of red, yellow, blue, green (now often faded to golden-brown), black, and white.

The Shapes of Body Parts

Facial profiles. An examination of the facial profiles in the codex showed all to be very similar. The forehead was vertical and usually slightly bulging, with the root of the nose indented and the nose itself large and sometimes bulbous. The upper lip, the teeth if shown, the lower lip, and the chin receded progressively down and back from the nose in a series of angular steps. This pattern was followed without any significant deviations or elaborations; there were, for example, no pug noses nor any cases in which the lower lip projected out farther than the upper lip. Figure 5 shows typical facial profiles.

The consistency of this profile throughout the codex indicated that the form was simply a characteristic of the general Mixtec artistic tradition in use in this manuscript.

Hands. Hands in the Colombino-Becker were depicted in several different forms, including open, clenched with the forefinger pointing, grasping an object, or simply relaxed. The form selected for analysis here is that in which the hand is open and extended, the fingers and thumb being together and straight. Open hands were usually drawn in the manuscript in a consistent manner. The thumb was outlined separately, but the individual fingers were not; instead, a white rectangle at the end of the finger area was divided into several squares to represent the fingernails and thereby imply the presence of the fingers. When the back of the hand was depicted, the hand appeared as a wedge that was widest at the fingernails and tapered towards the palm. Figure 6 shows examples of these hands in the Colombino-Becker.

127

63 64 65 66	67 68 69 70 71 72	102 103	104 105	106 107
85 83 79 77	76 75 74 73	101 99 100 98 97 96	95 94	X 111
82 81				
86 84 80 78	87 88 89 X	90 91	X X 92 93	X X X X X
11	12	13	14	15

X 214 215 216	X 217 218 219	X
X 209 208 206 207	224 223 222	221 220 X
204 X 205	225 226 227	X 228 X X
16	15	16

As was true for facial profiles, the form in which the open hand was drawn appears to reflect the general Mixtec artistic tradition used in the codex and does not express any unique information to the reader.

Feet. The investigation of the feet revealed that there were two quite different ways of depicting the toes. In one form, the toes were each drawn individually, but a toenail was provided only for the big toe. In the other, the separate toes were not drawn, but instead a rectangle or arc of white at the end of the foot was divided into four or five squares to represent the toenails, a simplification that implied the toes on the same order as that used for the fingers of the hand. Figure 7 shows these two different manners of depicting the toes.

An analysis of the distribution of these two toe forms revealed that the first feet that are now visible, those of figures #6 through #10, were drawn with the arc of squares representing the toenails. (These figures, and all others similarly indicated, refer to specific drawings of human-shaped figures in the Colombino-Becker, and can be located by their numbers in the outline of the codex shown in Figure 4.) But beginning with figure #11 and continuing through figure #54, all visible toes were drawn individually except for two figures. With figure #55 there was an abrupt shift back to the use of the arcs representing the toenails, and this usage continued (for visible feet) for the remainder of the extant codex except for the rare appearances of the individually drawn toes on five figures.

The depiction of the individual toes was characteristic of Style Area I only, and the use of this type of toe as early as figure #11 (Colombino 1-I) suggests that this style area may actually begin prior to Colombino 3. Style Areas II and III, and Style IV, all used the arc of squares. Style V contained both kinds of toes, while the feet of Style VI figures were all too badly damaged to be studied. The use of these two different toe forms does not seem to convey information to the readers of the codex, and the variations appear to be due entirely to the personal preferences of the various scribal painters working in this manuscript.

Mouths. Mouths in the Colombino-Becker were almost always shown closed, although these closed mouths were drawn in two different ways. In one form, a simple

108 X 109		122 X
110	121 120	
X 112 113 114 115 116	117 118	119
17	18	19

line between the angular lips was used, while in the other a narrow white arc divided into several squares was shown between the lips to represent the upper teeth. Open mouths were quite rare and showed only the upper teeth, never the lower, and usually occurred only when an action demanded it, such as for figures shown vomiting or swimming. The two types of closed mouths are illustrated in Figure 8.

In tracing the different forms of closed mouths through the Colombino-Becker, long sequences of pages can be noted in which one shape or the other was used exclusively. For the first 121 figures of the codex the simple line mouth was used almost entirely, dominating so completely that there were only eight figures showing a closed mouth with teeth. But beginning with figure #122 and continuing for all but 19 figures in the remaining 22 pages of the codex, the form having the mouth with teeth predominated. Among these 19 exceptions using the simple line mouth, all but one (figure #132) were found scattered through Style Area III.

Style Areas I and II, and Style IV, used the simple line mouth exclusively. The variations that occurred in the area of transition between Style Areas I and II suggested hands other than those characteristic of these two style areas. Styles V and VI utilized only the form in which the mouth was shown with teeth. In Style Area III there was an overwhelming use of the mouth with teeth, but not to the total exclusion of the simple line form. There do not appear to be any functional differences between the two types of mouths; each individual artist-scribe apparently utilized one or the other form almost exclusively, as a matter of personal choice.

Eyes. Open eyes in the Colombino-Becker were drawn in two different ways. One eye shape was round and contained a small circle at its center to represent the pupil; the other type was ovaloid, the top of the eye being straight and the bottom edge curved, with the pupil shown as a semi-circle against the middle of the top edge. The few dead persons shown in the manuscript had closed eyes that were lines or slits. In some ovaloid eyes a small red area was visible in the back corner, but the frequency of this was difficult to determine because of the general deterioration of the manuscript. Only one round eye having a red section at the back has survived (figure #6, in Style VI). Figure 9 shows examples of round and ovaloid eye shapes.

Style Areas I, II, and III all showed the use of both ovaloid and round eyes, but the proportional use of these forms differed in each, and in some cases eye shape was used as a subtle indicator of in-group identification. Ovaloid eyes with a red dot in the back corner were confined entirely within Style Area I. Proportionally, in this style area the ovaloid eye shape was used for 66% of the figures and the round form for the remaining 34%, with 37% of the ovaloid eyes characterized by the red dot in the rear. In Style Area II the usage for the two shapes was divided exactly equally, each occurring 50% of the time. For Style Area III, 40% of the eyes were ovaloid and 60% were round.

It was quite noticeable in the pictorial text of the Colombino-Becker that the same eye shape was not usually used for more than three consecutive figures in Style Areas I and II. This practice was also followed much of the time in Style Area III, although there were some notable exceptions. While some eye variation seemed to be random, perhaps merely for the sake of artistic appearance, there were a number of cases in

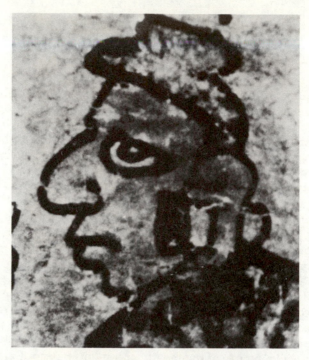

Figure 5. Typical facial profiles in the Colombino-Becker:
(a) Figure #33, Colombino 6-II.
(b) Figure #158, Becker 5-II.

Figure 6. Open hands in the Colombino-Becker are shown extended, with the thumb and fingers together and straight.
 (a) Figure #35, Colombino 6-II.
 (b) Figures #224 and #225, Becker 15-II-III.

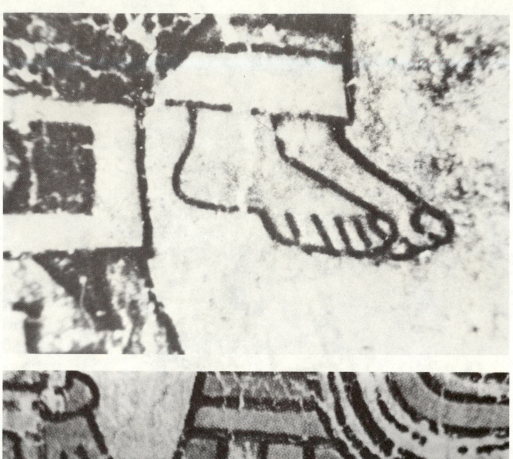

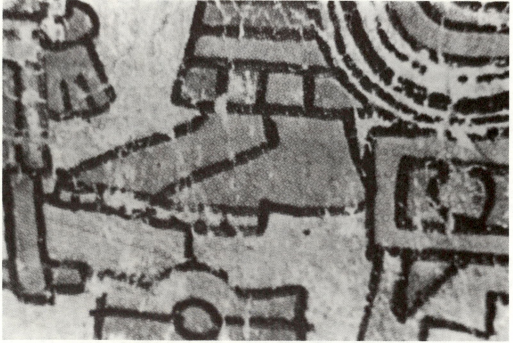

Figure 7. The two different forms of showing the toes in the Colombino-Becker:
 (a) Individually drawn toes, with a toenail shown only for the big toe.
 Figure #23, Colombino 3-II.
 (b) White squares across the end of the foot indicate the toenails and imply the toes.
 Figure #175, Becker 8-I.

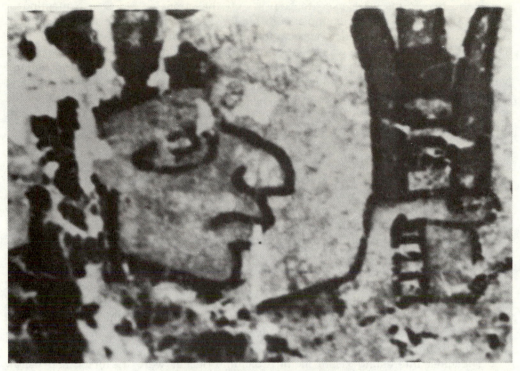

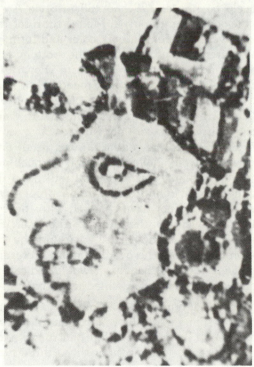

Figure 8. The two types of closed mouths used in the Colombino-Becker:
(a) Simple line mouth. Figure #30, Colombino 6-III.
(b) Mouth with upper teeth. Figure #1, Colombino 1-III.

which the two forms were used to help set off the opposing sides at a meeting or conflict. Figure 10 shows examples of this practice. Throughout the Colombino-Becker there was a tendency to use the round eye for supernaturals and their associates, but this practice was never completely consistent, as would be necessary if this shape was functioning as an identifying feature of such beings in the general Mixtec art style. There were numerous examples of humans with round eyes, and occasionally ovaloid eyes were shown on figures having supernatural attributes. While some painter-scribes showed more consistency than others in the use of these two eye forms, basically the choice appeared to have been a matter of individual discretion.

Clothing, Ornaments, and Body Paint

Male jackets. Males throughout the codex were pictured wearing a sleeveless jacket that scholars now usually call a *xicolli* (a name originating in the Nahuatl language of Central Mexico). Its color was shown as all red, all yellow, all black, white with red stripes, or white with black spots. In the Colombino-Becker this garment had two long ties at the neck and was decorated with a contrasting horizontal border near the bottom edge, below which hung a thick, multi-colored fringe (Anawalt 1979), as illustrated in Figure 11.

The *xicolli* jacket appeared 68 times in the codex, but was not found in Styles IV or V. Of these, 58 were all red, comprising 85% of all occurrences. Both examples of the white *xicolli* with red stripes occurred in Style Area I, while the six white *xicolli* with black spots were divided equally between Style Areas I and II. In Style Area III and Style IV only the red form was used.

The most interesting *xicolli* in the Colomino-Becker were the black and yellow jackets worn respectively by figures #79 and #80 in Style Area II. Whereas all the other *xicolli* shown in the codex had the usual Mixtec form for this garment described above, these two jackets were different in both color and form; the neck ties and the broad decorated band were lacking, and from the bottom edge hung a series of separate tabs instead of fringe. These two men were shown in the codex with their leader, the enigmatic Lord 4 Jaguar, at his first meeting with Lord 8 Deer. The main message conveyed to the Mixtec readers of the codex by the appearance of these atypical *xicolli* colors and form may have been simply that the men wearing them (and perhaps by implication, their leader) were not Mixtecs.

The very frequency with which the red *xicolli* was used, and the wide variety of contexts in which it appeared, would have deprived it of much meaning for the reader of the codex other than the minimal but important indication that the wearer was a male associated with the Mixtec ruling class. If the proper *xicolli* form was maintained, this basic meaning would not have changed with the color variations, which may correlate with historical events in the life of Lord 8 Deer. But deviations in both form and color would be of great importance, marking the persons wearing such jackets as members of an out-group. The overwhelming preference for the red *xicolli*, and its suitability for a wide range of activities, would indicate that it was a general Mixtec artistic characteristic that visually defined the Mixtec in-group.

Ear decorations. Almost all figures in the Colombino-Becker were shown wearing an ear decoration, which in shape might be round, square, or an oblong bar. The bar form was shown stuck through the earlobe, while the round and square shapes were large and concealed the entire ear. Examples of these three types of ear decorations are shown in Figure 12.

Of these three shapes the square was the least frequently used, being worn by only 11 of the 228 figures included in the present analysis, or 5%. All its occurrences

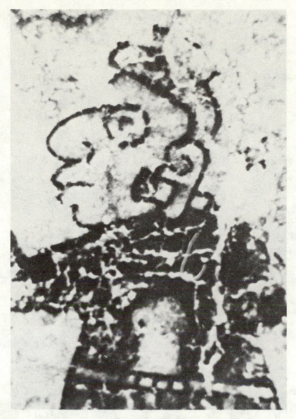

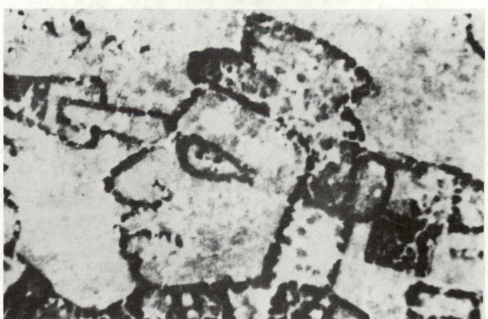

Figure 9. The two types of open eyes used in the Colombino-Becker:
(a) Round eye. Figure #5, Colombino 2-III.
(b) Ovaloid eye. Figure #10, Colombino 1-II.

Figure 10. The use of ovaloid and round eyes in the scenes of the Colombino-Becker to help distinguish between opposing sides at a meeting or conflict:

 (a) The supernatural Lord 13 Reed (left) meets with Lord 8 Deer. Figures #24 and #25, Colombino 3-III.

 (b) Lord 8 Deer's representative, at the left, meets with Lord 4 Jaguar. Figures #49 and #50, Colombino 10-II.

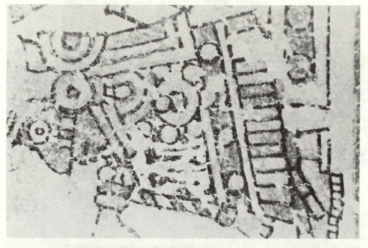

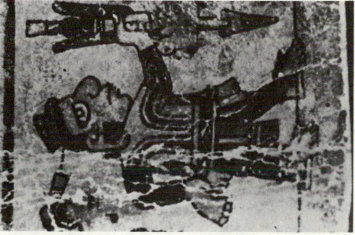

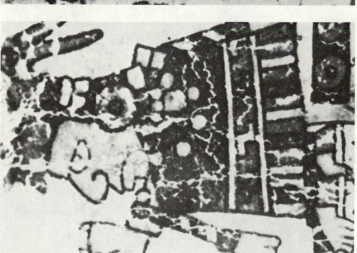

Figure 11. The form of the xicolli, a sleeveless jacket worn by Mixtec males, in the Colombino-Becker:
(a) Red xicolli. Figure #17, Colombino 3-I.
(b) White xicolli with red stripes. Figure #28, Colombino 4-III.
(c) White xicolli with black spots. Figure #121, Colombino 18-II.

137

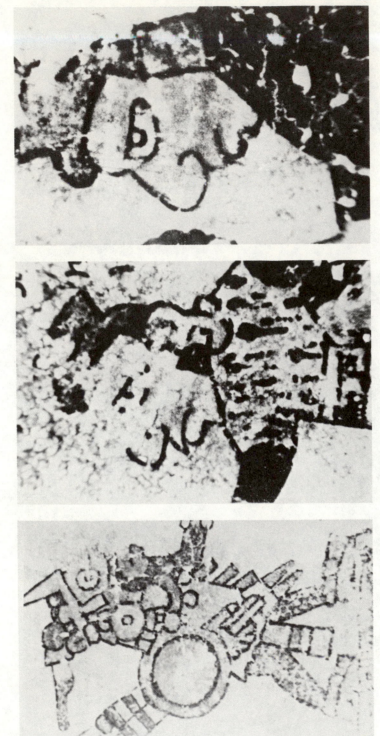

Figure 12. The shapes of ear decorations in the Colombino-Becker:
(a) Round. Figure #119, Colombino 19-III.
(b) Bar. Figure #38, Colombino 5-II.
(c) Square. Figure #34, Colombino 6-II.

but one (figure #132) are in Style Area I, and its use by figures #10 and #15 supports the suggestion made above that this style area probably begins prior to Colombino 3. Of the ear decorations still visible in Style Area I, 26% were square while 42% consisted of the bar and 33% were round. In Style Area II the round form occurred for 89% of the figures, while the bar shape was used only 12% of the time. In Style Area III the use of the bar increased somewhat, to 21%, but the round shape continued to dominate, comprising 79% of the ear decorations. All the figures in Style V wore the round form, while those of Style VI were divided equally between the round and the bar. The few simple figures of Style IV lacked any ear decorations.

Round and bar ear decorations both occurred throughout the manuscript, although the proportions of use varied considerably in the three large style areas. Style Area II marked the least use of the bar shape, the round form outnumbering it by more than seven to one. In Style Area I, despite substantial use of the square form, the bar was the most common shape and the round was the next most frequent. In Style Area III the round ear decoration dominated over the bar by almost four to one.

The high frequency and wide contextual use of the round shape indicated that it was the usual ear decoration and so probably the characteristic form of the general Mixtec style used in this codex. As in the *xicolli* analysis given above, the deviations from this norm would probably have been more informative for the Mixtec readers than the norm itself. Further analyses of ear decorations in comparison to the activities shown in the Colombino-Becker are still needed, however.

Facial colors. The faces of many figures in the Colombino-Becker were shown in the natural skin color, which in this codex is yellow, but many others were painted with a variety of designs. Faces were most commonly shown as all yellow (natural skin), all red, or with a red design covering about half the yellow face; a few other colors such as grey, black, or white also appeared. A variety of black markings may occur with any of these face colors, usually around the eye. Neither blue nor green was used for facial painting. Figure 13 shows several of the different patterns of facial paint found in Colombino-Becker. The present analysis focuses on the distribution of these various facial colors in the codex and does not extend to the design patterns themselves.

In Style Area I the use of the plain yellow face dominated overwhelmingly, 66% of the faces being shown simply as normal skin. An additional 6% of the yellow faces had a black mask painted around the eye and nose, a design identifying Lord 4 Jaguar and his associates. Only 6% of the faces were painted red. A combination of red and yellow was found on 21% of the faces, with the two colors divided by a black line 70% of the time and lacking such a line the remaining 30%.

In Style Area II, however, only 24% of the faces were plain yellow, and none had black eye markings. Red faces accounted for 13% of the figures; an additional 8% of these faces had the black mask, and 3% (two examples) had a yellow mask. The black and yellow masks were all associated with Lord 4 Jaguar and his men. The faces shown in patterns of red and yellow amounted to 52%, and in all cases the two colors were divided by a black line.

For Style Area III, faces with the natural yellow skin color constituted the largest group, 34% of the figures. An additional 9% with yellow faces had black eye markings, either the mask or a circle, spot, arc, or similar design. Ten percent of the faces were painted red; an additional 16% had black eye designs, principally the mask. Faces in a red and yellow pattern occurred 25% of the time, one of these also having the black mask painted around the eyes; a dividing line separated the colors for 32% of these patterns, but not the remaining 68%. Several unique combinations of colors

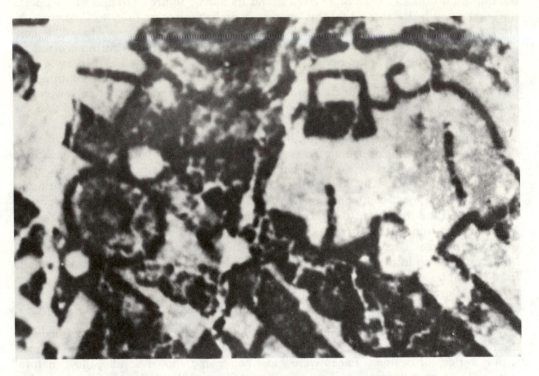

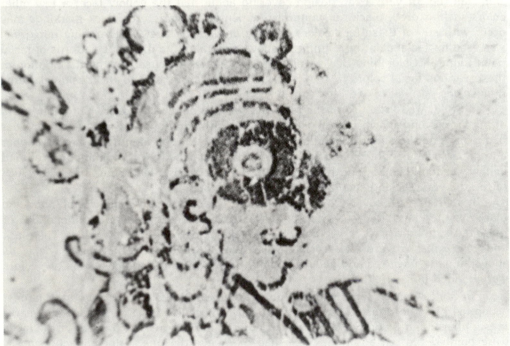

Figure 13. Some of the patterns of facial color in the Colombino-Becker:
 (a) Yellow face. Figure #21, Colombino 4-II.
 (b) Yellow face with black mask painted around the eyes. Figure #223, Becker 15-II.

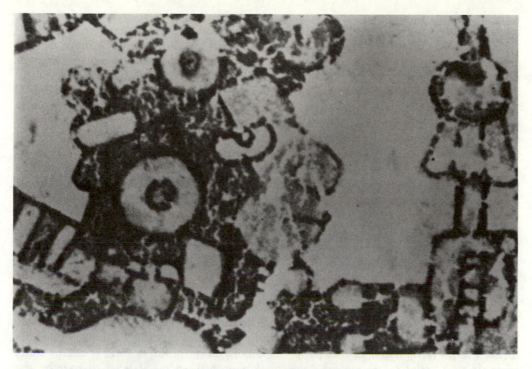

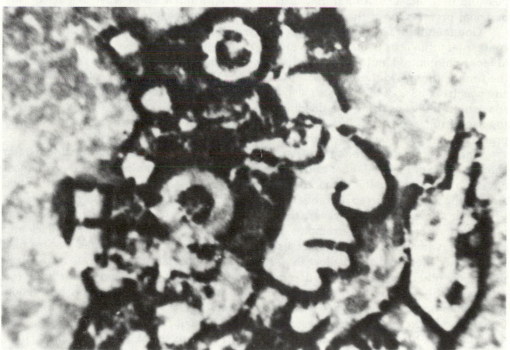

(c) *Red and yellow face. Figure #84, Colombino 11-II-III.*
(d) *Red and yellow face. Figure #108, Colombino 17-I.*

were found in this style area, some including the black mask. All mask designs were black and were worn by Lord 4 Jaguar and his supporters.

The figures in Style VI all had plain yellow faces, while those in Style IV all had yellow faces with an irregular black spot painted around the eye. In Style V there were figures with yellow faces, red faces (one with a black mask), and one painted red/ yellow with a black mask; both black masks were on Lord 4 Jaguar.

The large style areas were each characterized by markedly different proportional usages of the three basic facial colors of yellow, red, and red/yellow. If faces that were all yellow or yellow with black markings are taken together, then skin-colored faces were found on 72% of the figures in Style Area I, 24% of those in Style Area II, and 43% of those in Style Area III. The proportional use of such yellow faces was thus three times higher in Style Area I than in II, and nearly twice as high in Style Area III as in II. For red faces, again combined with those having black markings, the totals were 6% of the figures in Style Area I, 24% in Style Area II, and 26% in Style Area III; the proportional use in each of the latter two style areas was four times that of Style Area I. For those faces colored red and yellow, including those with black markings, the usages were 21% in Style Area I, 52% in Style Area II, and 25% in Style Area III, so that this combination of colors was found in Style Area II in twice the proportion as in the other two style areas.

While it is possible that some types of face paint were used because of historical factors in Lord 8 Deer's life, the variations in proportional usage among the style areas seem too extreme to be simply reflecting the flow of historical events. The shifts follow the patterns noted in this paper for other design features, and it seems quite possible that facial coloration may also have been influenced at least in part by the personal preferences of the individual Mixtec artist-scribes working in this codex.

One feature in facial coloring that can be examined independently of any possible contextual influences is the use of a dividing line between the areas of different colors in faces painted red and yellow. Such a dividing line was used in Style Area I 70% of the time and omitted the other 30%, while in Style Area III the almost precise oppo- site was true, 32% of the faces showing the line and 68% lacking it. Style Area II was consistent in always using the dividing line. Consequently, in such a small matter as the use of this separating line, the three major style areas showed distinctly different practices that could only reflect the preferences of the individual scribal painters.

The mask painted around the eye and nose that is a major visual distinguishing characteristic of Lord 4 Jaguar and his associates in the Colombino-Becker was almost always black and usually appeared on faces that were either yellow or red. In Style Area I the mask occurred infrequently but when used was black and the face was yellow. In Style Area II, however, the faces with masks were all red; the mask was black except for two yellow examples. In Style Area III the mask was always black and in the overwhelming majority of cases the face was red, although masks were also shown on yellow and red/yellow faces. Unique to this latter style area were black masks on other facial colors and combinations, such as grey, and white with red stripes. In Style V the mask appeared once on a red face and once on a red/yellow face, while no masks were shown in Styles IV or VI. The Mixtec artist-scribes of the Colombino-Becker were thus in accord that a mask should be used to distinguish Lord 4 Jaguar and his people visually from the other, more usual, Mixtec figures, indi- cating that this was a characteristic of the general Mixtec artistic practices used in this codex. The variations in mask color, while unusual, may show that it was mask shape, rather than color, that provided the basic identification clue to the reader.

These analyses reveal plainly that some of the variations in facial colors could be due to the different painter-scribes at work in this manuscript, and this possibility

must receive serious consideration in any attempt to correlate these colors or patterns with the historical events depicted in the Colombino-Becker.

The Relative Amount of Space Used by Figures

Vertically standing figures. The figures in the pictorial text of the Colombino-Becker were all painted within the constraints of quite limited space, although for any particular figure the amount of spaced actually available varied according to its precise location on a page. To test how the scribal painters of this manuscript designed their figures to fit within the space available for them, I made an analysis of the height of all vertically standing figures compared to the amount of vertical space available for each. Since the original total height of many figures cannot now be determined because of the damaged condition of the codex, I measured the figures from the pupil of the eye to the heel of the forward foot, these two points having survived in most instances. The available vertical space was also measured, this normally being the height of the band in which the figure appeared, unless another portion of the scene (such as a path) limited the useable space to less than the full band height. The two measurements were then compared and the eye-to-heel height of the figure expressed as a percentage of the available vertical space. So that the results of these measurements would be directly comparable, standing figures that leaned forward sharply from the vertical were eliminated from consideration, and a few figures that were relatively undamaged had to be excluded because either the eye or heel area was too destroyed for measurements to be made. Figure 14 shows examples of vertically standing figures, with marks indicating the points used in measuring the figure height and the height of the available space.

In Style Area 1 measurements were obtained for 19 figures, and the percentage of the available space utilized ranged mainly between 65% and 75%, the average for the 19 being 70%. Style Area II contained 33 measurable examples, of which 21 had a spatial utilization falling between 65% and 75%, while the remaining twelve were between 40% and 65%. In Style Area III suitable measurements were obtained for 24 figures. Nine of these were tightly clustered between 68% and 70%, and a total of 16 fell between 68% and 78%; this latter grouping meant that two-thirds of the figures in this style area were remarkably similar in space utilization. Of the remaining eight figures, two at 80% and 82% were only slightly beyond this range, but the remaining six figures used only 62% or less of the available space. Measurements could be obtained for only two figures in Style V, one having a usage of 75% and the other of 74%, while none of the figures in Styles IV or VI was depicted standing.

The figures in Style Area III showed the greatest uniformity in space utilization and were quite probably the work of a single artist with an exceptionally good eye for consistency. The small number of figures in this style area that fell significantly below the other percentages may reflect the intrusive hand of a different painter, and this situation may also be partially true for Style Area II, in which more than one-third of the figures showed a much lower percentage of space utilization than the remainder. Nevertheless, the main artist-scribes of the three style areas all produced a majority of figures that fell within the same range, the eye-to-heel height of the figures occupying approximately 65% to 75% of the available space. This would indicate that they shared a general artistic concensus concerning the appropriate size for vertically standing figures within bands the size of those in the Colombino-Becker.

Body Extremities Relative to the Torso

One arm overlapping the torso. As an example of the relationships possible between the body and the limbs of the figures in the codex, I studied all those figures

143

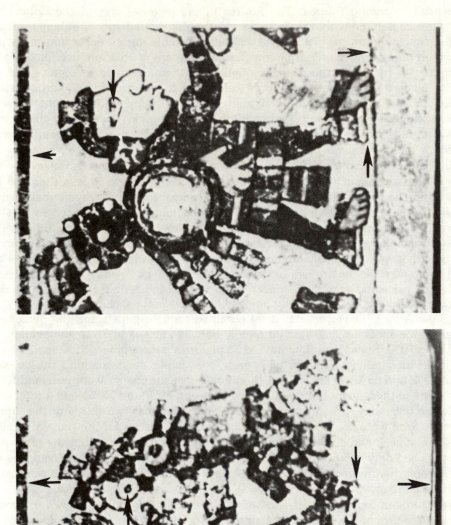

Figure 14. In these examples of vertically standing figures in the Colombino-Becker, the points are shown at which the height of the figure and height of the available space were each measured:
 (a) Vertically standing figure in which the entire height of the band is available for the drawing. Figure #78, Colombino 11-II-III.
 (b) Vertically standing figure in which the height of the available space is limited by a path. Figure #27, Colombino 3-III.

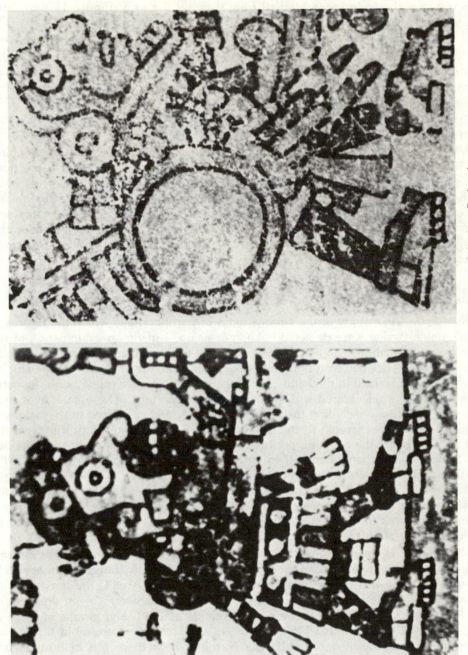

Figure 15. Examples of the arm overlapping the torso in Colombino-Becker drawings:
(a) Figure #65, Colombino 11-I.
(b) Figure #122, Colombino 19-I.

in which one arm was shown overlapping the torso. A figure is more complex to draw when its position involves the placement of an arm against the body, for if parts of the clothing and ornaments on the torso are to remain visible, they must be adjusted to compensate for the body space blocked from view by the arm. Figure 15 illustrates this pose.

In Style Area I, 59% of the figures were shown with an arm overlapping the body, while 41% were without any such overlapping. In Style Area II the usage was very similar, 57% of the figures displaying an overlapping arm and 43% lacking this feature. In Style Area III, however, the preference was strongly against the use of the overlapping arm, 67% of the figures being drawn without this trait while only 33% had it. In Style V one figure had the overlapping arm while seven lacked it. The few figures visible for Styles IV and VI were all without overlapping arms.

While Style Areas I and II were slightly inclined to the use of the overlapping arm, Style Area III showed a clear preference against the use of such a position. Figures in this style area were often drawn with the arms swinging clear of the body or with the arm towards the reader concealed inside a *xicolli* jacket. While some positions for figures in the codex were certainly dictated by the activity being carried out, the use or avoidance of the overlapping arm was a factor almost totally under the control of the artist-scribe, and the variations in this practice must be considered traits characteristic of the different individuals working in this manuscript.

Objects Held by Figures

Shield size. As a study of the various types of paraphernalia which the figures in the Colombino-Becker were depicted holding or using, I made an examination of the shields being carried, focusing on their size relative to the associated figures. (Shields not actually being gripped by a figure were excluded from the analysis.) These shields were intended to be held in the hand or on the arm, and all were round, with the outer circumference often decorated with feathers, tassels, or tabs. The diameter of each shield was measured, excluding the edge decorations, and compared to the height of the face of the figure carrying it, the face being measured along the profile from the bottom of the chin to the beginning of the hairline at the top of the forehead. The two measurements were then compared to obtain a percentage relationship, with 100% indicating that both were exactly equal, a percentage greater than 100 occurring if shield diameter exceeded facial height, and less than 100 if the face size was the greater. In some instances damage to the shields or to the faces prevented the pertinent measurements from being obtained, and these cases, thirteen in all, had to be omitted from the study. Figure 16 shows examples of persons holding shields.

Measurements were obtained for only four figures in Style Area I, these clustering into two groups, one at 128% and the other at 112-115%, indicating that shield diameter was somewhat larger than facial height. For Style Area II the ten examples that were measurable fell into four groups, with shield diameters being equal to or exceeding facial heights; there was a single example at 100% and groups of three at 114-123%, 130-136%, and 143-145%. Style Area III had 15 measurable figures, of which nine were tightly clustered at 100-106%, these shield diameters being the same as, or only very slightly larger than, facial height. The remaining six instances were scattered, two at 94-96% showing shield diameters slightly less than face height, while the other four were all larger than facial height at 113-136%. For Style V, measurements could still be obtained for only three examples, all considerably larger than face height: 129%, 137%, and 202%. Shields did not appear in Styles IV and VI.

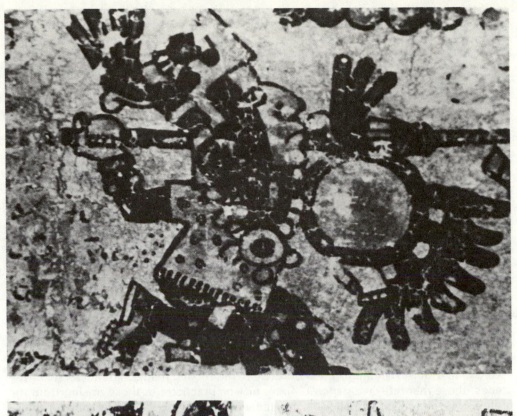

Figure 16. Figures in the Colombino-Becker holding shields:
(a) Figure #42, Colombino 6-I.
(b) Figure #125, Colombino 23.
(c) Figure #142, Becker 2-III.

Style Area III is the only one to show a significant consistency in the relationship between shield diameter and facial height; eleven of these 15 examples measured within 6% (greater or lesser) of being exactly equal. Shields in the other two style areas, and in Style V, were considerably larger than face height. Style Area II was sufficiently variable that the highest percentage (145%) exceeded the lowest (100%) by almost half. The largest percentage in all these codex measurements was the 202% found in Style V, in which the diameter of the shield was twice the height of the face of the figure holding it.

The major artist-scribe of Style Area III apparently intended shield diameter and facial height to be equal in most scenes. The remarkable consistency that was achieved in this recalls the consistency with which this same worker maintained the proportional heights of figures relative to the space available for them, discussed earlier. The other scribal painters of the codex do not appear to have shared this mental template concerning shield size, however, for all drew shields that were larger than facial heights, sometimes considerably so. This shows that there was no general Mixtec artistic canon concerning shield size, and that the variations were due to individual idiosyncrasies.

The various features discussed in this paper represent only a very few of the many elements that could be analyzed in the pictorial text of the Codex Colombino-Becker, these particular items typifying the wide range of designs in this manuscript. The purpose of the investigation has been to search for the clues and characteristics that would allow the meanings of such traits to be defined and assigned to one of three categories of pictorial information: as an example of those features that were essential in order to communicate accurately to the Mixtec readers the message of the scenes; those that reflected general Mixtec artistic practices; or those arising from the preferences and idiosyncrasies of the individual artist-scribes. The aim of these analyses is not simply to discover and ''map'' the distribution of these or other forms—such an end would be only a simplistic and sterile exercise—but rather to learn through such studies to understand the use and meaning of these features as they originally functioned in the complex pictorial communication system in which the texts of the Mixtec codices were composed, and thereby to increase the accuracy of the interpretations that recover the histories and other data so carefully recorded in these manuscripts.

Since there is now no way to predict which elements in the drawings expressed the most important information to the Mixtec readers, all features must be considered potentially informative and subjected to analysis. Consequently, the most useful approach is to concentrate upon determining which items can be traced to either the general Mixtec style or the peculiarities of a particular scribal artist. Those features unique to an individual worker may have been intended to convey a message to the readers, but if these traits were not also used by the other painter-scribes then they were probably not learned by the readers and hence did not actually fulfill a communication function. Those elements that were used in the same way by all the artist-scribes certainly carried information, although perhaps of a rather general nature. However, any deviations from the typical appearance or usage of such items would certainly be noticed by the readers, and therefore departures from the norm would actually carry a more striking message than the norm itself.

The work of the main scribal-painters of Style Areas I and III was particularly distinctive on the individual level, but for quite different reasons. The artist-scribe of Style Area I showed two unique painting traits: the occasional use of a red dot in the back corner of ovaloid eyes, and square ear decorations. This eye treatment was con-

fined entirely to Style Area I and does not appear to have had any functional—i.e., informative—purpose. All square ear decorations appeared within Style Area I except for one example, figure #132 on Colombino 24-III, which occurred many pages later. This square form does not correlate with any action or context and at present is not known to impart any particular information to the reader, but it does contrast well with the more usual round ear decoration and the somewhat less common bar shape. This use of the two features of the red dot in ovaloid eyes and the square ear decoration appears to be simply a personal effort on the part of the painter-scribe of Style Area I to create figures that could be differentiated from those of the other scribal artists who were also working on this codex. Figure #132, despite its separated location, displays all the traits characteristic of Style Area I and should be assigned to that artist-scribe. This is the only case I have identified so far in which a drawing by the main painter-scribe of a style area is found outside that style area.

The work of the main scribal artist of Style Area III contains few design idiosyncrasies such as those of Style Area I, but it is nevertheless distinctly set off from that of the other workers in the codex by the use of traits which in themselves may be shared with some of the other individual painter-scribes, but which are not used as a cluster by any of them. The consistency with which this artist-scribe drew standing figures and shields would indicate a very practiced hand. As such, and also perhaps because this style area occurs towards the end of the codex, some of the characteristic features used by this scribal painter may have been deliberately selected to create a subtle but distinctive contrast with the work of the prior artist-scribes in the codex. For example, in Style Areas I and II the use of the arm overlapping the torso was somewhat favored, but in Style Area III the preference was strongly against such positioning. In Style Areas I and II only the simple line mouth was used, while in Style Area III the mouth in which the upper teeth were visible was overwhelmingly preferred. Style Area III contains a number of unique combinations of facial paints, and differs from Style Areas I and II in usually omitting a dividing line between all facial colors, thereby forcing a more careful scan of the face to determine the nature of the patterns and colors (which probably also increased the notice of the mouth form). In short, the major artist-scribe of Style Area III obtained a readily recognizable personal style through manipulating some of the design elements of the bodies of the figures, rather than by introducing unique ornaments such as the square ear decorations used in Style Area I.

The general Mixtec artistic tradition controlled the forms of facial profiles and open hands, and neither element appeared to be intended to express information to the reader. The red *xicolli* jacket was used to signal that the wearer was a male of the Mixtec ruling class, minimal information considering the probable status of persons important enough to be included in a text covering a tumultous period of political history. However, for this jacket any deviations from the typical color or form would immediately attract the notice of the readers, and those differing in both traits could signal that such individuals wearing them were not Mixtecs. The round ear decoration, which was worn in a wide range of circumstances by humans and supernaturals of both sexes, may be primarily a characteristic of the general Mixtec style used in the Colombino-Becker and not intended to convey information to the reader, although more research is still needed on this point. As was true for the *xicolli*, the appearances of other shapes would probably be noted more than the occurrence of the round form itself. If so, then the artist-scribe of Style Area I may have carefully chosen to use a distinctive square ear decoration precisely because it was sure to be noticed, and the worker of Style Area III may have had to make use of a different form of

the mouth and some unusual facial paint combinations simply because other options for features on the face and head had already been pre-empted by the prior scribal painters.

Although the historical events depicted in the pictorial text of the codex may well have exercised a determining influence on facial colors in ways that are not yet understood or discovered, it seems quite possible that at least some of the variations in facial color noted in the Colombino-Becker were due to the choices of the individual painter-scribes. But the mask that consistently identified Lord 4 Jaguar and his associates was a general Mixtec artistic characteristic shared by all the scribal artists, showing clearly that such conventions did govern at least some facial markings. These findings stand as a pointed warning to interpreters who would try to correlate facial paint with only the events of Lord 8 Deer's life shown in this codex.

Other traits in the Colombino-Becker drawings, such as the two ways of indicating the toes, carried no information for the readers, each artist-scribe using one or the other form habitually. The distribution of the ovaloid and round eye shapes varied, and although the usage of the two forms appeared to be partially at random, there was some tendency for round eyes to be found on the figures of supernaturals or persons who may not be Mixtecs, but the distinction was not made consistently. Eye shapes were often used, however, to help distinguish between the members of two groups in a single scene, in this way serving as subtle indicators of group affiliation. Some of the usages in eye shapes were consistent within the bands done by some painter-scribes, while others appeared only in scenes of related events. Even these limited practices, however, showed clearly that the Colombino-Becker scribal workers were keenly aware of the problem of differentiating among their superficially similar figures, and were moving, at least on an individual basis, towards the use of eye shapes as a consistent indicator of distinctions.

It has been the aim of this paper to point out a few of the many ways in which stylistic analyses can make useful and often crucial contributions to the understanding of the pictorial texts of the Mixtec codices. By focusing here on some of the elements found in one such manuscript, the Codex Colombino-Becker, I hope to have delineated more clearly a basic problem in the study of these documents: that of determining not only the meaning but the nature and quality of the information these designs expressed to the intended Mixtec readers. The aim of the artist-scribes of the codices was to create forms and elements that were functional in recording events of importance to Mixtec history and culture, and the study of the differences in the execution of these drawings is one way in which modern scholars can work towards achieving an increasingly accurate interpretation of the ancient Mixtec life so skillfully preserved in these documents.

Bibliography

Anawalt, Patricia R.
1979 "The Mixtec-Aztec Xicolli: A Comparative Analysis." *Actes du XLIIe Congrès International des Américanistes*, vol. VII. Paris. Pp. 147-160.

Caso, Alfonso
1966 *Interpretación del Códice Colombino*. Mexico: Sociedad Mexicana de Antropología.

Codex Becker
1961 Graz: Akademische Druck- u. Verlagsanstalt.

Codex Colombino
1966 Mexico: Sociedad Mexicana de Antropología.

Smith, Mary Elizabeth
1973 *Picture Writing from Ancient Southern Mexico: Mixtec Place Signs and Maps*. Norman: University of Oklahoma Press.

Troike, Nancy P.
1969 "Observations on the Physical Form of the Codex Becker I." *Archiv für Völkerkunde* 23:177-182.
1970a "Observations on Some Material Aspects of the Codex Colombino." *Tlalocan* 6(3):240-252.
1970b "A Study of Some Stylistic Elements in the Codex Colombino-Becker." *Verhandlungen des XXXVIII Internationalen Amerikanistenkongresses*, Band II. Pp. 167-171.
1971 "The Structure of the Codex Colombino-Becker." *Anales del Instituto Nacional de Antropología e Historia, 1969* (7a época) 2:181-205.
1974 *The Codex Colombino-Becker*. Ph.D. dissertation, University of London.
1980 "The Identification of Individuals in the Codex Colombino-Becker." *Tlalocan* 8:397-418.

Towards a More Precise Definition of the Aztec Painting Style

Elizabeth Hill Boone
Dumbarton Oaks

Perhaps no other pre-Columbian culture is so widely recognized as the Aztecs of Mexico. Yet, for all its notoriety, certain aspects of Aztec civilization are very poorly known. Of special importance in this area of concern is Aztec painting. Contrasted with sculpture, only a very limited number of examples of truly pre-Hispanic works are known to exist. This paucity of data severely limits definition and understanding. Nonetheless, by extremely careful study and analysis, an accurate picture can be drawn of the Aztec style of painting.

WHEN AZTEC ART IS CONSIDERED, such monumental sculptures as the Calendar Stone and the Coatlicue come immediately to mind. The Aztec sculptural style is well known, having been partially defined or discussed by such scholars as Justino Fernández (1954), George Kubler (1975:58-63), and H. B. Nicholson (1971), to name a few. Yet the painting style of the Aztec-Mexica is poorly understood. Only a handful of pre-Conquest examples of Aztec painting have come down to us, and the style has traditionally been defined in terms of the styles of other Mesoamerican cultures or as contrasting with the European component of the painted manuscripts created in Central Mexico in the early Colonial period.

In their 1951 study of the sixteenth century Tovar Calendar, George Kubler and Charles Gibson outlined some general features of the Aztec painting style by identifying some of the pre-Columbian characteristics of this early Colonial manuscript from Central Mexico. They mentioned as being pre-Conquest the scattering of attributes across the painting surface and the use of straight lines and sharp angles to delineate form, and, using the Codex Borbonicus[1] (Figure 1) as an example, they noted that the Aztec draughtsman "strove for the greatest measure of iconographic clarity among all parts of the form, by spreading out the details of costume and ornament in two directions" (Kubler and Gibson 1951:38). Essentially, Kubler and Gibson indicated

1. For short discussions of and full bibliographic references to the pictorial manuscripts, see Glass and Robertson (1975).

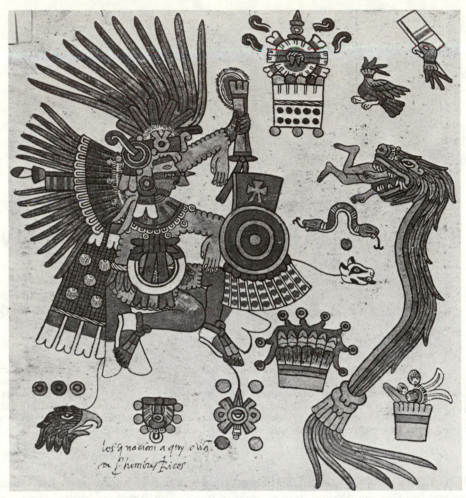

Figure 1. Main panel of the fourteenth trecena, *Codex Borbonicus 14* (*From Codex Borbonicus 1974*).

some of the characteristics not solely of Aztec painting, but of painting throughout Mesoamerica in the Late Post-Classic period.

Eight years later, Donald Robertson (1959) offered a more detailed definition of pre-Conquest painting in his *Mexican Manuscript Painting of the Early Colonial Period: The Metropolitan Schools*. Robertson was forced, however, to describe the specifically Aztec style of manuscript painting largely from the perspective of the Mixtec Codex Zouche-Nuttall and subsume this style under the larger pre-Conquest designation, because, as he noted, no indisputably pre-Conquest manuscripts exist from the Valley of Mexico. The absence of a single ''manuscript from the Nahuatl-speaking area without some evidence of European influence'' meant that the Aztec painting style had to be reconstructed by inference, by extracting the indigenous elements from early Colonial pictorials (as Kubler and Gibson had done), by exploring the canons of Aztec art in other media, and by an analysis of Mixtec manuscripts to determine the characteristics of the pre-Conquest manuscript style in general terms (Robertson 1959:9-12). Robertson concentrated his attention on the latter and provided a valuable tool for differentiating the characteristics of pre- and post-Conquest manuscripts.

Reviewing briefly, he noted that in pre-Conquest manuscripts the painted figures exist in a world of undefined space. There was no attempt on the part of the artists to show depth, and generally the forms are evenly distributed over the surface of the pages. Lines are neither fluid nor expressive and show no meaningful variation in width or intensity, for they function instead to frame and qualify areas of color. The colors themselves are flat, brilliant, and unobscured by modeling or shading. Human figures are depicted in a strict profile or in the mixed frontal and profile view in which the most characteristic features of each anatomical part are shown clearly, with the human forms being created by adding separable and interchangeable components to a torso.* Images are represented in a conventionalized rather than perceptually accurate manner (Robertson 1959:16-24). The Aztec painting style was thus considered within the aesthetic framework of the pre-Columbian Mixtec and Mixteca-Puebla styles, and indeed José Luís Franco (1959:374) labeled the post-Conquest Aztec Codex Borbonicus and the Tonalamatl Aubin as comprising one of four groups of Mixtec manuscripts.

In 1960 and again in 1971, H. B. Nicholson (1966:261; 1971:119, 123) classified Aztec art more precisely as one sub-style of the Mixtec-Puebla Horizon Style, a term he used to identify that important assemblage of stylistic and iconographic traits that mark much of Mesoamerican art throughout the Post-Classic period. Noting that Aztec art was so very similar to the art of the Mixteca-Puebla area proper as to be genetically related to it, he indicated, however, that the Aztec style of the Valley of Mexico was "marked throughout by a greater realism, plus certain iconographic differences," and that the symbolic system was "somewhat more literally and realistically conceived" (Nicholson 1971:119, 123). In painting, he saw the Aztec style as being best typified by the Codex Borbonicus (Nicholson 1966:261) (Figure 1). Without elaborating, Nicholson thus indicated that certain identifiable features differentiate Aztec art proper from the more universal style of the Late Post Classic.

These features, once they are pointed out, should enable us to define the Aztec painting style with greater precision and separate it more clearly from the other manifestations of the Mixteca-Puebla Horizon Style. They can be disclosed by considering the extant representations of Aztec painting and the early Colonial manuscripts that seem most free of European influence, and by comparing these to Aztec sculptures and to Mixtec and Borgia Group manuscripts.

The extant examples of decidedly pre-Conquest Aztec painting do not cover a broad range of images. Only a few Aztec murals remain, and these are in fragmentary condition. They include the procession of hunters or warriors painted on one wall of Structure III at Malinalco (Figure 2)—this being perhaps the best known example, two partial friezes of skulls and crossed bones painted on the sides of altars excavated at Tenayuca and Tlatelolco (Caso 1928:151; Villagra Caleti 1971:Fig. 33), and a much abraded cave painting from San Cristobal Ecatepec that Wilfrido Du Solier (1939:op. pg. 132, 133) has suggested depicts a circular temple with the deity Quetzalcoatl in his aspect as the planet Venus. Additionally, there are polychrome *sahumadores* and *ollas* uncovered during the Calle de Escalerillas excavations in Mexico City at the turn of the century (Batres 1902; Seler 1903) and the two painted boxes found at Tizapan, D. F. (Figure 6).

For most information about the Aztec painting style one must therefore turn to other media, such as monumental relief sculpture, and especially to the manuscripts

*Janet Berlo, in the article included in this volume, makes a similar point for Teotihuacan incense burners: there too the basic form could be modified by select additions from a repertoire of possibilities. —A.C.-C.

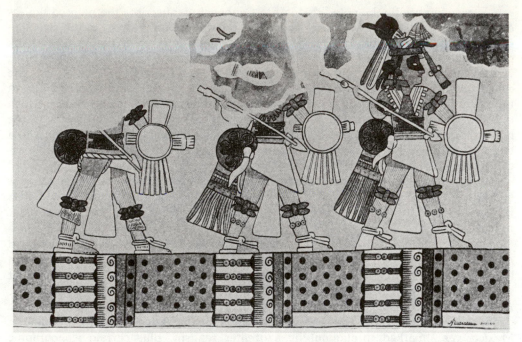

Figure 2. Mural of Structure III at Malinalco showing a procession of hunters or warriors in the costume of Mixcoatl (From García Payón 1946: op. pg. 20).

painted in Central Mexico after the Spanish Conquest. The most notable of these early Colonial manuscripts are those that show very little European influence, such as the previously mentioned Codex Borbonicus (Figure 1), from the Valley of Mexico, and the Tlaxcalan Tonalamatl Aubin, both of which are ritual screenfolds of bark paper that depict the Central Mexican *tonalpohualli* or sacred count of 260 days.[2] To these can also be added ten pages from the mid-sixteenth century Codex Magliabechiano, where on the rectos and versos of folios 3, 4, and 5, and on the rectos of folios 53, 54, 56, and 57 appear images painted by Magliabechiano Artist A who was trained and worked in the native tradition of manuscript painting (Boone n.d.) (Figure 3).

The Codex Borbonicus more than any other pictorial source is crucial to an understanding of Aztec painting, for it was almost universally considered pre-Conquest and had been used as a definitive indicator of the Aztec style until Donald Robertson cast doubts about its pre-Columbian date. Robertson (1959:88-90) pointed out that the images in the first part of the Borbonicus, the *tonalpohualli* section, appeared to have been organized to allow for the inclusion of Spanish glosses and that the manuscript must therefore have been painted after the arrival of the Spanish. He also saw European influences in the painting style of this first section, particularly in reference to the appearance of tonal variations in the feathers of some painted birds and the depiction of the Coatl or Serpent day-sign without the usual supra-orbital

2. An Itztapallapan or Colhuacan origin for the Codex Borbonicus has been proposed by H. B. Nicholson (1970), based on its iconography and content. Although John Glass (Glass and Robertson 1975:#15) has indicated that the Tlaxcalan provenience of the Tonalamatl Aubin is tentative, being based on a statement in the 1745 catalogue of the manuscript collection of Lorenzo Boturini, who once owned the *tonalamatl*, Nicholson (personal communication 1980) feels the considerable stylistic correspondences between the *tonalamatl* and the Tlaxcalan Codex Huamantla point strongly to a Tlaxcalan origin for the Aubin manuscript.

156

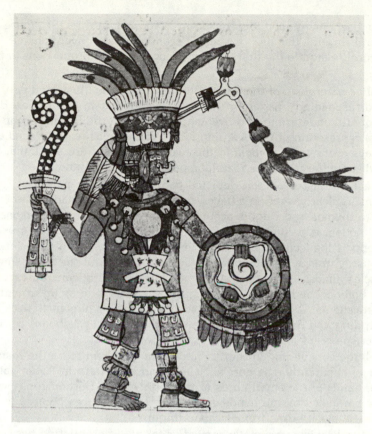

Figure 3. The pulque god Patecatl painted by Artist A in the Codex Magliabechiano, fol. 53 recto (From Codex Magliabechiano 1970).

plate and articulation of fangs, tongue, or scales (Robertson 1959:91-93) (Figure 12). Since then Betty Brown (1978) has additionally noted the presence of a number of European conventions in the final section of the document pertaining to the eighteen monthly feasts, and it can suffice to say that the Borbonicus codex is now generally regarded as early Colonial in date.

The central question, however, is not whether the Codex Borbonicus is chronologically pre- or post-Conquest, but whether the paintings in the first part of the manuscript accurately reflect the pre-Columbian Aztec painting style. Must we assume that because the Borbonicus was created after 1521, the elements that differentiate it pictorially from the pre-Conquest Mixtec and Borgia Group[3] manuscripts are all European intrusions? I think not, and I feel that many of these stylistic variances should be considered as illustrating the specific characteristics of Aztec painting. Images in the Codex Borbonicus can be used as a starting point in defining the Aztec style, especially when support material is available from other, and decidedly pre-Conquest, sources.

Two characteristic features that distinguish the Borbonicus paintings, and by extension Aztec painting in general, from the broader Mixteca-Puebla Horizon Style

3. The Borgia Group was first defined by Eduard Seler (1902:133), who clustered the Codices Borgia, Cospi, Fejérváry-Mayer, Laud, and Vaticanus B because of extensive similarities in their content. The Aubin Manuscript No. 20 has also been considered as belonging to the group (Robertson 1964:425).

have already been mentioned by Nicholson (1966:261; 1971:119), these being its relative naturalism and the use of specific iconographic conventions. A third outstanding feature, related to the first, is a tendency to certain proportions in the human figure.

The relative naturalism of the Codex Borbonicus can be illustrated very clearly by comparing corresponding images in the Aztec codex and in the Codex Borgia, the manuscript, of still undetermined provenience, for which the Borgia Group is named. The paintings representing the governing forces of the fourteenth *trecena* or "week" of thirteen days in the *tonalpohualli* in the two manuscripts are so similar in content that their stylistic differences are readily apparent (Figures 1 and 4).

The Xipe Totec impersonator, depicted on the left in both paintings, is rendered in the Borbonicus clearly wearing a flayed skin (Figure 1). The hands of this skin hang naturally, with thumbs and fingers accurately represented. The impersonator's body appears to function as a living organism; the head, torso, and limbs are carefully defined to support the iconic elements of costume without losing their integrity. The hand perceptually grasps the standard being held aloft, and the black lines framing the calf muscles almost approach the contour lines of European representations. In contrast, the body of the Borgia figure (Figure 4) serves only as an armature for the deity's accouterments. A comparison between the smaller human figures is perhaps even more striking, the Borgia figure appearing similar to a cardboard cut-out, with a rigidity and crispness of form not sought in the Borbonicus.

Although the cursive line in the Borbonicus might seem to be the result of European influence, apparently it is not, for it is found elsewhere in Aztec painting. The very graceful hands of the small Lords of the Night in the Borbonicus (Figure 5), for example, are paralleled by the hands of the four Tlaloc figures painted in one of the Late Post-Classic stone boxes from Tizapan (Figure 6).

Aztec naturalism is occasionally carried as far as differentiating between left and right feet. This situation is not usual in Aztec art, but to my knowledge it is never found in Mixtec art or in the manuscripts of the Borgia Group. It appears in the seventh *trecena* panel of the Codex Borbonicus where the female deity Cihuacoatl is shown with left and right feet (Figure 7), and it characterizes the pulque gods painted in the Codex Magliabechiano by the native trained Artist A (folios 53, 54, 56, and 57 recto) (Figure 8). As these are both post-Conquest documents, this could conceivably be an intrusive European element, were it not that the feet of the hunters or warriors on the Malinalco mural are differentiated (Figure 9), as are the feet of the bas-relief figures of Tizoc and Ahuitzotl on the stone commemorating the completion of the Templo Mayor in the year 8 Reed (Figure 10). This latter example is particularly notable, for it would normally seem that the relative difficulty of abrading stone as opposed to painting would hinder the depiction of such details especially if the depiction were considered aberrant.

Certainly all Aztec art can not be labeled naturalistic, but it would seem that naturalism was tolerated and often sought within the Aztec aesthetic, as is evidenced also by the creation of sensitively rendered sculptures of serpents (Figure 11), humans, and vegetables. The realism inherent in much of Aztec art probably also accounts for the perceptual accuracy of the Serpent or Coatl day-signs (Figure 12) and of the augery birds painted in the Borbonicus, as noticed by Robertson (1959:90-93). Serpents lacking supra-orbital plates and/or well-articulated fangs and scales are represented in Aztec sculpture, as shown in Figure 11, and Coatl day-signs similar to those in the Borbonicus and represented by full serpent images are also seen on the well-known Aztec Calendar Stone as well as in such early Colonial painted sources

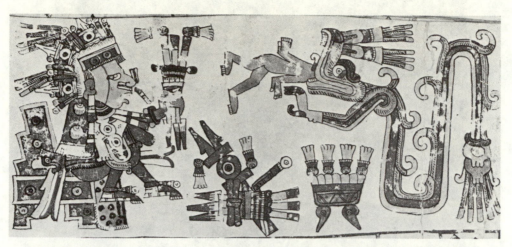

Figure 4. Main panel of the fourteenth trecena, Codex Borgia 67 (From Codex Borgia 1976).

Figure 5. Itztli or Tecpatl as the Lord of the Night of the day 4 Vulture, Codex Borbonicus 2
(From Codex Borbonicus 1974).

159

Figure 6. Detail of one of four Tlaloc figures painted on the bottom of one of the stone boxes found at Tizapan, D.F. (From Villagra Caleti 1971:Fig. 31).

Figure 7. Detail of the feet of Cihuacoatl from the main panel of the seventh trecena, Codex Borbonicus 7 (From Codex Borbonicus 1974).

Figure 8. Detail of the feet of the pulque god Patecatl painted by Artist A in the Codex Magliabechiano, fol. 53 recto (From Codex Magliabechiano 1970).

Figure 9. Detail of the feet of the left figure in the mural of Malinalco Structure III (From García Payón 1946:op. pg. 20).

Figure 10. Detail of the feet of Tizoc from the stone commemorating the completion of the Templo Mayor in the year 8 Reed (From Seler 1904:Abb. 47).

Figure 11. Aztec serpent. Robert Woods Bliss Collection #70, Dumbarton Oaks.

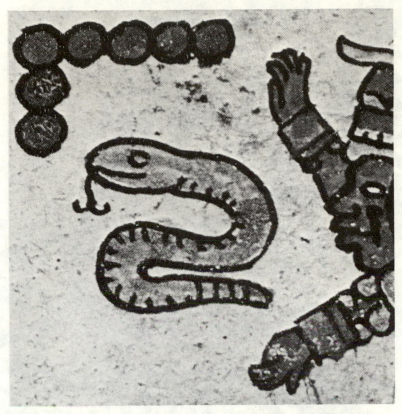

Figure 12. Detail of the Coatl or Serpent day-sign in the fifth trecena of the Codex Borbonicus, 5 (From Codex Borbonicus 1974).

from Central Mexico as the Tonalamatl Aubin, Codex Magliabechiano, Codex Tudela *tonalamatl*, Codices Telleriano Remensis and Vaticanus A (Ríos), Kalendario Mexicano, Latino, y Castellano, and calendars of Diego Durán and Bernardino de Sahagún.

Another feature that separates Aztec painting from the painting style of the Mixteca or of the manuscripts of the Borgia Group is the different proportional frameworks in which the artists worked. A comparison between human figures in the Codex Borbonicus (Figure 13) and the Mixtec Codex Zouche-Nuttall (Figure 14) shows that Aztec painted humans look decidedly taller than their Mixtec counterparts. Not that they are necessarily taller *per se*, but Aztec human images have proportionally smaller heads. In the first section of the Codex Borbonicus, the two major human images that are standing (pages 1 and 4) have an average height (measured from hairline to sandal) that is 5.57 times as great as the height of the heads (measured from hairline to chin), and the average height of all the standing humans and anthropomorphs, including the smaller, secondary figures, in the Borbonicus *tonalamatl* is 4.71 times the height of the heads.[4] The Zouche-Nuttall average, in contrast, is 3.61 heads to a body. Even the eleven deities and deity impersonators depicted in the Borbonicus in a pinwheel stance (Figure 1) have an average height of 4.41 heads. In the native style illustrations in the Codex Magliabechiano by Artist A, this body-to-head ratio is even greater, being 7.35 on the average (Figure 3).

4. This includes two major human forms, four secondary figures, and three major anthropomorphic images.

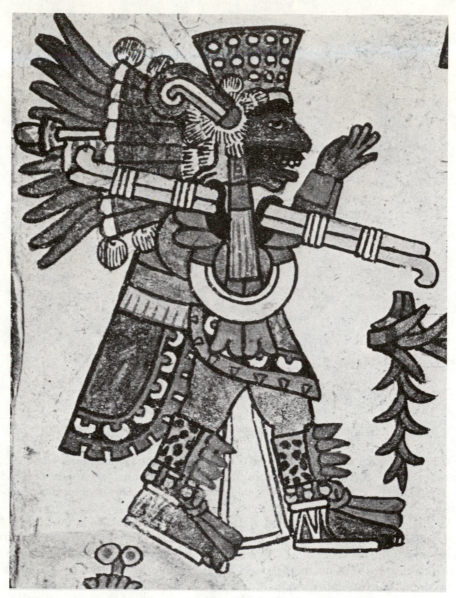

Figure 13. The deity Tonatiuh from the sixth trecena of the Codex Borbonicus, 6
(From Codex Borbonicus 1974).

Considering that the standard, natural human proportion is seven or eight heads
to body height, the effects of European artistic canons on the early Colonial Codices
Borbonicus and Magliabechiano might be proposed as explaining these proportional
ratios. But on the pre-Conquest Stone of Tizoc, the figures of Tizoc are 4.71 heads tall
on the average, and at Malinalco the painted processional figures are 6.30 heads in
height (Figure 2). This contrasts greatly with the height-to-head ratios in the Codices
Borgia, Laud, Cospi, Zouche-Nuttall, and Vienna, which are 3.35, 3.72, 3.10, 3.61, and
3.84, respectively.[5] In the Mixtec and Borgia Group manuscripts the height-to-head
ratio is consistently less than four to one; in pre- and post-Conquest Aztec painting
ratios of greater than four to one were clearly acceptable, if not universal.[6]

164

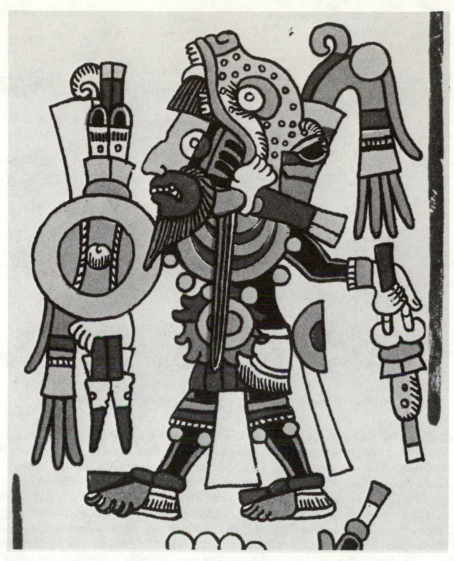

Figure 14. The ruler 8-Deer from the Codex Zouche-Nuttall, 49 (From Codex Zouche-Nuttall 1902).

In addition to its relative naturalism and its allowance of tall human proportions, Aztec painting, and Aztec sculpture as well, is distinguished by the use of specific conventions to depict a variety of natural phenomena and ideological concepts. Setting aside the range of very complex Aztec images, many of which have been thoroughly investigated by iconographers, such mundane and more frequently found conventions as the day-signs can reveal the Aztec proclivity for certain forms.

Although the day-signs from the codices of the Borgia Group have often been used to illustrate the component days of the Aztec calendar (cf. Caso 1973:Fig. 1),

5. The number of standing figures measured in each manuscript is as follows: Borgia—62, Laud—47, Cospi—9, Zouche-Nuttall—29, Vienna—14.

6. The nineteen standing figures in the Aztec Codex Boturini have an average body-to-head ratio of 4.70.

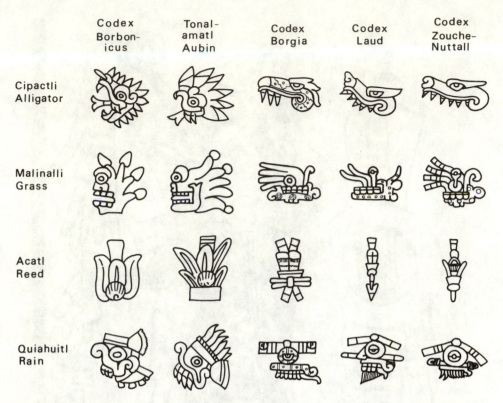

Codex Borbonicus	Tonal-amatl Aubin	Codex Borgia	Codex Laud	Codex Zouche-Nuttall

Cipactli Alligator

Malinalli Grass

Acatl Reed

Quiahuitl Rain

Figure 15. Comparison of four day-signs as represented in Aztec, Borgia Group, and Mixtec manuscripts.

specifically Aztec day-signs differ considerably from those in manuscripts outside the Aztec stylistic sphere (Figure 15). The images representing Cipactli or Alligator, Malinalli or Grass, Acatl or Reed, and Quiahuitl or Rain in the Codex Borbonicus and Tonalamatl Aubin, for example, are internally consistent and are paralleled by similar signs on the Calendar Stone and in the other early Colonial pictorials from Central Mexico. They also vary markedly from the representations for the equivalent signs in the Codices Borgia, Laud, and Zouche-Nuttall, which are equally consistent. The appearance on pre-Conquest sculptures of day-signs identical to those in the Borbonicus and Aubin manuscripts effectively rules out the possibility of European influence as a differentiating factor, and iconographic considerations are useless in explaining the divergence, for the images carry the same meaning from one document to the next. The variations are therefore based solely on style.

Two of these three characteristics of the pre-Conquest Aztec painting style, naturalism and the depiction of proportionally taller human figures, have generally been viewed as impurities of style when found in painted manuscripts from Central Mexico and have been attributed to artistic influences coming from Europe after the Conquest. The tendency toward naturalism and longer, leaner figures, however, seems already to have existed in Aztec painting prior to the arrival of the Spanish. These features, the consistent use of certain conventions, and undoubtedly many other visual features indicate that the Aztec style of painting was indeed a unique sub-style of the larger Mixteca-Puebla Horizon Style defined by Nicholson (1966), and that at least the first part of the Codex Borbonicus can once again be considered, with some caution, as representing the pre-Conquest style of Aztec painting.

166

Bibliography

Batres, Leopoldo
1902 *Exploraciones arqueológicas en la Calle de las Escalerillas*. Mexico: J. Aguilar Vera.

Boone, Elizabeth Hill
n.d. *The Codex Magliabechiano and the Lost Prototype of the Magliabechiano Group*. Berkeley: University of California Press (forthcoming).

Brown, Betty Ann
1978 "European Influences in Early Colonial Descriptions and Illustrations of the Mexica Monthly Calendar." Ph.D. dissertation, University of New Mexico.

Caso, Alfonso
1928 "Los jeroglíficos de Tenayuca, México." *Revista Mexicana de Estudios Históricos* 2:141-162.
1971 "Calendrical Systems of Central Mexico." *In* Robert Wauchope, Gordon Ekholm, and Ignacio Bernal, eds., *Handbook of Middle American Indians* 10. Austin: University of Texas Press. Pp. 333-348.

Codex Borbonicus
1974 *Codex Borbonicus, Bibliothèque de l'Assemblée Nationale—Paris*. Graz: Akademische Druck- und Verlagsanstalt.

Codex Borgia
1976 *Codex Borgia, Biblioteca Apostolica Vaticana*. Graz: Akademische Druck- und Verlagsanstalt.

Codex Magliabechiano
1970 *Codex Magliabechiano, Biblioteca Nazionale Centrale di Firenze*. Graz: Akademische Druck- und Verlagsanstalt.

Codex Zouche-Nuttall
1902 *Codex Nuttall, Facsimile of an Ancient Mexican Codex Belonging to Lord Zouche of Harynworth, England*. Cambridge: Peabody Museum of American Archaeology and Ethnology, Harvard University.

Du Solier, Wilfrido
1939 "Una representación pictórica de Quetzalcoatl en una cueva." *Revista Mexicana de Estudios Antropologicos* 3:129-141.

Fernández, Justino
1954 *Coatlicue. Estética del arte antiguo*. Mexico: Universidad Nacional Autónoma de México.

Franco C., José Luís
1959 "La escritura y los códices." *Esplendor del México Antiguo* 1. Mexico: Centro de Investigaciones Antropologicas. Pp. 361-378.

García Payón, José
1946 "Los monumentos arqueológicos de Malinalco, Estado de México." *Revista Mexicana de Estudios Antropológicos* 8:5-63.

Glass, John B., in collaboration with Donald Robertson
1975 "A Census of Native Middle American Pictorial Manuscripts." *In* Robert Wauchope and Howard F. Cline, eds., *Handbook of Middle American Indians* 14. Austin: University of Texas Press. Pp. 81-252.

Kubler, George
1975 *The Art and Architecture of Ancient America. The Mexican, Maya, and Andean Peoples*. Second Edition. Baltimore: Penguin Books.

——————, and Charles Gibson
1951 *The Tovar Calendar. An Illustrated Mexican Manuscript ca. 1585*. Memoirs of the Connecticut Academy of Arts & Sciences 9. New Haven.

Nicholson, H. B.
1966 "The Mixteca-Puebla Concept in Mesoamerican Archaeology: A Re-examination." *In* John A. Graham, ed., *Ancient Mesoamerica. Selected Readings*. Palo Alto: Peek Publications. Pp. 258-263. (Reprinted from the 1960 article published in the *International Congress of Anthropological Ethnological Sciences*:612-618.)
1970 "The Provenience of the Codex Borbonicus: An Hypothesis." Paper presented at the XXXIX Congreso Internacional de Americanistas, Lima, 2-9 Agosto.
1971 "Major Sculpture in Pre-Hispanic Central Mexico." *In* Robert Wauchope, Gordon F. Ekholm, and Ignacio Bernal, eds., *Handbook of Middle American Indians* 10. Austin: University of Texas Press. Pp. 91-134.

Robertson, Donald
1959 *Mexican Manuscript Painting of the Early Colonial Period: The Metropolitan Schools*. New Haven: Yale University Press.

1964 "Los manuscritos religiosos mixtecos." *Actas y Memorias del XXXV Congreso Internacional de Americanistas, México, 1962* 1:425-435. Mexico.

Seler, Eduard

1902 "Der Codex Borgia und die verwandten aztekischen Bilderschriften." *In* Eduart Seler, ed., *Gesammelte Abhandlungen zur Amerikanischen Sprach- und Alterthumskunde* 1. Berlin: A. Asher. Pp. 133-144.

1903 "Las excavaciones en el sitio del Templo Mayor de México." *Anales del Museo Nacional,* ép. 1, 7:235-260. Mexico.

1904 "Ueber Steinkisten, *Tepetlacalli,* mit Opferdarstellungen und andere ähnliche Monumente." *In* Eduard Seler, ed., *Gesammelte Abhandlungen zur Amerikanischen Sprach- und Alterthumskunde* 2. Berlin: A. Asher. Pp. 717-766.

Villagra Caleti, Agustín

1971 "Mural Painting in Central Mexico." *In* Robert Wauchope, Gordon Ekholm, and Ignacio Bernal, eds., *Handbook of Middle American Indians* 10. Austin: University of Texas Press. Pp. 135-156.

Early Colonial Representations of the Aztec Monthly Calendar

Betty Ann Brown
College of Continuing Education
Visual Arts Department
University of Southern California

Strictly speaking, this paper ranges beyond the bounds of pre-Columbian art history. However, by comparing what are often argued to be purely Aztec artistic representations with European ones of the period just prior to the Colonial era in Mexico, it becomes quite clear just what images were indigenous and what ones were not. This artistic comparative analysis has revealed that even early Colonial *documentary* data concerned with Aztec ritual was highly colored by European models.

SOON AFTER THE SPANIARDS conquered the Indians of Mexico, they established a colonial government with its capital located at Mexico-Tenochtitlan, the site of the pre-Conquest capital of the Aztecs. Throughout the remainder of the sixteenth century, or Early Colonial Period, the aim of the Spanish venture in Mexico was two-fold: to expand their control of land and tribute, and to convert the natives to Christianity. To accomplish these ends, it was necessary for the Spaniards to learn the Aztec language, Náhuatl, and to understand Aztec religion and calendrics. The knowledge of Aztec language and culture was facilitated by the writings and teachings of several Early Colonial Spanish friars; Náhuatl was taught and learned by means of a European model, the Latin language (Gibson 1966:70). It is becoming increasingly apparent that much of the information on Aztec culture, particularly on the Aztec calendar, was also understood and recorded in terms of European models. This paper examines illustrations from several of the Early Colonial chronicles that deal with the Aztec calendar in order to demonstrate how such European models—especially the calendars in Books of Hours—influenced their composition and content.

The Chroniclers and the Calendars

The Spanish friars who wrote on Aztec life and culture in the Early Colonial Period were certainly not the only Europeans who discussed exotic cultures in terms of European models and patterns. It was part of the long tradition of medieval encyclopedists to use European-based or "Europocentric" precepts to organize data on

foreign people and cultures. What would otherwise have been confusing or incomprehensible was made to appear orderly and to appear to fit European cultural expectations (see Hodgen 1964). Medieval encyclopedists are called "copyists" or "epitomizers" because they frequently copied earlier manuscripts, merely editing and adding new data if available, in works they signed and claimed as their own (Hodgen 1964:72).

Many Spanish Early Colonial writers drew on medieval encyclopedic prototypes (see Motolinia 1971:43, 46). For example, Donald Robertson (1959, 1966) has convincingly demonstrated that one of the major sixteenth century Spanish friar-chroniclers, Fray Bernardino de Sahagún, modeled his comprehensive *Florentine Codex* on the medieval encyclopedia of Bartholomaeus Angelicus. It can be said that such Early Colonial writers participated in the scholastic tradition of earlier manuscript writers, merely editing and adding new data when available. The process of editing by addition or correction of data is apparent when such Mexican manuscripts as *Codex Museo de America* (currently unpublished) and its near cognate *Codex Magliabechiano* (Graz 1970) are studied. The information, both textual and visual, established in their prototype (now lost) was copied and edited by the authors of these two codices (Boone 1977). *Codex Museo* and *Codex Magliabechiano* illustrate how many concepts of Aztec life recorded very early in the Colonial Period were perpetuated in the scholarly tradition.

These two codices are among the many Early Colonial manuscripts that record Aztec life and culture. The manuscripts were generally commissioned, supervised, and written by Europeans, but were often illustrated with drawings by native artists. These collaborative efforts need to be examined closely in the light of what is now known of the medieval copying tradition. Many such Early Colonial manuscripts contain descriptions of two Aztec calendars: the divinatory calendar (*tonalpohualli*) and the ceremonial calendar. Whereas the *tonalpohualli* was a cycle of 260 days composed of the conjunction of 20 day names with the numerals 1 through 13, the ceremonial calendar is often said to be a 365-day or solar year calendar composed of eighteen 20-day periods called "months" plus five extra days called *nemontemi*. The Early Colonial chroniclers describe the Aztec ritual cycle as having been composed of fixed feasts of the "monthly" (ceremonial) calendar and movable feasts of the *tonalpohualli*, a structure that closely resembles the fixed and movable feasts of the European Catholic calendar. In the Early Colonial chronicles, the rituals of the fixed or "monthly" cycles are emphasized over those of the movable or *tonalpohualli* cycle. For example, Fray Diego Durán, in *The Ancient Calendar* (1971), gives the ceremonial calendar more than twice the number of pages he devotes to the *tonalpohualli* (58 and 28 pages, respectively, in the 1971 English edition).

The Early Colonial manuscripts contain textual accounts and illustrations that very consistently describe the *tonalpohualli*. The signs given for the day names closely resemble those of pre-Conquest representations, such as on the well-known Aztec Calendar Stone. On the other hand, the Early Colonial textual accounts of the Aztec "monthly" calendar are markedly inconsistent. They differ in the order and nomenclature of the 20-day periods, in the correlation of the 20-day periods with the European calendar, and in the placement of the five extra *nemontemi*. Each 20-day period is presented as analogous to a Roman *kalend* or 15-day ceremonial period, in that it was dedicated to a patron deity for whom a ceremony was held during the period. The Aztec periods or "months" are said to have been named after these ceremonies. However, careful reading of the various accounts of the "monthly" calendar reveals that rarely are all 18 periods dedicated to single patron deities or celebrated by one

ceremony or ritual complex. Instead, many deities of apparently equal importance and many different rituals are often discussed. The descriptions of the last or eighteenth period often contain references to numerous deities celebrated in numerous ceremonies (see especially Durán 1967). It appears that any ceremony beyond the number that would fill a solar year cycle (that is, 18) was simply grouped in with the last one. Moreover, the illustrations accompanying the textual descriptions of the "monthly" calendar are markedly inconsistent in both arrangement and content of the pictorial matter.

There are numerous pre-Conquest calendrical notations involving *tonalpohualli* day-name signs and numerical coefficients. In fact, there is a pre-Conquest manuscript form, the *tonalamatl*, which recorded the 260-day cycle. The Early Colonial illustrations of the *tonalpohualli* closely parallel those seen in pre-Conquest *tonalamatl* manuscripts. When there was an indigenous manuscript prototype to work from, the Early Colonial artists seem to have followed it with careful and accurate pictorial fidelity.

There are no known pre-Conquest examples of signs clearly related to the 20-day periods or "months" of the Aztec ceremonial calendar. Nor are there known series of illustrations depicting the 18 "monthly" ceremonies. However, these ceremonies are represented in the Early Colonial sources and, in these sources, the illustrations of the ceremonies differ from each other in composition and content. The influences of European artistic conventions, minimal in the Early Colonial illustrations of the *tonalpohualli*, are quite notable in the illustrations of the "monthly" calendar. The remainder of this paper concentrates on the comparative analysis of the illustrations of two of the "monthly" ceremonies, *Xocotl Huetzi* and *Tlacaxipehualiztli*. Both are war-related and involve extensive sacrifice. *Xocotl Huetzi* means "The Xocotl falls" and concerns the erection and competitive climbing of a tall pole or ceremonial tree (see Brown 1979). *Tlacaxipehualiztli* means "the flaying of men" and was highlighted by the skinning of numerous war captives. Before being flayed, the captives were often made to participate in gladiatorial combat with jaguar warriors. (See Broda [1970] for the most complete discussion of this ceremony.)

Analysis of the varying format and content of the Early Colonial illustrations of these ceremonies indicates that while the artists often drew on the pre-Conquest repertoire of forms to execute the drawings, there was apparently no standardized manuscript prototype for the depiction of these, or by extension, *any* of the ceremonial periods of the kind of "monthly" calendar described in the Early Colonial chronicles. If no such pre-Conquest prototype existed, it is possible that the kind of monthly calendar described in the Early Colonial chronicles was not an important institutionalized calendar to the pre-Conquest Aztecs. (In fact, there are no known pre-Conquest calendrical notations that involve signs assuredly meant for these periods.) The ceremonies certain existed—we will see a pre-Conquest illustration of gladiatorial combat shortly—but it appears that they may not have formed part of a fixed or "monthly" calendar.

It is probable that, instead, the Early Colonial writers manipulated (either consciously or unconsciously) the data they received on Aztec ceremonies in order to make them fit the Europocentric model of a solar year of fixed monthly ceremonies, and that the resultant Early Colonial calendar was stressed in the chronicles because it met European cultural expectations. The fitting of Aztec ceremonial information to European patterns and structures can be clearly documented in the "monthly" calendar illustrations.

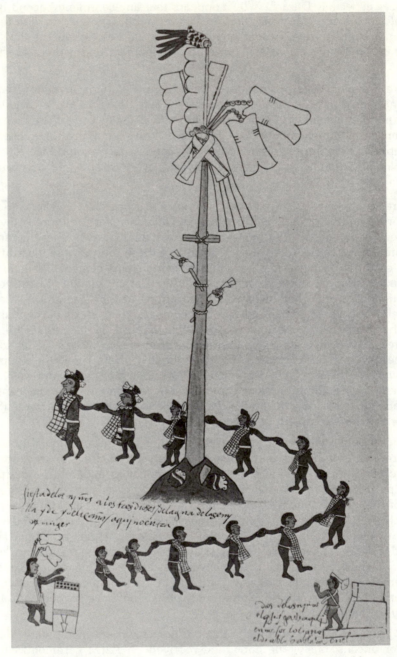

Figure 1. The Xocotl pole image on page 28 of Codex Borbonicus. *After Hamy, 1899.*

The Early Colonial Style: Xocotl Pole Illustrations

The contrast between images derived from native prototypes and images that combine native and European conventions—and are thus Early Colonial in style—is best seen in *Codex Borbonicus* (Paris 1899). The *tonalamatl* of *Codex Borbonicus* is formally very close to pictorials from the pre-Conquest era. It employs flat washes of color, bounded by an even frame line, and conventional conceptual forms that are characteristic of pre-Conquest graphic arts of the Mixteca-Puebla tradition (Nicholson 1960). These same features are also seen in the corresponding *tonalamatl* pages of

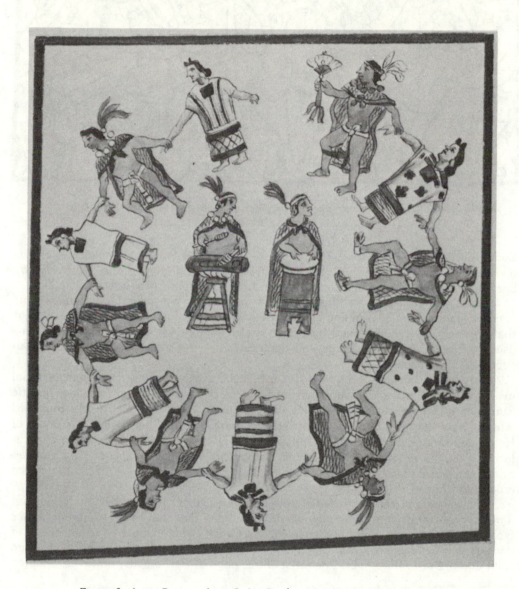

Figure 2. Aztec Dancers from Codex Durán. *After Durán 1971, Plate 31.*

Figure 3. Dancers circling a tree from the Grandes Heures (Paris, about 1490). After Hind 1963:685.

Codex Borgia (Mexico 1963).[1] The only sure indications that the *tonalamatl* of *Borbonicus* was, like most Early Colonial illustrations, commissioned and supervised by Spaniards, are the spaces left for glosses in European script (Robertson 1959:80).

On the other hand, the illustrations of the ceremonial calendar in *Codex Borbonicus* (pages 23 to 38) employ broken, sketchy contour lines, shaded areas of color that are frequently not framed by a line, and the more varied vocabulary of forms used in Early Colonial drawings—all demonstrating the influence of the European perceptual approach.

Donald Robertson (1959:40-45) has established that one way European pictorial modes were learned and assimilated by native artists was through copying specific European images, especially the prints that illustrated the European books imported into the New World. Many of these prints were employed as illustrations for Books of Hours and other religious books (Toussaint [1967] cites the *Flos Sanctorum* particularly). That the artist(s) of this part of *Borbonicus* had been exposed to European prints can be demonstrated by examining the illustration on page 28 of the dance around the *Xocotl* pole (Figure 1).

The dancers circling the *Xocotl* pole are not pictured from above, radiating out around a central drummer, as they would have been depicted in pre-Conquest times (see page 7 of the pre-Conquest style Mixtec *Codex Selden*). Such a radial image of dancers was available to Early Colonial artists and is seen repeated in an illustration from *Codex Durán* (Figure 2). The artist of this page of *Borbonicus*, however, adopted

1. There are no extant Aztec manuscripts that are indisputably pre-Conquest in date. For this reason, I follow Robertson (1959) in comparing the Early Colonial examples to pre-Conquest ones from the Mixteca-Puebla tradition, because Aztec art of the pre-Conquest era certainly belonged within this tradition (as seen in Aztec relief sculpture).

the new European forms for illustrating the "monthly" ceremony: the figures grasp each others' hands in the same manner as dancers circling trees in illustrations of European Books of Hours (Figure 3). Notice that the *Borbonicus* dancers diminish in size as they near the viewer. I suggest this is a case of misunderstood or "reverse" perspective on the part of the Early Colonial artist.

The *Xocotl* pole is a ceremonial tree. In the *Codex Borbonicus* illustration, it is shown resting in a mound of earth. The bottom of the mound is not framed by a line as pre-Conquest conventions would have dictated. In the mound are seen two stones and a rectangular wedge of wood (Figure 4). This, too, violates pre-Conquest conventions which dictated that trees—ceremonial or not—be illustrated either with exposed roots (see *Codex Vienna*, page 4), or set on an architectural platform (*Vienna,* page 7), or placed in a container of water (*Vienna,* page 38). This last method is used on page 10 of the *tonalamatl* of *Borbonicus*, where a small figure climbs a ceremonial tree flanked by two deity figures. Thus the artist illustrating the *Borbonicus* definitely had access to the pre-Conquest convention for depicting trees; however, when dealing with the "monthly" calendar, he chose another way. The symbolism of this artistic choice is interesting as well: European paintings and prints of the Crucifixion, often included in Books of Hours, conventionally depict the cross erected in a mound of earth on which are seen stones and wedges of wood (Figure 5). The *Xocotl* pole of the *Tovar Calendar* illustration (Figure 6) is likewise supported by stones and wedges of wood. That the *Xocotl* pole and the cross were equated in the Early Colonial mind is confirmed by Fray Durán (1971:209) who tells us, in describing how on-lookers rushed to grab splinters of the *Xocotl* pole after it was felled, that the Aztecs revered these splinters just as "we revere the relics of the wood of the Lingum Crucis" (True Cross).

Books of Hours

The Book of Hours was a very popular European book form from the eleventh through sixteenth centuries. Books of Hours often contained illustrated monthly calendars, Easter cycles necessary for the calculation of the date of this movable feast, and martyrologies (that is, illustrated accounts of the martyred saints worshipped on various days of the Catholic calendar). In addition to setting forth the Julian (and later Gregorian) calendar, there were also references in the Books of Hours to astrological calendars (see Hind 1963:676-98). The illustrated manuscript versions of Books of Hours, the culmination of which is seen in the *Très Riches Hueres* of the Duke of Berry (Cuttler 1968:28-33, Plate 3), were replaced in the fifteenth century with printed versions illustrated with wood block prints. It is my contention that not only did the European calendar described in Books of Hours serve as the model upon which Early Colonial writers structured the data of Aztec ceremonies they received, but that Books of Hours illustrations also served as models for many Early Colonial depictions of the Aztec "monthly" calendar.

Books of Hours were used both by church and lay people. In fact, a Book of Hours may have been the first European book in Mexico. Fray Aguilar, who had been shipwrecked on the coast of Mexico in 1511, carried a Book of Hours when he joined the Spaniards with Cortés in 1519 (Díaz del Castillo 1956:45).

The format of the Books of Hours pages vary. Many early manuscripts, such as the *Très Riches Hueres*, contain full-page monthly illustrations. Often included are depictions of monthly activities, representations of the patron deity of Greek or Roman mythology after whom many of the European months are named, and representations of either the ideographic sign or patron of the astrological period. At other times, the

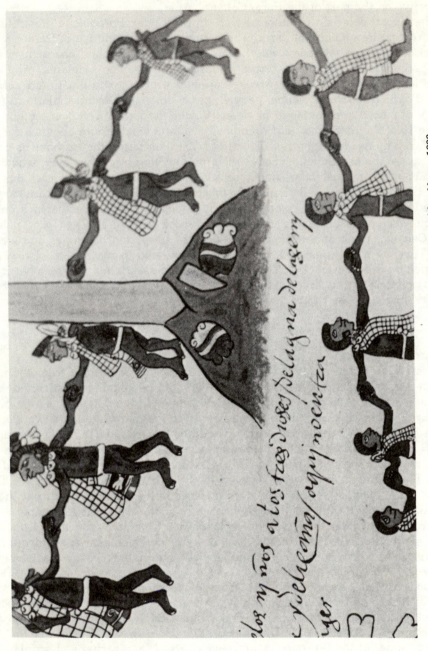

Figure 4. Detail of the Xocotl pole image of Codex Borbonicus. After Hamy, 1899

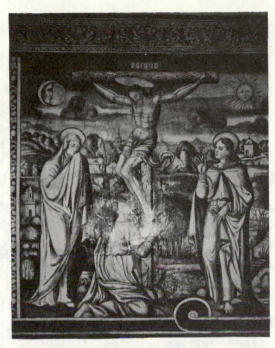

Figure 5a. The Crucifixion mural in the courtyard of the Acolman convent.

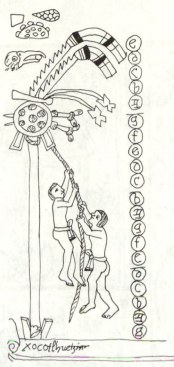

Figure 6. The Tovar Calendar illustration of the Xocotl pole. After Kubler and Gibson, 1951, Plate VIII. (Line drawing by the author.)

Figure 5b. Base of the cross, detail of the Crucifixion mural of the Acolman convent.

Figure 7. April, from a Roman Horae, Kirchheim, about 1490. After Hind 1963:340.

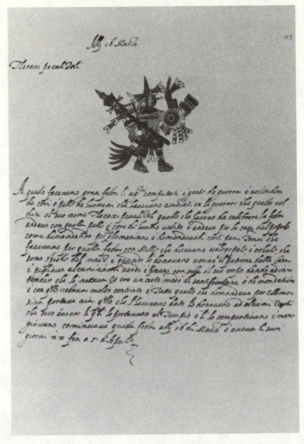

Figure 8. Codex Rios *illustration of* Tlacaxipehualiztli *folio 43). After Ehrle, 1900.*

main pictorial image is found in a framed rectangle at the top of the page with text below (Figure 7). These divided pages are often totally surrounded by decorative panels. The panels may contain garlands and grotesques or they may be composed of small sequential panels that tell the story of the Passion of Christ or the life of a saint. Many illustrations of saints in Books of Hours depict standing figures that hold the diagnostic attributes necessary for the identification of the saint (see Hind 1963:693). The saints are often dressed in long robes or togas, indicating that the images may ultimately derive from classical manuscript illustrations (see Hind 1963:402). The attributes may be anything from keys to palm fronds to whips.

Tlacaxipehualiztli Illustrations

Many Early Colonial Aztec "monthly" calendar illustrations are, similarly, single-figure representations of the patron supernatural of the period. Kubler and Gibson (1951:39) refer to this kind of illustration as "Theomorphic." For example, the illustrations for *Tlacaxipehualiztli* in *Codex Rios* (Figure 8), *Codex Durán*, and the *Tovar Calendar* are theomorphic. They all depict the patron of the ceremony, *Xipe Totec* ("Our Lord, the Flayed One"). While the figure of *Xipe Totec* is simply placed above the descriptive text in *Codex Rios*, the page formats of *Codex Durán* and the *Tovar Calendar* are more specifically derived from European prototypes. The calendar

179

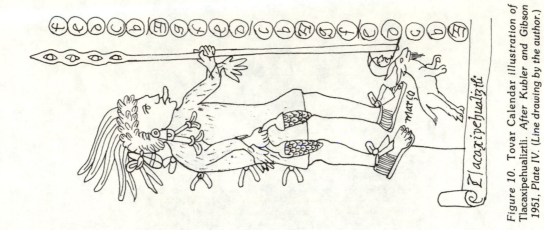

Figure 10. Tovar Calendar illustration of Tlacaxipehualiztli. *After Kubler and Gibson 1951, Plate IV. (Line drawing by the author.)*

Figure 9. Codex Durán illustration of Tlacaxipehualiztli. *After Durán 1971, Plate 39.*

180

pages of *Codex Durán* resemble the format of Books of Hours pages (Figure 9): the illustration panels are in the top third of the page, below are the descriptive texts, and flanking the illustration and text are columns of small red rectangles which encase each of the 20 day-name signs of the *tonalpohualli*. On each page, the first glyph is *cipactl* (alligator) and the last is *xochitl* (flower). However, because of the mathematics of the Aztec calendar, the "months" could not always start with the same day (20 does not fit evenly into the 365-day solar cycle), so Durán is presenting an ideal calendar to us. As Kubler and Gibson note (1951:37), the format of the *Tovar Calendar* page (Figure 10), bissected by dominical letters to which are tied symbols representing both Christian and "pagan" (Aztec) ceremonies, has precedent in European synoptic calendars (such as the French runic calendar of 1514) that they illustrate. Note that the *Tovar* illustration of *Tlacaxipehualiztli* includes a ram for the astrological period Aries and a crescent indicating the phase of the moon.

Figure 11. August page from the Compost et Kalendario des Bergères, Paris 1499, shows the monthly activity of harvesting grain. After Hind 1963:653.

Often, instead of the patron deity, the "monthly" ceremony is depicted in the Early Colonial illustrations. Representations of monthly ceremonies or activities are seen in many Books of Hours illustrations (Figure 11) and are the probable European analogues of such Early Colonial images. The Aztec ceremonies can be represented by "Simultaneous Illustration" of several stages of the ritual, by "Analytical Illustration" where each component of the ritual is depicted independently, or by representation of a single rite of the ceremonial complex, called "Emblematic Illustration" by Kubler and Gibson (1951:39).

The illustration of *Tlacaxipehualiztli* in *Codex Borbonicus* includes a figure who carries a double ear of corn and a small child in his outstretched arms (Figure 12). He approaches an elaborately dressed figure standing in front of a stepped pyramidal platform. The elaborately dressed figure wears the flayed skin of a sacrificial victim and carries the rattle staff and shield of concentric circles that identify him as *Xipe Totec* (or as an impersonator of that deity). The first figure may be bringing ritual offerings to the ceremony, and the second figure may represent a captive who, dressed as the patron deity, is to be sacrificed in gladiatorial combat. If so, two stages of *Tlacaxipehualiztli* are simultaneously represented in the *Borbonicus* illustration.

Simultaneous illustration is also found in Sahagúns *Primeros Memoriales* depiction of *Tlacaxipehualiztli* (Figure 13). Several figures that seem to zig-zag over the page in a composition reminiscent of the pre-Conquest boustrophedon patterns depict the various rituals of the "month." Included are two views of the flaying of a captive, and also figures representing gladiatorial combat. In Sahagún's later book, the *Florentine Codex*, each element of *Tlacaxipehualiztli* is represented in a single panel (Figure 14). Although European influence is manifest in the illustrations of both Sahaguntine manuscripts, it is especially apparent in the *Florentine Codex*, where each panel closely resembles European wood block prints.

It should be noted that the *Florentine Codex* illustrations accompany paragraphs of text that are contained within columns of dominical letters and that are prefaced by the letters "KL" (Sahagún 1951: Illustration opposite page 102). "KL" is the abbreviation for *kalend*, the Latin term for ceremonial period, from which our word calendar and the Spanish *calendario* are derived. Just as the *Florentine Codex* calendrical illustrations are framed by rectangular borders resembling European prints, so the accompanying text is framed by letters from the system of European calendrical notation.

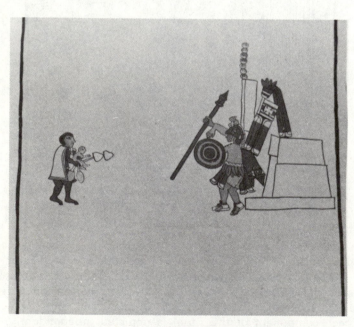

Figure 12. Codex Borbonicus *illustration of* Tlacaxipehualiztli,
page 24. After Hamy 1899.

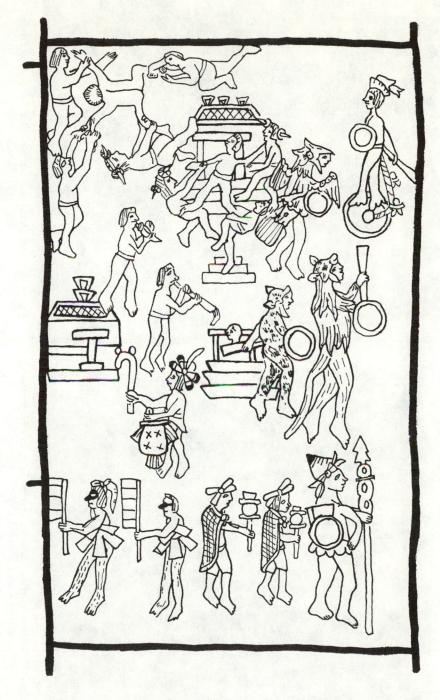

Figure 13. Tlacaxipehualiztli *illustration from Sahagún's Primeros Memoriales. After Paso y Troncoso 1905-07, Volume 6. (Line drawing by the author.)*

183

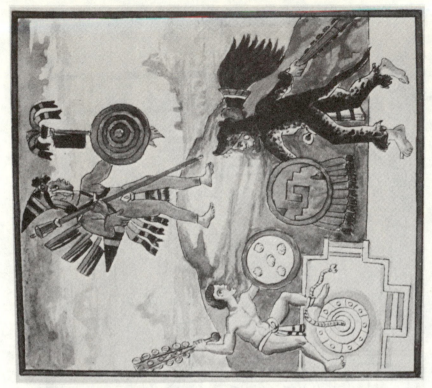

Figure 15. Codex Durán illustration of Xipe Totec. After Durán 1971, Plate 15.

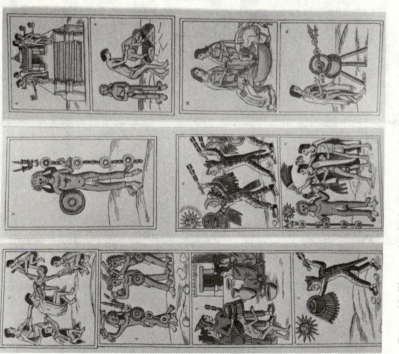

Figure 14. Tlacaxipehualiztli illustrations from Sahagún's Florentine Codex. After Paso y Troncoso 1905-07, Volume 5.

184

Figure 16. Mercury page from The Planets, *fifteenth century. The illustration shows Mercury in a disc above a landscape filled with people engaging in the kind of activities over which Mercury ruled. After Hind 1963:255.*

Sometimes the Early Colonial ritual depictions are placed below images of the patron god. The illustration from the section of *Codex Durán* dealing with the deities, in this case with *Xipe Totec*, is an example of such an illustration (Figure 15). *Xipe Totec* is pictured above two figures involved in gladiatorial combat. He stands on a hill above the illusionistically painted landscape in which the figures battle. The landscape, as well as the anatomy and the active, varied poses of the figures all demonstrate the artist's familiarity with European pictorial modes. The specific composition for such an illustration may derive from a common European astrological format in which the patron deity is placed above figures performing the activities ruled by the deity. Such compositions are seen in illuminated manuscripts of Europe (*Encyclopedia of World Art,* Vol. II, Plate 25) and in wood cuts that illustrated printed books (Figure 16). Notice that Mercury is flanked by circles containing ideographic signs of the astrological periods he rules (Virgo and Gemini). The ideographic signs of astrological periods parallel the signs for the Aztec ''months'' pictured in circles of clouds in Durán's calendar.

185

The *Codex Museo de America* illustration for *Tlacaxipehualzitli* is also composed of a *Xipe Totec* figure above two gladiators, although here the landscape has been omitted (Figure 17). In *Codex Magliabechiano*, the patron deity has been eliminated as well and only the single rite of gladiatorial combat remains (Figure 18). As in *Codex Museo*, the *Xipe Totec* impersonator is on the left. His torso is depicted frontally, and he raises a weapon in his right hand while his left holds a shield. His opponent, a jaguar warrior, has turned his back on the viewer, the raised weapon also in his right hand and the shield in his left.

This image of gladiatorial combat seems to have become fixed in the Colonial period, as it is repeated not only in the Durán illustration already seen (Figure 15), but also in Francisco de Clavigero's *Historia* (1780-81; 1944).

But these Colonial depictions of gladiatorial combat do not resemble depictions in pre-Conquest art of Mexico of such scenes as on page 83 of the Mixtec *Codex Nuttall* (Figure 19). In the pre-Conquest example, the captive dressed as *Xipe Totec* is opposed by two jaguar warriors (rather than one) who flank him, creating a composition of bilateral symmetry. Both jaguar warriors are in profile (neither has his back turned to the viewer) and both hold their shield and weapon in the left hand, the right bearing only the fierce jaguar claw. The victim carries no shield at all.

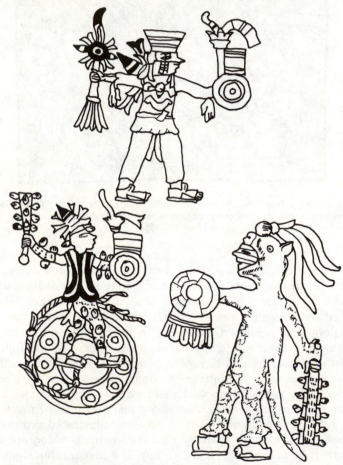

Figure 17. Tlacaxipehualiztli *from* Codex Museo de America. *After a copy in the Latin American Library, Tulane University. (Line drawing by the author.)*

186

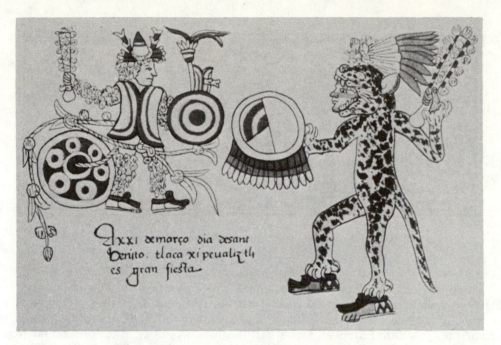

Figure 18. Tlacaxipehualiztli *illustration from* Codex Magliabechiano, *folio 30. After the Graz 1970 facsimile.*

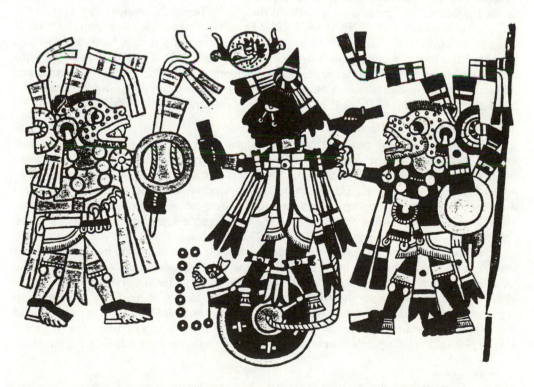

Figure 19. Gladiatorial combat scene from Mixtec Codex Nuttall, page 83.

187

Figure 20. Bàs de page *combat scene from a 1498 Book of Hours. After Bliss 1928:63.*

It appears that the Early Colonial artists who developed the new convention for the representation of gladiatorial combat did not use a pre-Conquest prototype. The composition of two warriors, one frontal and the other with his back to the viewer, is actually the standard European format for illustrating combat. It is seen in numerous Books of Hours illustrations, such as *bàs de page* detail (Figure 20) which is echoed in the *bàs de page* panel of Figure 7. Full-page print images of two similarly positioned combatants are also found in European books (Hind 1963:589). Another possible European source for the image of battling men is Pollaiuolo's engraving "The Battle of Ten Nude Men" (1465: Hartt 1974:272). Pollaiuolo's print was so popular that it was often copied into "vulgarized" wood block versions and it may have been in this form that the image reached the New World (Hind 1963:451). That the Pollaiuolo print was available to Early Colonial artists has also been suggested by Ellen Taylor Baird (personal communication) who points out that it was the ultimate prototype for Panel 32 of the illustrations of Book II of Sahagún's *Florentine Codex* (1951).

Ideographic Signs for Tlacaxipehualiztli

The Early Colonial pictorial representations of the Aztec "monthly" calendar vary in form and content. While many include iconographic complexes derived from the pre-Conquest repertory of conventional forms (such as the *Xipe Totec* impersonator and the jaguar warrior), European influence is apparent as well. It does not seem that the artists were copying a standardized system of representation for the ceremonial calendar. The same can be said of the ideographic signs for the "months" (see Figure 21 to compare the various signs for *Tlacaxipehualiztli*).[2]

Tlacaxipehualiztli is represented ideographically in *Codex Rios* by a pointed hat similar to the one worn by the *Xipe Totec* impersonator in *Codex Nuttall*. The same form is repeated in the *Veytia Calendar Wheel #4* (Veytia 1944). The *Veytia Calendar Wheel #5* omits *Tlacaxipehualiztli* altogether; in the *Boban Wheel*, the ceremony is represented by a red and white ritual bundle including a shield, a pear, a banner, and the skin of a victim. Jacinto de la Serna, who wrote in 1656, gives the sign for *Tlacaxipehualiztli* as a prone human figure possibly representing a flayed victim. If so,

2. It is, of course, possible that the difference in signs, like the difference in pictorial representations, may be accounted for in part by regional variation. However, this is an issue the chroniclers ignore as they describe the "monthly" calendar as a far-reaching standardized form.

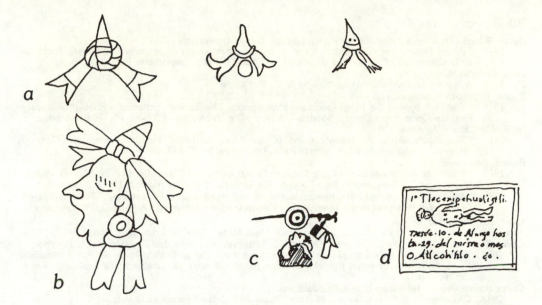

Figure 21. The Ideographic Signs for Tlacaxipehualiztli.
a. is (left to right) the image from folio 47r of Codex Mendoza (after Cooper Clark, 1938), the image from folio 89r of Codex Rios (after Ehrle 1900), and that from the Veytia Wheel #4 (after Veytia 1907).
b. is the head of Xipe Totec from the Codex Humboldt (after Seler 1904).
c. is from the Boban Wheel (after Doutrelaine 1867).
d. is from Serna (1892).

Serna's sign is a rebus, that is, a picture that visually "spells out" the meaning for the word it represents. *Tlacaxipehualiztli* is illustrated by a visual translation of "the flaying of men."

The ideographic signs for the "monthly" ceremonies, not found as date signs in pre-Conquest art from the Aztec region, are represented in the Colonial period in widely varying forms. Kubler and Gibson (1951:40) suggest that the signs may in fact be Colonial inventions connected with tribute collection. If this is the case, the signs represent the structuring of Aztec ceremonies into fixed, Europocentric calendar for the purpose of monetary gain by the Spaniards in Mexico. The codification of ceremonial illustration (following European models such as Books of Hours) then served both of the Spanish Colonial aims: It aided in the expansion of land and tribute control, and supported the religious conversion.

Fray Durán (1971:51) begins his book with the statement,

I am moved, O Christian reader, to begin the task of (writing this work) with the realization that we who have been chosen to instruct the Indians will never reveal the True God to them until the heathen ceremonies and false cults of their counterfeit deities are extinguished, erased.

Little did he realize that he, as most of the Early Colonial chroniclers, was so bound by his cultural expectations that much of the information he was about to relate—his stress on the ceremonial calendar as more important than the *tonal-pohualli*; his presentation of the ceremonial calendar as a fixed, institutionalized form; and his illustration of the ceremonies in European, rather than native, modes—speaks as much of European concepts as of Aztec ones.

Bibliography

Boban Wheel (Providence, John Carter Brown Library, Brown University)
 1867 Colonel Doutrelaine. Rapport . . . sur un manuscrit mexicain de la collection Boban. Archives de la Commission Scientifique de Mexique, 3:120-33, Paris: Imprimerie Imperiale.
Bliss, Douglas Percey
 1928 *A history of wood-engraving.* New York: E. P. Dutton.
Boone, Elizabeth Spotswood Hill
 1977 "The Prototype of the Magliabechiano Manuscripts. The Reconstruction of a Sixteenth Century Pictorial Codex from Central Mexico." Austin: The University of Texas. Ph.D. dissertation.
Broda (de Casas), Johanna
 1970 "Tlacaxipehualiztli. A Reconstruction of an Aztec Calendar Festival from 16th Century Sources." *Revista español de antropologia Americana,* 5:197-273.
Brown, Betty Ann
 1977 "European Influences in the Early Colonial Descriptions and Illustrations of the Mexica Monthly Calendar." Albuquerque, New Mexico: The University of New Mexico. Ph.D. dissertation.
 1979 "All Around the Xocotl Pole, Reexamination of an Aztec Sacrificial Ceremony." Paper delivered to the 1979 meetings of the International Congress of Americanists, August, 1979, Vancouver.
Clavigero, Francisco J.
 1944 *Historia antigua de México.* J. Joaquin de Mora trans., Mexico: Editorial Delfin.
Codex Borbonicus (Paris, Bibliothèque de l'Assemblée Nationale Chambre des Deputés, Palais Bourbon)
 1899 E. T. Hamy. *Codex Borbonicus. Manuscrit mexicain de la Bibliothèque de Palais Bourbon (livre divinatoire et rituel figure) publié en fac-simile avec un commentaire explicatif.* Paris: Ernest Leroux.
Codex Borgia (Rome, Biblioteca Apostolica Vaticana)
 1963 *Comentarios al Códice Borgia.* Mexico: Fondo de Cultura Economica. 3 vols.
Codex Durán
 See Durán 1971.
Codex Magliabechiano (Florence, Biblioteca Nazionale Centrale, No. XIII, 3)
 1970 *Codex Magliabechiano (Codices Selecti, vol. 23).* Graz, Austria: Akademische Druck-u. Verlagsan Stalt.
Codex Mendoza (Oxford, Bodleian Library, Ms. Arch. Seld. A.1)
 1938 *Codex Mendoza. The Mexican Manuscript Known as the Collection of the Mendoza.* James Cooper Clark, ed. London: Waterlow and Sons. 3 vols.
Codex Nuttall (London, British Museum Mss. 39671)
 1975 (Dover Publications Reprint of the 1902 edition.) *The Codex Nuttall, a picture manuscript from ancient Mexico.* The Peabody Museum facsimile, edited by Zelia Nuttall.
Codex Rios. Also called Codex Vaticannus A. (Rome Biblioteca Apostolica Vaticana, No. 3738)
 1900 *Il manoscritto messicano vaticano 3738, detto il codice Rios, riprodotto in fotocromografia a spese di su eccellenza il duca di Loubat per cura della Biblioteca Vaticana.* Franz Ehrle, ed. Rome: Stablimento Danesi.
Codex Selden (Oxford, Bodleian Library)
 1964 Alfonso Caso. *Interpretación del códice Selden 3135 (A.2).* Mexico: Sociedad Mexicana de Antropología.
Codex Vienna. Also called Codex Vindobonensis. (Austrian National Library, Vienna).
 1974 *Codex Vindobonensis Mexicanus 1 (Codices Selecti, vol. 5).* Graz, Austria: Akademische Druck-u. Verlagsan Stalt.
Cuttler, Charles D.
 1968 *Northern Painting From Pucelle to Bruegel.* New York: Holt, Rinehart, and Winston, Inc.
Díaz del Castillo, Bernal
 1956 *The Discovery and Conquest of Mexico.* A. P. Maudslay, ed. New York: Farar, Straus, and Cudhay.
Durán, Fray Diego
 1967 *Historia de las Indias de Nueva España e Islas de la Tierra Firme . . . da a luz Angél María Garibay* México: Editorial Porrua. 2 vols.
 1971 *The Book of the Gods and Rites and The Ancient Calendar.* Fernando Horcasitas and Doris Heyden, trans. Norman: The University of Oklahoma Press.
Encyclopedia of World Art
 1961 Volume II. New York, McGraw-Hill Book Co., Inc.
Field, Richard S.
 n.d. *Fifteenth Century Woodcuts and Metalcuts.* Washington, D.C.: National Gallery of Art.
Florentine Codex
 See Sahagún 1951.
Gibson, Charles
 1966 *Spain in America.* New York: Harper and Row.
Hartt, Frederick
 1969 *History of Italian Renaissance Art.* Englewood Cliffs, New Jersey: Prentice-Hall, Inc.
Hind, Arthur M.
 1963 *An Introduction to a History of Woodcut with a Detailed Survey of Work Done in the Fifteenth Century.* New World: Dover Publications. (Reprinted from the 1935 edition.) 2 vols.

190

Hogden, Margaret T.
 1964 *Early Anthropology in the Sixteenth and Seventeenth Centuries.* Philadelphia: University of Pennsylvania Press.

Kubler, George, and Charles Gibson
 1951 *The Tovar Calendar. An Illustrated Mexican Manuscript of ca. 1585. Reproduced with a Commentary and Handlist of Sources on the Mexican 365-day Year.* New Haven. (Memoirs of Connecticut Academy of Arts and Sciences, vol. 11).

Motolinía (Fray Toribio de Benavente)
 1971 *Memoriales o libro de las cosas de la Nueva España y de los naturales de ella.* Edmundo O'-Gorman, ed. Mexico: Universidad Nacionale Autónoma de México, Instituto de Investigaciones Históricas.

Nicholson, Henry B.
 1960 "The Mixteca-Puebla concept in Mesoamerican archaeology: A reexamination." *5th International Congress of Anthropological and Ethnological Sciences,* pp. 612-7. Philadelphia.

Paso y Troncoso, Francisco del
 1905- *Historia general de las cosas de Nueva España, by Bernardino de Sahagún.* Madrid: Fototipia
 1907 de Hauser y Menet. 4 vols.

Primeros Memoriales
 See Paso y Troncoso 1905-07.

Robertson, Donald
 1959 *Mexican Manuscript Painting of the Early Colonial Period: The Metropolitan Schools.* New Haven: Yale University Press.

 1966 "The Sixteenth Century Mexican Encyclopedia of Fray Bernardino de Sahagún." *Cuadernos de historia mundial* 9(3):617-28.

Sahagún, Fray Bernardino de
 1951 *Florentine Codex, General History of the Things of New Spain, Book 2, The Ceremonies.* Arthur J. O. Anderson and Charles E. Dibble, trans. Santa Fe, New Mexico: The School of American Research and The University of Utah.

 1956 *Historia general de las cosas de Nueva España.* Angél María Garibay, ed. México: Editorial Porrúa. 4 vols.

Seler, Edward
 1904 *Alexander von Humboldt's Picture Manuscripts in the Royal Library at Berlin.* Smithsonian Institution, Bureau of American Ethnology, Bulletin 26: 123-229.

Serna, Jacinto de la
 1892 "Manual de ministros de indios." *Anales del Museo Nacional, primera epoca, tomo VI.* pp. 265-480. Mexico.

Toussaint, Manuel
 1967 *Colonial Art of Mexico.* Elizabeth Wilder Weisman, trans. Austin: The University of Texas Press.

Tovar Calendar
 See Kubler and Gibson 1951.

Veytia, Mariano Jose Fernandez de Echeverría y
 1907 *Los calendarios mexicanos.* México: Museo Nacional.

Acknowledgments

The material in this article is taken from my doctoral dissertation from the University of New Mexico (1977) and I would like to take this opportunity to thank my advisor, Dr. Mary Elizabeth Smith, for her tremendous help throughout my studies. In addition, the material herein was delivered verbally at the May 1976 meeting of the Society for American Archaeology, and I would like to thank Dr. Nancy Troike who invited me to give the paper on her panel there.

Dating the Sculpture of San Agustín: A Correlation with Northern Peru

Karen Olsen Bruhns
Department of Anthropology
San Francisco State University

The importance of Colombia's monolithic, monumental stone sculpture at San Agustín has long been recognized and, while many studies have attempted to determine its meaning and cultural affinities, its date remains ambiguous. This paper aims to fix the sculpture in time and, in so doing, reveals an avenue of possible Peruvian artistic influence via a creature-image known in Peru during the beginning of the Early Intermediate Period.

THE ANCIENT CULTURE of San Agustín is in many ways the best known of the prehistoric civilizations of Colombia. Located in a series of sites in the modern *municipios* of San Agustín and San José de Isnos in the Department of Huila in southern Colombia, the San Agustín culture has continually aroused interest because of its many tombs, large scale earthworks and, especially, because of its wealth of elaborate stone statuary (Figure 1). San Agustín has been visited, described, and excavated by a long series of travellers, scholars, and archaeologists, both Colombian and foreign, with the result that there is a fair corpus of descriptive information regarding the area. More recently a considerable amount of archaeological data has been retrieved as well, including a fairly well dated ceramic sequence (Reichel-Dolmatoff 1972, 1975).

Unfortunately, this ceramic sequence cannot be closely associated with the spectacular sculptural remains since the statues have mainly been discovered by farmers or looters and have been so moved about that not a single piece remains *in situ*. There are few if any positive associations between individual monuments and remaining architectural features that could indicate something of the temporal placement of these statues, and without such information any discussions of the place of San Agustín in the larger South American or Central American cultural sphere have had to remain tentative and speculative. All that exists is the more or less reliable information that a piece may have come from Las Mesitas or the Alto de Lavapatas or some other site, its original placement within the site being problematic. Any means

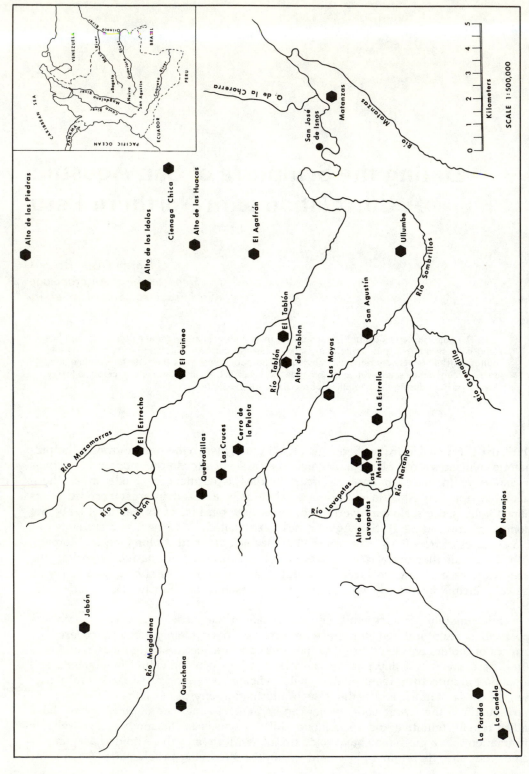

Figure 1. Map of San Agustín showing locations of major sites and geographic features. Drawn by Alice Faye Wood.

194

of associating the sculptures with other cultural remains have been lost. Even though a few of the statues were excavated by archeologists, either no ceramics were found in association or the excavation records were incomplete. The result is that, although there is now a well-delineated series of cultural phases based upon stratigraphic excavation of habitation sites and dated through radiocarbon tests, there is no good chronological placement for any single statue. This situation is especially unfortunate since the sculpture of San Agustín represents one of the few iconographically complex art styles of the northern Andes and could provide answers to many intriguing problems of religion, mythology, and cultural contacts.

It seems clear that the statues were erected in conjunction with a religious cult with a strong mortuary emphasis (Bruhns 1974, 1980). The statues themselves were associated with large earth and stone tombs, many similar to the barrow tombs of northern Europe. These tombs contained burials within the tomb chambers as well as in the fill of the covering tumuli and in the surrounding area. Sites like Las Mesitas (now the Parque Arqueológico de San Agustín) appear to have been elaborate cemeteries containing both the primary burials of important people and the less elaborate interments of their followers, families, or servants. From the meager information available, the statues appear to have served various functions: some as markers on or in front of the tumuli, others as lids for stone or wooden sarcophagi, and still others as guardian figures within the tomb chamber. A few of the statues themselves were buried in specifically prepared stone lined crypts in mounds (cf. Preuss 1929; Pérez de Barradas 1943; Duque Gomez 1966). Although the exact placement of the statues vis-à-vis the various types of tombs and other constructions has largely been lost, the evidence that they were associated with mortuary rites and commemorations is excellent.

A number of scholars have tried to seriate the statuary of San Agustín or to suggest possible dates for one or more stylistic groups, but their efforts have been largely unsuccessful (cf. Patterson 1965; Reichel-Dolmatoff 1972). In part, this is due to the small sample that has been available for study outside of Colombia, although preconceived ideas of stylistic evolution may also have been at fault. The major problem in any seriation or relative dating of the San Agustín statuary, however, has been the lack of any associations that might indicate the direction or ramifications of the evolving sculptural style(s) (Bruhns 1971). Without appropriate archaeological information from the sites one is forced to rely solely upon subjective criteria for any discussion of the meaning of the statuary or its stylistic affinities. The possibility of comparison with other stone sculptural styles of South or Central America does exist and has been explored, but has likewise been largely unsuccessful because the situation at San Agustín is commonly repeated at these other sites and the result can only be circular argumentation (Bruhns 1974, 1980). Thus stylistic cross dating has not been notably successful in dealing with the problem of San Agustín, but the possibility of comparative dating does exist and may provide the key to an unravelling of the development of the San Agustín tradition as well as opening up new perspectives of its place in pre-Hispanic South America.

In 1972 Gerardo Reichel-Dolmatoff published a discussion of the culture of San Agustín in which he delineated a series of major stylistic groups within the extant San Agustín sculpture. One of these groups he has named "expressionistic," a group that in its most developed—that is, its most "realistic"—form depicts human, animal, and supernatural figures with a wealth of detail of anatomy, clothing, jewelry, and other motifs, all shown in a manner readily comprehensible to an outsider. There are a number of subsets to this group which involve less detail and flatter relief, among

other features; these suggest that the style was current for a considerable period of time. Variations within this style group are found within a single site area so that local contemporary variation seems not to be involved.

The expressionistic style is well suited for delineating intercultural contacts because of the wealth of information it holds concerning both figures and accoutrements of humans and supernaturals. In general, there appear to be several types of information encoded in these statues; all are concerned with a religion that contained both shamanistic and non-shamanistic elements, and had as a major function the remembrance and protection of the important dead (Bruhns 1980). Such concerns in representational art have been set forth for many other cultures of both Meso- and South America (cf. Sharon and Donnan 1974; Furst 1975; Cordy-Collins 1977 *inter alia*). The fact that similar motifs and apparently similar functions are to be seen in the sculptural art of San Agustín makes the exact temporal placement of these statues a matter of some concern for the comprehensive understanding of the growth and development of ancient American religions. Located at a series of crossroads between the highland and lowland culture areas of South America, San Agustín connects two areas in which complex religious ideas expressed through complex iconography developed, two areas that seem to have cross-fertilized each other to bring into existence such complex civilizations and art styles as that of Chavín of northern Peru (Lathrap 1971; Cordy-Collins *ibid.*). Moreover, San Agustín is located on the north-south routes of travel and trade and evidently had ties with other cultures of the so-called intermediate area, extending perhaps as far north as the Pacific piedmont of southern Mesoamerica (Bruhns 1980). Dating the statues is essential for an understanding of the development and influences over this spread of regions.

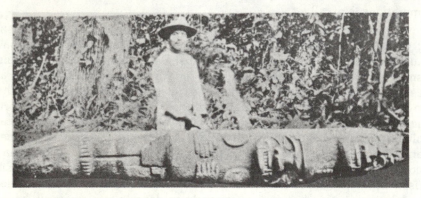

Figure 2. Front view of the Alto de las Piedras statue (lying on its side with man for scale). The original position of this statue within the site is unknown, but was probably associated with the burial(s) of the main chamber and corridor of the tumulus. Height: 3 cm. Photograph after Preuss 1929, plate 73:1.

Any serious study of San Agustín and its influence has been hampered by the near absolute lack of any temporal placement for its most outstanding manifestation: the statuary. To a person familiar with the iconography of Andean religion, however, there exists a way out of this problem. At two sites of San Agustín there are a pair of statues that strongly suggest a more or less direct connection between the site and the Central Andes, and furthermore suggest that this connection was not earlier than 150 B.C. nor later than A.D. 450. These statues may provide us with a center point from which we may discuss the art of San Agustín and its relationships with other great art styles of the Andean and Isthmian region.

196

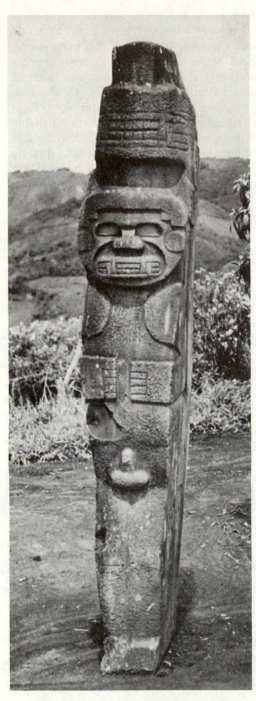

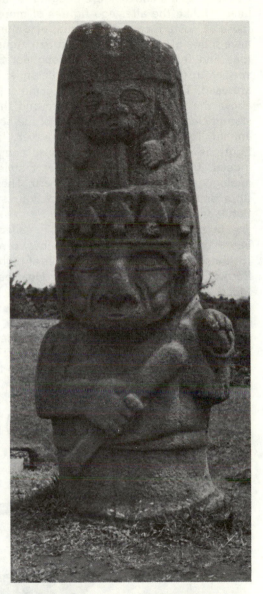

Figure 4. Guardian figure with reptilian alter ego from Meseta B. This statue was found buried in the northwest barrow and forms one of a pair of very similar, although not identical, warriors. Height: 1.96 m. Photograph by author.

Figure 3. Front view of the Alto de Lavapatas statue. The exact original position of this figure within the site is unknown. It too probably served as a guardian statue within the main tomb chamber or in the corridor leading to the chamber. The subject of the main figure is the same as that of Figure 2. Height: 2.9 m. Photograph by author.

The two statues are in the expressionistic style and form part of a group of statues that represent human or supernatural figures with an "alter ego" attached (Figures 2, 3, 4). The alter ego is shown, as is common in ancient South American cultures, as a smaller figure clinging to the back of the main figure, peering over its head. Unlike the alter ego figures of more northerly stone sculptural styles, such as those of Costa Rica or Nicaragua, or a number of Peruvian clay figures, all of which have feline alter egos, all known San Agustín figures have reptilian alter egos. Reptiles and felines both occur throughout San Agustín art as clearly distinguishable species in the same expressionistic style; but for the alter ego only reptilian figures are used. The reptile alter ego is commonly shown in low relief with the face directly above the face of the main figure and the body hanging down to the back of the statue. Normally, the rear portion of the body shows only the hind legs and tail of the animal. In these two statues, however, in place of an ordinary reptile, a hanging figure is shown which is otherwise completely unknown in San Agustín art, or, indeed, in any other Colombian art style. This figure does, however, have close analogues in the art of northern Peru. These analogues are so close that there can be little doubt that the San Agustín figures were carved by someone who had seen Peruvian depictions of this figure.

In northern Peru the figure is called the Moon Animal, a conventional name based on occasional associations between it and the crescent moon in Moche art (Bruhns 1977). The Moon Animal is of highland origin, first appearing in the art of the Recuay culture of the Callejón de Huaylas, beginning perhaps ca. 150-200 B.C. The Moon Animal in its Peruvian form is a long-bodied creature with a large square muzzle filled with teeth and fangs (Figure 5). It has four limbs that usually terminate in feet with long curving claws. A very large circular or pointed oval eye is also characteristic. The Moon Animal is further distinguished by a long crest that issues from the muzzle or the top of the head. This crest, which is a supernatural signifier peculiar to the Recuay style, continues to the rear of the animal, paralleling the long tail that comes from the opposite direction. The crest and long tail are always shown

Figure 5. Moon Animal painted on a Moche (Phase IV) stirrup bottle. The association of these animals with celestial symbols first appears in this phase of the Moche culture; it is from such associations that the Moon Animal has received its name. By this time the Moon Animal had been changed somewhat to conform to Moche ideas of what a monstrous supernatural should be like and, although retaining the distinctive crest and decorated tail, the body has become sinuous and the figure has acquired some minor decorative details of a type seen on other monstrous figures of quite different origin. Drawing by T. W. Weller.

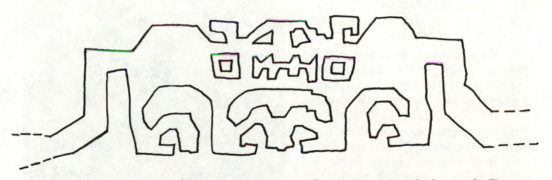

Figure 6. Details of a rare Recuay textile showing small crested animals and other motifs. The medium (wool tapestry) has led to simplification of the figure(s) which, as is common in other media in the Recuay culture, is subordinate to the major theme of the piece (in this case crested heads with toothy mouths). Drawing by the author from a textile in the collection of the California Academy of Sciences, San Francisco.

as separate elements, and are disposed to fill available space tightly from the top to rear of the animal. Both are frequently decorated with triangles, zig-zags, or other geometric motifs.

Depictions of the Moon Animal in Recuay and in the earlier phases of Moche art are virtually identical, and the coastal appearance of this creature is definitely a borrowing by Moche from Recuay (Bruhns 1977). In Recuay art the Moon Animal appears in a number of media: carved stone reliefs, apparently of architectural use, resist- and slip-painted decoration on pottery vessels and figurines, and on textiles (Figure 6). In Moche art it is found mainly on ceramics, but is also depicted on metal

199

objects from Loma Negra (Piura), and in textiles. There seem to be no associations of the Moon Animal with symbols other than astral ones (and these only in late Moche and Chimu art) and the exact meaning of the figure is unclear. It is certainly a Recuay invention or transformation, however, and from Recuay the Moon Animal passes early into Moche art, in which it continues as a subsidiary figure through the demise of Moche and into the succeeding cultures on the north coast. At the very latest, the Recuay culture itself ceases to be a recognizable entity by A.D. 400. On the coast, where the Moon Animal survived the vicissitudes of political and cultural change, continuing to appear on ceramics (and perhaps textiles) until the early Colonial Period, the representations of the figure changed. By ca. A.D. 400 the depiction of the crest had changed, being often replaced by a crescent-shaped element, a status signifier more in line with Moche (and succeeding Chimu) iconography.

The two Moon Animals of San Agustín appear on separate statues at separate sites: one at Alto de Lavapatas, the other at Alto de las Piedras. These two sites are about 10 km apart as the crow flies (somewhat farther if one travels by land). There can be little doubt that the statues were carved at much the same time; certain details, such as the rendering of the shoulders and of the rear of the figures, strongly suggest that they may even have been carved by the same person. It is also possible that the two statues represent the same individual, again based on details of decoration and expression. Regardless of such speculations, the statues are very similar and are almost certainly contemporaneous.

The statues are roughly the same height: Alto de las Piedras is approximately 3 meters high, and Alto de Lavapatas is about 10 centimeters shorter. Both represent standing supernatural males with their arms bent at the elbows and their hands held over their abdomens (Figures 2 and 3). The subject of these two statues is common in the extant sculpture of San Agustín, although more commonly represented without the alter ego figure. This subject, for want of a better name, I have named the "Great God." This personage is always male and is generally shown in a highly detailed and realistic manner, completely human in form save for the fanged mouth (Figure 7). He is usually shown with oval eyes, a broad nose with pronounced cheek lines, and is often elaborately dressed. On the Alto de las Piedras statue, he is

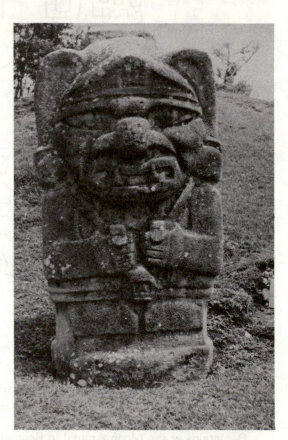

Figure 7. One of the most common supernaturals in San Agustín sculpture: the "Great God." This statue shows the supernatural without an alter ego figure, wearing a headdress that also has analogues in northern Peruvian art, and holding a trophy head suspended around his neck. Meseta B, buried in the chamber of the northwest barrow. Height: 1.77 m. Photograph by author.

shown with a stepped haircut and a large-eared headdress. This headdress is clearly depicted on a number of statues of the Great God and may well be peculiar to this deity (or deified ancestor). In the earspool position of this figure there is a knotted tie motif, a type of ear ornament that appears on many other statues (Figure 8). The figure wears a stepped loincloth, but wears no other garments. This type of loincloth is likewise quite common and appears on both human and supernatural figures at San Agustín. The alter ego figure on the Alto de las Piedras statue is quite large and is highly detailed. It is clearly a reptile of some sort, shown with fangs, a human-like nose, and the round eyes typical of animal and monstrous figures at San Agustín. The alter ego figure also bears an unusual forehead ornament that continues back over its body. The forearms are bent with the forefeet to the front. However, in place of the hind feet at the tail end that this alter ego usually possesses, the alter ego changes in mid-body to a low-relief representation of the Moon Animal (Figure 9). The elongated square muzzle filled with teeth (including large frontal fangs), the prominent eye, and the jagged crest are all present. The crest is attached to the forehead ornament of the alter ego figure. The forepaws of the Moon Animal are rendered, as is the rest of the figure, in low relief and simply hang down the back.

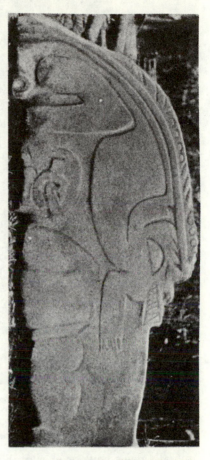

Figure 8. Side view of Moon Animal alter ego on the Alto de las Piedras statue. The crest and large eye of the pendant Moon Animal are clearly visible as is the integration of the second Moon Animal head into an alter ego figure peering over the face of the Great God. Photograph after Preuss 1929, Plate 73:3.

The Alto de Lavapatas figure is slightly different. The main figure, again a Great God, has the same stepped haircut (Figure 3). The earspools and headdress are somewhat different from the previous statue. Here the earspools clearly show the knotted tie motif but as part of a more standard ear flare ornament. The arms and hands are identical to the Alto de las Piedras figure but in place of a stepped loincloth the figure is nude, and shown with an erect penis. This element is found on many San Agustin statues, both human and supernatural. The legs and feet on both statues are shown with normal proportions, slightly bent at the knees as is typical of the expressionistic style.

The alter ego on the Alto de Lavapatas statue shows two Moon Animals. The top one, which peers over the deity's head, has been modified slightly to make it more reptilian and hence more in line with conventional alter ego figures. Basically, the muzzle has been shortened slightly and the mouth rounded at the corners. The crest, however, is clearly shown. The pendant Moon Animal has a crest that is longer and straighter than that of the Alto de las Piedras figure, and in place of the jagged upper edge it is shown with a series of incised diagonal lines (Figures 9 and 10). The fore-legs of the lower Moon Animal's hand have large claws, although the upper Moon

201

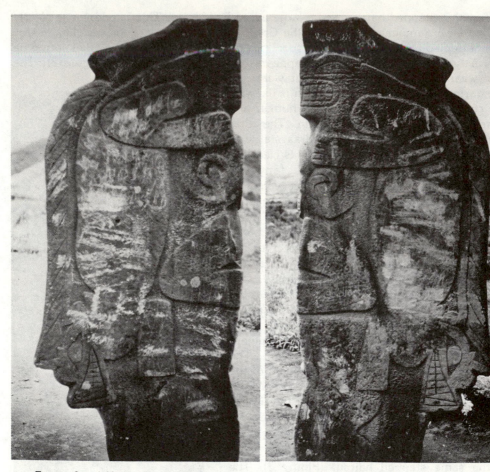

Figures 9 and 10. Views of both sides of the Alto de Lavapatas statue. The crest of the upper Moon Animal is rendered in relief. The faces of the two Moon Animals are somewhat different: that of the upper one is rendered more in accord with the canons of San Agustín sculpture; that of the lower Moon Animal is a clear copy of a foreign model. Photographs by author.

Animal's paws have been slightly anthropomorphized, again bringing it more within the canons of San Agustín animal representations.

There can be little doubt that the figures shown on these alter ego statues are the Moon Animal of northern Peru. The peculiar constellation of motifs that characterize the Moon Animal and no other creature are all present; these motifs are not found in either San Agustín or other Colombian art styles and hence cannot be of local origin. Thus, although the figures have been somewhat modified to fit into the pattern of San Agustín alter ego figures, there can be no question that their identity is a foreign element. The other aspects of the statues are completely local in style; the only element distinguishing them from a number of other statues is the transformation of the alter ego headdress into a Moon Animal.

What these statues suggest, then, is that the sculptor had seen something that was decorated with Moon Animals. There is no suggestion from the San Agustín representations that the sculptor was aware of its significance to the Peruvians (whatever this significance may have been); perhaps he knew only that it was a supernatural animal figure and presumably a status signifier of some sort. The source of the Moon Animal is a different matter. Both the Recuay and the Moche used this

202

motif on portable goods: pottery, textiles, and metal. It is thought that Recuay and Moche had close connections with the Amazonian cultures, trading for feathers, exotic animals, and perhaps for various plant materials including drugs. Indications of this interchange are found in both art and artifacts, especially in Moche where there has been considerably more scientific excavation than in the Recuay area. What these peoples traded in return is not known, although fine manufactured goods seem to be a distinct possibility. Of these goods, textiles and perhaps metal are logical sources for the Moon Animals of San Agustín. The Moon Animals of Colombia are quite similar to textile representations, or to what seem (from the ceramics) to be textile representations, where double-headed Moon Animals are fairly common. The fact that there are only two statues with Moon Animals suggests that objects with Moon Animal representations may not have been common, that the artist (or the patron) saw something with a Moon Animal, was aware that in some respects it was a supernatural or guardian figure, and then copied it onto two otherwise perfectly ordinary alter ego figures.

Regardless of the exact medium of transferal, the mere appearance of these Moon Animals gives us an indication of when the statues were carved. They cannot have been erected before about 150 B.C., because before then there were no Moon Animals to copy. It is unlikely that they were erected after A.D. 400, since by that time representations of the Moon Animal had ceased in the highlands and the Moon Animal on the coast had begun to change form. The San Agustín renditions are clearly derived from the crested form and, subjectively speaking, from a fairly early version of this form. This then gives us a range of more than 500 years for this style, a long period of time, yet still closer dating than has hitherto been possible for any of the sculpture at San Agustín.

Although the radiocarbon dates for San Agustín indicate a total span of occupation of about 2,000 years, there is some evidence from Pérez de Barradas's 1937 excavations that the expressionistic style pertains to Reichel-Dolmatoff's Isnos period, dating to the first centuries of the Christian era (Reichel-Dolmatoff 1972). This would fit in well with the evidence from Peru.

The Isnos period at San Agustín was a time of cultural expansion and elaboration. Large earthworks were constructed, elaborate pottery was produced, metallurgy appeared, and there is ample evidence of an intensive interchange with other Colombian cultures. It is then entirely likely that this interaction was not limited to the cultures of the north and west, but stretched along the natural routes into the Amazonian lowlands and perhaps along the highland routes into Ecuador, where, incidentally, the only piece of Recuay art decorated with Moon Animals has been found outside of Peru (Saville 1907). Direct contact with Peru cannot be proven, but at this time the Peruvians themselves were interacting with outside cultures; apparently at least one Peruvian artifact made its way either to San Agustín or to some place where a San Agustín artist saw it. The fact that the artist (or his patrons) were impressed enough by this foreign figure to represent it on two statues not only tells us something of the exterior contacts of their culture, but gives us one more piece of evidence in our attempt to discover when these enigmatic people of southern Colombia flourished and created their singular works of art.

Bibliography

Bruhns, Karen Olsen
 1971 "The Iconography of San Agustín, Colombia." Paper given at the 36th Annual Meeting of the Society for American Archaeology, Norman, Oklahoma.

1974 "Animal Guardian or Animal Soul: Themes in the Mortuary Sculpture of the Northern Andes." Paper given at the XLI Congreso Internacional de Americanistas. México.

1977 "The Moon Animal in Northern Peruvian Art and Culture." *Ñawpa Pacha* 14:21-40. Berkeley Institute of Andean Studies.

1980 "A View from the Bridge: Intermediate Area Sculpture in Thematic Perspective." *Cuarta Mesa Redonda de Palenque*, June.

Cordy-Collins, Alana
1977 "Chavín Art: Its Shamanic/Hallucinogenic Origins." *In* A. Cordy-Collins and J. Stern, eds. *Pre-Columbian Art History: Selected Readings.* Palo Alto: Peek Publications.

Duque Gomez, Luis
1966 *Exploraciones Arqueólogicas en San Agustín.* Bogotá: Imprenta Nacional.

Furst, Peter
1975 "House of Darkness and House of Light: Sacred Functions of West Mexican Funerary Art." *In* Elizabeth Benson, ed. *Death and the Afterlife in Pre-Columbian America.* Washington: Dumbarton Oaks.

Lathrap, Donald W.
1973 "Gifts of the Cayman: Some Thoughts on the Subsistence Basis of Chavín." *In* D. W. Lathrap and J. Douglas, eds. *Variation in Anthropology: Essays in Honor of John C. McGregor.* Champagne-Urbana: Illinois Archaeological Survey, Inc.

Patterson, Thomas C.
1965 "Ceramic Sequences at Tierradentro and San Agustín." *American Antiquity,* 31:1:66-73. Society for American Archaeology.

Pérez de Barradas, José
1943 *Arqueología Agustiniana.* Bogotá: Imprenta Nacional.

Preuss, Konrad
1929 *Monumentale vorgeschischtliche Kunst, Ausgrabungen in Quellegebeit des Magdalena in Columbien. 1913-1914.* Göttingen.

Reichel-Dolmatoff, Gerardo
1972 *San Agustín: A Culture of Colombia.* London: Thames and Hudson.

1975 *Contribuciones al Conocimiento de la Estratgrafía Ceramica de San Agustín, Colombia.* Bogotá: Biblioteca Banco Popular.

Sharon, Douglas and Christopher B. Donnan
1974 "Shamanism in Moche Iconography." *In* C. B. Donnan and C. W. Clewlow, Jr., eds. *Ethnoarchaeology.* Monograph IV: 51-80. Los Angeles: Archaeological Survey, Institute of Archaeology, University of California.

Saville, Marshall H.
1907 *The Antiquities of Manabí, Ecuador. A Preliminary Report.* Vol. 1 of *Contributions to South American Archaeology. The George G. Peabody Foundation.* New York: Heye Foundation, Museum of the American Indian.

Earth Mother/Earth Monster Symbolism In Ecuadorian Manteño Art [1]

Alana Cordy-Collins
Department of Anthropology,
University of San Diego;
San Diego Museum of Man

The most striking image within the Manteño artistic repertoire is a splayed reptillian creature. Along with the reptile, there are also splayed human females. These two motifs are without precedent in Ecuador, but they do find counterparts in Central Mexico *and only there*. The argument is proposed herein that the Manteño splayed figures were the result of diffusion, a contact probably taking place in the Intermediate Area between Ecuadorians and carriers of Mexican culture. Not only did the means for such contact definitely exist, but the special properties of the Mexican splayed dual deity were in apparent concert with Manteño practices.

WHEREAS IN PRE-AGRICULTURAL SOCIETIES female fertility deities are invariably huntresses and responsible for the abundance of game animals, in agrarian cultures female fertility deities assume a much broader role as the purveyors of all life, be it animal, plant, or human. Such latter-day fertility goddesses are called "Earth Mothers." An understandably characteristic artistic form of the Earth Mother is that of the "Displayed Female," "Hocker," or "Heraldic Woman." The Displayed Female is an artistic device which has been—and still is—employed by diverse cultures throughout the world (Figure 1). The Displayed Female is shown frontally with the arms to the sides and bent at the elbows with the hands upraised. The knees are also drawn up and splayed to the sides, thus exposing the genital area. Such a posture carries an immediate message of sexual receptivity and reproduction. [2]

In the New World, the Aztecs of Mesoamerica employed the Displayed Female to represent the goddess *Tlazolteotl* (Figure 2). This deity was one of a number of supernaturals who shared an earth-fertility complex (cf. Nicholson 1971b:414-424). However, in Aztec art, *Tlazolteotl* had a counterpart to her persona of life-giver:

1. A preliminary version of this paper was presented at the 19th annual meeting of the Institute of Andean Studies, January, 1979 (Berkeley).

2. For the motif's circum-Pacific distribution, see Fraser 1966: 36-99.

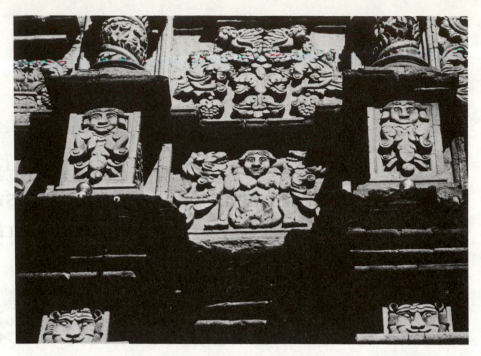

Figure 1. A standard concession to propriety has been made for the Displayed Female motif on the façade of the San Francisco church in La Paz, Bolivia by providing her with a floral "fig leaf." (Jack Riesland photo.)

Tlaltecuhtli, conceptualized as a great toad (Figure 3). In female guise the goddess was the Earth Mother, the source of life. As the great toad with its fanged and gaping jaws, she was the Earth Monster, the taker of life.[3] Thus was the earth personified during Aztec times; it was that from which all life came and that to which all life returned.

Elsewhere in the pre-Columbian New World the Displayed Female motif was rather rare. Peru, with its wealth of art and symbolism, made little use of this striking image.[4]

However, in Ecuador, the Displayed Female image made a sudden appearance in the art of the Manteño culture during late pre-Hispanic times. Carved on large, free-standing stone slabs, the Displayed Female imagery is unmistakable (Figure 4). Other stone slabs found associated with those bearing Female representations, however, carry three other image types. One of these appears to be a standing male; another consists of mainly geometric forms. The final type is a fantastic creature with a long tail, spaghetti-like fingers and toes, and a geometric head (Figure 5). The creature has been called a lizard, an insect, and a frog; but the animal is clearly none of these. It may be a composite beast or a mythical one. I have proposed to call it the Splayed Creature (Cordy-Collins 1970). The association is quite reminiscent of the duality of *Tlazolteotl* in Aztec art. Whether the association in Manteño art between the Female and the Creature is real, and, if so, whether there might be any connection with Aztec Mesoamerica, will be explored within the context of this paper.

3. There is some sexual ambiguity with reference to *Tlaltecuhtli,* but H. B. Nicholson concludes that the female characteristics are overriding (1967:85).

4. The motif does appear briefly in the art of the Callejón and of the Moche.

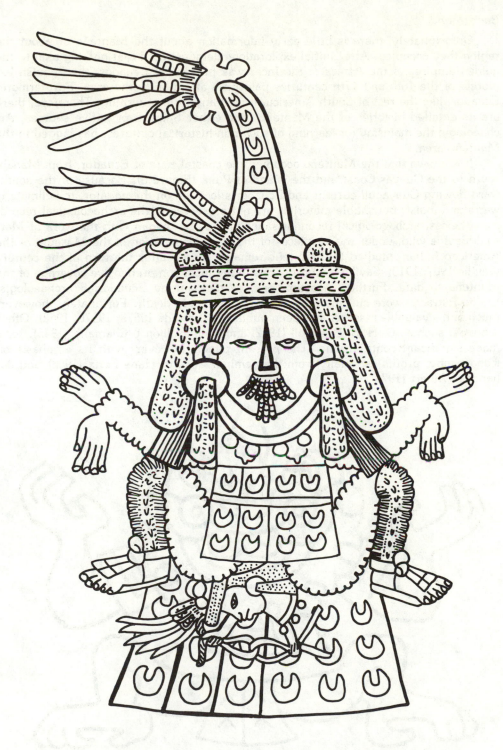

Figure 2. The Aztec fertility goddess, Tlazolteotl. Her fertility aspect is intensified by her garb, the ''yellow to-and-fro,'' a flayed human skin associated with Xipe Totec rituals of springtime and rejuvenation. From the Codex Borbonicus. (Redrawn from Caso 1958:55.)

Background

Unfortunately, there is little early information about the Manteño or about the region they occupied. After initial explorations demonstrated that nothing akin to the golden empires of the Aztecs or the Incas was present in Ecuador, the Spanish explorers of the 16th and 17th centuries paid little attention to the area. Furthermore, Ecuador, like the rest of South America, lacked any form of writing. Therefore, there are no detailed histories of the Manteño from either Spanish or native sources. Archaeology, the mainstay for learning of such non-historical cultures, has lagged in the Manteño area.

It is known that the Manteño occupied the coastal zone of Ecuador, from Manabí south to the Guayas Coast and the island of Puná (Figure 6). Because of the southward flowing Guayaquil current and Ecuador's location on the equator, the climate is warm and moist; perishable materials are not preserved in the archaeological record. Nonetheless, archaeological reconnaissance in the area began with the work of Marshall Saville who, under the auspieces of the Heye Foundation of the Museum of the American Indian, studied the Manteño remains shortly after the turn of the century (Saville 1907; 1910). Saville's reports are still the most comprehensive coverage of the Manteño to date. Further investigations, carried out by Ecuadorian archaeologist Emilio Estrada, were cut short by Estrada's untimely death. Fortunately, however, much of his valuable research has been published (Estrada 1957a; 1957b; 1962). Other scholars, such as G. H. S. Bushnell (1952) and Jacinto Jijón y Caamaño (1945), have made significant contributions. The present paper, however, with its emphasis on iconography, profits especially from the seminal work of Hans Feriz (1958) and Johannes Wilbert (1974).

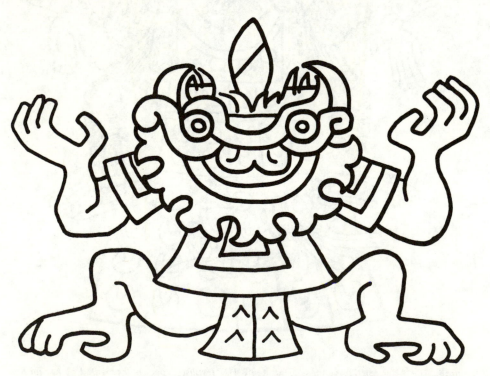

Figure 3. The Aztec earth monster, Tlaltecuhtli, *which appears as a voracious and fearsome toad, is the counterpart of* Tlazolteotl. *From the* Codex Borbonicus. *(Redrawn from Caso 1958:52)*

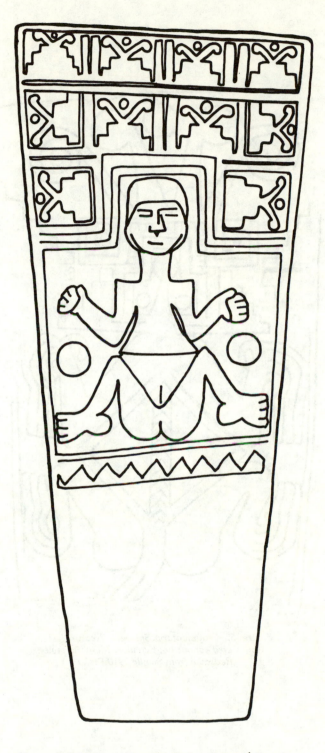

Figure 4. A Displayed Female stela from Manabí, Ecuador.
Manteño style. (Redrawn from Saville 1910:Pl. IV.2.)

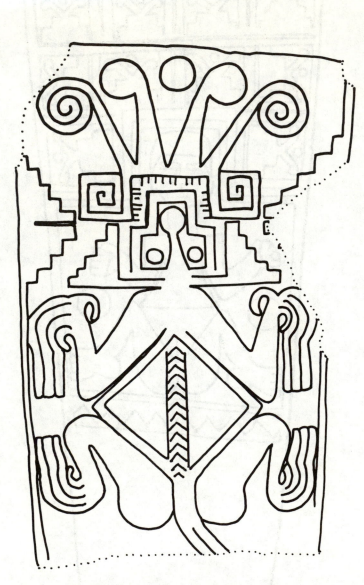

*Figure 5. Fragmentary Splayed Creature stela
from Cerro Jaboncillo, Ecuador. Manteño style.
(Redrawn from Saville 1910:Pl. VI:1.)*

Figure 6. Map of pre-Columbian America with enlarged detail of Ecuador. (Redrawn from Wilbert 1974:Fig. 3.)

211

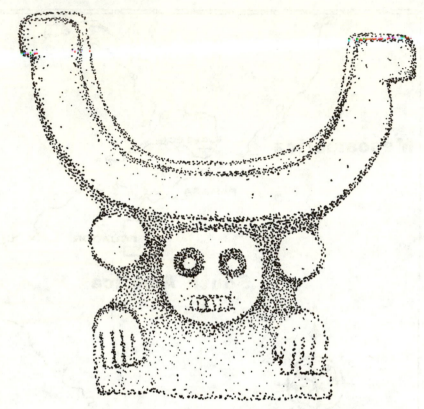

*Figure 7. Stone "throne" from Cerro de Hojas, Ecuador. Manteño style.
(Redrawn from Saville 1907:Pl. XXIII.1.)*

It is the consensus of the investigators who have studied the carvings on the stone slabs that these images are definitely the product of the Manteño culture. The Manteño appear in Ecuadorian prehistory during the Integration Period which spans the years A.D. 500-1500. Thus, the Manteño were among the last purely pre-Columbian cultures of Ecuador prior to the Spanish arrival early in the 16th century. Many of the traditions of Manteño culture are traceable to earlier indigenous people such as the Guangala, Bahía, and Jama-Coaque. However, there is no evidence in these preceding cultures for the stone slab carving of the Manteño. Therefore, the motifs were either developed *sui generis* by the Manteño or were imported from afield.

The stone slabs, or stelae, which bear the Female and Creature were all found on hilltops. All but two were found on Cerro Jaboncillo; one was discovered on Cerro Jupa, and the other in the La Roma district. Thus, these locales circumscribe the Manteño territory. All slabs are in mutilated condition, the most complete measuring just over a meter in height. The slabs were found inside ruined house sites (called *corrales* in the Spanish literature, though they should not be thought of as animal corrals) associated with stone "thrones." The so-called thrones have U-shaped seats, which are elevated on a base that is usually carved with the image of either a zoomorphic or anthropomorphic being (Figure 7). Thrones were also found on Cerro de Hojas, not far from Cerro Jaboncillo. There, however, no associated stelae were found. This fact, along with the better preservation of the thrones than the slabs,

suggested to Bushnell that the two items were not contemporary; he believed the thrones were carved later (Bushnell *op. cit.*:58-59). However, there is good internal evidence to the contrary that argues for the contemporaneity of the thrones and the slabs. This evidence will be discussed further on.

In order to attempt to understand the reason for the stone-carving activity, it is necessary to examine the details of the carvings. For the purposes of this discussion the stelae motifs are analyzed in three categories: the Displayed Female, the Splayed Creature, and the geometric carvings—the Crescent-and-Disc.[5]

The Displayed Female

The Displayed Female is shown frontally and completely nude. She has a short coiffure (or possibly a cap). Her facial features are simple and generalized. Her elbows are bent at the waist, with forearms extending upward and the hands either clenched or open palm outward. The body is horizontally divided at waist level, thighs are exaggerated and splayed. The knees are bent. Primary and, usually, secondary sexual characteristics are depicted.

Thus rendered, the Female occupies the central area of the upper portion of the slab, a demarcation delineated by a geometric band beneath her haunches. The lower portion of the stela is blank. The Female is flanked either by discs (Figures 4 and 8) or by monkeys (Figures 9, 10, and 11), and her head fits into an ornamental niche which resembles an enormous headdress. This niche/headdress is composed of a number of square compartments. These pigeonholes, in turn, are occupied by either single- or double-stepped motifs which are sometimes surmounted by a V or U motif. Occasionally, the V or U is accompanied by

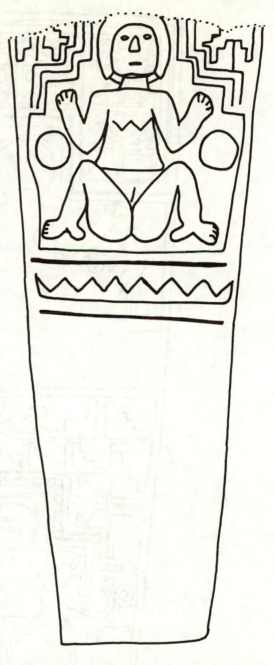

Figure 8. Partial Displayed Female stela. Manteño style, Ecuador. (Redrawn from Saville 1910:Pl. IV.3.)

smaller duplicates of itself set to the sides at right angles. Commonly, one or more of the discs is positioned above the primary V or U.

5. The Standing Males are so limited in number and completeness that they must receive only passing mention (p. 206).

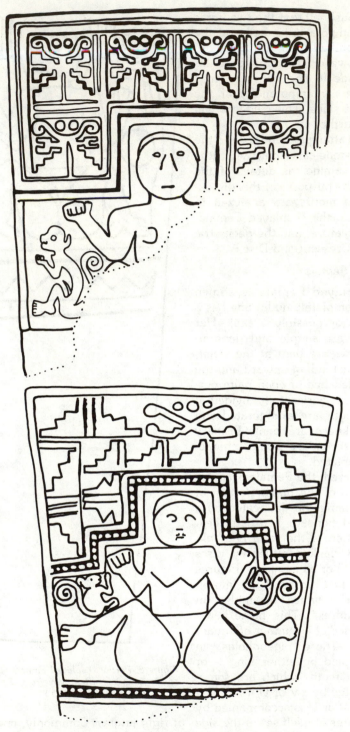

Figure 9. (Above) Fragmentary Displayed Female stela. Ecuador, Manteño style. (Redrawn from Saville 1910:Pl. IV.5.)

Figure 10. (Below) Upper portion of a Displayed Female stela. Ecuador, Manteño style. (Redrawn from Saville 1910:Pl. IV.4.)

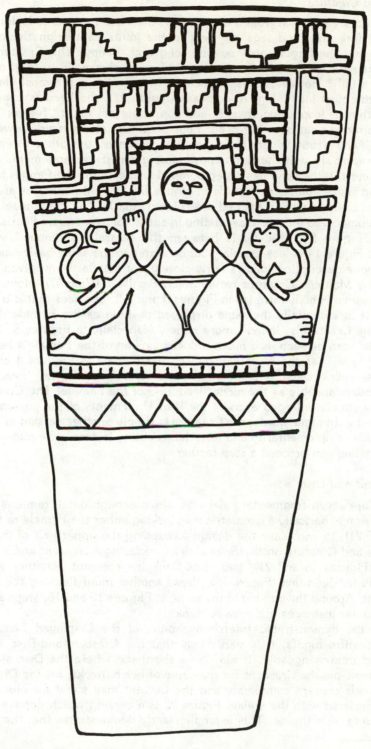

Figure 11. Displayed Female flanked by monkeys. Manteño style, Ecuador.
(Redrawn from Saville 1910:Pl. IV.6.)

The Splayed Creature

The Creature is shown from a dorsal view; the viewer seems to look upon it from above. The fore and hind legs are bent at the joints as though the animal were swimming, and the fingers and toes are long and droopy. The Creature's body is diamond-shaped with the spinal column prominently shown. In at least one case the animal has a tail.[6] However, it is the beast's head which is the most elaborate and, therefore, the most intriguing. In one case (Figure 12), the head is pancake-shaped and has both eyes looped together. In addition, there are eight "feelers" or "antennae" which radiate out from the head. Four discs are interspersed between the side "antennae" and a bat hovers over the rest. However, the other examples of the Splayed Creature show the head in a much more geometric arrangement. In two cases (Figures 5 and 13), the head has a step pyramid shape, with step-flanges to the side in Figure 5 and single volutes to the side in Figure 13. The animal's eyes are plain discs and the nose is also a disc on the end of a column muzzle. The "antennae" branch out from this geometrized muzzle area, ending in curls, volutes, squared curls, or stepped volutes. In Figure 5 a disc floats between the central "antennae" volutes. The Creature in Figure 14 is less angular, but conforms to the same basic design.

The above description follows fairly closely the standard one given in most accounts of the Manteño Creature carvings (cf. Saville 1907:66-67). However, looking only at the animal's body form (as in Figures 5 and 12), one sees that it is obviously a hocker—it is in essentially the same displayed position as the Female. Next, if one examines the Creature's "head" more closely (especially in Figures 5, 13, and 14), the "muzzle" can be seen as a much-reduced version of the Female's head, and the Creature's "eyes" as the discs which flank the Female in Figures 4 and 8. If one makes these subtle visual adjustments, the Creature's geometric "head" suddenly becomes understandable as the niche/headdress of the Female! The Creature's "antennae" are simply enlarged arms of the V or U elements of the pigeonholes in the Female's niche. In other words, the Creature is simply another *version* of the Female.

Once this complementarity and interchangeability is seen—the pun understood—the investigation can proceed a step further.

The Crescent-and-Disc

There are seven fragmentary slabs on which enough detail remains to ascertain that the design is basically a geometric one, lacking either the Female or the Creature (Figures 15-21). In each case the design (occupying the upper half of the slab as do the Female and Creature on theirs) is a niche enclosing a crescent and a disc. In two instances (Figures 15 and 21), two birds flank the crescent. Another example, too fragmentary for definition (Figure 16), shows another motif flanking the space below the crescent. Around the outside of the niche in Figures 15 and 16, steps and discs are shown. In other instances this area is blank.

Given the demonstrated interchangeability of the Displayed Female and the Splayed Creature motifs, it is very likely that the Crescent-and-Disc is also comparable and interchangeable. It may be a shorthand where the Disc stands for the Female's head and the Crescent for the curve of her buttocks; or, the Disc may stand for the Female concept completely and the Crecent may stand for *one of the stone thrones* associated with the stelae. Figure 22 is a carving which depicts a Displayed Female *sitting on* a throne. This example clearly demonstrates that the thrones and

6. Some of the slabs are so fragmentary that only the top is extant, thus making a determination of whether or not the animal was originally tailed impossible.

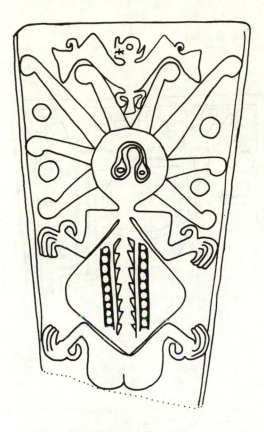

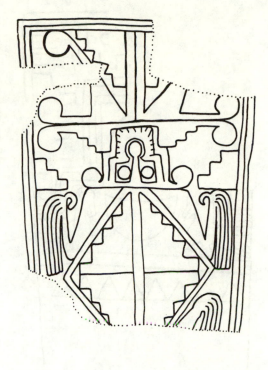

Figure 12. (Above) *Splayed Creature surmounted by a bat. Manteño style stela, Ecuador.* (*Redrawn from Saville 1910:Pl VI.4.*)

Figure 13. (Above right) *Geometrized Splayed Creature stela carving. Ecuador, Manteño style.* (*Redrawn from Saville 1910:Pl. VI.2*).

Figure 14. (Lower right) *Manteño stela with Splayed Creature motif. Ecuador. (Redrawn from Saville 1910:Pl. VI.3*).

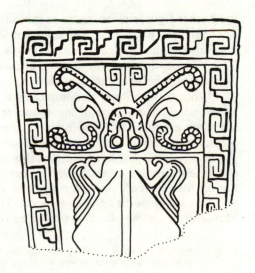

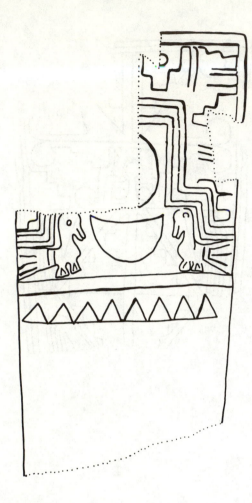

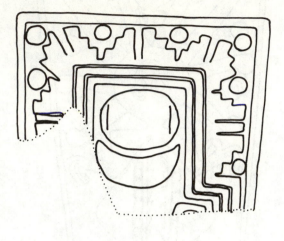

Figure 15. (Left) Fragmentary Crescent-and-Disc motif flanked by birds. Ecuadorian Manteño style. (Redrawn from Saville 1910:Pl. VII.3.)

Figure 16. (Right) Upper portion of Crescent-and-Disc stela. Manteño style, Ecuador. (Redrawn from Saville 1910:Pl. VII.4).

the hocker figures were in use *at the same time*, and not sequentially as suggested by Bushnell (see page 213). The crescent-like shape of the throne and the positioning of the Female above it constitute a single motif not dissimilar from the Crescent-and-Disc. A second throne (Figure 23) allows for the identification of the V and U designs in the pigeonholes of the Female's niche (as in Figure 4) as throne representations.[7]

What this analysis demonstrates is that the Manteño stone work constitutes an interrelated assemblage of iconographic information: the Female = the Creature = the Crescent-and-Disc; the niche V's and U's = the creature's "antennae" = the stone thrones. Suddenly, what had been isolated motifs can be understood as an integrated whole. These interrelationships are not accidental; and, therefore, they are the concrete examples of an ancient culture's mental set. *We are looking at the codification of a vanished culture's thoughts!* The Female, the Creature, and the Crescent-and-Disc all embodied the same idea. Therefore, whenever any one of them occurs in Manteño art, it may be interpreted as representing the whole complex.

7. This was independently noted by Manuel González de la Rosa (1908:90) who, however, was convinced that the thrones were altars where sacrifices were tendered to the sun and the moon.

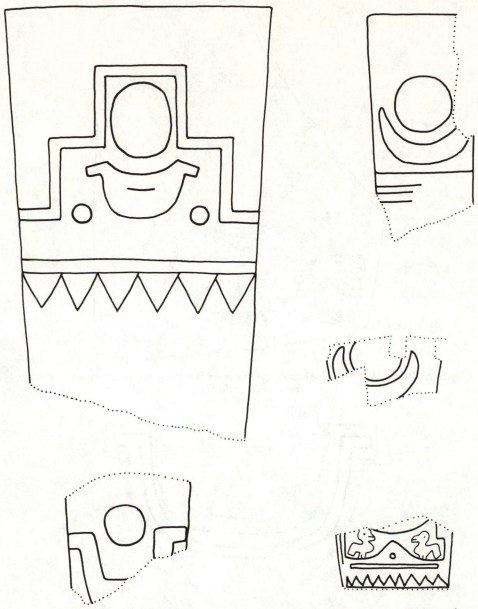

Figure 17. (Upper left) *Manteño stela with Crescent-and-Disc motif intact. Ecuador. (Redrawn from Saville 1910: Pl. VII.1.)*

Figure 18. (Lower left) *Partial Crescent-and-Disc stela. Manteño style. Ecuador. (Redrawn from Saville 1910: Pl. VII.5.)*

Figure 19. (Upper right) *Fragmentary Crescent-and-Disc stela from Ecuador Manteño style. (Redrawn from Saville 1910:Pl. VII.2.)*

Figure 20. (Middle right) *Extremely fragmentary Crescent-and-Disc stela in the Manteño style, Ecuador. (Redrawn from Saville 1910:Pl. VII.6.)*

Figure 21. (Lower right) *Middle portion of Manteño Crescent-and-Disc stela with birds. (Redrawn from Saville 1910:Pl. VII.7.)*

219

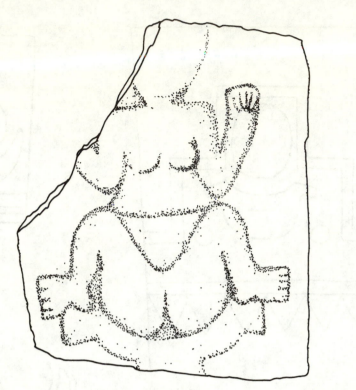

Figure 22. Partial Manteño stela showing the Displayed Female occupying a ''throne.'' (Redrawn from Saville 1910: Fig. 17.)

Figure 23. Manteño stone ''throne'' with characteristic U shape. The support base, rather than carved in human or animal form, is designed in a V, the center of which is now eroded. (Redrawn from Saville 1910:Pl. XL.)

When this idea is understood, that one part of the complex may stand for the entire complex, then a great many miscellaneous Manteño designs and artifacts take on a greater significance. Figure 24 illustrates five carved stones. One is a disc. Two others may be either halves of discs or abstracted crescents. By themselves these five stones have little interest; but, in the light of the foregoing examination, they take on a new importance. They appear to be mobile forms of the Crescent-and-Disc.

Figure 24. Individually carved crescents and discs. Manteño style, Ecuador. (Redrawn from Saville 1910:Pl. LX)

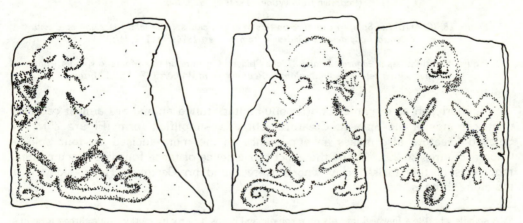

Figure 25. Three fragmentary stonecarvings of simplified Splayed Creatures. Manteño style, Ecuador. (Redrawn from Saville 1910: Pl. LIX.)

2 cm

Figure 26. Clay spindle whorl with Splayed Creature motif. Manteño style. Ecuador. Private Collection. (Alana Cordy-Collins photo.)

Figure 27. (Left) Manteño clay spindle whorl from Ecuador showing Splayed Creature image. (Redrawn from Wilbert 1974:Fig. 133, top.)

Figure 28. (Center) The Splayed Creature on this Manteño clay spindle whorl is elaborated with a central body design. (Redrawn from Wilbert 1974:Fig. 132, left.)

Figure 29. (Right) As in Figures 26 and 27, the Splayed Creature on this Manteño spindle whorl is shown with a detailed spinal column. (Redrawn from Wilbert 1974:Fig. 134, top.)

Similarly, three examples of a droopy-digited, tailed animal are almost certainly more carvings of the Splayed Creature, but in a simplified form (Figure 25). The Splayed Creature also makes an appearance as the motif incised on four spindle whorls (Figures 26-29).[8] While the exact provenience of these four is undocumented, thousands of tiny incised clay whorls were found on Cerro de Hojas along with the stone thrones.[9]

8. A spindle whorl is a flywheel that fits on a spindle and keeps it in rotary motion while thread is spun.

9. For an intensive examination of spindle whorl imagery, see Wilbert 1974.

222

Finally, the throne motif itself, as V's and U's (sometimes surmounted by a disc), pervades Manteño art. The throne in Figure 30 is decorated with intersecting V's and flanked with the squared curl which appears in the Creature stela of Figure 5. Four pottery stamps also carry the interlocking V motif (Figures 31-34). In three cases (Figures 31-33) the interlocking V's can be seen from four separate vantage points and, together, create a diamond form like the body of the Creature. Two of the four stamps have a disc in the center of the diamond which, of course, accommodates itself

Figure 30. Back view of a Manteño stone "throne" showing details of seat carving. (Redrawn from Saville 1907:Pl. XV.4.)

to any and all of the V's (Figures 31 and 32). In Figure 33 a disc is nestled in the crux of two of the outer V's (see arrows). The fourth stamp (Figure 34) carries a variation of the motif where the V's are not joined to form a diamond, but cross to form an X (as in Figure 30). Yet at each interstice is a disc. A last spindle whorl bears another version of the throne and disc (Figure 35). The V's are joined to form a diamond as in Figures 31-33, and an ornamental disc is placed in the center of the diamond, while four more flank it.

Figure 31. Manteño clay stamp with design of two abutted V-motifs with discs. The Plebian Indian Arts Gallery, La Jolla. (Alana Cordy-Collins photo.)

2.5 cm

223

Figure 32. Partial Manteño clay stamp similar to Figure 31. Private Collection. (Jack Riesland photo.)

3 cm

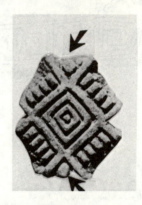

Figure 33. Manteño clay stamp with V and disc motifs (latter identified by arrows). The Plebian Indian Arts Gallery, La Jolla. (Alana Cordy-Collins photo.)

5 cm

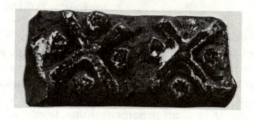

Figure 34. Manteño clay stamp two-thirds complete showing multiple V and disc motifs. Private Collection. (Jack Riesland photo.)

3 cm

Figure 35. Manteño clay spindle whorl illustrating joined V and flanking disc motifs. Private Collection. (Jack Riesland photo.)

2 cm

Lastly, two press-molded figurines are exemplary of the complex as well (Figures 36 and 37). While the figures themselves seem at first unrelated, an examination of their headdresses (virtually identical) reveals the now ubiquitous V which stands for the throne which, in turn, stands for the entire Displayed Female/Splayed Creature/Crescent-and-Disc complex.

5 cm

Figure 36. Manteño press-molded ceramic figurine with V-element in headdress. The Plebian Indian Arts Gallery, La Jolla. (Alana Cordy-Collins photo.)

5 cm

Figure 37. Manteño press-molded ceramic figurine with V-element in headdress. The Plebian Indian Arts Gallery, La Jolla. (Alana Cordy-Collins photo.)

The Meaning

To begin to understand the meaning of the Displayed Female motif in her various forms and abbreviations, certain salient points must be taken into consideration: First, as has been noted, there are no precursors for the motif in Ecuador. Second, while

225

hocker, or heraldic, figures are occasionally found in Andean art further south in Peru, the pairing of the Displayed Female and the Splayed Creature is notably absent there. Third, there is only one other locus where the pairing of these two motifs exists: ancient Mesoamerica.

Either the Displayed Female complex developed, *sui generis*, among the Manteño, or it diffused from Mesoamerica. In order to determine which is true, the following hypothesis is suggested: The Manteño Earth Mother/Earth Monster image complex is derived from the Central Mexican Earth Mother and her counterpart the Earth Monster, known in Late Post-Classic times as *Tlazolteotl* and *Tlaltecuhtli*, respectively.

This basic hypothesis may be refined in any of three ways: The diffusion could have occurred by Ecuadorians travelling to Mesoamerica and acquiring the information; or, by Mesoamericans travelling to Ecuador, carrying the information with them. Tests for both the former refinements would include the expectation of discovering either stylistically pure Ecuadorian artifacts in Mesoamerica or stylistically pure Mesoamerican artifacts in Ecuador. Neither event has transpired. The third and most plausible refinement of the hypothesis is that diffusion occurred through intermediaries. This refined hypothesis is testable against ethnohistoric data, albeit in a somewhat indirect fashion.

It has been established beyond a doubt that Central Mexican influence permeated as far south as Panama in the form of a migration, or series of three migrations. An early interpretation of the sixteenth century Spanish chronicles suggests that an initial migration, or diaspora, emanated from Teotihuacan at the height of the city's power, around A.D. 400-500. Some Teotihuacan émigrés settled in the Gulf Coast region, near El Tajín. Later, a second diaspora, caused by the fall of Teotihuacan, triggered migrations from the Gulf Coast as well as from Teotihuacan itself. The date of this second population shift is ca. A.D. 700-900. The third migration suggested by the Spanish *cronístas* took place between A.D. 1000-1200 and involved peoples from the northern part of the Valley of Mexico as well as descendants of former migrants from the southern and eastern areas.[10] This sequence has been recently challenged with a new interpretation suggesting that the diaspora of Central Mexican Nahua speakers resulted from the collapse of Tula (Tollan) around A.D. 1180 (Davies 1977:120). From the point of the present investigation, either interpretation is adequate, for the crucial information is that influence did stream out of the Gulf Coast. This may have taken place after the fall of Teotihuacan (three-migration theory), or after the fall of Tula (late-migration theory). Davies (*op. cit.*:387) clearly states that Tula was receiving religious input from the Huastec people of the Gulf Coast. This is a pivotal point because there is an overwhelming concensus of opinion that the goddess known in Aztec times as *Tlazolteotl* was of Huastec origin (Davies *loc. sit.*; Krickeberg 1964: 144: Nicholson 1971b:420).

Therefore, we now have both a locational source for the cult of *Tlazolteotl* in the Huasteca region of the Mesoamerican Gulf Coast, and a population movement of

10. These emmigrants are known as the Pipil, the Nicarao, and the Nonoalco. Stephen de Borhegyi argued for three main migrations, or diasporas, but doubted a fourth suggested by the Spanish chroniclers (de Borhegyi 1965:38-41). The initial diaspora of A.D. 400-500—a primarily religious and commercial venture—was that of the "Teotihuacan-Pipil" (*ibid.*:39). He referred to the second wave of migrants (ca. A.D. 700-900) as that of the "Tajínized-Teotihuacan-Pipil," or "Pipil-Nicarao" (*ibid.*:40). His final migration (A.D. 1000-1200) consisted of a combined group of Toltec-Chichimecs, from the north of the Valley of Mexico, and "Nonoalcos," themselves a hybrid group composed of the "Tajínized-Teotihuacan-Pipils" and Teotihuacan refugees from Cholula. Borhegyi termed this final migratory group the "Nonoalco-Pipil-Toltec-Chicimecs" (*ibid.*:40-41).

Tlazolteotl worshippers from Mesoamerica southward through Costa Rica, Nicaragua, and into Panama. But nowhere is there any suggestion that Nahua speakers ventured below Panama. How, then, might the Ecuadorians have learned of the Mesoamerican deity?

Several Spanish sources from the time of the Conquest report that there was a lively trade carried on by Ecuadorian merchants who ventured northward into Panama. Bartolomé Ruiz, Pizarro's navigator, while sailing south from Panama, encountered a large balsa-wood boat under full sail and loaded with impressive cargo making its way north from Ecuador (Prescott 1892:231-232). It is also reported from other sources that the Panamanians were well aware of Ecuadorian llama pack animals as well as balsa sailing craft (Stone 1966:229n). In summary, it can be stated quite securely that the means definitely existed for the transportation of ideas as well as goods. Therefore, not only can it be argued with some conviction that the Central Mexican Earth Mother/Earth Monster gave rise to the Ecuadorian Earth Mother/Earth Monster, but this fact can help to date the Manteño culture more securely. Whereas the Manteño heretofore have been assigned to the Integration Period as a whole (A.D. 500-1500), they can now be dated at least as late as A.D. 700 (the proposed beginning date of the conjectured second migration), and more likely after A.D. 1180 (the beginning of the Nahua migration following the fall of Tula).

A final point in favor of the argument for the Manteño Displayed Female complex having a Mesoamerican origin concerns a specific attribute of the Huastec goddess: cotton (Caso 1958:54; Nicholson 1971c:15). Walter Krickeberg offers the following details:

> As this region [the Huasteca] was the principal purveyor of cotton for the Valley of Mexico, the goddess [*Tlazolteotl*] wears a band of raw cotton around her forehead and [over] her ears [more] of the same material, with two spindles in her coiffure . . . her alternative name of *Ixcuina* is of Huastec origin and actually signifies "Lady of Cotton" (Krickeberg, *op. cit.*:144). [My translation]

There is ample evidence both for the presence of cotton cloth in Manteño society and for the sacredness of its weaving. Cotton has a long history of domestication in Ecuador, extending back into the Formative Period with the Valdivia culture, at least 4,000 years ago (Marcos 1979). Brief Spanish reports from the Contact Period underscore the importance of cotton cloth in the Manteño region. The balsa boat sighted by Ruiz in 1531 was rigged with a square sail of fine cotton (Prescott, *loc. cit.*); and cotton tapestries were used as door hangings in mainland structures (Meggers 1966:125). In addition, cotton clothing was elaborate and plentiful (*ibid.*).

Certainly, the ubiquitous Manteño spindle whorls attest to the sacredness of weaving. As has been pointed out (p. 222), some bear motifs from the Displayed Female complex. Wilbert, moreover, in his treatise on the Manteño whorls, has provided strong support for the interpretation of weaving itself as a ritual function directly connected with female fertility (Wilbert, *op. cit.*:29-32).

So, not only are there formal similarities of the Ecuadorian and Mexican Earth Mothers and their Earth Monster counterparts, but there are functional similarities as well. Both Females have an intimate association with cotton, spinning, and weaving. The case for diffusion grows ever stronger.

A prime factor in the proposed adoption of the Mexican Displayed Female complex by the Ecuadorians might have been precisely the cotton association. While cotton has rather mundane connotations for twentieth century Westerners, in ancient South America, cotton was actually deified (Cordy-Collins 1979).

In addition to cotton and its processing, there may be other symbols held in common by the two complexes. A subsidiary attribute of the Mexican earth-fertility goddess was lunar (Krickeberg, *loc. cit.*). Several students of Manteño iconography have concluded that the Ecuadorian Displayed Female complex had lunar associations too (di Capua, personal communication 1979; Gonzáles de la Rosa, *loc. cit.*; Larrea, *op. cit.*:118). While this possibility is not to be discounted without further analysis, the basis for it seems to be the interpretation of the crescent-shaped thrones and/or the attendant discs. There is a definite danger in interpreting ancient motifs on the sole basis of what they look like to us. (For an examination of problems inherent in lunar interpretations, see Cordy-Collins 1977).

Nevertheless, whatever minor disagreements may still exist, the overwhelming weight of evidence points to a definite link between the Mexican and Ecuadorian Earth Mothers/Earth Monsters.

Bibliography

Bonavia, Duccio
 1968 *Las Ruinas del Abiseo*. Lima: Universidad Peruana de Ciencias y Technología.

Bushnell, G. H. S.
 1952 "The Stone Carvings of Manabí, Ecuador." *In* Proceedings of the Thirtieth International Congress of Americanists. London: The Royal Anthropological Institute.

Caso, Alfonso
 1958 *The Aztecs*. Lowell Dunham, translator. Norman: University of Oklahoma Press.

Cordy-Collins, Alana
 1970 "Ritual Iconography of the Manteño" Ms. in author's possession.
 1977 "The Moon is a Boat!: A Study in Iconographic Methodology." *In* Alana Cordy-Collins and Jean Stern, eds. *Pre-Columbian Art History: Selected Readings*. Palo Alto: Peek Publications.
 1979 "Cotton and the Staff God: Analysis of an Ancient Chavín Textile." *In* Ann Pollard Rowe, Elizabeth P. Benson, and Anne-Louise Schaffer, eds. *The Junius B. Bird Pre-Columbian Textile Conference*. Washington, D.C.: The Textile Museum and Dumbarton Oaks.

Covarrubias, Miguel
 1954 *The Eagle, the Jaguar, and the Serpent*. New York: Alfred A. Knopf.

Cox, Marian Estelle
 1969 *Stone Sculpture of the Manteño Culture (Central Coast of Ecuador)*. M.A. thesis, Department of Art. University of California, Los Angeles.

Davies, Nigel
 1977 *The Toltecs*. Norman: University of Oklahoma Press.

de Borhegyi, Stephan F.
 1959 "Pre-Columbian Cultural Connections Between Mesoamerica and Ecuador." *In* Middle American Research Records, II(6):143-156.
 1960 "Pre-Columbian Cultural Connections Between Mesoamerica and Ecuador: Addenda." *In* Middle American Research Records II(6):159-164.
 1965 "Archaeological Synthesis of the Guatemalan Highlands." *In* Gordon R. Wiley, ed. *Handbook of Middle American Indians* 2(1):3-58. Austin: University of Texas Press.

di Capua, Costanza
 1966 "Semejanza en la Iconografía de las Culturas de Mesoamérica y las del Ecuador Precolombino." *In* Humanitas VI(1):142-152. (Quito: Editorial Universitaria)

Estrada, Emilio
 1957a *Ultimas Civilizaciones Pre-Históricas de la Cuenca del Río Guayas*. Guayaquil: Publicación del Museo Víctor Emilio Estrada (no. 2).
 1957b *Los Huancavilcas: Ultimas Civilizaciones Pre-Historicas de la Costa de Guayas*. Guayaquil: Publicación del Museo Víctor Emilio Estrada (no. 3).
 1957c *Prehistoria de Manabí*. Guayaquil: Publicación del Museo Víctor Emilio Estrada (no. 4).
 1958 *Las Culturas Pre-Clasicas, Formativas, o Arcaicas del Ecuador*. Guayaquil: Publicación del Museo Víctor Emilio Estrada (no. 5).

1962 *Arqueología de Manabí Central.* Guayaquil: Publicación del Museo Víctor Emilio Estrada (no. 7).

_____ and Betty J. Meggers
1961 "A Complex of Traits of Probable Trans-Pacific Origin on the Coast of Ecuador." *American Anthropologist* LXIII:913-939.

Evans, Clifford and Betty J. Meggers
1966 "Mesoamerica and Ecuador." *In* Gordon F. Ekholm and Gordon R. Willey, eds. *Handbook of Middle American Indians* 4:243-264. Austin: University of Texas Press.

_____, Betty J. Meggers, and Emilio Estrada
1959 *Cultura Valdivia.* Guayaquil: Publicación del Museo Víctor Emilio Estrada (no. 6).

Ferdon, Edwin N., Jr.
1950 *Studies in Ecuadorian Geography.* Monographs of the School of American Research. Santa Fe: School of American Research and the University of Southern California.

Feriz, Hans
1956 "The Problem of the Stone "Thrones" of Ecuador and the Stone "Yokes" of Tajín." *In* Proceedings of the Thirty-Second International Congress of Americanists. Copenhagen: Munksgaard.

Fraser, Douglas
1966 "The Heraldic Woman: A Study in Diffusion." *In* Douglas Fraser, ed. *The Many Faces of Primitive Art.* Englewood Cliffs: Prentice-Hall, Inc.

Gonzáles de la Rosa, Manuel
1908 "Les Caras de l'Equateur et les premiers résultats de l'Expedition G. Heye sous la direction de M. Saville." *Journal de la Société des Américanists de Paris* V(1):85-93.

Jijón y Caamaño, Jacinto
1951 *Antropología Prehispánica del Ecuador.* Quito: La Prensa Católica.
[1945]

Krickeberg, Walter
1964 *Las Antiguas Culturas Mexicanas,* 2da ed. Sita Garst y Jasmin Reuter, traductores. México, D.F.: Fondo de Cultura Económica.

Kroeber, A. L.
1946 "A Cross-Cultural Survey of South American Indian Tribes: Esthetic and Recreational Activities: Art: Ecuador." *In* J. H. Steward, ed. *Handbook of South American Indians* 5:462-475. Smithsonian Institution Bureau of American Ethnology, Bulletin 143. Washington, D.C.: Smithsonian Inst.

Larrea, Carlos Manuel
1958 *El Misterio de las Llamadas Sillas de Piedra de Manabí.* Quito: Editorial Casa de la Cultura Ecuatoriana.

Marcos, Jorge
1979 "Woven Textiles in a Late Valdivia Context (Ecuador)." *In* Ann Pollard Rowe, Elizabeth P. Benson, and Anne-Louise Schaffer, eds. *The Junius B. Bird Pre-Columbian Textile Conference.* Washington, D.C.: The Textile Museum and Dumbarton Oaks.

Meggers, Betty J.
1966 *Ecuador.* New York: Frederick A. Praeger.

Métraux, Alfred
1946 "A Cross-Cultural Survey of South American Indian Tribes: Religion and Shamanism." *In* J. H. Steward, ed. *Handbook of South American Indians* 5:559-599. Smithsonian Institution Bureau of American Ethnology, Bulletin 143. Washington, D.C.: Smithsonian Institution.

Miles, S. W.
1965 "Summary of Pre-Conquest Ethnology of the Guatemala-Chiapas Highlands and Pacific Slopes." *In* Gordon R. Willey, ed. *Handbook of Middle American Indians* 2(1):276-287. Austin: University of Texas Press.

Murra, John
1946 "The Historic Tribes of Ecuador." *In* J. H. Steward, ed. *Handbook of South American Indians* 2:785-821. Smithsonian Institution Bureau of American Ethnology, Bulletin 143. Washington, D.C.: Smithsonian Institution.

Nicholson, H. B.
1967 "A Fragment of an Aztec Relief Carving of the Earth Monster." *Journal de la Société des Américanists* (de Paris) LVI(1):81-95.

1971a "Major Sculpture in Prehispanic Central Mexico." *In* Gordon F. Ekholm and Ignacio Bernal, eds. *Handbook of Middle American Indians* 10(1):92-134. Austin: University of Texas Press.

1971b "Religion in Prehispanic Central Mexico." *In* Gordon F. Ekholm and Ignacio Bernal, eds. *Handbook of Middle American Indians* 10(1):395-446. Austin: University of Texas Press.

1971c "The Iconography of Classic Central Veracruz Ceramic Sculptures." *In* Ancient Art of Veracruz: An Exhibit Sponsored by the Ethnic Arts Council of Los Angeles at the Los Angeles County Museum of Natural History, February 23-June 13, 1971. Los Angeles: The Ethnic Arts Council of Los Angeles.

Osborn, Harold
1968 *South American Mythology.* Middlesex: Paul Hamlyn.

Phillips, Phillip
1966 "The Role of Transpacific Contacts in the Development of the New World Pre-Columbian Civilizations." *In* Gordon F. Ekholm and Gordon R. Willey, eds. *Handbook of Middle American Indians* 4:296-315. Austin: University of Texas Press.

Porras G., Pedro I. y Luis Piana Bruno
1976 *Ecuador Prehistorico*, 2da ed. Quito: Instituto Geográfica Militar.

Prescott, William H.
1892 *History of the Conquest of Peru, I.* Philadelphia: David McKay, Publisher.

Saville, Marshall H.
1907 *The Antiquities of Manabí, Ecuador: A Preliminary Report.* Contributions to South American Archaeology, The George G. Heye Expedition, I. New York: Museum of the American Indian.

1910 *The Antiquities of Manabí, Ecuador: Final Report.* Contributions to South American Archaeology, The George G. Heye Expedition, II. New York: Museum of the American Indian.

Schuster, Carl
1951 "Joint Marks, a Possible Index of Cultural Contact Between America, Oceania and the Far East." *In* Medeling No. XCIV Afdeling Culturele en Physische Antropologie No. 39. Amsterdam: Koninklijik Institut voor de Tropen.

1952 V-Shaped Chest Markings: Distribution of a Design Motif in and around the Pacific." *Anthropos* 47(1-2):99-118.

Stone, Doris
1966 "Synthesis of Lower Central American Ethnohistory." *In* Gordon F. Ekholm and Gordon R. Willey, eds. *Handbook of Middle American Indians* 4:209-233. Austin: University of Texas Press.

Townsend, Richard Fraser
1979 *State and Cosmos in the Art of Tenochtitlan.* Studies in Pre-Columbian Art and Archaeology, Number Twenty. Washington, D.C.: Dumbarton Oaks.

Wilbert, Johannes
1974 *The Thread of Life: Symbolism of Miniature Art From Ecuador.* Studies in Pre-Columbian Art Archaeology, Number Twelve. Washington, D.C.: Dumbarton Oaks.

14

Cupisnique Pottery: A Cache From Tembladera

Peter G. Roe
Department of Anthropology
University of Delaware

One of the Andean area's most fascinating art styles is also the region's earliest: Chavín. During the time the Chavín culture held sway throughout what is now Peru (ca. 1500-300 B.C.), almost all media of art were produced. However, as with most archaeological cultures, ceramics is the most ubiquitious extant medium. The current study focuses upon three vessels of the Cupisnique pottery substyle. By careful scrutiny it has been possible both to place the bottles' iconography within the mainstream of Chavín art and to identify the bottles themselves as products of a single artist or a single workshop.

THE OBJECT OF THIS PAPER is to present an interesting new set of heavily modeled Chavín-style stirrup-spout vessels found near Tembladera in the Jequetepeque or Pacasmayo Valley of the north coast of Peru. These examples form a useful addition to the illustrated literature on a hitherto sparsely pictured variety of "Cupisnique" pottery. Since the vessels come from an undocumented context they will be described first, and then an effort will be made to relate what could be determined concerning the circumstances of their recovery. Next, judgments will be offered as to their authenticity and relative dating by relying upon a comparison of the designs on the pieces with the stylistic sequence of monumental stone sculpture established for Chavín de Huantar.[1] Lastly, some speculations will be advanced on the iconography of the designs as a small exercise in the analysis of archaeologically derived aesthetic artifacts.

The Vessels: Circumstances of Discovery

The three specimens (Figures 2, 3, 4) were originally part of at least a five-vessel cache and are now part of a private collection in Southern California where their

1. According to information received by John Rowe (personal communication, 1979) from Richard Burger, ". . . the people of Chavín bitterly resent having their town referred to as 'Chavín de Huantar.' Huantar is a rival town down the road. The designation was invented in modern times . . . to distinguish the Chavín in Ancash from Chavín de Pariarca in Huánuco"; yet this name is established in the archaeological literature and I will therefore retain it here with all due apologies to the citizens of Chavín in Ancash.

keeper kindly allowed me to examine them.[2] Hereafter, these are referred to as the "California Bottles." The following information has been gathered on the circumstances of their discovery: The original accumulation of numerous pot fragments was found in 1969 near a tributary of the Jequetepeque River, probably on the north side, where they came from within the shaded area on the map in Figure 1, between Tembladera on the west and Chilete on the east.* There were no structures or other surface remains at the place of their discovery, the site being just an eroded hillside. Some pieces of the vessels were found over a surface area of several square meters while other pieces were buried and were recovered by probing. The surface sherds still bear traces of sand-pitted abrasion and, indeed, were apparently uncovered by wind erosion. Many other sherds of the restored vessels have their surface essentially intact, indicating that the major portion of the vessels was buried. The method of their discovery is indicated by the huaquero "signature" of a circular probe-caused perforation on the stirrup of one of the vessels. The pots were broken when found. Because of their reconstructably-complete nature, they must have either been accidentally broken or ceremonially "killed" in place. No other artifacts were associated with them. The pieces were then restored. Extensive reconstruction was needed in only a few areas. Therefore, the designs which are shown have not been much modified. There are remaining sherds, from which only partial vessels could be constructed. Of the two other pots not in this keeper's possession, one is in Miami and the other in Europe. The former is a single-spout bottle, black monochrome with a feline face. The latter is a 33 cm-high stirrup-spout bottle with two linked heads in the same style. I examined a xerox copy of a photograph of the latter which was not clear enough to permit me to illustrate the piece here. All look similar and were apparently made by the same individual; the three specimens shown in this paper certainly were.**

The Vessels: Description

All three have identical surface preparation and general proportion, even down to the same beveled "flange" rim. They differ in size, in the playful recombination of body elements for the basal section, and in the degree to which the identical designs intrude upon the spout, but otherwise they represent a similar conception.

Let us begin with the largest one. Figure 2, with its curious carinated plain base, is, at 35.5 x 23 cm, one of the largest stirrup-spout vessels I have seen. It, together with the two others, is characterized by a high level of technical excellence and represents one of the gems of Cupisnique art. The raised designs, as one broken wing-element revealed, were done by appliqué with subsequent modeling and then fine-line incision. The plain background of the vessel's surface was carefully polished with some hard, smooth object, probably a small water-worn pebble, when leather-hard as

2. The exact technique of the construction of the figures in this paper is as follows: I first made macro-photographs and accurate full scale drawings of the actual specimens in pencil. The final rapidograph and ink renderings were made on tracing vellum in a 1:1 scale from the original full-sized pencil drawings. To further insure accuracy, the renderings were then photographically reduced. Section drawings were impossible due to the restored state of the vessels, but the measured rim profile which accompanies every figure is accurate in orientation and dimension as far as the calipers reached.

* Since the writing of this article the editor has been told that the vessels came from the Hacienda Quirigua at the entrance to the Sierra de Libertena.—A.C.-C.

** A fourth vessel appeared after this article was written which is undoubtedly from the hand of the same artist or studio. The new bottle is somewhat shorter than the others, is a single spout—rather than stirrup spout—form, and has a silvery, gun-metal surface. However, the iconography is identical to the three California Bottles, the ceramic has a carinated base as in the example shown in Figure 2a, and it is said to have been found in the same locale as the previous three.—A.C.-C.

its shining surface indicates. Then the whole vessel was fired under very uniform and well-controlled circumstances in a reducing environment to produce a black to chocolate brown monochrome surface. Together, these technological details, as well as the stylistic and iconographic aspects to follow, and the accidental indications of discovery and weathering, too subtle to falsify, all indicate to me that these pieces are not fakes, but original and very revealing Cupisnique specimens. In fact, I take the three pieces illustrated here to represent a set of variations on one conceptual theme by the same artisan. The general body design depicted in Figure 3 is repeated in identical form on both sides of this and the other two vessels. Iconographically, as we shall later see, it represents the adumbrated ceramic equivalent of the bas-relief carved Cornice Birds of the New Temple at Chavín de Huantar (Rowe 1967:101, Fig. 12). They are similar to the "probably contemporary" (*ibid.*:94, note for Fig. 13) specimen pictured here as Figure 5a.

I regard these depictions, both in stone and in ceramics, as an intermediary pictorial stage between the "guardian angels" of the Black and White Portal of the New Temple, on the one hand, and the Black and White Portal Cornice Birds above them, on the other. Like the "guardian angels," the ceramic birds shown here are in a "heraldic" posture, set frontally with both wings extended and with only the head turned in profile. Yet unlike them, and like the Black and White Portal Cornice Birds, the California Bottle birds are purely zoomorphic jaguar-bird composites.[3] In contrast, the Black and White Portal bird monsters are heavily anthropomorphic (*ibid.*: 100, Figs. 8, 9). The ceramic birds, however, also contrast with the Black and White Portal Cornice Birds despite their shared zoomorphic nature. The former appear in the "heraldic" position while the latter assume a profile posture (*ibid.*:101, Fig. 15). In a sense, then, these ceramic birds align with the New Temple Cornice Birds and fall between their two stony kin: they have a "heraldic" posture like the Portal bird monsters yet are purely avian like the Portal jaguar-birds.

Rowe called the most elaborate of this series "guardian angels" (*ibid.*:86) because they seem to represent subsidiary companion figures to more major deities (*ibid.*:85). I agree and propose an additional distinction between these and their less elaborate exemplars. Within the role of "guardian angel" I reserve "angel" for the anthropomorphic figures and "guardian" for the zoomorphic representations. These ceramic figures then become bird guardians. Several free-floating, S-shaped elements occupy the spaces between each depiction.[4]

The second largest bottle, measuring 33 x 23 cm., is shown in Figure 3a. The vessel body form of this specimen differs from the first in its much narrower basal carination. Above that elaboration, the body is much the same as that of the first bottle. The body is large relative to the stirrup and spout and is nearly spherical. The stirrup itself is rounded and fat with the negative space formed within the stirrup

3. I differ from Rowe in my insistence that the "guardian angels" are truly monstrous because of their felinic mouths armed with saber-like canines. He considers them to be just part human and part bird with ". . . nothing feline about them" (personal communication, 1979). This is odd since he earlier noted the widespread "figurative use of the cat mouth in Chavín art" (Rowe 1967:80), and the guardian angels of the Black and White Portal clearly have ill-fitting bird beak "masks" over their feline mouths.

4. Based on Donald Lathrap's (1973:96) identification of male and female caymanic manifestations composing the Tello Obelisk images, Patricia Lyon (1979:100) argues that, within the specific context of that obelisk, these S-shaped elements may indicate female identity. If that identification holds, the S-shaped element may symbolize the vulva. However, as that same element appears widely in Chavín art particularly as she points out in the pottery from the Ofrendas Gallery at Chavín de Huantar (Lumbreras 1977:Fig. 47), it is unclear whether it has the same meaning wherever it appears.

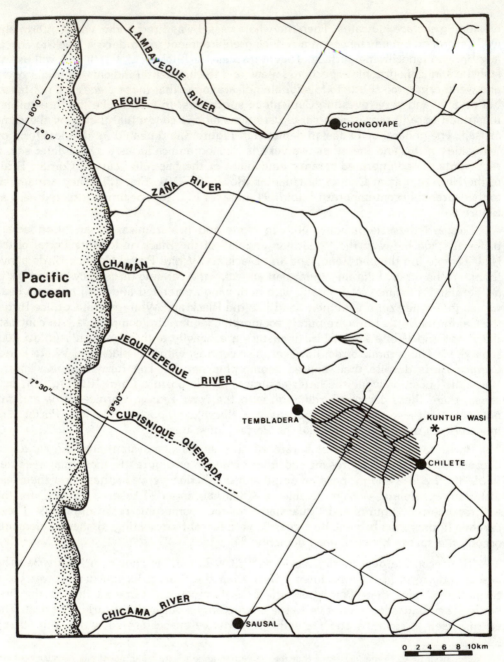

Figure 1. Map of the Coast of Peru showing the general area of recovery of the Cupisnique stirrup-spout vessels.

almost perfectly circular. The spout departs from the stirrup at a right angle and is squat in proportion and vertical in ascent toward the beveled "flange" rim.

Since the designs on the second stirrup-spout vessel are nearly identical to those on the body of the first, instead of illustrating them I have drawn a closeup of the appliqué relief which similarly adorns the stirrups of both vessels (Figure 3b). The relief covers the whole lower stirrup, from its juncture with the body of the vessel to

the point where it joins the spout. The lower element is a simplified version of the front face-breast of the bird guardian; but, because of space constraints, it lacks teeth. Above it is the same collar element found in the full body depiction. Surmounting the top of the stirrup is the face of the bird-feline guardian, its bird beak-mask intruding onto the spout itself. In effect, what we have here is a copy of the figure on the body, lacking only the tail feathers and the feet to complete the design. The two wings of the bird guardian spread over the front of the stirrup and can best be seen from a front view of the pot. The feathers have been drastically reduced because of space limitations to an almost vestigial form.[5]

Figure 4a shows a side view of the last stirrup-spout bottle. At 33 x 22.5 cm., the third bottle is the smallest of the three and lacks any basal elaboration. On it the spherical body merely ascends evenly from a flat base. The body is covered with the same figures as the other two vessels, but the stirrup and spout lack any decoration. Since they are identical to the others in their configuration, rim and lip modification, the unadorned stirrup and spout of this last specimen allows a better appreciation of their outlines than can be discerned from the more heavily encrusted pieces. The side view presented here depicts the bulging convex profile of the spout as it reaches from the stirrup to the rim.

The front elevation in Figure 4b shows how similar the rim profile on this pot is to the rim of the other two bottles. Interestingly enough, were one to have just rim sherds to work with from these three vessels they would appear to differ considerably less than they do when the whole profile is present. They would no doubt have been reconstructed with the same simple globular body as this bottle.

In Figure 4c, I present a tentative reconstruction of a derivational chain which can connect the somewhat simplified subsidiary profile agnathic heads on the wing feathers in the middle of 4a to the slightly more complete versions of the same motif found on analogous wing elements of the other two bottles. One can start with the head in the upper right where the nose has been deleted and the above-the-nose-fold rests directly on the upcurled lip. This possibility is very similar to another Cupisnique depiction (Roe 1974:65, Fig. 39d). The second stage—present on some of the wing elements—shows the upcurling of the lip deleted, due to a narrowing of the design field, and a consequent placement of the fold right next to the eye. Finally, the last step in the lower left shows the motif as it is seen on some other wing elements where the fold becomes three curved lines and the teeth are deleted and replaced by just the tongue/feather elements (which also, in this complex style, serve as teeth).

The Vessels: Stylistic Comparisons With Chavín Stone Sculpture

Several stages can exist in the analysis of any set of aesthetic artifacts.[6] The first consists of a kind of "artifact physics" in which the artifact is recovered, provenanced, measured, described, typologically classified and recorded in its technical aspects, such as we have already done with these vessels. Next comes a discussion of

5. In their present rudimentary form it is interesting that the wings look almost like ear elements for the breast mask, a pun which may have been intentional. This surmise is strengthened by the similarity they have in their reduced form to the common ear elements (Roe 1974:16, Feature 102) of Phase D subsidiary face depictions in the lapidary art of Chavín de Huantar (*loc. cit.*, Feature 101). The representations on both the stirrup and the body make intelligible other similar, but simplified, designs in Cupisnique art (*ibid.*:62, Fig. 36b).

6. By "aesthetic artifacts" I mean human-produced or ·modified objects which are elaborated beyond the necessities of technological efficiency to produce "non-instrumental form" (Maquet 1971:8) in a creative or playful way (Roe 1980:56) in order to psychosocially "affect" an audience (Armstrong 1971:6).

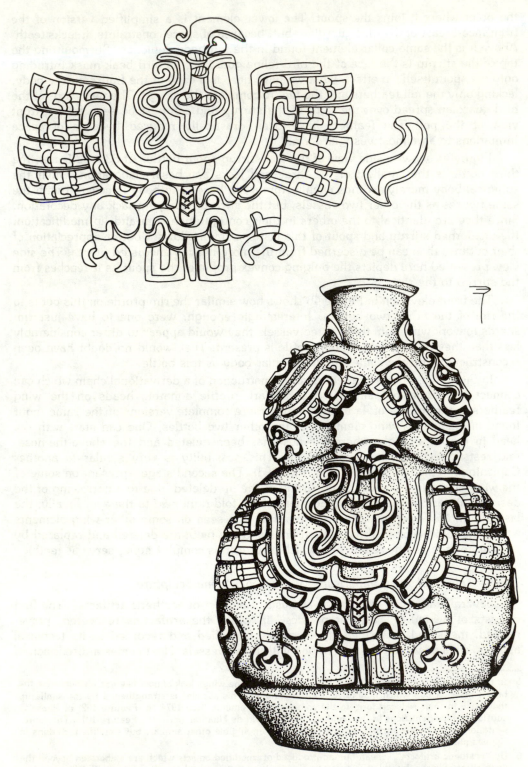

Figure 2. **a,** *A front elevation of the largest stirrup-spout vessel of the set. Height 35.5 cm, width 23 cm;* **b,** *A roll-out of the Eagle Guardian which adorns both sides of the bottle.*

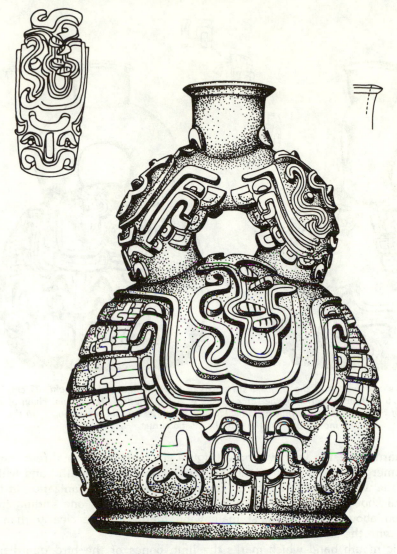

Figure 3. **a**, *A front view of the second largest stirrup-spout bottle of the cache. The Decorative Eagle is slightly off-center. Height 33 cm., width 23 cm;* **b**, *A roll-out of the Abbreviated Eagle which adorns both sides of the stirrup of the vessel.*

the playful variation in their production, the decisions, and the behavior which went into the creation of aesthetically pleasing results. The manipulation of the lower vessel body wall of these Cupisnique specimens stands in contrast to the stereotyped nature of their designs as an example of such a process. Continuing, but still within the realm of what Thomas Munro (1963:370) calls "technique," comes a discussion of the stylistic aspects of the artifacts.

In any discussion of technique, a useful way to begin is to break down the design into component parts and then to postulate what "rules" or ordering principles may have been used to construct it (Roe 1980:59, Fig. 8). While this process has only begun for Chavín art (Roe 1974:46, Fig. 10; Rowe 1967:77-82), enough has been accomplished to analyze the structure of the figural designs on the California Bottles.

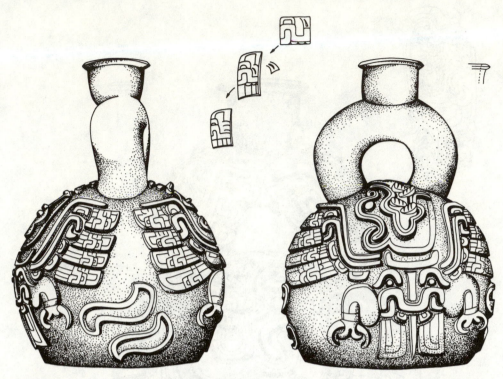

Figure 4. **a**, A side elevation of the smallest stirrup-spout bottle of the cache. Height, 33 cm, width 22.5 cm; **b**, A front elevation of the same vessel; **c**, A hypothetical Derivational chain of the variations of the wing element profile agnathic faces on the three vessels proceeding from the most representational to the most abstract.

The bird guardian design is shown here (Figure 2b) with the normal four major wing elements emerging as "kenned" tongues from a continuous mouth band which also doubled as the wing bones of the bird. The more "skeletal" organization of the ceramic portrayal shows the two parallel wing bones (the outside one ending in a shorter projection above the uppermost main wing feather) more clearly than is usually the case with the stone sculpture.

The agnathic mouth band which marks the limb bones of the bird guardian's wing falls half way between the stone depictions. In the New Temple Cornice Birds and related Phase AB avians like Figure 5a, the eye is at the bottom of the mouth band, thus forming a profile mask whose teeth project toward the wing elements and away from the bird's body. In the Phase D exemplar which I have reconstructed in Figure 5b, on the other hand, the eye, although still on the bottom, is situated in such a way as to suggest that the now full mouth band projects toward the body and away from the wing elements. On one of the related Phase D Black and White Portal angel's wings (Rowe 1967:100, Fig. 8), in contrast, the eye appears at the *top* of the mouth band, and the upper teeth project *toward* the body. In our ceramic bird guardians the eye is on the *top*, but the teeth project *away* from the body and toward the wing feathers.

Interestingly enough, the teeth of the mouth band in Figure 2b show an even more derived kenning than that exhibited for the feathers, since each of the three teeth on either side has an eccentric pupil which converts them into eyes. I am aware of "at most one very dubious specimen" (Rowe, personal communication, 1979) with

238

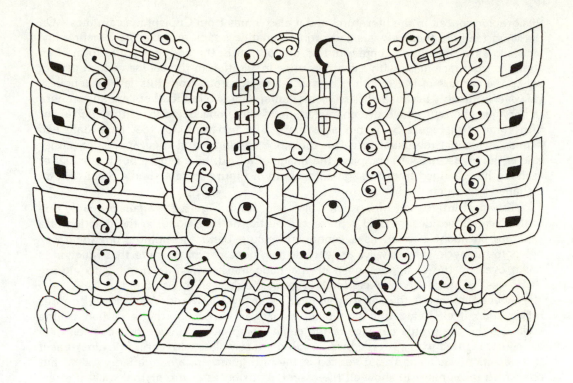

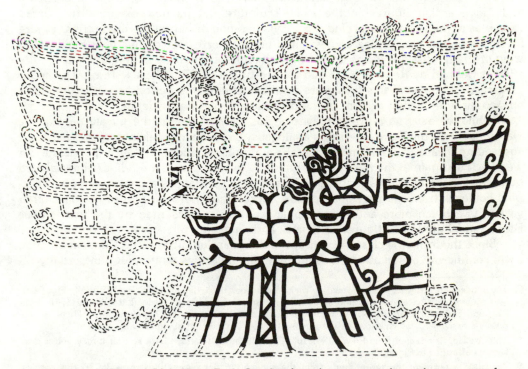

Figure 5. **a,** A Phase A Male Harpy Eagle Guardian from the cornice on the north east corner of the old south wing of the Temple at Chavín de Huantar (reversed). **b,** A reconstruction of a Phase D Male Harpy Eagle Guardian found in the same area at 5a.

this graphic conceit in the literature, and it also comes from Cupisnique ceramics.[7] On the wing feathers themselves small profile agnathic heads are executed in fine line incision. As in the other examples of this kind of figure, the body takes the form of an agnathic front-face mask with a central canine in addition to the canines which project out of the corners of the mouth. The tail feathers sprout from this jaw as tongues. However, probably because of space constraints, only two tail feathers are shown here rather than the four which are characteristic of the stone depictions (the central, or fifth element in Figure 5b is not a feather). The two raptorial feet have only two talons, as against the usual three for the stone carvings; and they appear on either side of the breast mask to complete the image of a bird. Like Figure 5b, the anklet of each leg has changed from the agnathic mouth of Figure 5a to a simple band with an L-shaped greave on the inside.

The most interesting innovation which appears in Figure 2b, again probably due to the compressed design field represented by the bottle's body, is the deletion of a separate backbone kenned as a continuous mouth band ascending from the face/pelvis to the neck which always appears on the stone carvings. Here that function is taken over by the elongated nose of the body mask which is fitted with zig-zag ''wrinkles'' to mimic the zig-zag tooth array of the deleted mouth band.

Above the nose is the collar, now plain as in the Black and White Portal figures rather than itself being a mouth band as it was earlier in the evolution of the style. Lastly, the profile cat face of the eagle, complete with eyebrow, eye, and ear elements, is fitted with a profile bird's beak-mask complete with cere. It is almost as if this depiction was a shorthand version of the bird guardian, a simplified version, but one which takes pains to show all the essential attributes of the mythological figure.

After spelling out these generalized similarities between the ceramic portrayal and the guardian figures of the stone sculpture, let us now examine two dated examples of the latter as a prelude to a consideration of dating for the bottles. Figure 5a shows one of the cornice eagles found off the north-east corner of the old south wing of the temple.[8] It forms one of the primary documents for the AB Phase of the style as defined by Rowe (1967)[9] and refined by Roe (1974, Chart I, 1a,b). The spare ''classical'' outlines of this figure are characteristic of this period as is the emphasis on circularity in design evident in the profusion of curvilinear detail.

While we have no representatives of this class of being (the purely naturalistic Harpy eagle on the Tello Obelisk is analogous, but not identical in concept) from the succeeding Phase C of the monumental sculptural seriation, it clearly persisted, for we pick it up again in the next phase, Phase D. In this phase, the feline/raptorial bird guardian comes in two variants. The less common variant is a conservative zoomorphic holdover from the previous periods, represented here by Figure 5b. The other variant is a much more anthropomorphic rendition, represented by the two famous Black and White Portal figures of a hawk and an eagle.

Since the former is closer in concept to the guardian bird on the Cupisnique pots, I will confine my observations to their mutual similarities while only tangentially re-

7. The inadequate drawing I was forced to make from poor book illustrations (Roe 1974:62, Fig. 36d) was a composite based on two photos of different sides of the same bottle (Larco-Hoyle 1941, Fig. 210, and Bushnell 1957, Pl. 8). As Rowe (personal communication, 1979) points out, ''There is one possible extra 'eye' which shows in the Bushnell photo, but it is not obviously also a tooth.''

8. This drawing is adapted from Rowe (1967:101, Fig. 13), but is reversed here so that it may better present its affinities to Figure 5b.

9. Actually, in terms of the recent finds from the sunken circular plaza (Lumbreras 1977), this cornice figure may actually belong to a Phase ''A'' of the style (Roe 1978:3), since Lumbreras (1977:17) postulates, and I agree with him, a Phase ''B'' date for the associated figures of the sunken plaza.

ferring to the latter more anthropomorphic variant. In Figure 5b, I offer a tentative reconstruction of a sculptural fragment Rowe pictures (1967:101, Fig. 14) which may represent the analogous zoomorphic variant.[10] It comes from a cornice stone found at the same place as Figure 5a, but clearly belongs to a later period in time. While the upper section of this bas-relief is conjectural, there are many different lines of evidence which buttress the general impression the reconstruction yields. In such an enterprise the "architectonic" aspects of the Chavín style with its rigid patterning and studied symmetry is of great aid to the reconstructor.

First of all, since four wing elements are standard for Chavín bird guardians and angels, I have drawn this figure with four feathers as well. The upper wing-tip alula is also a common feature, originally kenned as a snake with protruding tongue (as in Figure 5a), but judging from other remaining appendages, is probably plain in this case. The backbone recapitulates the central tail element in the much better preserved Black and White Portal figures; so I have added one here. The collar represents the only point of real uncertainty in this reconstruction, since judging from the analogous forms it should by this time have changed from an agnathic mouth to a plain band, yet several projecting canines clearly come from it. Perhaps this is a transitional form of collar between the anatomical and plain forms. The specific form of the head in Figure 5b is based on my assumptions concerning its chronological placement and figural nature,[11] but conforms in general to figures of this kind. They all have a cat head fitted with a bird mask, and so does this one. Specific details of what remains even indicate in which direction the head was turned, to the right rather than to the left as in the actual form of Figure 5a. Concurring with Rowe (1967:94), I have drawn this being as an eagle, without the hawk markings below the eye. A glance back to Figure 2b shows how similar in conception this piece of Chavín stone sculpture is to the Cupisnique bottles from near Tembladera.

Chronologically, the stone carving in Figure 5b falls squarely within Rowe's Phase D of the evolution of the Chavín art style (loc. cit.).[12] Overall trends which distinguish this phase from the proceeding and preceding ones, such as increasing rectilinearization and anthropomorphization, are evidenced in detail here. The transverse-reflected noses of the breast mask, with their attendant above-the-nose-folds, are clearly more rectangular in outline than earlier analogous forms. As for the tendency toward increasing anthropomorphization (Kano 1979:35; Roe 1978:23), compare the pelvis breast face on this guardian with the same part on the earlier Figure 5a to see how features which were once more animalistic now portray more transparently human forms.

Using the features from my earlier publication (Roe 1974:15-17), specific Phase D elements which can be used to date just the unreconstructed areas of Figure 5b are:

10. I feel that it is best to make an attempt, as I have done elsewhere (Roe 1974:46, Fig. 9; 47, Figs. 11, 12; 48, Fig. 14; 49, Fig. 15; 50, Figs. 17, 18; 51, Fig. 19), to reconstruct Chavín works of art in as complete a form as possible. Thus students of the style will see images as the total configurations they were originally intended to be and not as enigmatic fragments. A close chronological and componential study of the art (ibid.:46, Fig. 10) as well as its "aesthetic syntactics," or formal rule structure, will allow one to reconstruct works which are true in their broad outlines, if, on occasion, somewhat conjectural in detail. It is the difference this approach makes between an acceptable reconstruction and such interesting, if largely imaginative, earlier efforts such as Rojas Ponce's Chavín reconstructions (Carrión Cachot 1948:44, Lámina XVI,e,f,h; 46, Fig. 9; 50, Fig. 11).

11. These specific details include the Phase D main-figure eye form, Feature 76 (Roe 1974:15) and Feature 84 (loc. cit.), and the main-figure mouth form with the decorative point characteristic of this period. Since I will identify this bird as a Harpy eagle, I added feather head crests.

12. A recent C-14 test made on a Phase D Chavín textile has yielded the date: 950 B.C. ± 100 (LJ [UCSD] 4198, December 1977) (Alana Cordy-Collins, personal communication, 1981).

Feature 93, the rapier-like teeth; Feature 114, a simple-snake variant;[13] Feature 115, the simple-snake combined with scrolls; Feature 119, a variant of the central zig-zag "backbone" mouth band; and Feature 120, long versions of the recurved rays which proliferate in the late style. I have gone into such detail on the dating of both figures 5a and 5b because they bracket, and thereby define, the guardian depictions on the Cupisnique bottles under discussion here.

The Vessels: Dating

This brings us to a consideration of the relative dating of these three vessels specifically. Stylistic analysis reveals a mixture of Phase C and D traits.[14] The main figure mouth of Figure 2b with its medial incision and lips curved above the canines has affinities with the classical Phase C continuous mouth band (*ibid.*:13, Feature 50). The blunt canines with their diagonal line markings confirm this attribution with their close similarity (once allowance is made for differences in media) to the typical canine form of Phase C (*loc. cit.*, Feature 55). However, the small profile faces incised on the wing elements more closely relate to a Phase D form (*ibid.*:15, Feature 89), as does the diagnostic late Phase D trait of L-shaped canines (*loc. cit.*, Feature 90). What actually weights the entire depiction more toward the Phase D end of the continuum is the whole front face agnathic breast mask which parallels an important Phase D feature (*ibid.*:16, Feature 101). That feature ties it to the angels of the Black and White Portal. This, coupled with its close similarity to Figure 5b, a pure Phase D depiction, suggests a chronological placement for the California Bottles from near Tembladera at a point overlapping terminal C and initial D of the central sequence.

The Vessels: Ceramic Affinities

At one fell swoop this new find of three heavily modeled Cupisnique bottles has greatly increased our sample of such curiously decorated and ornate coastal Chavín specimens. The few illustrated examples of this "high-relief" type share the traits of short tubular spouts, heavy applique relief modeling, and the beveled "flange" rim on a black monochrome body. There are a number of specimens in the literature from various sites along the desert coastal strip of Peru which share the same general "high-relief" features as these California Bottles. Beginning in the North Coast archaeological region and proceeding to the south from the Jequetepeque Valley, stirrup-spout bottles with similar relief decoration (in method if not in theme or specific design elements) have come from the Chicama Valley,[15] the Moche Valley,[16]

13. Note that the earlier collared cat-snake of Figure 5a is not represented here, yet another indication of what I mentioned in an earlier study (Roe 1974:15-17), the paradox of increasing visual complexity being built up out of the multiplication of increasingly *simpler* constituent elements which overtakes Chavín art in its later "baroque" manifestations.

14. There are, of course, problems in seriating across space and media, but as long as the chronology and regional development of Chavín ceramics remains in as sorry a state as it is today, there will be little alternative to using the stone sculptural sequence as the benchmark for dating regional ceramics. As Rowe (personal communication, 1979) points out:

 I agree that the Tembladera bottles [California Bottles] show a combination of features most similar to those of Chavín Phases C and D sculpture. I am not so sure that we ought to expect any of the high-relief ceramic pieces to match the stone sculpture sequence exactly. It is perfectly possible that they constituted a special category of vessels which preserved some older features deliberately, like the Panathenaic amphorae of ancient Athens.

15. These include bottles with depictions of profile "human" faces with fanged mouths such as Larco Hoyle 1941, Figure 63, a grave lot specimen, Barbacoa A, Grave 21. It was associated with an incised bottle Figure 23—see p. 204—compare with a bottle from the Vélez López collection, provenience unknown (Larco Hoyle 1938) (Rowe, personal communication, 1979).

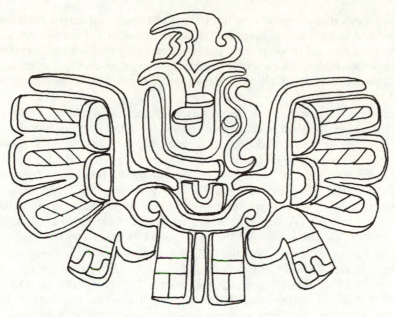

Figure 6. A provisional rendering of a Cupisnique high-relief stirrup-spout bottle Eagle Guardian drawn from secondary sources (see text). Some details uncertain.

and in the North Central archaeological region, the Nepeña Valley,[17] and the Casma Valley.[18]

On the level of specific thematic similarities to the California Bottles, I concur with Rowe (personal communication, 1979) that the closest parallel is the bird on a stirrup-spout bottle of which I earlier published an incomplete rendition (Roe 1974:62, Fig. 36b). That depiction is revised here to include its beak and presented as Figure 6. This bottle from the Rafael Larco Herrera Museum, Lima (Larco Hoyle 1963, Fig. 40; 1966, Fig. 9), ''. . . has a single pair of smooth fangs found in the Vélez López bottle and the gravelot cup (Larco Hoyle 1941, Fig. 63)'' (Rowe, personal communication, 1979). It has a number of specific correspondences with the California Bottles under discussion here. The design on the bottle depicts a cat-eagle guardian[19] in a heraldic position, but facing in the opposite direction from those on the California Bottles. Unlike them, it only has three wing elements rather than four—the upper edge of the wing is more enlarged (Figure 6) than it is in Figure 2b so that it functions like a fourth feather. However, Figure 6 does have eyes kenned as teeth like Figure 2b even though it lacks 2b's profile mask of which they were a part. The California Bottle eagles have four canines with incised lines while the Larco Herrera eagle has only two plain ones. Its lines appear as inserts to the wing elements rather than on the canines.

16. A heavily modeled bottle with an undecipherable design from Huaca El Dragón seems similar in general cast (Cordy-Collins 1976:30, Fig. 14).

17. Unfortunately, this high-relief bottle is merely decorated with the ubiquitous Chavín S-shaped element (Proulx 1973 :234, Plate IA), so its similarities to the California Bottles remain on the level of general technique.

18. This find is another profile face in high relief on a black ware potsherd from Pallka, Yautan (Tello 1956:45, Fig. 17i).

19. Rafael Larco Hoyle recognizes the cat-bird nature of this figure because he notes that the vessel is decorated ''. . . with relief representing the feline and the condor'' (1966:233), even though it is an eagle.

The U-shaped neck piece appears on both the California and Larco Herrera eagles, but the latter one lacks the complete frontal breast mask of the former ones. Instead, Figure 6 has only that mask's agnathic jaw and the tail elements and central canine-like appendage descending like a tongue without its incisors and L-shaped canines. In short, all elements from the California depictions seem to be in place, if somewhat abbreviated in this figure.

The complete missing fullface breast mask of the Larco Herrera eagle appears isolated on the exquisitely modeled stirrup-spout blackware bottle which Larco Hoyle (1941:54, Fig. 77, Lámina D) had drawn as an example of his type "Cupisnique sin colorido." Now in the Museo Nacional de Antropología y Arqueología, Pueblo Libre, Lima, and hereafter called the "Lima Bottle," this specimen has been attributed to the Chicama Valley (Carrión Cachot 1948:77) while Rowe (1971:115, Fig. 21) has cautiously listed it as "provenience unknown." Long regarded as an unusually complex gem of ceramic art (Willey 1971:124, Fig. 3-43), this bottle's depiction offers some close parallels to the California Bottles' fullface breast masks.

The Lima Bottle shows an agnathic upper jaw, L-shaped canines, two incisors, and a central canine like the California masks, but differs in that its central canine does not come down far enough to match the shared "tail feathers" kenned as paired tongues, which both depictions do share, and which are the stigmata of the face's avian function and ancestry. The round eyes are also shared by both designs, but then specific differences begin to emerge. While the nose of the California mask has the "correct" wrinkles along its sides, the Lima Bottle's face has them separated on the curious dual elements above the flat nose with two nostrils which it shares with the anklet fullfaces of the Black and White Portal Phase D angels (Rowe 1967:100, Figs. 8, 9). The face on the Lima Bottle also shares its double ear elements and separate unified eyebrow curl with the anklet faces of the female Harpy Eagle angel (loc. cit., Fig. 9), whereas the California faces have the simple eye form from the same period.

However, the use of the Lima Bottle presents difficulties because Rowe (1971:113, 115) suggests that it may be an archaism from a later time. One major difficulty is that "The flatness of the relief distinguishes this piece from such unquestionable Chavín style pieces as the relief-decorated mug from Grave 21, Barbacoa A, Chicama" (ibid.:113), and, indeed, from these California pieces. In addition, I would add from the perspective of these bottles that by merely appearing alone, without its eagle associations, this motif becomes suspicious.[20] Therefore, while next to the Larco Herrera bottle depiction, the Lima Bottle figure comes closest to the design on the California Bottles from Tembladera, it is dubious as a comparative aid. Rephrased, these California Bottles throw more light on the Lima Bottle than the Lima Bottle casts on them.

The whole "Cupisnique" phenomenon may be a mere catchall for diverse coastal Chavín and Chavinoid materials. Within it, Larco Hoyle's "Cupisnique Transitorio" phase—to which these bottles have some formal affinities—is in a state of flux (Burger 1978:366). Therefore, I will not attempt to make any further chronological comparisons of these bottles with it here.

20. As Rowe notes, "There are some funny things about the design of this [Lima] piece which do not look to me like 'correct' Chavín. The fangs should be L-shaped, as you show them in your [1974:67, Fig. 41b] drawing. In fact, the left one [from the point of view of the face] has a downward bend in the end [Rowe 1971:115, Fig. 21]. Also, the design dividing the main faces [ibid., Fig. 22] is very peculiar. The reason I suggested archaism is that this piece has real problems not found in the better documented Chavín pieces. Of course it has some legitimate characteristics: an archaistic piece has to have a model." (Personal communication, 1979.)

A similar revision is going on in the related ceramic sequence at Chavín de Huantar. Luis Lumbreras's chronological chart (1971:9, Fig. 6), which mixed Chavín and regional pieces together, can not be used as a corroborative device (Rowe, personal communication, 1979). The "Rocas" complex which appears on it was just a typological segregation of uncertain cultural integrity (Burger 1978:265). This is unfortunate since "Rocas" high-relief materials are those which share the most traits with these bottles.[21]

Richard Burger has recently developed a ceramic sequence from Chavín de Huantar that will illuminate that "Rocas" connection (1978:26). It is based on extensive test excavations. He describes three phases, all Chavín in cultural affinity, which progress developmentally from one another. In the order of their antiquity they are: Urabarriu, Chakinani, and Janbarriu.

The Urabarriu ceramics date the beginning of the construction of the most imposing ruin on the site, the Old Temple (ibid.:306). They are characterized by single-necked bottles similar to pieces from Las Haldas and a cup with a general affinity, paralleling the other similarities in vessel shape and surface decoration, to vessels from the site of Kotosh (ibid.:49). Three radiocarbon dates average 2,798 B.P. (848 B.C.) for this complex (ibid.:52). There is little in this phase that parallels the California Bottles even though there is a North Coast connection in the Urabarriu phase.[22]

The "Ofrendas" ware from the literature is dated to Phase C of the Rowe Chavín seriation via its exemplar of the Tello Obelisk (Roe 1974:6). Burger (1978:288) relates it to the latter part of his Urabarriu phase and the early part of his next phase, Chakinani. This pottery correlates with the second building stage at Chavín de Huantar when the first addition was made to the Old Temple. It is C-14 dated at 2,350 ± 100 B.P. (UCR-693) = 400 B.C. (ibid.:126). Detailed similarities between this phase of the central sequence and the California Bottles are slight.

It is in the next developmental phase, Janabarriu, that the affinities become overwhelming and argue for a cross-dating of the Cupisnique pieces with it. Burger dates Janabarriu to Phase D of the Rowe sculptural seriation (ibid.:319-320; 495, Fig. 408) and possibly to Phase EF as well (ibid.:321). No C-14 dates are available, but its duration is estimated at 2-3 centuries based on refuse accumulation (ibid.:168). This dating would take the Janabarriu phase to 200 B.C. "It is during the Janabarriu phase that the settlement at Chavín expanded beyond the scale of a ceremonial center with a small associated population" and became a synchoritic "large city" of up to 5,000 inhabitants covering some 40 square hectares (ibid.:323) with at least some evidence of distinct social stratification (ibid.:314).

21. "The place where Lumbreras identifies the pieces actually found in the Galería de las Rocas, and hence from Chavín as opposed to Chicama or Paracas, is in Lumbreras and Amat (1969). Therein is one fragment of a stirrup-spout with high-relief decoration (loc. cit., lámina IIK = Lumbreras 1971, Fig. 9E) which appears to have lines on the single fang. The pattern is apparently not the same as that on Tembladera fangs, but the piece is the only one I know of that has lines on the fangs at all" (Rowe, personal communication, 1979).

22. That connection is represented by a sherd from an exotic vessel which bears a motif (Burger 1978: 456, Fig. 111) which is undeniably Cupisnique in design (see Roe 1974:65, Fig. 39K) and which Lumbreras (1971) and Burger (1978:124) both relate to the motifs on Cupisnique bottles from the cemetery of Barbacoa, Chicama (Larco Hoyle 1941:219). Lumbreras related this piece to his "Raku" ware (Burger 1978:124) which he, in turn, related to Larco Hoyle's old "Cupisnique Transitorio" (ibid.:274). Burger mentions that "The Raku pieces from the Ofrendas Gallery may be partially contemporary with some of our Urabarriu phase pottery" (loc. cit.). I note, however, that this might be the late range of Urabarriu since the Cupisnique motif looks a little too late for the Rowe phase AB dating of the Old Temple. Indeed, Burger (ibid.:306) states that the Ofrendas Gallery must postdate it.

It is both the variability and quantity of ceramics in this Phase D complex versus the other two, and the pervasive evidence of outward expansion via its monumental art (Roe 1974:22) which relates these distant North Coast Cupisnique bottles to the Chavín de Huantar orbit.

Concerning vessel body form, Burger has illustrated similar sherds from his Janabarriu phase at Chavín de Huantar (1978:481, Figs. 281-283). These Janabarriu fragments are from reduction fired blackware stirrup-spout bottles that evidence the same kind of externally thickened and beveled "flange" rims (*ibid.*:186, 338) as the California Bottles.

This impression is also strengthened on the level of surface decoration. The parallels begin with a kind of deep incision found on the surface of the Janabarriu pottery. "The effect of this incision is not unlike some low relief applique modeling" (*ibid.*:211-212). It continues with a plethora of high relief modeled and incised appliqué similar to that found on the California Bottles. These devices include: nubbins (*ibid.*:22), fluting (*ibid.*:223), tierring (*ibid.*:224), and banding (*ibid.*:226). "An equally complex use of bands is one in which many bands and raised areas are used to form complex images from Chavín iconography" (*ibid.*:227). This describes a reduced black sherd which looks similar to the decoration on the vessels under study here.

Further, the high-relief decorated Janabarriu techniques are akin to "Rocas" ceramics from Chavín de Huantar (Burger 1978:265). Burger also notes a similarity to some heavy appliqué sherds recovered by Tello (*ibid.*:260). These sherds Julio Tello described congruently as made of "arcilla negra con ornamentación de figuras mitológicas en alto relieve" (1960:340, Fig. 161; 341, Fig. 162). In summation, the California Bottles relate to the Janabarriu ceramics of the eponymous site in both vessel form and surface decoration.

The Vessels: Iconography and Representational Meaning

I have already alluded to what Rowe (1967:77) refers to as the level of "convention and figurative expression" in Chavín art, principally its extensive use of the rhetorical device of "kenning" (*ibid.*:78) in the wing elements, breast mask, and other areas of the Cupisnique bird guardians. Now I will move on into what Rowe (*ibid.*:82) calls "representational meaning," the significance of the animals—were-animals and animal monsters—such as these birds that constituted what was obviously an intricate web of Chavín religious symbolism.

Lathrap (1973:94-95) develops a tri-leveled system of analysis into the symbolism of Chavín art which will guide the present investigation:

> We must now face squarely the very difficult problem of meaning in religious art. I would like to propose a tripartite division in this domain. A first level of meaning in religious art might be designated as formal . . . The realm of discourse is the stigmata which permit one to tell man from beast from deity and to distinguish the various species of animal. The formal rules for organizing these clues into total designs must also be treated in a grammar which permits an infinite number of unambiguous formulations. A second level of "meaning" . . . might be called mythic. Any visual expression of a religious system may depict the key incident of the myth or myth cycle which validates the religious system, and the key actor or actors in these myths . . . It is always easier to go from the myth to the concrete artistic expression than from a fossilized concrete expression to a full reconstitution of fossilized myths . . . of greatest interest to the anthropologist studying cultural evolution . . . A third level of meaning in religious art might be called structural. The numbering and ordering of iconographic elements in a particular concrete expression of a religious system may also reflect the organization of the

functioning social units of a society or the contrasting units in various other domains of culture.

The first, or "formal," level of the analysis of what the designs on these vessels may have originally meant to the culture that produced them leads to the question of what creature is represented here beyond just a "raptorial bird." It is not a hawk because the characteristic "hawk markings" (Yacovleff 1932) are not present. I agree with Rowe (personal communication, 1979) that the bird is a "crested eagle." However, where he favors the Black and Chestnut eagle,[23] I agree with Lathrap (1971:76); that it represents the tropical forest Harpy Eagle (*Harpia harpyja*). I do so not only because of the specifics of the pictorial depictions, but because Chavín has ". . . an iconography which emphasizes exotic animals . . . and plants today associated with the tropical lowlands to the east" (Burger and Burger 1980:27). Indeed, Lathrap (1971:75; 1973:95) has made a good case that all the major and some of the minor Chavín supernaturals came from the tropical forest including the jaguar (*Felis onca*), the black cayman (*Melanosuchus niger*), the anaconda (*Eunectes murinus gigas*), the howler monkey (*Mycetes seniculus*), and possibly the piranha (*Serrasalmus piraya*).

On Lathrap's second, or mythic level, of analysis, the Harpy Eagle functions in modern lowland oral tradition as the major companion of the sun. While the bulk of its symbolism connotes celestial and positive masculine qualities (Roe 1982), it is also true that all the major supernaturals, including the eagles, are dualistic, and have male and female manifestations with overlapping meanings (*ibid.*). I believe it is possible to decode this ancient highland and coastal art style with modern Peruvian jungle myths because of the increasing evidence for the tropical forest connections of Chavín, not just in supernatural animal metaphors as discussed above, but also in ceramics (Lathrap 1971) and in the use of jungle hallucinogens which elicit those symbols. Lathrap (1973:96) originally suggested the use of ayahuasca (*Banisteriopsis caapi*) and *Piptadenia* snuff in the context of Chavín shamanism. Most recently, Alana Cordy-Collins has argued persuasively for both the snuff (1980:86) and the liquid (*ibid.*:91) psychotropic agents as explanations for stylistic elements in Chavín art.

The male "Staff God" which Cordy-Collins associates with ayahuasca-kenned snake staffs is truly masculine in sex. It has what I call a "male girdle face." Both Lyon (1979:95) and I (Roe 1978:23) independently identified an important Chavín figure (a version of which is depicted in Roe 1974:48, Fig. 14) as female. I did so on the basis of the two prominent eyes on this image's chest, which I believed to be breasts kenned as eyes since they were absent on the "male" depictions of the same character. Another obvious key to the female nature of this figure is the *vagina dentata* of the pelvic region. The *vagina dentata* is a key mythic prop in lowland oral traditions (Roe 1981). The Chavín "male" Staff Gods, on the other hand, have either a plain "double snake-head belt" and G-string with no pubic covering (Roe 1974:49, Fig. 15) or a simple triangular pubic covering located in the middle of the snake-head belt (*ibid.*, Fig. 16). The latter element probably represents a stylized breechclout.

23. "There are several crested eagles in South America, and one of them, the Black and Chestnut Eagle (*Oroaetus isidori*), has a range much closer to Chavín than the Harpy Eagle. It is quite possible that the people of Chavín lumped all crested eagles together, but the one they would see most often would be the local species." Lathrap (1971:76) has already considered and rejected this species through a comparison of its beak development with the stone sculptural eagles. Even if the Black and Chestnut Eagle was the one most seen because of its *ceja de montaña* habitat, it could still have represented the widespread and more impressive lowland species through a process of "mythological substitution," whereby a local species is made to fulfill the functions of a different original species as is common in the lowlands today (Weiss 1975:490) and on the coast in the archaeological past where local foxes (Sawyer 1966:108), otters (*ibid.*:123) and ocelots (*ibid.*:124) replaced the Chavín jaguar.

Then I noticed that on major deities this belt-G-string was more elaborate; and, in specimens like the male "falcon" angel of the Black and White Portal (Rowe 1967:100, Fig. 8) the triangular pubic covering is replaced by a "pelvic face" whose central canine metaphorically replicated the triangular breechclout. Perhaps, it occurred to me, this triangularly-pointed tooth also stood for the penis? Then I noted in confirmation that this figure's "female" counterparts, such as the female "Harpy Eagle" angel of the Black and White Portal (ibid., Fig. 9) lack a front face with central fang and have instead two opposed toothy faces forming a *vagina dentata*. I then noted that other Harpy Eagles from earlier periods were also female because of their opposed pelvic *profile* mouths (ibid., Fig. 11), while other contemporary eagles were male (ibid.:101, Fig. 12, 13 - my Fig. 5a) because they had a continuous *front* face mouth with a central canine. Later analogous versions (ibid., Fig. 14 - my Fig. 5b) were also male because they had the same traits. The Cupisnique Harpy Eagle guardians under discussion here are also obviously male, and for the same stylistic reasons. Only in their case, because of space constraints, their frontal face pelvic masks have become breast masks. Since in the stone sculpture and in ceramics we have either male and female eagles and hawks, what are the differences in symbolism between them?

Cordy-Collins has, I believe, clearly identified male staff gods with hallucinogens like ayahuasca and *Piptadenia* snuff (1980:89, Fig. 5; 91, Fig. 6). However, these associations are not exclusively masculine since a female eagle (Rowe 1967:100, Fig. 11) has the snuff-induced "mucus strings" ascending from its nose to join its head curls (feathered crests). While I believe she has correctly identified the plant-rayed emanations on Chavín "Staff Gods" as Peruvian cotton (*Gossypium barbadense*), I disagree that they are characteristic of the "Staff God." Instead, they are the exclusive traits of the "Staff Goddess" (ibid.:59, Fig. 21; Roe 1974:48, Fig. 14) because in all instances they are on females with *vagina dentatas* while the males lack them.[*]

This pattern of associations correlates with the lowland data of a connection of the earth and vegetative growth with females (Roe 1981). With the redundancy of myth, the round bolls of the cotton (Cordy-Collins 1979:53, Fig. 4; 59, Fig. 24) are additionally feminine because in the lowlands round plants, especially fruits, and other objects are associated, as hollow containers, with the round bellies and wombs of females (Roe 1982).

What this means with regard to the eagle and hawk guardians and angels is that the male specimens might have participated in the male domain of the sky (from the eastern horizon to the zenith) and that the females might have participated in the female (earth-connected) domain of the sky (from the zenith to the western horizon and underworld). As analogs of the King Vultures of the lowlands, these female birds may have qualified the masculine celestial world. At present, these are speculations based on analogous lowland myths, but they do serve as hypotheses for future iconographic decoding and as explanatory aids in the present inquiry. For example, the male Harpy Eagle guardians of the California Bottles are separated from each other by curious S-shaped elements on all three bottles. If Lyon's earlier speculations on the female connotations of these elements are right, then these motifs occupy their places not as meaningless space-fillers, but as meaningful short-hand notations of paired female presence between the opposed paired male eagles.

[*]Cordy-Collins' 1979 publication was originally submitted for publication in 1973 when the term "Staff God" was a generic one, and was not used to indicate specifically a male deity. Cordy-Collins has subsequently joined forces with Lyon and Roe in support of a dualistic Staff Deity ("The Dual Divinity Concept in Chavín Art," *El Dorado*, 1980). — A.C.-C.

The last level of analysis of Chavín art exemplified in these vessels and in analogous monuments is what Lathrap termed the "structural" level. This level includes any information which may be derived from the correlations, oppositions, juxtapositions, or hierarchical relations within the designs which, with the aid of comparative sociological or psychological data, could be used to conjecture about the social organization or ideology of the society which produced the art. In what John Fischer (1961:80) calls the "latent content" of art style, several things are self-evident in Chavín artifacts. A high degree of craft specialization and patroniage is indicated by the quality and scale of art work in textiles, metallurgy, ceramics, bone, and stone attributed to the Chavín culture or Chavínoid cultures. Next, its hierarchically stratified organization is mirrored in the complexity of the supernaturals pictured in the art style if one uses Fischer's (ibid.:81) correlations between artistic complexity—the integration of a large number of unlike elements—and social complexity. The specific nature of the depictions can also be used to argue for this position. The high development of Chavín graphic and plastic arts argues for the fixity of artists within local nucleated settlements (Wolfe 1969:4) and the separation of artists, perhaps males, by the barriers of differentiated sodalities, occupational groups, classes, or castes which necessitates communication, via art, between the groups (ibid.:11).

With regard to specific stylistic devices, the comparative data strongly accord with this picture. Claude Lévi-Strauss (1967) has already argued for the correlation of intensive stylization, schematization, and split-representation (all devices which Chavín art shares with the Shang-Chou and Northwest Coast art he analyzed) and the splitting between the biological individual and his social role, which is characteristic of hierarchical society with individuals enmeshed in prestige struggles, "mask cultures" as he calls them. The prevalence of "masks" in Chavín art could support this position.

The Chavín bias for little irrelevant (empty) background space in the design field (Fischer 1961:81), a horror vacui, which becomes increasingly marked as the style evolves (Roe 1974:25), the presence of strong enclosures around figures (Fischer 1961:81), which also intensifies in the rectilinearization of the later Chavín art (Roe 1974:8), all point to the rigid social order of Chavín society.[24]

On the level of projecting individual Chavín artists' personalities into their art work, there is additional congruent evidence. The following graphic conventions occur in Chavín art which have been given psychological significance in the literature: lack of background, relative nudity of human figures together with extreme ornamentation, generally compressed design, tendency to outline form-elements carefully in black, emphasis on ornate headgear, horror vacui, complexity of design, profusion of tiny form figures, tendency to give human figures short necks and thick wrists, and the tendency to present human heads, and often torsos, in profile (Wallace 1971:26-27). While the shortcomings of these Western-culture derived correlations are all too evident, they all argue for (but unfortunately without the possibility of modern verification in the case of Chavín) a reading similar to the "stereotyped social façade; shallowness of emotional relationships to other people and the preoccupation with oral

24. The only exception is Fischer's (1961:81) hypothesis that symmetrical design characterizes egalitarian and not stratified society. This is clearly not the case in Chavín art where bilateral symmetry within figural designs (Cordy-Collins 1980:92) and whole design fields (Cordy-Collins 1979:55, Figs. 11,12) comprise a hallmark of the style. However, it is also clear that the symmetry of a Chavín depiction on a vessel is not the symmetry of a design on an Acoma pot. Large-scale asymmetrical design details (ibid.:57, Figs. 17,18) show that Chavín art is capable of both symmetry and asymmetry. This measure of Fischer's will have to be refined more before it can be used comparatively.

and phallic rituals" which Anthony Wallace drew for the Classic Maya (ibid.:24) and which agree with the general inferences of hierarchy derivable from an analysis of the art style.

On the level of what Fischer (1961:80) calls the "overt, or representational content" of Chavín art, some interesting congruent conjectures can also be made. The earlier cat/bird guardian of these Cupisnique Phase C-D ceramics is supplemented in Phase D by essentially human (complete with torso, arms and legs but still retaining the animal "heel spur" [Cordy-Collins 1979:55]) angels with "were-cat" and "were-bird" attributes. Examples of this trend are the already discussed Black and White Portal angels. Together with the greater frequency of the appearance of human figures as naturalistic subsidiary elements in the style beginning in Phase C (Roe 1974:20-21), this anthropomorphization of what were originally—save for the Lanzón —purely animal depictions (ibid.:9) hints at a parallel kind of process to what J. Eric S. Thompson (1970) has documented for the Maya. That process is a shift away from the animistic-shamanistic basis of Chavín art (Cordy-Collins 1977; Sharon and Donnan 1977) to a more anthropocentric stratified organization where priests worshipped increasingly anthropomorphic deities.[25]

Summary and Conclusions

Recent treatments of Chavín-related North Coast art (Moseley and Watanabe 1974:155) have emphasized the regional autonomy of the Cupisnique, or coastal Chavín, style. My present attempt to date depictions on a cache of Cupisnique stirrup-spout vessels based on their similarities to the lithic art of Chavín de Huantar in the Central Highlands does not mean that I am unaware of the difficulties of seriating across topography and regional styles. Rather, this reliance upon Chavín de Huantar's sculpture to define Chavín art reflects the uncertainty of the present definition of Cupisnique as a coherent stylistic unit with discernible subphases. Until we have such a definition, the central sequence must be our point of departure.

Using the relative seriation of lithic art from Chavín de Huantar, the authenticity and dating of these three huaquero-discovered bottles found near Tembladera in the Jequetepeque or Pacasmayo Valley of the North Coast of Peru has been determined. These stirrup-spout bottles are representative of a class of heavily modeled and incised deep-relief black monochrome ware which carries depictions of mythic Chavín figures. In this case, the depicted supernatural is the male Harpy Eagle guardian figure, a major subsidiary animal metaphor. By analogy with current lowland myths, this creature may have been associated with the sun and the positive masculine domain of the celestial vault from the eastern horizon to the zenith.

Stylistically, a direct comparison of the ceramic designs from the California Bottles with those of the stone relief sculpture yields a placement of the vessels span-

25. If, as I believe, the evidence for the early close connections of the Chavín art style with the jungle is persuasive, and if the evidence is clear as to the dependence of much of the symbolism of the art is on the shamanistic taking of hallucinogens, as is characteristic today of tribal societies in lowland South America, we may be justified in employing the concept of "culture lag" in investigating the iconography of Chavín. In other words, although Chavín appears to have been a state, maybe even a "pristine state" by Phase A times, its symbolism more accurately may have reflected the concerns of tribal, or chiefdom-level shamanism with its animistic bias (Roe 1982) out of which it had originally come, than the complex character of the then current supporting institutions which in contemporary stratified highland contexts lead to a more anthropocentric view (Bastien 1978:37). This conservatism of anachronistic symbols is commonplace in the anthropological study of art style, symbolism, and culture change (Adams 1974:336); there is no reason why it cannot be applied to Chavín as well. However, since the "hierarchy of culture" is a homeostatic mechanism, this temporary manifestation of culture lag was bound to change. In Phase C and later times the art style began to reflect more accurately the radical hierarchical changes which had accompanied the origin of the Chavín state (Swanson 1960).

ning the division between Phases C and D of the monumental sculptural sequence. Being conservative regional representatives of the earlier zoomorphic tendencies of Chavín religious art, the figures appliquéd, modeled, and incised on these vessels throw light on the increasingly anthropomorphic evolution of a major subsidiary character of Chavín iconography.

Bibliography

Adams, Marie Jeanne
 1974 "Symbols of the Organized Community in East Sumba, Indonesia." *Bijldrazen voor Taal-Land-en Volkerkunde* 130:324-347.

Armstrong, Robert Plant
 1971 *The Affecting Presence: An Essay in Humanistic Anthropology.* Urbana: University of Illinois Press.

Bastien, Joseph W.
 1978 *Mountain of the Condor: Metaphor and Ritual in an Andean Ayllu.* American Ethnological Society Monograph 64. St. Paul: West Publishing Company.

Burger, Richard Lewis
 1978 "The Occupation of Chavín, Ancash, in the Initial Period and Early Horizon." Unpublished Ph.D. Dissertation, Department of Anthropology. Berkeley: University of California at Berkeley.

——————————— and Lucy Salazar Burger
 1980 "Ritual and Religion at Huaricoto." *Archaeology* 33:26-32.

Bushnell, G. H. S.
 1957 *Peru.* New York: Frederick A. Praeger, Publishers.

Carrión Cachot, Rebeca
 1948 "La cultura Chavín. Dos nuevos colonias: Kuntur Wasi y Ancón." *Revista del Museo Nacional de Antropología y Arqueología* 2(1):99-172. Lima.

Cordy-Collins, Alana
 1976 "An Iconographic Study of Chavín Textiles from the South Coast of Peru: The Discovery of a Pre-Columbian Catechism." Unpublished Ph.D. Dissertation, Institute of Archaeology. Los Angeles: University of California at Los Angeles.
 1977 "Chavín Art: Its Shamanistic/Hallucinogenic Origins." *In* Alana Cordy-Collins and Jean Stern, eds. *Pre-Columbian Art History: Selected Readings.* Palo Alto: Peek Publications. Pp. 353-362.
 1979 "Cotton and the Staff God: Analysis of an Ancient Chavín Textile." *In* Ann Pollard Rowe, Elizabeth P. Benson, and Ann-Louise Schaffer, eds. *The Junius B. Bird Pre-Columbian Textile Conference.* Washington, D.C.: The Textile Museum and Dumbarton Oaks Research Library and Collections. Pp. 51-60.
 1980 "An Artistic Record of the Chavín Hallucinatory Experience." *The Masterkey* 54(3):84-93.

Fischer, John L.
 1961 "Art Styles as Cultural Cognitive Maps." *American Anthropologist* 63:79-93.

Kano, Chiaki
 1979 *The Origins of the Chavín Culture.* Studies in Pre-Columbian Art & Archaeology 22. Washington, D.C.: Dumbarton Oaks Research Library and Collections.

Larco Hoyle, Rafael
 1938 *Los Mochicas.* Vol. 1. Lima: Casa Editorial "La Cronica."
 1941 *Los Cupisniques.* Trabajo presentado al Congreso Internacional de Americanistas. Lima: Casa Editora "La Cronica" y "Variadades."
 1963 *Las épocas peruanas.* Lima.
 1966 *Peru.* James Hogarth, trans. Cleveland: World Publishing Co.

Lathrap, Donald Ward
 1971 "The Tropical Forest and the Cultural Context of Chavín." *In* Elizabeth P. Benson, ed. *The Dumbarton Oaks Conference on Chavín, October 26th and 27th, 1968.* Washington, D.C.: Dumbarton Oaks Research Library and Collections. Pp. 73-100.
 1973 "Gifts of the Cayman: Some Thoughts on the Subsistence Basis of Chavín." *In* Donald Ward Lathrap and Jody Douglas, eds. *Variation in Anthropology: Essays in Honor of John C. McGregor.* Urbana: Illinois Archaeological Survey. Pp. 91-105.

251

Lévi-Strauss, Claude
1967 "Split Representation in the Art of Asia and America." *In* Claude Lévi-Strauss, ed. *Structural Anthropology,* Claire Jacobson and Brooke Grundfest Schoepf, trans. Garden City: Doubleday & Co. (Anchor). Pp. 239-263.

Lumbreras, Luis Guillermo
1971 "Towards a Re-evaluation of Chavín." *In* Elizabeth P. Benson, ed. *The Dumbarton Oaks Conference on Chavín, October 26th and 27th, 1968.* Washington, D.C.: Dumbarton Oaks Research Library and Collections. P. 1-28.

1977 "Excavaciones en el Templo Antiguo de Chavín (sector R): Informe de la sexta campana." *Nawpa Pacha* 15:1-38,Lám. I-XX.

───────────────── and Hernán Amat Olazabal
1969 "Informe preliminar sobre las Galerías Interiores de Chavín: Primera temporada de trabajos." *Revista del Museo Nacional de Antropología y Arqueología* 34:143-197. Lima, 1965-1966.

Lyon, Patricia
1979 "Female Supernaturals in Ancient Peru." *Ñawpa Pacha* 16: 95-140. Plates XXVII-XXXIV.

Maquet, Jacques
1971 *Introduction to Aesthetic Anthropology.* A McCaleb Module in Anthropology. New York: Addison-Wesley.

Moseley, Michael Edward and Luis Watanabe
1974 "The Adobe Sculpture of Huaca de los Reyes: Imposing Artwork from Coastal Peru." *Archaeology* 27:154-161.

Munro, Thomas
1963 *Evolution in the Arts and Other Theories of Culture History.* The Cleveland Museum of Art. New York: Harry N. Abrams, Inc.

Proulx, Donald A.
1973 *Archaeological Investigations in the Nepeña Valley,* Peru. Research Report 13, Department of Anthropology. Amherst: University of Massachusetts.

Roe, Peter G.
1974 *A Further Exploration of the Rowe Chavín Seriation and Its Implications for North Central Coast Chronology.* Studies in Pre-Columbian Art & Archaeology 13. Washington, D.C.: Dumbarton Oaks Research Library and Collections.

1978 "Recent Discoveries in Chavín Art: Some Speculations on Methodology and Significance in the Analysis of a Figural Style." *El Dorado* 3(1):1-41.

1980 "Art and Residence Among the Shipibo Indians of Peru: A Study in Microacculturation." *American Anthropologist* 82:42-71.

1982 *The Cosmic Zygote: Cosmology in the Amazon Basin.* New Brunswick: Rutgers University Press.

Rowe, John Howland
1967 "Form and Meaning in Chavín Art." *In* John Howland Rowe and Dorothy Menzel, eds. *Peruvian Archaeology, Selected Readings.* Palo Alto: Peek Publications. Pp. 72-103.

1971 "The Influence of Chavín Art on Later Styles." *In* Elizabeth P. Benson, ed. *The Dumbarton Oaks Conference on Chavín, October 26th and 27th, 1968.* Washington, D.C.: Dumbarton Oaks Library and Collections. Pp. 101-124.

Sawyer, Alan R.
1966 *Ancient Peruvian Ceramics: The Nathan Cummings Collection.* The Metropolitan Museum of Art. Greenwich: The New York Graphic Society.

Sharon, Douglas G. and Christopher B. Donnan
1977 "The Magic Cactus: Ethno-Archaeological Continuity in Peru." *Archaeology* 30:374-381.

Swanson, Guy E.
1960 *The Birth of the Gods: The Origin of Primitive Beliefs.* Ann Arbor: University of Michigan Press.

Tello, Julio C.
1956 *Arqueología del Valle de Casma. Culturas: Chavín, Santa o Huaylas Yunga y Sub-Chimú.* con revisión de Toribio Mejía Xesspe. Publicación Antropológica del Archivo "Julio C. Tello" I. Lima: Imprenta de la Universidad Nacional Mayor de San Marcos.

1960 *Chavín, cultura matriz de la civilizacion Andina.* Primera Parte. con revisión de Toribio Mejía Xesspe. Publicación Antropológica del Archivo "Julio C. Tello" II. Lima: Imprenta de la Universidad Nacional Mayor de San Marcos.

Thompson, J. Eric S.
1970 *Maya History and Religion.* Norman: University of Oklahoma Press.

Wallace, Anthony F. C.
 1971 "A Possible Technique for Recognizing Psychological Characteristics of the Ancient Maya from an Analysis of Their Art." *In* Carol F. Jopling, ed. *Art and Aesthetics in Primitive Societies.* New York: E. P. Dutton. Pp. 11-29. Originally published in *American Image* 7(3):239-258, 1950.

Weiss, Gerald
 1975 *Campa Cosmology: The World of a Forest Tribe in South America.* Anthropological Papers 52, Part 5. New York: The American Museum of Natural History.

Willey, Gordon R.
 1971 *An Introduction to American Archaeology: Volume 2, South America.* Englewood Cliffs: Prentice-Hall.

Wolfe, Alvin W.
 1969 "Social Structural Bases of Art." *Current Anthropology* 10:3-29, 42-44.

Yacovleff, Eugenio
 1932 "Las falcónidas en el arte y las creencias de los antiguos Peruanos." *Revista del Museo Nacional de Antropología y Arqueología* 1:35-111. Lima.

Acknowledgments

I wish to express my thanks to the keeper of this collection for allowing me to examine it and for his recognition of the aesthetic and scientific importance of these Cupisnique bottles. Thanks also go to Alana Cordy-Collins for her encouragement of this study of materials which she had already independently begun to work on and for her efforts to pursue the original circumstances of these bottles' excavation, both via the structuring of questions and interviewing in the U.S. and in Lima, Peru. I would also like to express my debt to John Rowe for his helpful comments on two earlier versions of this paper. Richard Burger was also kind enough to offer me some insights based on his work with Chavín ceramics. The help of these experts, however, should not be construed to mean their agreement with all of the views I have expressed herein.

The Chronological Relationship of the Linear, Block Color, and Broad Line Styles of Paracas Embroidered Images

Anne Paul
Department of Art
University of Georgia, Athens

All too often, once an art historical study has been done, it is generally assumed that no further benefits or insights may be obtained from further analyses of that material. That supposition is confronted by the present study of the Paracas embroideries from south coastal Peru. Herein the accepted interpretation that chronology alone can explain style change is challenged by another interpretation: that style differences may also reflect an attempt to communicate different kinds of information.

TWO THOUSAND YEARS AGO the leaders of a south coast Peruvian culture known today as Paracas wore splendid woven garments that were decorated with images embroidered in vivid colors. Cloaked in magnificent mantles that concealed tunics, ponchos, skirts, and loincloths, these rulers moved against the backdrop of the arid desert landscape of the Paracas Peninsula and the verdant plains of the nearby Pisco River Valley (Figures 1 and 2). When each leader died, he was carefully wrapped with the precious garments worn in life, with other textiles presented as gifts, with quantities of plain cloth, and with various items of ritual paraphernalia. The burial bundles were interred in different zones of the peninsula, where they remained undisturbed until the early part of this century.

In the late 1920's, the Peruvian archaeologist Julio C. Tello excavated one of these burial precincts, called the Necropolis, and found 429 mummy bundles of different sizes. Nearly fifty of the largest of the Necropolis bundles were unwrapped by Tello and his associates. The ideas presented here are based on my study of the contents of these opened bundles, which date from the Early Horizon Period Epoch 10 through the Early Intermediate Period Epoch 2 (approximately 450 B.C. to 150 B.C.). This essay focuses on the *style* of Paracas embroidered images. After reviewing the characteristics of two styles previously defined in the literature on Paracas, I will describe a distinct third style of embroidery. I will then discuss the chronological relationship of these three styles, with special attention given to the distribution of garments decorated in the third style. This critical examination of the third style and its

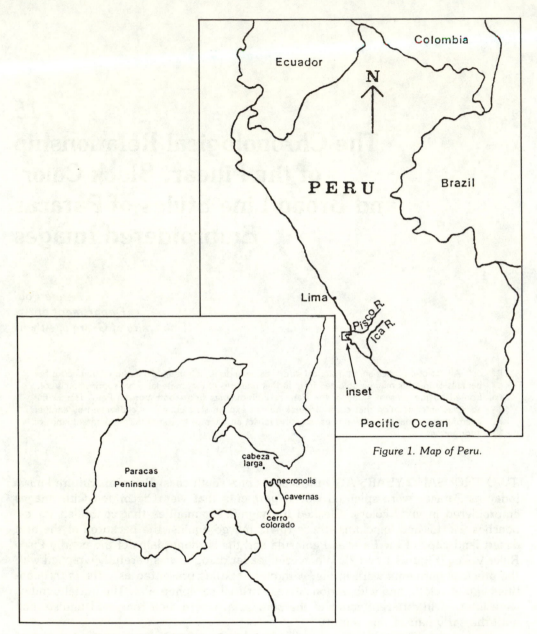

Figure 1. Map of Peru.

Figure 2. Map of Paracas Peninsula.

limited spatial distribution revises past interpretations of the chronology and stylistic meaning of Paracas embroideries.

I. *The Formal Organization of Embroidered Images*

The Linear Style

Numerous scholars have noted that Paracas embroidered images fall into different stylistic groups. The first group, called the linear, style by Jane Dwyer (n.d.), emphasizes the geometric form of figures by creating an image whose contour is

based on straight horizontal, vertical, and diagonal lines (Figures 3 and 4).[1] In this style "all elements of the design figure are created by a series of narrow, closely spaced parallel lines" (Dwyer n.d.: 86). Thin lines of different colors are inscribed in conventionalized arms, legs, tails, eyes, noses, and mouths; forms do not overlap. The torso of a primary figure contains smaller figures, and the spaces surrounding it are filled with miniature images. There are no large solid areas of color in the design unit.

Other authors have described linear style images under different names. Rebeca Carrión Cachot labeled this style group "figures with straight outlines" (1931) and "geometric" (1949); Eugenio Yacovleff and Jorge C. Muelle (1934) and Cora E. Stafford (1941) also referred to this style of figure as "geometric" or "geometrical." Alan Sawyer's (1966) term for this style is "Cavernas-related Necropolis style," while George Kubler (1962) has chosen the terms "plectogenic" or "rectilinear" style. I prefer Dwyer's terminology for several reasons. First, since it is possible to have a geometric image executed in a style that is not linear, the term "geometric" as a style designator can be confusing. Second, "Cavernas-related Necropolis style" does not describe the distinguishing feature of the style. Third, while "plectogenic" accurately describes a style that imitates, in embroidery, the structural limitations of the loom technique ("plecto": weaving; "genic": derived from), "linear" or "rectilinear" is more straightforward and is a better term for images that are embroidered rather than woven.

Although linear style images have been accurately described in previous literature, the conceptual attitude expressed by this style has rarely been considered. Yacovleff and Muelle (1934:144) remarked upon the ideographic qualities of this style and said that all linear images were religious in nature. Kubler (1962:296) also observes that the linear style is ideographic rather than pictorial, noting that it "permitted kinds of statements impossible with a pictorial system based on visual effect." None of these scholars developed these arguments further, possibly because of the limitations imposed on their work by the small number of black and white drawings available at the time they were writing. With more data from the burial bundles now available, it is possible to build upon their contributions.

In linear style images (Figures 3 and 4) the color of the "background" is always the dominant color of the head, torso, and limbs of the figure; details such as the eyes, mouth, nose, and inscribed images are embroidered with threads of a different color. The distinction between figure and ground is minimized as the two become interlocked on the same color plane. The transparency of the figure, in conjunction with the fact that a multitude of narrow lines prevents the eye from focusing on any detail, results in an image that is visually elusive.

Anthropomorphic images embroidered in the linear style, such as those illustrated in Figures 3 and 10, do not wear garments and adornments. They are usually depicted empty-handed, although some examples have a trophy head, small triangular-shaped knives, or spears suspended or projecting from the hands. Zoomorphic images, such as felines and birds, are not identifiable by species.

The linear style was very traditional in that it was not subject to major iconographic and stylistic changes over time, a fact revealed by Dwyer's (n.d.) stylistic and thematic seriation of Paracas textiles and by my own examination of material from the Necropolis bundles. While there are fewer than thirty different types of images executed in the linear style, any single linear style image generally appears in a great

1. The term "linear" was proposed by Lawrence Dawson (Jane Dwyer, personal communication, 1980). Dwyer (n.d.) worked out the definition of the term.

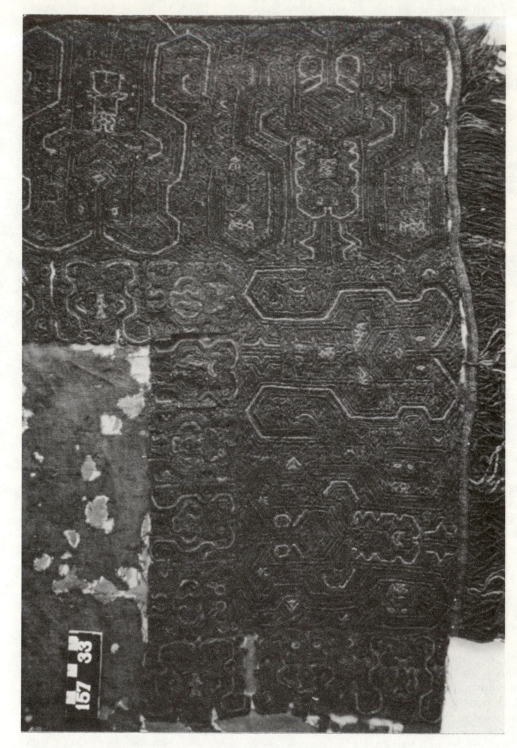

Figure 3. Detail of specimen 33, bundle 157 (mantle). Early Horizon 10B. Museo Nacional, Lima. Photograph by the author.

258

Figure 4. Detail of specimen 26, bundle 157 (*mantle*). Early Horizon 10B, Museo Nacional, Lima. Photograph by the author.

number of bundles and is distributed over a long period of time.

The formal characteristics of the linear style—that is, those stylistic features which make it visually elusive—together with the absence of elements of costume and details that allow identification of animal species, suggest that linear style images are representations of abstractions rather than physically real objects.

The Block Color Style

The second method of constructing forms in Paracas embroidery is referred to by Dwyer (n.d.) as the block color mode. Figure 5 illustrates a feline in the block color mode. This style "consists of forms created with solid color areas rather than with the numerous multicolored parallel lines" (*ibid.*:87). Curved and rectilinear shapes are first outlined with small stitches and then each shape is filled in entirely with one color of thread. In most instances the background areas are not filled with secondary figures.

An image rendered in the block color mode is depicted part by part. The characteristic pose of an anthropomorphic image, such as that seen in Figure 6, presents and combines the most informative aspects of the parts of the body: the head and torso are looked at frontally to provide maximum information about headdresses, marks, and costuming; legs are shown in profile to reveal the most prominent feature of the human leg, its ability to bend; feet are represented simultaneously from the side and top in order to show both the arch and toes; and hands are shown from the broadest point of view so that fingers can be articulated.

Figure 5. Detail of specimen 18, bundle 378 (skirt). Early Intermediate 1B. Museo Nacional, Lima. Photograph by the author.

260

Figure 6. Detail of specimen 1, bundle 310 (mantle). Early Intermediate 1B. Museo Nacional, Lima. Photograph by the author.

The careful delineation of opaque parts within a block color mode figure, and the absolute demarcation of figure and ground, produce an image that is visually clear and legible. Forms overlap, suggesting limited depth relationships, although there is no use of foreshortening nor modeling. This style of representation produces images that are corporeal in comparison to the intangible linear style figures.

The term "block color" mode was first proposed by Lawrence Dawson (Dwyer n.d.:86); Dwyer (*ibid.*) defined and published the term in her thesis on Paracas textiles. This style of embroidery had previously been given many labels, none of which is as satisfactory as the one adopted by Dwyer. Carrión (1931) referred to these images as "figures with curved outlines," even though some figures have curved *and* straight outlines; she later (1949) subdivided that stylistic group into "natural" images of realistically represented animals and "mythological" figures which she called gods. These distinctions are iconographic rather than stylistic and, therefore, do not seem appropriate as terms for the style. Yacovleff and Muelle (1934) called this second style "seminaturalistic"; Stafford (1942) used the term "plastic convention-alized" style; and Sawyer (1966) employed the label "naturalistic." None of these terms describes the formal organization of a block color image.

Kubler (1962:292-297) isolates three stylistic groups among the images described by Dwyer as block color mode figures. Two of these three groups are "dimorphic"—that is, forms are both rectilinear and curvilinear. The first of these dimorphic groups has "static anthropomorphic and animal figures of simple contour," while the second has "animated figures rendered by overlapping planes." There are difficulties inherent in these distinctions. First, since images in both of Kubler's dimorphic groups have overlapping planes, this particular feature cannot be used to distinguish between them. Second, "static" and "animated" describe poses rather than style. Block color mode figures are depicted in one of five different poses which I call the bent body pose, the bent head pose, the forward bent body pose, the inverted head pose, and the static pose. I view pose as an attribute of a given image rather than as a style designator. Thus, the difference between "static" and "animated" is iconographic rather than stylistic. Kubler's third stylistic group is called "curvilinear only." He describes this mode as more complex and ornate than the other modes, with contorted figures, indented contours, and a multiplication of attributes. The definition of this group is somewhat unclear, for the illustrations that accompany the text show figures with *both* curvilinear and rectilinear forms. It is difficult to see how this group is stylistically different from the dimorphic groups; a compounding of attributes does not necessarily imply a different style.

The results of Dwyer's (*ibid.*) work on Paracas textiles show that the block color style was technically, compositionally, and iconographically more innovative than the linear style. The artist embroidering in the block color style used a broader spectrum of colors, experimented with methods of depicting forms in more naturalistic ways, and introduced many new images. My data indicate that in the Necropolis sample there are approximately four times as many different images executed in the block color mode as there are in the linear style. However, it is important to note that any one of these images appears in only a few bundles. While there is a great variety of block color mode images, there is a limited use of any particular image. Furthermore, when one type of image appears in more than one bundle, those bundles are often roughly contemporary. This distribution is very different from that described for linear style figures. Here, a single image was not shared by many persons and was not in continual use throughout the cultural sequence represented by the Necropolis bundles. Rather, a given block color mode image is normally identified with only a few bundles, or with the individuals in those bundles.

The block color style, in contrast to the linear style, usually records elements of the visible world as it was known on the Paracas Peninsula. This style facilitated the rendering of carefully observed physical beings and objects. It depicts figures dressed in the same types of garments and ritual paraphernalia actually present in the burials of the members of Paracas society, as well as some of the animals which in fact lived in the region (although it never represents them in a naturalistic setting). This style focuses on the careful description of tangibles, such as the regalia of offices or the salient characteristics of a specific animal.

The Broad Line Style

While the linear and block color modes have been defined in the earlier literature on Paracas, there is a third style which has not been previously isolated. The "broad line" style is illustrated in Figures 7 and 8.

As in the linear style, straight lines predominate, although curved lines do appear. However, in the broad line style a single broad line of a solid color replaces the numerous thin multicolored lines used to define a form in the linear style. Limbs and appendages often have a thin line of the background color down their center, and there are always major portions of the face and torso that are embroidered with threads of the ground color; the background of the figure is part of the figure itself. The resulting transparency creates an image that is locked into its background, much like linear style figures. The broad line style shares other qualities with the linear style: the areas around the central figure are filled with small images, the torso of the primary figure may contain miniature figures, and forms do not overlap.

Carrión (1931) included illustrations of figures in this third style with discussions of both her stylistic groups; Yacovleff and Muelle (1934) illustrated this style of figure as an example of their geometric style. Kubler (1962) and Sawyer (1966) do not include broad line style figures in their discussions; this omission may be due to the fact that without access to either the original material or good color photographs the distinctions between this style and the others are not always obvious.

Dwyer (ibia.:87) describes images that are executed in the third style, but she sees them as examples of an early phase of the block color mode. I believe, on the other hand, that the broad line style is formally different from both the block color and linear modes, but that it is formally, iconographically, and conceptually related to the linear style (compare Figures 9 and 10, 12 and 13). There are approximately twenty-five different broad line images in the Necropolis sample, many of which are iconographically similar to linear images. Anthropomorphic figures embroidered in the broad line style are usually shown without costumes and adornments, either empty-handed or "holding" a trophy head, small knife, or spears (Figures 7 and 9). Animals in this style include the felines, serpents, birds, and fish found in the linear style, as well as monkeys; none of these zoomorphic images is identifiable by species (Figure 8). As with linear style figures, the formal and iconographic characteristics of broad line depictions reveal a desire to represent abstractions rather than physically real objects. The distribution of broad line figures is very different from that of both linear and block color style images and will be discussed below.

II. *The Chronological Relationship of the Linear, Block Color, and Broad Line Styles*

According to Edward and Jane Dwyer's (1975) relative chronology for Paracas textiles, the linear and block color styles represent opposite ends of a developmental style sequence. The broad line style is not isolated in their chronology, but rather is

Figure 7. Detail of specimen 195, bundle 157 (tunic). Early Horizon 10B. Museo Nacional, Lima. Photograph by the author.

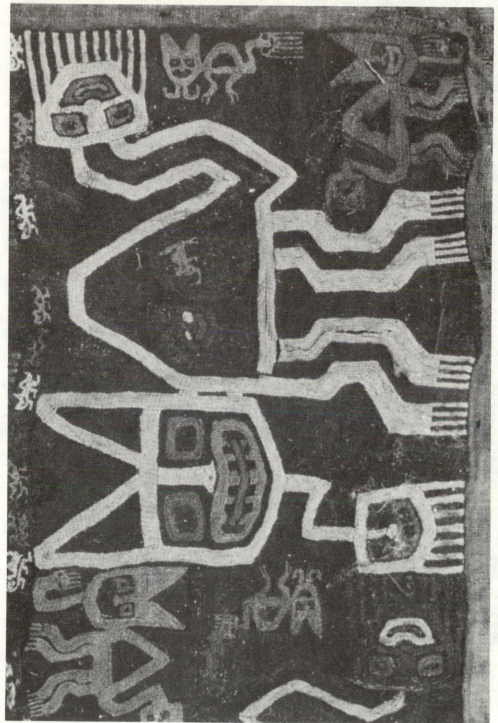

Figure 8. Detail of specimen 68, bundle 157 (tunic). Early Horizon 10B. Museo Nacional, Lima. Photograph by the author.

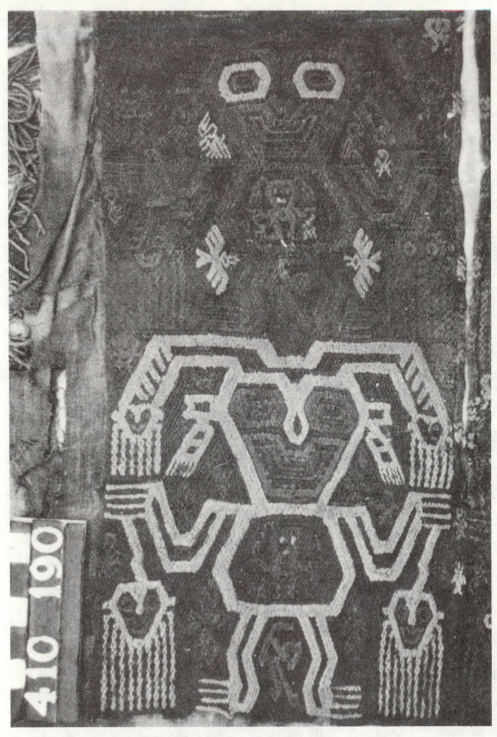

Figure 9. Detail of specimen 190, bundle 157 (tunic). Early Horizon 10B. Museo Nacional, Lima. Photograph by the author.

266

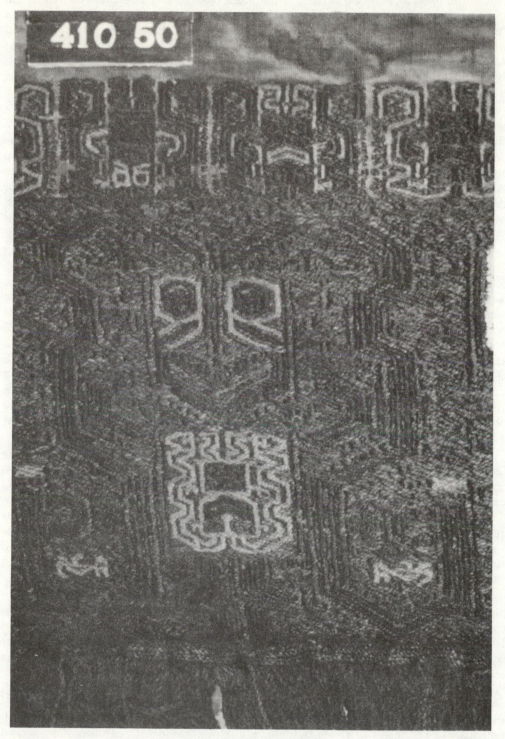

Figure 10. Detail of specimen 50, bundle 157 (mantle). Early Horizon 10B. Museo Nacional, Lima.
Photograph by the author.

considered to be an early expression of the block color mode. They believe that in the earliest phases there is a preference for the linear style, In the middle phases "development moves toward more realistic or naturalistic depictions" (ibid.:148), and in the latter part of the sequence there is a predominance of block color mode images. While not explicitly stated, it is implied that there is a single style development with the linear mode at one end of the continuum and the block color mode at the other (see also Jane Dwyer 1979).

Dwyer's (n.d.) stylistic and iconographic seriation of Paracas textiles utilizes a method called similiary seriation.[2] This procedure is based on the assumption that if one extreme of a sequence is known, the order in which changes take place can be determined by "arranging a continuous group of features and variations in a theme in order of their decreasing similarity to the known extreme" (Dwyer ibid.:9). The primary goal of Dwyer's (loc. cit.) seriation "was to determine those modifications or changes which might be indicative of chronological units and to establish a detailed sequence of these changes taking place over time."

The developmental sequence established by Dwyer is sound in many respects, but the weakness in the seriation approach is that it assumes that all stylistic and iconographic differences may be explained by chronology. While the linear and block color modes do represent some general chronological distinctions, as indicated by the fact that the earliest bundles have no block color mode images while the latest bundles have few or no images embroidered in the linear style, the majority of bundles throughout Early Horizon 10 and Early Intermediate 1 contain examples of both styles. Both styles appear throughout the layers of a bundle, with linear style examples often added on the outer levels of a bundle. For example, Figures 11 and 12 illustrate details from two mantles in Necropolis bundle 378. The garment decorated in the linear style was found on the outside of the bundle, while the garment embroidered in the block color style was closer to the body. This fact would seem to preclude the notion that garments with stylistically late images were added to an older bundle years after that bundle was placed in the ground.

Although the possibility exists that linear style weavings in late bundles were family heirlooms, older than other material in the bundle, I believe that the fact that approximately seventy-five percent of all examined Necropolis bundles contained examples of both styles indicates that the linear and block color modes were two distinct stylistic traditions that developed simultaneously through most of the Paracas culture sequence represented by the Necropolis bundles. Dwyer (ibid.:217-219) states that both the linear and the block color methods of formal construction were used simultaneously, oftentimes associated in the same gravelot or mummy bundle, but she does not explore the significance of their separate, simultaneous developments.

The linear and block color modes coexisted for approximately 250 years within peninsular Paracas culture. The Early Horizon 10A Necropolis bundles in my sample contained textiles decorated with linear style images only, but during Early Horizon 10B the block color mode was introduced as a style of textile embroidery (Dwyer ibid.: 86). While the genesis of the embroidered linear style was likely based in the structurally created designs of earlier Paracas textiles from Cavernas (Bird and Bellinger 1954:58), the origin of the block color style is unknown. Once introduced, however, it developed side by side with the other style, and in a few late bundles it is the only style represented. I think that one reasonable explanation for the simultaneous use of these two styles is that the different modes of representation served

2. This method was proposed by John H. Rowe (1961).

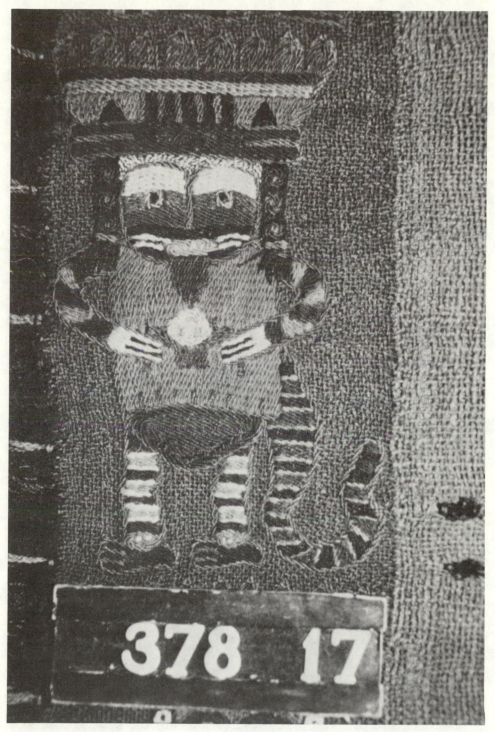

Figure 11. Detail of specimen 17, bundle 378 (mantle). Early Intermediate 1B. Museo Nacional, Lima. Photograph by the author.

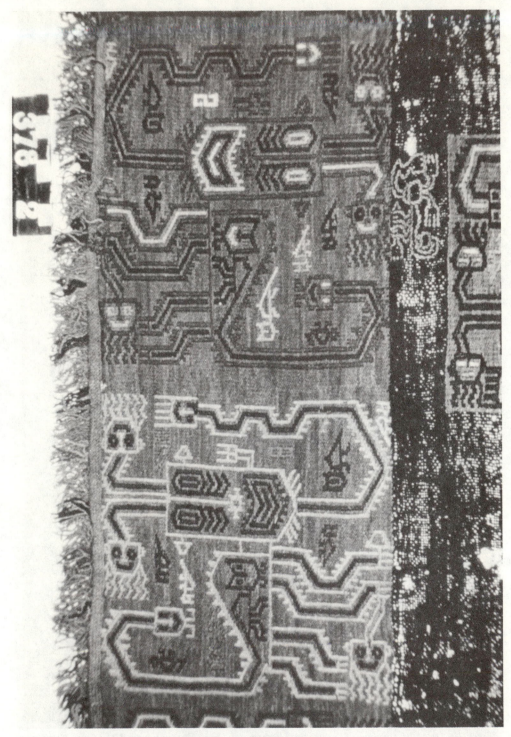

Figure 12. Detail of specimen 2, bundle 378 (mantle). Early Intermediate 1B. Museo Nacional, Lima. Photograph by the author.

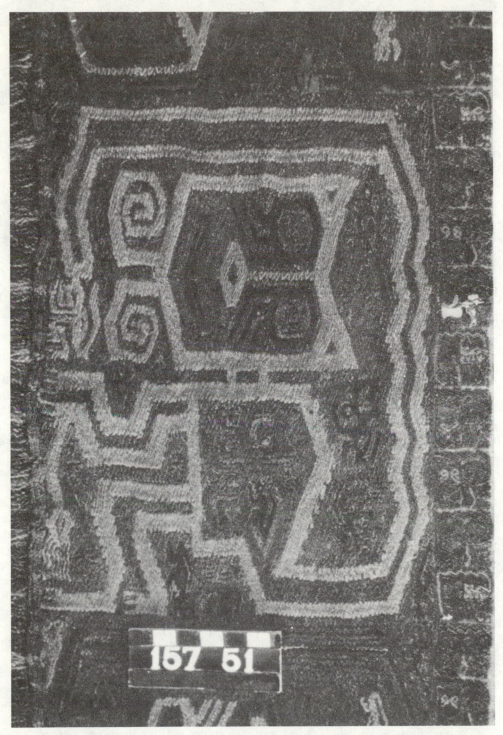

157 51

Figure 13. Detail of specimen 51, bundle 157 (mantle). Early Horizon 10B. Museo Nacional, Lima. Photograph by the author.

271

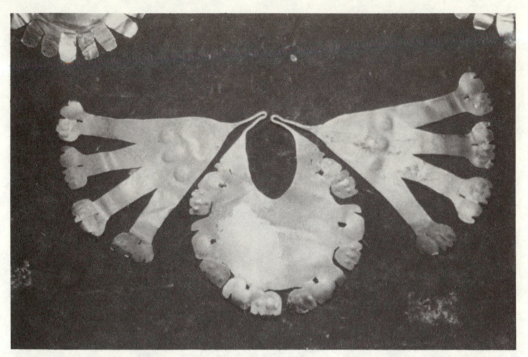

Figure 14. Gold nose ornament, specimen 173, bundle 157. Early Horizon 10B. Museo Nacional Lima. Photograph by the author.

distinct purposes. Dissimilar kinds of information could be communicated by the different styles. The older linear style was used for older traditional images, while the block color style probably arose in connection with the need for a new content. The complex relationship between these coeval traditions and the changing nature of the relationship can be more fully explained only after further study of the other opened Necropolis bundles.

While the linear and block color styles appear together in most of the opened Necropolis bundles, the broad line style has a very different distribution. Fifty percent of a total of 114 garments decorated with this style of embroidery come from one bundle, number 157. Bundle 157 (which also has the number 410) is an Early Horizon 10B bundle. It was the largest Necropolis bundle, containing approximately 120 embroidered garments, as well as 33 plain wrapping cloths placed within the bundle at five different levels. Included in this bundle were over forty small pieces of hammered gold (Figure 14 illustrates one), a unique fox headpiece made of leather and feathers (Figure 15), a wooden pendant which was possibly a mirror (Figure 16), and a stone club. Bundle 157 is unusual in another respect: after analyzing the dyes of red threads from over one-hundred Necropolis garments, Max Saltzman (personal communication, 1981) reported that only three were dyed with cochineal. All three samples came from bundle 157.

The size and uniqueness of the contents of bundle 157 suggest that the person buried in that bundle occupied a position of high rank within Paracas society. I hypothesize that the broad line style, so strongly associated with bundle 157, may have been a personal style of the important individual in this bundle.

Three other Necropolis bundles together contained twenty-seven percent of the garments decorated with the broad line style (Figures 17, 18, 19). One of these,

272

Figure 15. Fox mask, specimen 4, bundle 157. Early Horizon 10B. Museo Nacional, Lima. Photograph by the author.

Figure 16. Wooden pendant, possibly a mirror, specimen 163, bundle 157. Early Horizon 10B. Museo Nacional, Lima. Photograph by the author.

Figure 17. Detail of specimen 9, bundle 401 (mantle borders). Early Horizon 10B. Museo Nacional, Lima. Photograph by the author.

Figure 18. Detail of specimen 54, bundle 49 (tunic). Early Intermediate 1A. Museo Nacional, Lima. Photograph by the author.

Figure 19. Detail of specimen 56, bundle 421 (mantle). Early Intermediate 1A. Museo Nacional, Lima. Photograph by the author.

number 401, was contemporary with bundle 157 according to Dwyer's seriation. The other two, numbers 49 and 421, date to Early Intermediate 1. Although the chronological seriation of the Necropolis bundles has not yet been refined to the point where it is possible to seriate the bundles within a single period, the position of bundles 49 and 421 within the broad chronological scheme suggests that they contained individuals one or two generations removed from the individuals in bundles 157 and 401. The broad line style appears in relatively large numbers in only four bundles over a time period of approximately fifty to seventy-five years. I suggest that this third style of Paracas embroidery was a personal or "family" style, and that the persons in bundles 49 and 421 were lineally related to the individuals in numbers 157 and 401.

These preliminary observations on the chronological relationship of the linear and block color styles and on the distribution of the broad line style, suggest that the stylistic and iconographic differences seen in Paracas embroidered images cannot be explained by chronology alone. Rather, several explanations must be considered simultaneously. As noted earlier, both the linear and block color modes were found in most of the Necropolis bundles, coexisting for approximately 250 years within peninsular Paracas culture. These two different styles of embroidery likely served as vehicles for the presentation of different kinds of information. The broad line style, on the other hand, was distributed among relatively few bundles: only four bundles contained seventy-seven percent of all garments decorated in this style. Therefore, this style may have been the hallmark of certain high-ranking individuals and families. This new interpretation sheds a completely different light on the role and cultural significance of elaborate textiles from the Paracas Necropolis.

Bibliography

Bird, Junius, and Louisa Bellinger
 1954 *Paracas Fabrics and Nazca Needlework: 3rd Century B.C. - 3rd Century A.D.: The Textile Museum, Catalogue Raisonné.* Washington D.C.: The Textile Museum.

Carrión Cachot, Rebeca
 1931 La indumentaria en la antigua cultura de Paracas. *Wira Kocha: Revista Peruana de Estudios Antropólogicos* 1(1):37-86. Lima.

 1949 *Paracas Cultural Elements.* Lima: Corporación Nacional de Turismo.

Dwyer, Jane Powell
 n.d. *Chronology and Iconography of Late Paracas and Early Nasca Textile Designs.* Ph.D. dissertation, Department of Anthropology, University of California, Berkeley, 1971.

 1979 "The Chronology and Iconography of Paracas-Style Textiles." *In* Ann Pollard Rowe, Elizabeth P. Benson, and Anne-Louis Schaffer, eds. *The Junius B. Bird Pre-Columbian Textile Conference.* Washington, D.C.: The Textile Museum and Dumbarton Oaks. Pp. 105-127.

Dwyer, Edward, and Jane Powell Dwyer
 1975 "The Paracas Cemeteries: Mortuary Patterns in a Peruvian South Coastal Tradition." *In* Elizabeth P. Benson, ed. *Death and the Afterlife in Pre-Columbian America.* Washington, D.C.: Dumbarton Oaks. Pp. 145-161.

Kubler, George
 1962 *The Art and Architecture of Ancient America: The Mexican, Maya, and Andean Peoples.* Baltimore: Penguin Books.

Rowe, John Howland
 1961 "Stratigraphy and Seriation." *American Antiquity* 26(3):324-330. Salt Lake City: Society for American Archaeology.

Sawyer, Alan R.
 1966 *Ancient Peruvian Ceramics: The Nathan Cummings Collection.* New York: The Metropolitan Museum of Art.

Stafford, Cora E.
 1941 *Paracas Embroideries: A Study of Repeated Patterns.* New York: J.J. Augustin.

Yacovleff, Eugenio, and Jorge C. Muelle
 1934 "Un fardo funerario de Paracas." *Revista del Museo Nacional* 3(1-2): 63-153. Lima.

Moche Iconography—
The Highland Connection

Raphael X. Reichert
Department of Art
California State University, Fresno

One of the most revealing and yet least explored aspects of pre-Columbian cultures is their interaction with one another, particularly as shown through hierarchial themes. The following essay explores artistic relationships between two early Peruvian cultures, Recuay and Moche. Through an examination of large Moche and Recuay ceramic inventories it has been possible in specific instances to chart the direction of idea flow. Moreover, the extent of actual contact between the two cultures can be estimated by the degree of accuracy in their adoption of each other's hieratic ideas.

THE EARLY INTERMEDIATE PERIOD of pre-Columbian Peru is characterized as a time when regional cultures existed largely independently. It is becoming increasingly evident, however, that such regional groups were not existing in ignorance of one another and that some contact did occur between disparate cultures.

This paper will focus on contact between two northern Peruvian cultures, the coastal Moche and the highland Recuay. Awareness of interaction between Moche and Recuay is certainly not new. Observations have been made by Kutscher (1954), Larco (1958), Disselhoff (1956), Reichert (1977a), and Smith (1978) in regard to similarities between the ceramic styles of the two peoples. The question that has not been adequately addressed, however, regards the direction in which the influence traveled.

The goal of this paper is modest: it seeks only to present evidence derived from their ceramic art traditions to suggest that the Moche were recipients of influence originating from the Recuay culture. In other words, that the direction of influence flow was from highland to coast.

The data employed in the following discussion were gleaned from two photo archives: Donnan's Moche file documenting over 7,000 vessels, and the author's documentation of over 1,000 Recuay specimens. Obviously the format herein does not permit discussion of all instances of sharing between Moche and Recuay. The purpose of this paper will be best served by limiting discussion to two instances in which a particular blending of Moche and Recuay elements exists. Before concentrating on these specifics, however, it is necessary to review some general aspects of the two ceramic traditions.

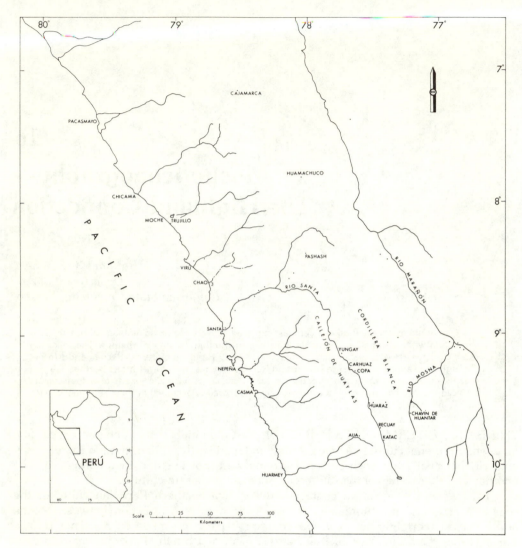

Figure 1. Map of northern Peru.

The geographic distribution of the two pottery styles was essentially separate but with some overlap. The Recuay style was basically highland and appears to have been concentrated in the Callejón de Huaylas and upper Marañón basin. A secondary and very limited distribution extends from the coastal valleys of Pacasmayo to Casma with a single vessel reported from the province of Guayas in southern Ecuador (see map, Figure 1).

The Moche style is encountered with greatest frequency in the coastal valleys bordered by, and including, the Lambayeque in the north and the Nepeña in the south. Highland occurrences of the style are rare with the easternmost distribution being a small number of specimens found at Chavín de Huantar.

The two pottery styles were essentially coeval, with Recuay developing and ending somewhat earlier than Moche. The Recuay style may have come into being as

early as 200-100 B.C. Moche became a recognizable entity approximately 100 years later. The terminal date for Recuay was approximately A.D. 500-600, whereas for Moche it was A.D. 600-700. The Moche style has been seriated into five phases designated by Roman numerals. At this writing, despite references to "early" and "late" Recuay specimens (e.g., Smith 1978), there remain insufficient data to reliably seriate that style.

Detailed descriptions of both ceramic styles may be found in Donnan (1976) and Reichert (1977a). It is sufficient to state here that the styles were distinct in terms of vessel construction, finish, and in modeling of human anatomy. Recuay vessels were hand built, emphasized 3-color resist, and had geometrically modeled figures. Moche vessels were mold-made, finished in bichromatic slip, and had naturalistically modeled figures.

Hybrid Moche-Recuay Vessels

Perhaps the most distinct link between the two cultures is a group of six hybrid vessels that were made by Moche potters, but combine Moche and Recuay features. Such specimens have been described as "exact replicas" of Recuay vessels (Smith 1978:164). Actually this group is Recuay only in general aspects of vessel form and layout of modeled features, but Moche in terms of chamber profile and finish. That these vessels were made by Moche potters is evident from the use of molds in their construction and the naturalistic rendering of the human faces. Neither feature is known within the Recuay tradition.

The prototype for these hybrid vessels is a Recuay jar type (Figure 2) that has a flat disc rim, strap handle, and a trio of modeled figures under the disc rim. The central modeled figure is always a human male with a spout extending forward from his headdress. Flanking this figure is a pair of secondary figures. In the Recuay style, these flanking figures may be felines, birds, feline-headed serpents, or women.

The six vessels actually comprise two groups. Within the groups the vessels are sufficiently similar to suggest that only two artists or workshops were responsible for all specimens.

There are four vessels in the first group: specimens now located in the Field Museum, Chicago (Figures 3a, b, c), the National Museum of Archaeology and History, Lima (Figures 4a,b,c), the Warrington Museum, Warrington, England (Figures 5a,b,c), and the Linden Museum, Stuttgart (Figures 6a,b,c). Each of these vessels has an ovoid chamber, a flaring collar, a modeled central human figure flanked by felines, and is finished in two slip colors.

Although at first glance the four vessels appear stylistically divergent (they are painted differently and one central figure appears to have a bird head), a close examination suggests that they were made from the same mold. Here it should be recalled that Moche potters used molds to produce the vessel chamber that often included low-relief modeled elements. Features such as fully modeled heads and painted details would have been added after the basic form had been created. One thus may find variations in painting and modeling on Moche vessels created from the same mold.

In addition to their clearly similar ovoid chambers and flaring collars, the low-relief feline bodies also indicate that the vessels were made from a single mold. In each instance the positions of anatomical features appear to be congruent; the tails arc close to the strap handle, the sausage-form bodies are horizontal with limbs hanging down and the front leg joint touching the lower edge of the human's garment.

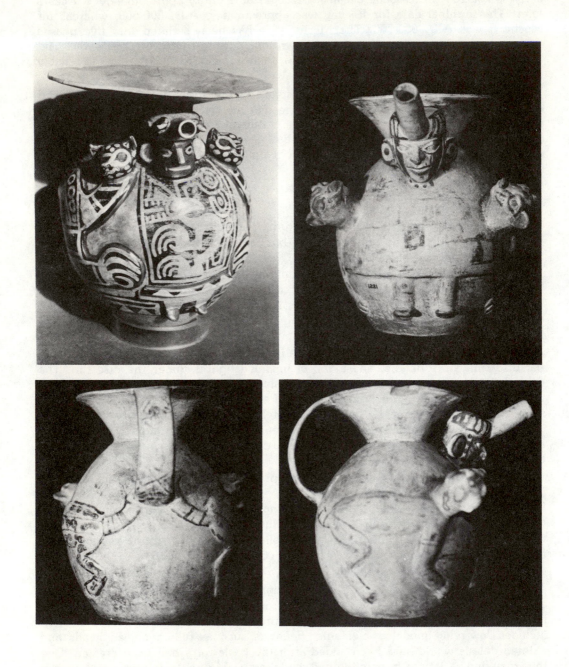

Figure 2. (Above left) Recuay, private collection, h. 20.7 cm.

Figures 3a, b, c. Moche, Field Museum, Chicago, #1221, h. 19.5 cm., photograph courtesy Robert Feldman.

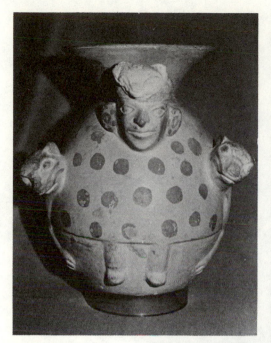

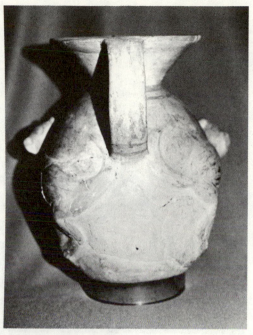

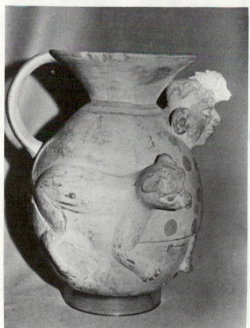

Figures 4a, b, c. Moche, Museo Nacional de Antropología y Arqueología, Lima, #UH/15004, h. 20.1 cm.

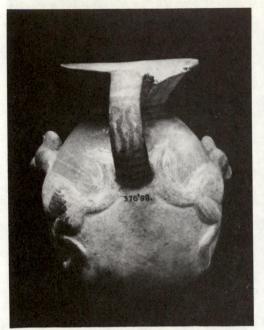

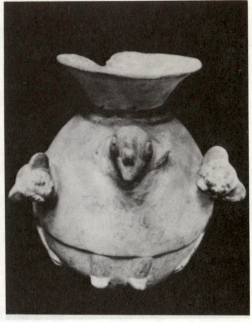

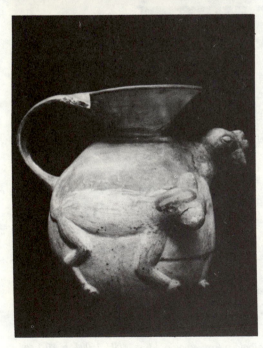

Figures 5a, b, c. Moche, Warrington Museum, Warrington, England, #376'98, h. 19.0 cm., photograph courtesy Christopher Donnan.

Figures 6a, b, c. Moche, Linden Museum, Stuttgart, #57919, h. 19.7 cm., photograph courtesy Christopher Donnan.

All four vessels probably originally had modeled heads like those of the Chicago and Lima pieces.[1] The Warrington vessel appears to be an awkward and incorrect reconstruction, probably done in modern times. The bird head, judging from its pronounced caruncle and ruff, probably depicts a condor and appears to have come from another vessel. Not only is the transition from torso to head extremely awkward, but a knob extends from the left of the bird's head. This projection is probably a remnant of the original sculpture from which the bird head came. The theme of a bird-headed man is unknown in Recuay, but common in Moche. It would seem that the person reconstructing the vessel was aware of the latter fact, had several fragments at hand, and simply combined them in what he considered a likely manner.[2]

The Stuttgart vessel is of special interest because of the checkerboard garment worn by the now headless central figure. Within the Recuay style, the use of the checkerboard motif is restricted to women of apparent high status.[3] The existence of the checkerboard in this context implies an ignorance or misunderstanding of Recuay tradition. If the missing head was of a male, the likely possibility, then the figure is garbed in a pattern reserved for Recuay females. If the original head was of a woman, the composition deviates from Recuay norms: in Recuay hieratic group compositions, women are never depicted in the central position.

The second group contains two vessels: one from the Museum für Völkerkunde, Berlin (Figure 7), the second from the Museum of Archaeology and Ethnology, Cambridge University (Figure 8).[4] Although it is impossible to determine from available photographs whether the Berlin and Cambridge vessels were also created from a single mold, it can be seen that they are clearly related to each other. In addition to the closely similar faces of the humans, both men have earspools with depressed centers, and both are being grasped by the flanking felines.

The Crested Animal

Among the two-dimensional motifs shared by the two styles is one that has been variously referred to as a crested jaguar, crested feline, moon animal, and the crested animal. This image is most common on Recuay vessels but is also found in limited numbers on Moche, Salinar, Gallinazo, and northern Huari ceramics. It is impossible at this time to state unequivocally that the crested animal originated in the Recuay style; however, because of the large numbers of its representations and great variation in its depiction therein, it seems evident that the crested animal played its greatest role here and may indeed have originated within the Recuay tradition.

In the Recuay style, although the crested animal (Figure 2, tunic motif) undergoes certain configural modifications which may relate simply to the shape of the register in which it is depicted (essentially this consists of the creature expanding or contracting to fill the register frame), it nevertheless maintains certain consistent aspects: it is always in profile and two-dimensional; the head is consistently made up of concentric circles, the outer representing the head itself, the inner outlining the

1. The Lima vessel originally had a spout, the hole of which is now filled with plaster.

2. Unfortunately such faulty reconstructions are common, even in major museum collections (cf. Reichert 1977b).

3. The only instance within the entire Recuay sample in which the checkerboard pattern does not occur on a woman is on a supernatural animal from Pashash (Grieder 1978:Color plate 5). The use of the motif in the Pashash example may be an indication of gender for a creature whose sex would otherwise not be apparent.

4. There is a third vessel which may belong to this group. Unfortunately the specimen has been published as only a single small photo (Smith 1978:165). It is excluded from this discussion until it can be analyzed in detail.

eye; the muzzle is always a pair of lines extending from the outer circle (these lines may be parallel or flare slightly apart); the ear, when present, is a triangle appended to the head circle; a triangle is also at the tip of the muzzle suggesting a nostril; the torso is a solid line which arches in a pronounced ''C'' form; and claws are concentric ''C'' elements of diminishing size.

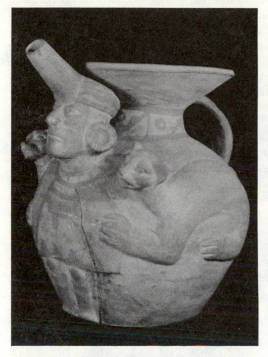

Figure 7. Moche, Museum für Völkerkunde, Berlin, #VA 18605, h. 20.3 cm., photograph courtesy Christopher Donnan.

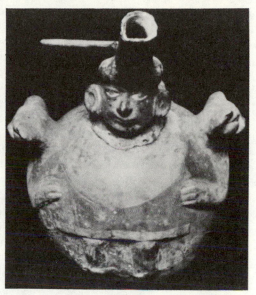

Figure 8. Moche, Cambridge University Museum, #221080, h. 19.0 cm.

The crested animal endures through all phases of the Moche style, but undergoes modifications from the Recuay model. Stylistically, the creature is closest to the Recuay form during the early Moche phases as illustrated by a Moche I vessel (Figure 9). In this instance, although the crested animal is actually rendered in three-dimensions, it is clearly derived from a two-dimensional prototype. In fact, the form is not far removed from a linear two-dimensional depiction, as both sides are nearly planar. Because on Recuay ceramics the crested animal is only depicted in two dimensions, it would be a likely model for this Moche I example.

Figure 10 illustrates a Moche II vessel with an effigy chamber of a seated man with garment drawn over his knees in typical Moche fashion. Painted on his chest are two crested animals facing the center of the chest. The geometric quality of these figures suggests a weaving technique, and indeed the heads are similar to motifs on published textiles (e.g., Bird and Bellinger 1954:Pl. CXXV; Garaventa 1978:26-27).

Moche III depictions of the crested animal (Figure 11) show distinct changes from a Recuay type. Instead of a circle for the entire head, only the eye is round; the remainder of the head consists of an irregularly outlined jaw and muzzle. These characteristics continue to be present through Moche IV (Figure 12) during which

time the creature is depicted in a calligraphic fine-line manner in keeping with the Moche trend in this direction.

Since the Moche style relied increasingly upon molds for vessel construction, it is fitting that a Moche V representation of the crested animal is depicted by a press-mold relief method (Figure 13). The creature retains its identity only because it possesses the crest. Stylistically, the beast is now far removed from its antecedents. In place of the geometric renderings of Recuay and early Moche, there is now a head and torso with the softened curvilinear transitions of a feline form. Not only does this evolution of the crested animal accurately reflect the later preferences of Moche style, but, more importantly, it charts the move away from what is undoubtedly the source of the motif, the Recuay model.

In the above paragraphs I have discussed stylistic changes that took place in Moche depictions of the crested animal through time. Equally important is an awareness of the relative importance given the crested animal in its depiction in the Recuay style versus the Moche style.

The basic distinction between the two styles' representation of the crested animal is in the degree to which its depiction dominates the design of the vessel. Although there are more examples of the creature in the Recuay style than in any other, on no Recuay vessel does the animal dominate the composition. As shown previously, the Recuay style emphasizes hieratic composition, especially trios of humans and animals with special attention given the middle figure. In no Recuay composition where hierarchy is implied by size, position, or degree of elaboration does the crested animal occupy the highest rank. There is no doubt that the motif is extremely important within the Recuay style. It is, however, always subordinated to a dominant human, or, associated with a number of additional motifs.

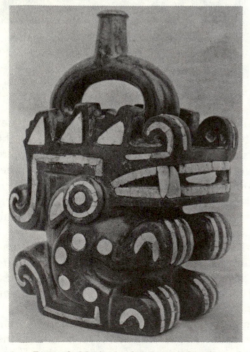

Figure 9. Moche I, after Larco 1965:111, h. approx. 18 cm.

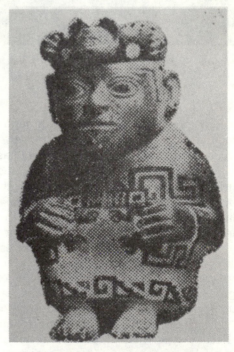

Figure 10. Moche II, after Larco 1948:28, h. approx. 15 cm.

288

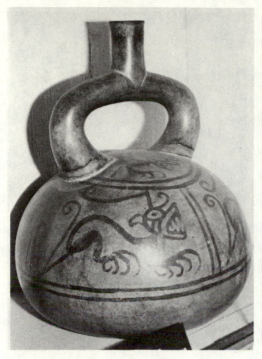 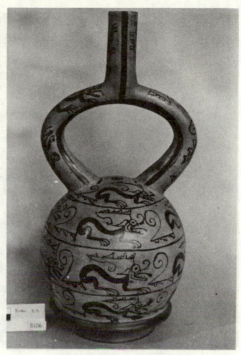

Figure 11. Moche III, Museo del Arte,
Lima, h. approx. 17 cm.

Figure 12. Moche IV, private collection, h.
approx. 30 cm.

Although the basic features of Moche crested animals remain true to the Recuay prototype, their treatment in terms of the overall composition of the vessel is completely different. When the crested animal occurs on Moche vessels, it is always in a prominent situation, either as the principal design element on a vessel, or in a central position within a composition.

The Phases I, III, IV, and V examples (Figures 9, 11, 12, 13) show the Moche tendency to isolate the crested animal. Two specimens from Phases II and IV demonstrate further the special treatment given the crested animal in the Moche context. The creatures on the Phase II vessel (Figure 10) are painted directly beneath the man's sculptured hands in such a manner that he appears to hold them. It is true that the crested animals in this instance may be meant to be woven patterns on the garment; nevertheless, the intended relationship between the man's hands and the animals appears clear. This is the sole example from any Peruvian art form of which I am aware in which the crested animal occupies such an intimate association with a human being. Although the crested animal also appears on garments of Recuay figures, within that style it is never treated as a separate entity, that is, something capable of being held.

A Phase IV vessel (Figure 14) also has a dominant, centrally positioned crested animal. In this case, the creature, holding a trophy head, is painted within a square on the chamber top directly in front of an elaborately dressed seated man. On the figure's left is a typical Moche mace. On the chamber are painted figures dressed in the same manner as the seated person. The painted figures hold maces and square shields indicating that the square in front of the seated figure probably also represents a shield.

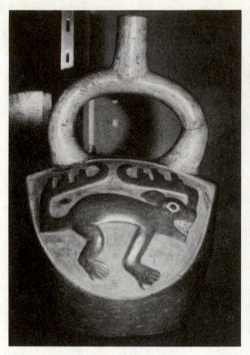 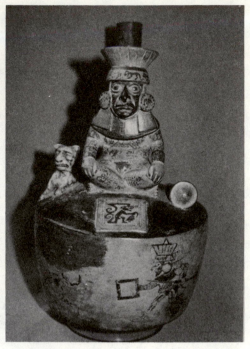

Figure 13. Moche V. Museo Nacional de Antropología y Arqueología, Lima, #WS/17092-559-A, h. 27.4 cm.

Figure 14. Moche IV, Museo Nacional de Antropología y Arqueología, Lima, #1/3148, h. 22.9 cm.

The most significant aspect of the crested animal on the shield is its association with a trophy head. This is a major change from the Recuay context in which the crested animal is never represented as a taker of human heads. Although it is evident that the crested animal is a supernatural with considerable status wherever it is depicted, in this instance it appears to have been elevated to a position of special power not evident in its original Recuay context.[5]

Conclusions

What inferences can be drawn from the preceding data? In the first place it appears that the contact that occurred between the Recuay and Moche peoples was quite limited. Within the large samples of Moche and Recuay vessels available for study, only a small number of truly hybrid vessels—those combining features uniquely Moche and Recuay—are known to exist.

Secondly, the direction of influence can be seen to have traveled from the highlands to the coast. In the case of the hybrid vessels it is evident that the artists creating the pots were Moche, apparently inspired by highland models. The crested animal, when it appears in Moche art, was shown to have evolved from a Recuay model.

In addition, the contact between the two groups appears to have been superficial. The misinterpretation of rigid Recuay artistic canons by Moche artists suggests that these coastal people were not intimately aware of the nature of highland society. One

5. On the North Coast of Peru the association of crested animal with trophy head continued into the Middle Horizon as shown by a Huari Norteño B vessel illustrated by Proulx (1973:Pl. 9c).

290

is struck, instead, by the impression that the lowlanders were treating borrowed highland motifs with a certain reverence. This is certainly the case with the crested animal judging by its domination of vessel compositions and elevated supernatural status.

During the three pre-Columbian horizon eras of Chavín, Huari-Tiahuanaco, and Inca, many Peruvian coastal populations were influenced by highland cultures. Given this pattern it is not surprising that during the Early Intermediate Period, highlanders also exerted a definite although reduced influence on their coastal neighbors.

Bibliography

Bird, Junius B. and Louisa Bellinger
 1954 *Paracas Fabrics and Nasca Needlework.* Washington, D.C.: National Publishing Co.
Disselhoff, H. D.
 1956 "Hand-und Koptrophäen in plastischen Darstellungen der Recuay-Keramik." *Baessler-Archiv* Neue Folge IV: 25-32.
Donnan, Christopher B.
 1976 *Moche Art and Iconography.* Los Angeles: UCLA Latin American Center.
Garaventa, Donna M.
 1978 "Peruvian Textiles." *Pacific Discovery* XXXI (4): 21-27.
Grieder, Terence
 1978 *The Art and Archaeology of Pashash.* Austin: University of Texas Press.
Kutscher, Gerdt
 1954 *Nordperuanische Keramik.* Berlin: Geber. Mann.
Larco Hoyle, Rafael
 1948 *Cronológia arqueología del norte del Perú.* Buenos Aires: Sociedad Geográfica Americana.
 1958 *La Cultura Santa.* Lima: Lit. Valverde.
 1965 *Checan.* Geneva: Nagel.
Proulx, Donald A.
 1973 *Archaeological Investigations in the Nepeña Valley, Peru.* Research Report No. 13, Department of Anthropology. Amherst: University of Massachusetts.
Reichert, Raphael X.
 1977a *The Recuay Ceramic Style—A Re-evaluation.* Unpublished Ph.D. dissertation, Department of Art. Los Angeles: University of California at Los Angeles.
 1977b "Pre-Columbian Ceramics: The Problem of Partial Counterfeits." *In* Alana Cordy-Collins and Jean Stern. eds. *Pre-Columbian Art History: Selected Readings.* Palo Alto: Peek Publications.
Smith, John W.
 1978 *The Recuay Culture: A Reconstruction Based on Artistic Motifs.* Unpublished Ph.D. dissertation. Austin: University of Texas.

17
Moche Murals from the Huaca de la Luna

Carol J. Mackey
Department of Anthropology
California State University, Northridge
and
Charles M. Hastings
Museum of Anthropology
University of Michigan, Ann Arbor

Analysis of a newly discovered series of Moche murals from the Pyramid of the Moon in northern Peru has not only shed great light on the Moche mural painting style and its process, but, most importantly, it has raised new questions about current theories of cultural succession on the North Coast between A.D. 700 and 1000. The murals' iconography indicates that it is unnecessary to postulate a Huari invasion, since the motifs could have been derived from within Moche culture.

ON THE NORTH COAST OF PERU, Moche artists painted elaborate polychrome murals on the monumental architecture associated with Moche sites. Although the extant Moche murals are few, they are widely scattered over the area once occupied by the Moche state (100 B.C. - A.D. 850). In the Lambayeque Valley, the northern region of the Moche state, there are murals at the sites of Huaca Facho (Donnan 1972) and Huaca Pintada (Schaedel 1978). In the southern region of the Moche state, in the Nepeña Valley, there are murals at the site of Pañamarca (Schaedel 1951; Bonavia 1961). In the Moche Valley, the center of the Moche state, Conrad (1974) reported seeing vestiges of painted figures on the walls of the adobe compound at Galindo. Seler exposed a mural on the Huaca de la Luna in 1910 which was reported upon some years later by Kroeber (1930). Garrido (1956) exposed another mural at the Huaca de la Luna. During a 1972 study of the Huaca de la Luna by the Chan Chan-Moche Valley Project this mural was rediscovered. An examination of the mural revealed that it was actually the third in a succession of murals that had been painted over each other. Bonavia (1974) briefly reported on these murals.

This paper will focus on this series of three murals. We will argue that the style and content of the murals basically belong to Phase IV, or next to last phase, of the Moche sequence, but that they also reveal some foreign influence, probably from the Huari culture (A.D. 600-1000). Various lines of evidence, from stylistic and architectural sources, will be presented to support this hypothesis. The final goal of the paper is to extract from the data further implications regarding contact between Moche and Huari cultures and to suggest a model for such contact.

The Site of Moche

The longest and densest Moche occupation within the Moche Valley was at the Pyramids at Moche (Huaca del Sol and Huaca de la Luna). The pyramids are located on a bleak, level plain some 6 km inland on the southeast bank of the Moche River. Excavations in recent years have established that this site was the capital of the Moche polity and the most important center in the realm (Topic 1977). At the northwest edge of the site is the Huaca del Sol (Pyramid of the Sun), the largest platform of solid adobe construction in this valley and one of the largest structures in South America. Across the plain is the Huaca de la Luna (Pyramid of the Moon).

Stratified refuse minimally 2 m deep covers an area of more than 1 sq. km at the pyramid site. Moche style ceramics are found throughout the entire site area, including the pyramid structures themselves. Pottery of the Moche culture has been seriated into five phases of unknown length (Larco 1946) spanning a period of nearly 1000 years from 100 B.C. to A.D. 850. Phases I-IV are represented in the pottery of the pyramid site, but the fifth and final Moche phase is absent from the occupational sequence.

The Huaca de la Luna is actually a complex of structures rather than a single pyramid. This complex, which we will refer to as the "Luna complex," consists of three separate adobe platforms connected by four courts, occupying an area of approximately 300 m by 160 m (Figure 1). The Luna mural uncovered by Seler (Kroeber 1930) covered the interior of a summit structure on Platform 3. The murals discussed in this report are found on the largest of the Luna structures, Platform 1. Polychrome murals have not been discovered elsewhere in the Luna complex or anywhere in the Huaca del Sol.

The principal structures of the Moche site have a long, complex history of construction, in which phases of construction at different parts of the site alternated with use periods of varying duration (Hastings and Moseley 1975). Platform 1 in the Luna complex grew vertically in at least three well-defined stages (I-III), the first of which dates to the earliest phase of monumental architecture known at the pyramid site. In Stage I a platform 95 m long by 85 m wide and up to 20 m high was completed, on which were built numerous rooms, corridors, other walled structures, and flagstone pavements. Stage II construction filled in these rooms with adobe bricks and raised the platform some 3 to 4 m. New rooms were then built on this summit, one of which was decorated with the murals to be discussed below. The murals were subsequently sealed by Stage III construction which filled in the rooms and further elevated the top of the platform (Figure 1: 1A).

The Murals

The murals on Platform 1 of the Luna complex are a series of paintings superimposed one over the other. Each mural was painted; then the wall was replastered and the new mural painted. The murals are designated as Mural I through III from earliest to latest. Each mural will now be discussed according to its size, technique of application, color, and motif.

Mural I. The preliminary step in applying Mural I was to cover the wall with white paint. Moche artists then partitioned the wall into a single row of units, each 3.4 m long by 2.4 m high and separated by a 34 cm border of inverted "S" motifs within a vertical band (Figure 2). Each unit was further divided into a grid system of small incised squares 3.5 cm on a side. The motif was painted by coloring in the appropriate squares with white, yellow, red, and black pigments. The color scheme was repeated in each unit.

294

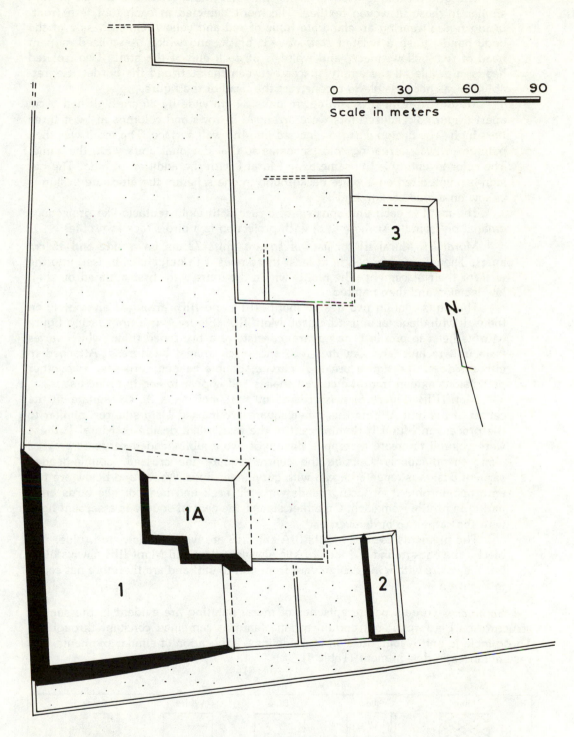

Figure 1. Platforms and courts of Huaca de la Luna. Platforms are numbered 1-3 and courts are textured. (Drawing by Staff of Chan Chan-Moche Valley Project.)

The grid technique used in laying out this mural created a design pattern similar to those in woven textiles. The motif depicted in each unit is a front-facing figure wearing an elaborate tunic of red and yellow. On each side of the body hands grasp a twisted staff of red, black, and white. A stylized serpent head of red, yellow, black, and white is at each end of the staff. Two isolated heads in profile fill the empty spaces between the staff and the border. Regretably, it was not possible to reconstruct the head of the figure.

Mural II. Mural II is laid out in units 34 cm wide by 26 cm high and 5 cm apart (Figure 3). These units were arranged in rows and columns at least three tiers high. The design was first incised into the wall surface. The motif was then painted in two alternating color schemes so that diagonal units were the same. The color inventory is the same as in Mural I with the addition of blue. The design is painted red on a white background in one scheme; the alternate design is yellow on a blue background.

The motif in each unit consists of a face with eight tentacle-like projections emanating from it. At the end of each projection is a bird's face in profile.

Mural III. Mural III consists of square units 72 cm on a side and 15 cm apart. They were arranged in at least three rows with guidelines incised into the wall for their placement. The motifs within the units were first outlined by shallow incision and then painted.

The units contain two design motifs (IIIA and IIIB) arranged alternately on the wall with diagonal units identical. Motif IIIA (Figure 4) is a front-facing figure with its head in profile. The apparel consists of a two-toned tunic, which varies from unit to unit, and a white, red, and black animal headdress. Attached to either side of the figure are red, curved, double-headed serpents. Two other protrusions extend from the curved snakes and appear to end in feline heads.

Motif IIIB (Figure 5) was created by first incising a 21 cm square in the center of the unit. Within this inner square are incised 1 cm squares, similar to the process in Mural I. Reminiscent of the textile-like design of Mural I, these were colored to create a stepped design of two double-headed serpents crossed along the diagonals. Outside the central square the crossed, double-headed serpent design is repeated again with curvilinear lines. Above and below are two anthropomorphic front-facing heads with the neck and head of two birds emanating in profile from each. On either side of the central square is a serpent head with the same two birds overhead.

The pigments used in Motifs IIIA and IIIB are white, yellow, red, blue, and black. The background of Motif IIIA is always yellow and Motif IIIB always blue, but the colors within the design vary from unit to unit and are therefore not coded in Figure 5.

Summary. Three separate episodes of mural painting are evident in the summit structure on Platform 1, but certain artistic features remained constant throughout. These include unit layout, incision of guidelines, application of similar pigments, and resemblances in design motif (Table 1).

Color Key for Illustrations.

Figure 2. Mural I. Front-facing figure grasping twisted staves. (Drawing by Staff of Chan Chan-Moche Valley Project.)

297

Figure 3. Mural II. Front-facing heads with eight tentacle-like projections ending in birds' faces. (Drawing by Staff of Chan Chan-Moche Valley Project.)

298

All three murals consist of units of varying size separated by a standardized spacing. Only Mural I used a decorated vertical band to separate one unit from the next. In Mural I the motif and color scheme were repeated from unit to unit. The motif of Mural II is also repeated, but in alternating colors, and Mural III alternates both motif and color scheme.

The same technique of incising the motifs first and then painting them was used in all three murals. The grid incision of the motif on Mural I and part of Motif B on Mural III created a stepped design imitating a textile pattern. In Mural II and most of Mural III the design was first incised freehand into the plastered wall and then painted.

The pigments white, red, yellow, black, and blue were used in all three murals, with the exception that Mural I has no blue. In Murals II and III a conscious effort was made by the Moche artists to use alternating colors, especially of the unit background. The background of Mural II alternated white and blue, and Mural III alternated blue and yellow.

Figure 4. Mural III. Motif IIIA is a front-facing figure with head in profile. (Drawing by Staff of Chan Chan-Moche Valley Project.)

Although these murals were painted on three separate occasions over an extended period of time, some continuity of thematic content is evident. Mural I features a front-facing figure with serpent-headed staffs. Mural II, which we will later show was partly contemporary with Mural I, introduces two different motifs: a hanging head and bird heads with serrated necks. Mural III postdates both these murals, but maintains and combines their motifs. A similar front-facing figure with serpent staffs reappears in Motif IIIA, and Motif IIIB preserves virtually the same hanging head accompanied by snakes and birds with serrated necks.

Architectural Context

These murals decorated the interior walls of a large room or court in the northeast corner of the principal platform of the Luna complex. This court was built atop the Stage II summit of the platform and partially preserved by subsequent Stage III construction. Summit architecture of the Stage II pyramid is only very incompletely

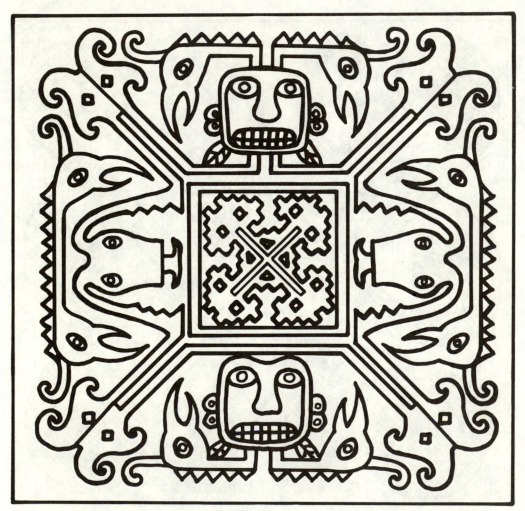

Figure 5. Mural III. Motif IIIB consists of front-facing anthropomorphic and serpent heads with tentacle-like projections ending in birds' faces. (Drawing by Staff of Chan Chan-Moche Valley Project.)

300

Table I. Murals from Huaca de la Luna, Platform 1.

UNIT LAYOUT	I (Fig. 2)	II (Fig. 3)	IIIA (Fig. 4)	IIIB (Fig. 5)
Unit Size	3.4 m x 2.4 m	34 cm x 26 cm	72 cm x 72 cm	72 cm x 72 cm
Unit separated by decorated band	X			
Unit separated by uniform spacing	X	X	X	X
Grid incised into unit	X			X[1]
Design incised into unit		X	X	
PIGMENTS				
White, black, yellow, red	X	X	X	X
Blue		X	X	X
ALTERNATION OF COLOR				
Units alternate color		X	X	X
Colors used in alternation				
Blue		X		X
Yellow		X	X	
Units placed in columns and rows		X	X	X
DESIGN MOTIFS				
Front-facing figure holding snake staff	X		X	
Disembodied heads, with double ear, open mouth		X		X
Bird heads with serrated body		X		X
Serpent heads	X		X	X
Feline heads	X		X	

[1]Only center portion of design has grid incision.

known, but parts of a walled court and adjoining corridor complex are in evidence (Figure 6). Polychrome murals were painted onto the inside walls of the court three times, and the structure itself was remodeled several times on a minor scale. Architectural evidence discussed below and the preservation of the murals indicate that the structure was used over a relatively long period of time.

Looting has destroyed most of this architecture, and only two incomplete court walls and several outer corridor walls remain. Surviving portions of the court are an 18 m section of the east wall and a 4.4 m section of the south wall, both of which probably stood higher than 3 m. The original dimensions cannot be determined, and it is not known if the court was open on one or more sides or whether it was roofed. Walls of the court and adjoining corridor were plastered and painted white.

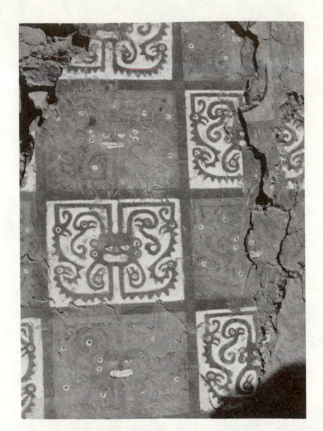

Figure 6. (Left) Mural II.

Figure 7. (Below) Mural III (Motif IIIB), partially covering Mural II. (Photographs by M. E. Moseley.)

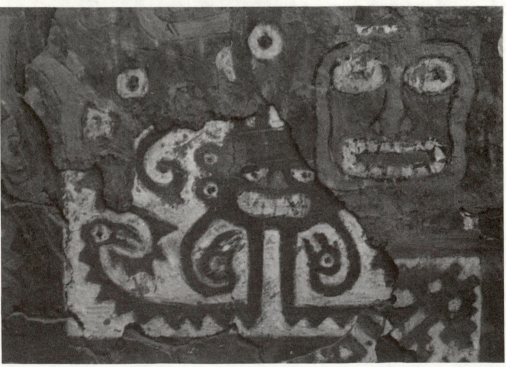

The court had already been in use for some time when the first mural was painted onto it. The south wall had been lengthened twice and the east wall widened once to its final thickness of about 1 m. Mural I was then painted, covering the inside of the court to a height of at least 3 m above the floor. Further remodeling was undertaken after this mural had become slightly weathered. A wide bench about 1 m high was installed in the northeast corner of the court, and an additional doorway was cut through the east wall. A short, L-shaped addition was built out from this doorway into the corridor, restricting somewhat the accessibility of this entrance (see B on Figure 8).

Knocking the new doorway through the wall had damaged Mural I, and ragged edges on both sides of the entrance had to be replastered. On the south side the repaired surface was repainted in the Mural I design. On the north side of the new door, Mural I was stripped off the exposed wall surface above the new bench, new plaster applied, and Mural II painted. Mural II is found only in this north section of the wall and was therefore contemporary with Mural I for a period of time.

With the passage of time much of Mural I became weathered and began to crumble and fall off. However, before Mural II showed signs of deterioration, all inner walls were recoated with a thin layer of plaster, and Mural III was painted on all walls. Mural III gradually became weathered during the continued usage of the court until the court and other summit structures were finally filled with adobe bricks in Stage III of platform construction. The amount of time that had passed since the initial construction of the court on the Stage II summit was evidently considerable. Activities

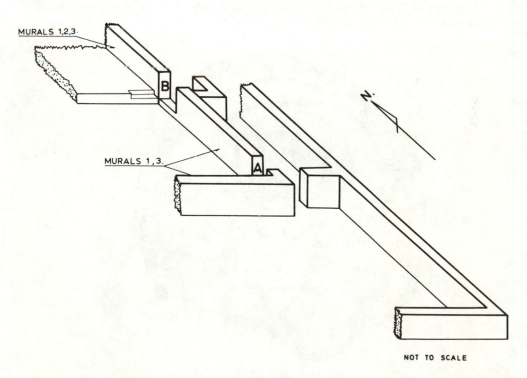

Figure 8. Partially preserved sections of painted walled court and adjoining corridor, atop the Pyramid of the Moon. (Drawing by Staff of Chan Chan-Moche Valley Project.)

within the court did not produce an accumulation of refuse, and there are no associated artifacts that might indicate how long the structure was in use. However, the remodeling of the court, the succession of three murals, and the weathering of these paintings all point to a relatively extended period.

Stylistic Antecedents in Moche Culture

In design, technique, and artistic style the murals of the principal Luna platform belong within the Moche cultural tradition, although certain foreign elements are also present. Polychrome murals were painted on monumental structures in many Moche sites, and numerous similarities can be noted with the murals of Luna Platform 1. For instance, the Luna murals and the Moche mural at Pañamarca share such common elements as painted black legs, serpents, and a border design of a bird head and serrated body. Murals with Moche stylistic affiliation at Luna Platform 3, Pañamarca, Huaca Facho, and Huaca Pintada are compared with the Luna Platform 1 murals in Table II, exhibiting similarities in methods of application and the selection of pigments. In matters of design layout, ties are shown to be strongest with the Facho and Pintada murals of Lambayeque, a point of chronological significance to be discussed separately.

The motifs depicted in the Luna murals and many of their stylistic attributes are also reproduced in Moche ceramic art, especially on vessels dating to Phases III and IV. A front-facing, standing figure associated with a staff and serpent is a common Moche theme. Two ceramic examples (Figures 9a and 9b) show such figures associated with a double-headed serpent. The first example (Figure 9a) is probably part of a whistle and was excavated in front of Luna Platform 1 from a deposit dating to Moche III and IV (Topic 1977). The other vessel (Figure 9b) is without provenience, but dates within the Moche seriation to Phase IV.

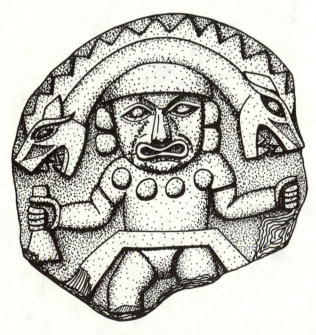

Figure 9a. Front-facing figure with arched double-headed serpent from ceramic fragment of a whistle. (Drawing by Staff of Chan Chan-Moche Valley Project.)

304

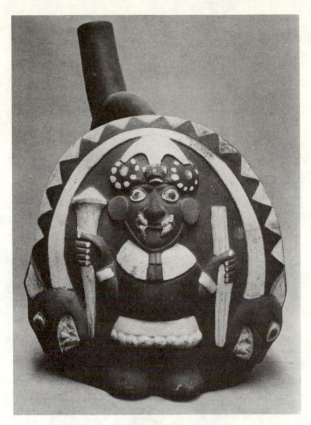

Figure 9b. Front-facing figure holding staves with arched double-headed serpent, from ceramic vessel. (Museo Nacional de Antropología y Arqueología, Lima, #42482.)

The hanging head motif appearing in Murals II and III is also a common theme in Moche ceramic art and always appears with the same ear and mouth treatment. This is seen, for example, in the design painted on a Phase IV dipper (Figure 10a) excavated from a tomb located between the Pyramids of the Sun and Moon (Donnan and Mackey 1978) and in another vessel without provenience but seriated to Phase III (Figure 10b). It is not known if the hanging head represents the same personage as the standing, front-facing figure, but both motifs often share crossed fangs and the association of the serpent.

Serpent and bird motifs have appeared side by side in Andean art at least since the time of Chavín, and their association has great time depth within the Moche tradition as well. In the Phase III vessel shown in Figure 11, they are portrayed together, but without the hanging head motif. Elements in Moche art are often shown separately, since, as noted by Donnan (1976; 1978), the Moche viewer was fully aware of the significance and context of the total theme.

Other features found in both the murals and Moche ceramic art include the painted black legs, headdress, and the "S" element in the border of Mural I. The hooked eye treatment of Mural III (Figure 4) had been previously associated only with Moche V and the Middle Horizon, but recent research has disclosed the use of this hooked-eye element in Phase IV and possibly even Phase III (Donnan, personal communication 1980).

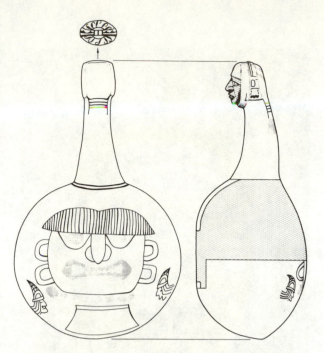

Figure 10a. Front-facing head, on ceramic dipper from tomb between the Pyramids of the Sun and Moon. (Drawing by Finerty, 1978.)

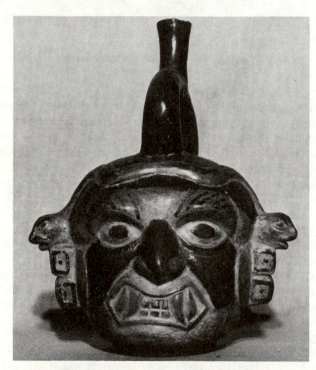

Figure 10b. Front-facing head associated with serpents, on ceramic vessel from Phase III. (Museo Nacional de Antropología y Arqueología, Lima, no number.)

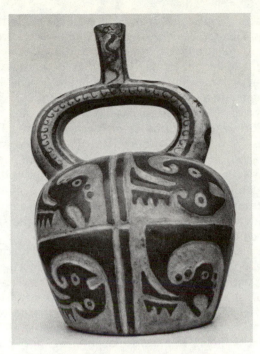

Figure 11. Serpent and bird heads similar to Mural III, Motif IIIB. (Museo Nacional de Antropología y Arqueología, Lima, no number.)

Foreign Influence and Contact

Although the Luna murals were executed largely within the norms of the Moche tradition, a minor degree of foreign influence is manifested in thematic concepts and in the schematic layout of the murals. This outside influence is informative in regard to the nature of cultural contact between the Moche polity late in its history and Huari and Tiahuanaco cultures emanating from the southern highlands. It has long been maintained that peoples from Huari succeeded the Moche during the Middle Horizon (A.D. 600-1000) and imposed their culture on the north coast of Peru (Kroeber 1930; Schaedel 1951). Recent research in the Moche Valley does not support any such invasion hypothesis (Mackey, n.d. 1,2), but other processes of cultural contact could account for foreign influence in Moche art.

The figures in the Luna murals are representations of mythical beings associated with ideological or religious concepts. The full-standing figure in Mural I and Motif IIIA is similar to the ancient mythical Peruvian personage often referred to as the Staff God and generally attributed to the Chavín culture (1300-375 B.C.). There appears to have been a revival of this and other Chavín themes on the North Coast in Moche Phase III and later in Huari and Tiahuanaco cultures of the Middle Horizon (Rowe 1971). Schaedel (1978) suggests that a religious continuum of 1000 years existed on the north coast, beginning late in the Moche sequence and lasting until about A.D. 1500.

In the Moche III revitalization of Chavín themes, the Staff God emerges in ceramic art associated with a serpent. Most Moche representations of this deity show the serpent in an arc above the figure. (This figure is also known as the Sky God; see Carrión 1959, and Menzel 1977). However, the personages of the Luna murals are

holding twisted, serpent-head staffs at their sites, in truer imitation of the Chavín Staff God and the Staff God figures of Huari and Tiahuanaco iconography. This closer adherence to tradition may reflect a return by the Moche to the more orthodox tradition of the ancient ideology. It may be further proposed that one reason why Huari culture was never forcefully imposed upon the Moche is that both peoples already shared a common or related ideological base.

External influence in Moche art is also manifest in the schematic layout of polychrome murals during the last phases of Moche culture. This is illustrated by comparing the murals from Luna Platform 3 and Pañamarca with those from Luna Platform 1, Huaca Facho, and Huaca Pintada. Murals from the first two pyramids show many figures in action within borders at the top and bottom. Those from the latter three structures differ from this layout by enclosing motifs within individual units. These units are arranged in rows and columns and employ alternating color schemes. We will argue below that the first group predates the second within the last phases of the Moche culture.

Donnan (1972:92, 95), in analyzing the murals from Huaca Facho, was first to note that the impaneling of figures and use of alternating colors originated in the ceramic and textile traditions of Middle Horizon Huari art. The literature is replete with examples of Huari shirts or ponchos with applied tapestry bands or patches (e.g., Schmidt 1929; Lapiner 1976). In discussing Moche strips of textiles found by Ubbelohde-Doering in Moche V tombs at the site of Pacatnamu in the Jequetepeque valley, Keatinge (1978:34) notes with particular interest "the 'patches' which feature repetitive motifs woven in a single narrow band, meant to be cut apart and sewn on the front and back of ponchos." These textile patches are arranged in rows on the shirt front and generally show alternation of color and/or design along the diagonal (Figure 12).

It appears that the Luna Platform 1 murals were conceptually patterned after the repetitive, color-contrasted designs found on these shirts or ponchos. The transfer of ideographic messages via textiles has been well demonstrated for the diffusion of Chavín iconography (Cordy-Collins 1976), and we propose that textile art could also have functioned as a mechanism for diffusing a Huari-derived concept of motif layout into the North Coast late in the history of the Moche culture. Indeed, Mural I is painted in clear imitation of a textile panel, and Motif IIIB shows us the transformation from a textile pattern to a free-line painting. This fits in with the lack of archaeological data for a Huari intrusion into the Moche Valley and suggests a more gradual, non-militant means of contact between the two cultures, such as might be based in exchanges of material goods and/or ideological concepts.

Chronological Interpretation

We have approached the problem of dating the Luna Platform I murals by attempting to date their design content, schematic layout, and architectural context in terms of the five-part Moche pottery seriation. The ceramic evidence from extensive and prolonged excavations indicates that the Moche pyramid site was abandoned prior to the onset of Phase V. As discussed above, the front-facing personage, hanging head, and serpent and bird motifs appearing in the murals are also found in ceramics belonging to Phases III and IV. The hooked eye seen in the third mural could be dated on stylistic grounds as early as Phase III or as late as the Middle Horizon. The practice of impaneling motifs in an alternating color scheme is believed to have been introduced into the Moche Valley via contact with the Huari culture of the Middle Horizon.

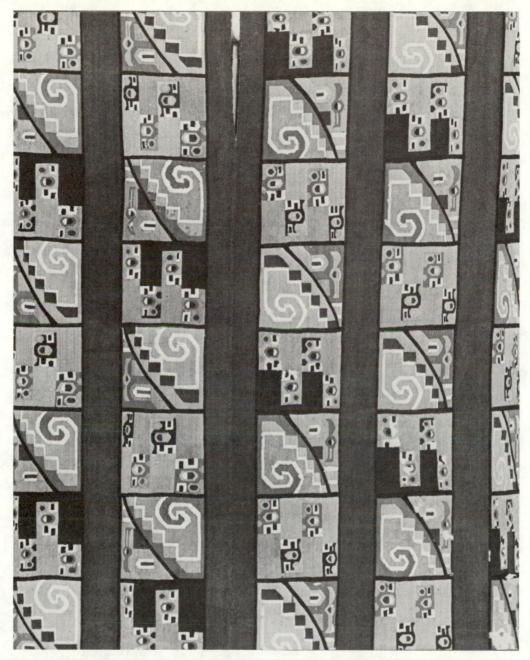

Figure 12. Huari tapestry shirt with motifs in alternating colors. Cotton and wool. 42 x 37 inches. (Adopted from Lapiner, 1976, by permission of Harry N. Abrams, Inc.)

Table II. Moche Murals

	A LUNA Platform 3	B PAÑAMARCA	C LUNA Platform 1	D HUACA FACHO	E HUACA PINTADA
Designs incised into walls	X	X	X	X	X
Pigments Red, yellow, white, black, blue	X	X	X[1]	X	X
Designs placed in narrative lines	X	X			X[2]
Designs placed in units			X	X	X
Units placed in columns and rows			X	X	
Alternation of color in units			X[1]	X	
Possible association with Staff God			X	X	X
Chronological placement within Moche seriation	Phase III or IV	Phase IV	End of Phase IV	End of Phase IV or start of Phase V	End of Phase V or after

[1] Does not exist in all three murals.

[2] Schaedel (1978) indicated units border a larger drawing which has a front-facing figure.

A chronology of adobe brick types worked out by Hastings and Moseley (1975) can be used to bracket the age of construction and abandonment of the court in which the murals were painted. This chronology is a seriation of adobe brick types by techniques of construction and is correlated to the pottery seriation through tombs excavated from different building stages of the Huaca del Sol. Stage I of Luna Platform 1 was built prior to or during Moche Phase III; Stage II, on which the painted court was built, dates either to the end of Phase III or more likely to Phase IV. The adobe bricks used to fill in the painted court during Stage III construction are of a type that predates most or all of Moche Phase V and was most common in Phase IV. A low percentage of these bricks was impressed with makers' marks, a practice which began gradually toward the end of Phase III, peaked during Phase IV, and all but disappeared by Phase V. This final construction stage of the Luna principal platform can thus be dated to the end of Phase IV or early Phase V, bracketing the age of the murals within Phase IV or into the beginning of Phase V. Combining these architectural and stylistic lines of evidence, we consider the second half of Phase IV to be a best estimate of the antiquity of the murals.

A tentative seriation for the known Moche murals is proposed in Table II. Adobes used in the structural core of Luna Platform 3 are of a type thought to be earlier than those in the Stage II summit of Platform 1, on which the painted court was built. Platform 3 was remodeled various times with a later brick type, on which basis the Luna mural described by Kroeber (Table II:A) could date to either Moche Phase III or IV. The Pañamarca mural (Table II:B) is stylistically quite similar and is located in a valley where only Phase IV pottery is found (Proulx 1973). We maintain that the Luna Platform 1 murals (Table II:C) date to the latter half of Phase IV or the beginning of Phase V, and on stylistic grounds the Facho mural (Table II:D) should be about the same age. The Moche art style is less evident in the Huaca Pintada mural (Table II:E, Schaedel 1978:34-35), which is ordered last in the sequence and dates to Moche Phase V or immediately thereafter.

Conclusions

We have attempted to show that the murals from the principal platform of the Luna pyramid complex are stylistically and ideologically rooted in Moche culture. The elements in these murals which are different from earlier Moche murals are concerned with formal layout, in particular the impaneling of the motif and alternation of colors. These features appear to originate in Huari culture and may have diffused into the Moche capital via the mechanism of textiles.

In the literature of the North Coast, the Middle Horizon is always considered to begin with Moche Phase V. This, however, is more of a self-perpetuating assertion than an established fact and has little if any concrete supporting evidence. We have argued that the Luna murals date to Moche Phase IV and were buried by or before the beginning of Phase V. For the Huari influence manifested in these murals to have diffused into the North Coast via the medium of textiles, the Middle Horizon would have to have already been underway well before the murals were painted. It follows that the correlation between Moche and Huari sequences should be rethought.

Bibliography

Bonavia, Duccio
1961 "A Mochica Painting at Pañamarca." *American Antiquity*, 26 (4): 540-543.
1974 *Pinturas Murales Prehispanics*. Lima: Fondo del Libro del Banco Industrial del Perú.

Carrión Cachot de Girard, Rebeca
 1959 *La religión en el antiguo Perú* (norte y centro de la costa, periodo post-clasico). Lima: Tipográfia Peruana, S.A.

Conrad, Geoffrey W.
 1974 "Burial Platforms and Related Structures on the North Coast of Peru: Some Social and Political Implications." Ph.D. dissertation, Department of Anthropology, Harvard University.

Cordy-Collins, Alana
 1976 "An Iconographic Study of Chavín Textiles from the South Coast of Peru: The Discovery of a Pre-Columbian Catechism." Ph.D. dissertation, Institute of Archaeology, University of California, Los Angeles.

Donnan, Christopher B.
 1972 "Moche-Huari Murals from Northern Peru." *Archaeology*, 25(2): 85-95.

 1976 *Moche Art and Iconography*. Los Angeles: University of California, UCLA Latin American Center Publication.

 1978 *Moche Art of Peru*. Los Angeles:Museum of Cultural History, University of California.

 _____ and Carol J. Mackey
 1978 *Ancient Burial Patterns in the Moche Valley, Peru*. Austin: University of Texas Press.

Garrido, José Eulogio
 1956 "Descubrimiento de uno muro decorado en la "Huaca de la Luna" (Moche)." *Chimor*, Boletín del Museo de Arqueología de la Universidad de Trujillo, año IV, No. 1. Pp 25-31.

Hastings, C. Mansfield and M. Edward Moseley
 1975 "The Adobes of Huaca del Sol and Huaca de la Luna." *American Antiquity*, 40(2): 196-203.

Keatinge, Richard W.
 1978 "The Pacatnamu Textiles." *Archaeology*, 31(2): 30-41.

Kroeber, Alfred L.
 1930 Archaeological Explorations in Peru, Part II: The Northern Coast. *Anthropological Memoirs*, 2:2. Chicago: Field Museum of Natural History.

Lapiner, Alan
 1976 *Pre-Columbian Art of South America*. New York: Harry N. Abrams, Inc.

Larco Hoyle, Rafael
 1946 "A Culture Sequence for the North Coast of Peru." *In* J. H. Steward, ed. *Handbook of South American Indians*, vol. 2. Bureau of American Ethnology, Bulletin 143. Washington, D.C. Smithsonian Institution, Pp. 149-176.

Mackey, Carol J.
 n.d.1 "The Middle Horizon as Viewed from the Moche Valley." *In* M. Moseley and K. Day, eds. *The Andean Desert City*. Albuquerque: University of New Mexico Press for the School of American Research.

 n.d.2 "Chimú Ceramics in the Late Middle Horizon." *In* R. E. Schaedel, ed. *Diagnostics of the Middle Horizon.*

Menzel, Dorothy
 1964 "Style and Time in the Middle Horizon." *Ñawpa Pacha*, 2:1-106. Berkeley: Institute of Andean Studies.

 1977 *The Archaeology of Ancient Peru and The Work of Max Uhle*. Berkeley: University of California. Lowie Museum of Anthropology.

Proulx, Donald
 1973 *Archaeological Investigations in the Nepeña Valley, Peru*. Research Report No. 2, Department of Anthropology, Amherst: University of Massachusetts.

Rowe, John H.
 1971 "The Influence of Chavín Art on Later Styles." *In* Elizabeth P. Benson, ed. *Dumbarton Oaks Conference on Chavín*. Washington, D.C.: Dumbarton Oaks Research Library and Collection, Trustees for Harvard University. Pp. 101-124.

Schaedel, Richard
 1951 "Mochica Murals at Pañamarca." *Archaeology*, 4(3): 145-154.

 1978 "The Huaca Pintada of Illimo." *Archaeology*, 31(1): 27-37.

Schmidt, Max
 1929 *Kunst und Kultur von Peru*. Berlin: Impropylaen-Verlag.

Topic, Theresa Lange
 1977 "Excavations at Moche." Ph.D. dissertation, Department of Anthropology, Harvard University.

Acknowledgements

This research was supported by grants from the National Science Foundation and National Geographic Society. Sincere thanks go to Donna McClelland for her helpful comments on earlier manuscripts and information on Moche iconography.

Chancay, a Pottery Style
of Ancient Peru

Janet Brody Esser
Department of Art
San Diego State University

This article is directed toward identifying and discussing the range of variability in Chancay ceramic art. Produced during the Late Intermediate Period in Peru (ca. 1000-1400), Chancay potteries—unlike Chancay textiles—have not benefitted from a detailed discussion. Commonly dismissed as crudely or indifferently executed, the ceramic repertoire of the Chancay has long been in need of careful and unbiased analysis. The following study provides data crucial to our ultimate comprehension of Chancay culture.

DURING THE FIRST HALF of the second millennium of our era a distinctive culture —Chancay—existed on the desert coast of Peru a short distance north of Lima, the present capital (see map, Figure 1). This culture is known to us only through its material remains, consisting mostly of pottery, textile, and metal work, found in community refuse heaps and in the numerous burials left by the people. The language, specific history, and legends of the people of Chancay are unknown; the accounts of the early Spanish chroniclers were neither systematic nor wholly accurate. The people of Chancay left no literature, nor did they record in their pottery, as did other ancient Peruvian peoples, an account of their daily activities.

It is apparent that intense study of this area has been neglected by specialists, who favor other areas in the Central Andes. This neglect may reflect a lack of interest stemming in part from the low opinion of Chancay pottery's artistic merits, an opinion shared by a number of specialists in Andean studies (see, for example, d'Harcourt 1950:164; Kroeber 1951:213; Kubler 1962:278; Larco Hoyle 1966:189; Sawyer 1966:64; Lanning 1967:145). Chancay pottery has been described in the literature as crude, regressive, and naïve. The style, however, is not without its partisans (see, for example, Means 1931:187). What some perceive as crude, others take for the unmistakable signs of bold originality. This study will examine the nature of this black-on-white pottery found in the Chancay river valley, and related styles from the adjacent Chillón Valley (Figures 2, 3, 5, 6 and 7).

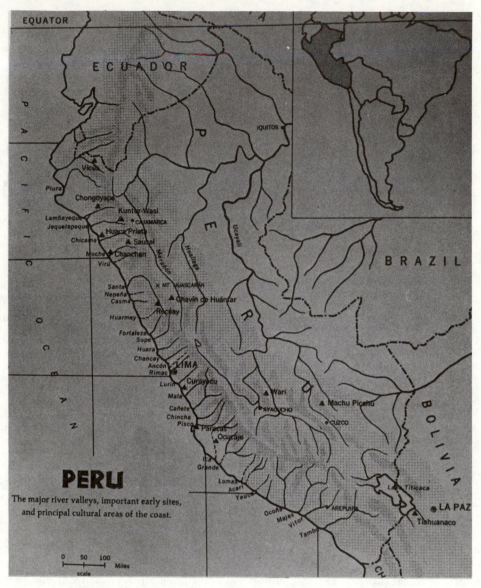

Figure 1. Map of Peru showing principal river valleys. (Sawyer 1966:8.)

Chancay style pottery was produced during a period of regional differences in Peru (Lumbreras 1974:179). Isolation has been suggested as an explanation for the striking difference between Chancay pottery and the elegantly finished wares produced by most other pre-Columbian Peruvian cultures. But grave goods found in Chancay burials suggest this isolation was far from total. Trade goods, by no means rare, came not only from neighbors to the north and south, but also from as far away as the Amazon. While Chancay pottery has been deemed inept, the excellence of that culture's textiles has been generally recognized (Figure 4). These textiles, along with silver sculptures of great intricacy and inventiveness, have been found in the tombs of the Chancay elite. Included in the same tombs were quantities of Chancay pottery. It is suggested that the Chancay pottery style was neither the result of isolation nor

314

clumsiness, but, rather, that these ceramics give tangible evidence of the diversity and autonomy of late pre-Columbian Peruvian art styles.

Chancay Style Pottery: Sites and Variants

The black-on-white pottery with which this study is primarily concerned is what is intended when the term "Chancay" is used in the literature, although many earlier pottery styles have been found at the site of Chancay. Black-on-white pottery is also referred to in the literature as Late Chancay and Chancay-Inca. The style takes its name from sites in the Chancay Valley. Related black-on-white ware has been found at sites at Ancón between the Chancay and Chillón Valleys where it is called Late Ancón II, and at sites in the Chillón Valley to the south where it is referred to as Chancay, Chancay-like, or Sub-Chancay (Kroeber and Strong 1925:139).

The designation Chancay, then, implies pottery type rather than provenience. Chancay-like pottery has been found as far south as the Lurín Valley at the far more ancient site of Pachacamac, while sherds have been found at sites in the Chilca, Alleria, and Mala Valleys to the south and as far north as Huacho.[1] However, manufacture and greatest distribution seem to have been centered in the Chancay and Chillón Valleys (Lothrop and Mahler 1957:9).[2]

The valley of Chancay lies approximately on the center of the Peruvian coastline at about eleven degrees south of the equator. It takes its name from the Chancay River, one of the sixty rivers originating in the high Andes and transversing the Peruvian coastal desert to the Pacific Ocean. The Chancay valley lies some thirty-five miles north of the capital city of Lima. The Chancay River irrigates an area of 53,228 acres and covers a drainage area of 1,594 square miles. Relative to others on the coast, it is a medium-sized river, and provides the valley with a fairly stable supply of water. Its heaviest volume is carried from January to March, the height of the rainy season in the sierra. Its minimum flow occurs during July and August. The Chancay Valley is unsuitable for agriculture until about nineteen miles from the coast, where it begins to increase its width. From here until the salt marshes near the sea are reached, the surrounding plains are intensively cultivated. Ancient occupation sites in the valley include Lauri, Pisquillo, Chancayllo, and Quilca.

Chancay black-on-white pottery was produced from about A.D. 1000 until 1476. Most of the pottery was probably used in ceremonial contexts. Chancay pottery was distinct from that produced by neighboring groups; stylistically its closest parallels are to be found in the northern Andes and the Amazon basin (Bennett 1954:84), but no evidence of diffusion or contact from these regions has been established. However, in common with the Peruvian South Coast tradition, Chancay pottery emphasized the container aspect rather than the effigy, and, in common with the North Coast, used no polychrome. Like all pre-Columbian Peruvian pottery, that of Chancay was sculptural and made use of textile patterns as source material for surface treatment.

1. The Chancay culture was spread through the Huaura Valley as well, and reached the northern part of the Chillón delta (Lanning 1967:152).

2. The Chillón Valley is of medium size, smaller than the Chancay and not large enough to have been the center of a valley group culture, kingdom, or confederation. Although the high sea cliff blocked the Chillón from the Chancay Valley, there is evidence that a major road existed in pre-Columbian times farther inland. Agriculturally the Chillón was connected with the Rimac and Lurín Valleys to the south and when the Spanish conquerors arrived they found that entire area under cultivation, irrigated by a complex series of interconnecting canals. The Chillón was not discovered to have been connected in like manner to the Chancay Valley, but its cultural affinities in that direction were closer than with its southern neighbors (Stumer 1954:171-72).

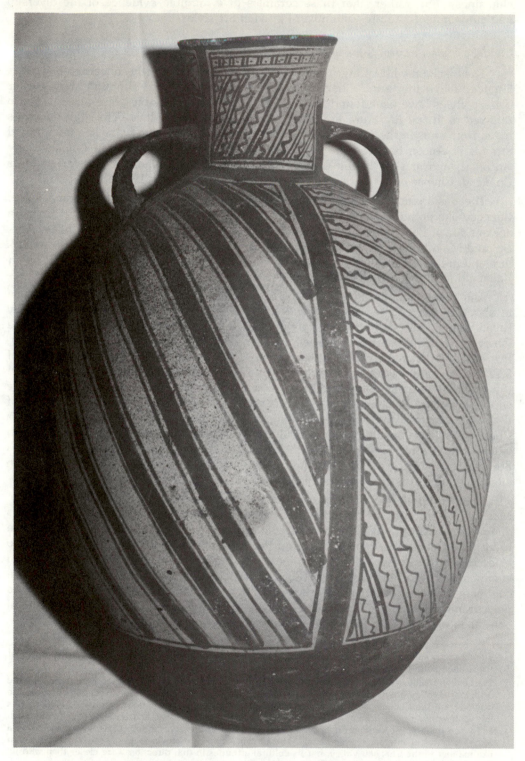

Figure 2. Globular vessel collected at Lauri, Chancay Valley, 1962. Private collection.

Figure 3. Miniature animal sculptures collected at Lauri, Chancay Valley, 1962. Private collection.

Black-on-white pottery was produced during the Late Intermediate Period.[3] This followed a period of about 400 years during which effects of Peru's first attempt at "empire" were felt, the coast having fallen under the sway of the Huari civilization. The beginning of the Late Intermediate Period was a time of return to local cultures: Chimú in the north, having its roots in the earlier cultures of the Moche and Lambayeque Valleys; Ica and Chincha in the south, drawing upon the earlier cultures of the Paracas Peninsula; and Chancay, developing out of a long central coast ceramic sequence, having as its direct antecedent, perhaps, a style known variously as black-white-and-red geometric, three-color geometric, and Late Ancón I (Lothrop and Mahler 1957:11).

In the Chancay and Chillón Valleys this period appears to have been one of relative isolation, undisturbed by direct contacts with other cultures. Production of black-on-white ware overlapped, at least in part, the Late Horizon, during which time first Chimú and then Inca influences made themselves felt at locations on the coast. In Chancay-style graves a small amount (about seven per cent at Ancón) of Chimú-type black *bucchero*[4] ware has been found and these may represent trade pieces. Absence of Inca influence on Chancay pottery has been thought to demonstrate the ability of local groups to maintain cultural integrity in the face of political domination by the

3. Peru's cultural history appears to have followed a pattern of periods of local cultures (natural to the geographical isolation of the individual coastal valleys) succeeded by periods of pan-Peruvian, unifying civilizations, some more far-reaching and lasting in their influence than others. Nevertheless, the coastal divisions of North, Central, and South are consistently reflected in the distinctiveness of pottery styles throughout time. Archaeologists divide the coast of Peru into North, Central, and South. The Central Coast begins at the Fortaleza Valley about 140 miles north of Lima and ends with Cañete, 100 miles south of Lima. The three regions are separated from each other by strips of desert rather wider than the average separation of about twenty-five miles. The divisions therefore can be considered geographical as well as archaeological and are also reflected in cultural differences.

4. This word, which traditionally is applied to Etruscan blackware, is often used to describe the blackware of the North Coast of Peru which was manufactured likewise in a reducing fire, achieved by application of dampened fuel toward the end of the firing period.

Inca (Bennett 1946a:139).[5]

In the Late Intermediate Period the return to regionalism was based on political organization rather than technology. Basically, all technological innovations had been diffused and assimilated during the Early Intermediate Period (Lanning 1967:126). Balance of power then shifted to those whose territorial dominion was most extensive. Consequently, the North Coast cultures achieved political ascendency over the Central and South Coasts because the northern valleys were larger and were assured of a more dependable water supply (Bennett and Bird 1960:150). Greater strength allowed the Chimú kingdom to subjugate its neighbors to the south before it was defeated by the Inca conquest. Late Chimú and still later pan-Peruvian Inca ware have been found in quantity at sites at Pachacamac, Chincha, and Pisco (Kroeber 1926:269). The paucity of these wares at Chancay and Ancón lead one to speculate that perhaps this culture was either not seriously invaded by the Chimú or the Incas, or had been granted some special immunity from subjugation and was left free to develop its own local style while the remainder of Peru was submerged.[6]

Scientific study of Peruvian prehistory commenced with the activities of Max Uhle, who in 1904 excavated six sites in the Chancay Valley. The results of his studies at Chancay and Ancón, based on his unpublished reports and on the works collected by him at those sites and housed at the University of California, Berkeley, were analyzed, reviewed, and the findings published (Kroeber and Strong 1925; Kroeber 1926).[7]

The population of the Central Coast, as everywhere in the Central Andes during the Late Intermediate Period, must have been very large, as attested to by the vast number of graves that have been discovered. Agricultural techniques, which included use of irrigation, crop-rotation, and fertilizers, permitted efficient and abundant pro-

5. Larco Hoyle (1966:188) wrote incorrectly of the existence of a "kingdom of Chancay" reaching from Huacho to Lima and the Lurín Valley. There is nothing in the data to indicate that such a kingdom ever existed (Proulx 1967:555-56). It is also doubted that the Chancay Valley was, as has been claimed, part of a state or intervalley confederation known to the conquering Incas as Cuismancu (Means 1931:186). Archaeological evidence fails to demonstrate the existence of such a confederation. The Chancay style in the Huaura, Chancay, and Chillón Valleys is distinct from that of the "Huancho" culture of the southern Chillon, Rimac, and Lurín Valleys where a coarse white painted pottery with appliqué designs was widespread (Lanning 1967:152).

6. Kroeber (1926:270) speculated that the valley's isolation or independence may have been responsible for the use of a two-color scheme by the Chancay potter:

 Color variety had evidently been shrinking in Peru for a considerable time until the Inca influence partly reinvigorated it . . . This general Peruvian tendency toward shrinkage of color scheme seems to have been carried to its undisturbed conclusion in the coast nook of Chancay where for some reason it was not subjected to the color restoring ones of Inca.

7. The pottery sequences established in the report on Ancón formed the basis for studies of the area for the next thirty years, until questioned by Lothrop and Mahler (1957). For the necropolis of Ancón, Kroeber and Strong give the following temporal sequence commencing with the earliest: Early Ancón; Middle Ancón I; Middle Ancón II consisting of a four-color epigonal (to Huari) style, an impressed red style and a white-on-red style; Late Ancón I consisting of a black, white and red geometric style and a white and black-on-red style; Late Ancón II consisting of a black-on-white style and a plain white style. Inca influence possibly had reached the valley, but no true Inca-type ware was included in the Uhle collection. At the time of the arrival of the Spaniards it would appear that the necropolis of Ancón had been abandoned. Lothrop and Mahler (1957:12) found in their excavations that overlapping and contemporaneity of the above pottery styles were established as well as the supposed sequence. Based on investigation of several sites in the Chillón Valley, they suggested that some communities changed their pottery styles while others did not. Bordaz (1958:200), however, criticized Lothrop and Mahler for having based their conclusions on a few color and decoration considerations. Kroeber and Strong, on the other hand, had examined distributions of forty separate ceramic traits in establishing their chronology of the Uhle collection. Distribution of traits may have reflected either a local preference as suggested by Lothrop and Mahler or a disturbance of the graves; but since the mixed graves were in a minority, the sequence suggested by Kroeber and Strong has not been seriously challenged.

duction of food. The Chancay dead were carefully buried; the corpses were wrapped in layers of cloth and padded about with wads of cotton and leaves, perhaps to aid in the process of desiccation (Lothrop and Mahler 1957:4). The dead were accompanied by quantities of grave furniture, including pottery, metalwork, textiles, and weaving implements.[8]

What name the people of Chancay called themselves we may never know; nor is it likely we will know the language that they spoke. The Incas applied the name "Yungas" to the entire coastal region and called the linguistic group or groups that occupied the Central Coast valleys, the Yauyo (Bennett 1946:16). By the time the Spaniards arrived, Quechua, the imperial tongue, had replaced most of the coast languages. The Spaniards followed suit and actively encouraged Quechua as a *lingua franca*, and in short order most of the aboriginal languages disappeared.

Form and Elaboration of Chancay Pottery

Late Chancay pottery is thin, porous and coarse; it has a gritty texture and is usually unpolished and non-reflective. The body of the clay, or paste, was fired in an oxygen-rich atmosphere at a relatively low temperature and is either red, orange, rose, or white in color. Characteristically the pots were entirely covered with a thin white slip which tends to scale or flake easily. This slip is not a pure white in color, varying from grayish-white through a yellowish-cream to a pinkish-sand. Linear, geometric patterns were applied to this ground in a black, sepia, or purple-brown slip. Sometimes large areas were filled in solidly with a wash of black slip, the varying shades of which may be due to the effects of long burial, or to differing pigment composition in the original slips.

Black-line painting over a solid white slip on a red-fired clay body appears to have been, from sheer quantity, the most characteristic style produced by the Chancay culture. Contemporaneous with Chancay black-on-white ware were a number of variants, among them a white ware, represented by unslipped, undecorated small bowls and figurines; pieces of white clay, unslipped but decorated with a black line; red clay vessels, white slipped but unpainted; red clay pieces, white slipped and painted with black and red pigments; and red clay ware, red slipped and painted with either white alone or white and black (Lothrop and Mahler 1957:10).

Painting was probably executed with brushes. Brushes have been found in refuse heaps at various sites on the coast (Linné 1953:110-23).[9] The character of the

8. This abundance of grave goods, plus the fact that during the nineteenth century interest in pre-Columbian artifacts underwent a resurgence, gave birth to the occupation of *huaquero*, or professional grave robber. (Pre-Columbian pots are commonly known as *huacos* in Peru.) It is part of the folklore of Peru that during the *semana santa* the dead rise closer to the surface of the earth in anticipation of Resurrection, and it is during this time that *huaquero* activity reaches its peak (Lothrop and Mahler 1957:v.). In the 1960s it was possible to engage a *huaquero* at the Lauri, Pisquillo, Chacayllo, or Quilca cemeteries in the Chancay Valley to unearth Late Intermediate Period graves. Needless to say, such excavations were hardly scientific in method. Interest aroused in the nineteenth century brought many amateur archaeologists and collectors into the field. Numerous examples of Chancay black-on-white ware were included in extensive private European and American collections before any systematic study of the area had been undertaken.

9. It is fairly usual to encounter weaving implements in Chancay as in other Central Andean culture burials. To my knowledge there is no report of pottery tools having been likewise entombed. This may be due to lack of data or possibly has some bearing upon the different status assigned to each craft. Was weaving to continue to be practiced in the afterlife and pottery not? Weavers were depicted in Chancay needlework and metalwork. In important burials (to judge by the quantity and quality of the contents) textiles lined the walls of the tomb (Linné 1953:110-23). Of course, absence of pottery tools in the inventories of pre-Columbian grave furniture may be due to the relative transient and simple nature of such implements and have no bearing upon the status of the practitioner.

319

Figure 4. Cotton brocade with bird and feline figures. Chancay Valley. (Inca No Orimono 1966:56; Asahi Shimbun Sha, Tokyo.)

Figure 5. Human effigy vessel. Chancay Valley (?). (Frederick Dockstader 1967:157; Indian Art in America. New York Graphic Society, Greenwich, Connecticut.)

painting is "free" in the sense that it is neither mechanical nor precise. In the parlance of contemporary art criticism it might be termed "painterly" or "calligraphic." It would seem that an inflexible brush was used to apply the designs (Russum and Stroup 1958:41).[10] In some pieces, because of the transparency of the slip, it is apparent that the painter brushed over certain areas several times, but with no attempt made to duplicate the same line or area. Other areas appear to have been executed with single strokes. In every case each line carrying the design appears directionally to have been executed in a single stroke. Superimposed strokes each carry the design in different directions. Thus, in a design composed of a wide vertical band of black with rounded openings in the center where the underslip of white shows through (like a vertical chain of B's) the lateral looping line appears to be done with one stroke and the vertical side bandings with another. The edge of a line or stroke may vary from extremely crisp to extremely irregular. Indeed, in some cases, further accentuated by the flaking away of the pigment, the line has the appearance of "drybrush" painting technique.

Lothrop and Mahler (1957:8-9) have divided patterns found on Chancay black-on-white ware into five categories:

(1) *Hanging line motifs:* These are composed of grouped vertical lines, pendant from a horizontal banding usually around the neck of the vessel and broadening with the fullness of the pot.

(2) *Parallel line motifs:* The field is filled with closely parallel lines, either straight or alternately straight and zig-zag and/or wavy.

(3) *Interlocking panels:* The field contains horizontal bands of zig-zags, interlocking triangles, and stylized small animals and fish. This treatment may be related to the black and red-on-white geometric style of the Central and North Coasts; indeed, the whole group may have developed out of the so-called Interlocking Style of an earlier period. Contemporary with Late Chancay pottery are pyro-engraved gourds with designs based, for the most part, on the bilaterally symmetrical motifs that dominated the Interlocking Style of the Early Intermediate Period and appear also to be similar in style to black and red-on-white and black-on-white wares.

(4) *Dotted zones:* The field is divided into small areas by means of cross-hatching or zig-zags, and a single dot is placed within each area. Similar motifs were seen on coast ware from the Middle Horizon—the time of the Huari-Tiahuanaco expansion—and were then usually executed in four colors.

(5) *Silhouette:* Black paint is applied in such a way that white linear areas are formed by allowing the unpainted white underslip to show through. The effect is that of white lines having been painted on a black ground. Some vessels have the bottom thirds or halves painted solidly in black, and certain effigy vessels have large areas on the back, with the entire crown and the features as well as attendant patterns painted in black. In addition, there are fields filled in checkerboard fashion; stepfret and Greek-key motifs are also found. Occasionally, incising is used. Weaving was very important to the Chancay people, and doubtless there is a relationship between the motifs applied to their pottery and to their textile designs.

10. In many areas of the Central Andes today a brush is made by chewing the end of a twig. This makes for a strong, vigorous line that differs in character from the Oriental line made with a long bristle brush (Russum and Stroup 1958:41).

Figure 6. Double vessel in sub-Chancay style. Rimac Valley, Pachacamac. (Dockstader 1967:155.)

The shapes of pottery done in the black-on-white style are limited. Roughly, they can be divided into two major categories: containers and figurines. Containers were produced in larger quantity, a fact that available data show was true of the other Central Andean civilizations. It is possible, however, that figurines were produced in greater abundance by the Chancay culture than by other ancient Peruvian cultures. Within the figurine category are small, rounded sculptures of animals, some undoubtedly meant to represent llamas. There are also large, less rounded, more frontally modeled effigies of naked humans of both sexes with flaring, flattened crowns or headdresses.[11]

11. If the heads of these figurines were meant to represent head deformation, it is interesting to note that during the Late Period, skeletal remains in the Central Coast had 34 percent undeformed crania—a maximum for all periods. Moreover, no crania with pronounced deformation were found (Newman 1947:10).

Some of the figurines can stand unsupported. The outstretched arms are generally short and flipper-like with cupped hands. Faces were mold-made or mold-impressed with sharply arching eyebrows joining a narrow, aquiline nose. Female figures have pierced ears, perhaps for attachment of earrings. Genitals are indicated by shallow incising.

Figurines fashioned of many materials were widespread throughout the Central Andes. Because of the desert conditions of the Peruvian coast, many examples of pottery, metal, wood, and cloth figurines are preserved. Some were made of yarn-wrapped reed bundles with needlework faces. Many were found wrapped or dressed in miniature clothes, woven to size. Figurines were found in burials, in women's workbaskets, in community trash heaps, and broken and scattered at shrines. Were these intended to serve as idols or fetishes or were they more profane in nature and meant to serve as playthings or companionable keepsakes? Data do not supply this information (Bird 1962:203).

Chancay pottery containers were made in a variety of shapes and sizes ranging from miniature bowls and dishes four centimeters in diameter to urns a meter or more in height. Characteristically, urns have globular or egg-shaped bodies with rounded bottoms, flaring or swollen necks, broad ribbon-shaped handles, and lugs or other ornaments (*adornos*).[12]

Effigy urns have swollen necks upon which human features were painted. Of these urns the container aspect of the pot dominates that of the effigy although facial features, ears and earspools, were often modeled and rudimentary arms and feet affixed. In some instances arms and legs were modeled in low relief. Often the hands hold a small bowl or goblet modeled in the round. A vague suggestion of nipples or breasts may be found modeled on the upper portion of the vessel, and legs were painted in black, the feet usually ending well above the base of the pot. It is probable that the rounded base served to provide a firm anchorage for the vessel in the sandy soil of the area and was thus hidden from view. The legs were depicted flexed, in profile, but painted on the front of the vessel as mirror images of each other. A slight depression in the center of the pot and above the flexed knees may have been meant to represent either the navel or genital area. Notched appliqués of clay, which possibly represented feathers, were often affixed at regular intervals and at right angles to the crown headdress. In some instances the entire face and crown area was treated as a separate bowl shape with a flaring rim. Handles were placed high on the shoulders of the pot, near the middle, or lacking entirely. Eyes were often ringed in black, and additional facial markings result in what has been described as a bespectacled look (Kroeber 1926:266). These markings may be related to the markings of birds and to the weeping eye motif that persisted in pre-Columbian Peruvian art for at least 2,000 years (Yacovleff 1932). The mouth was usually superimposed with a square or rectangle of black paint that may represent either a mouth mask or face painting. The effigy thus elaborated with headdress, facial markings, ear spools and cup, may represent a priest, shaman, or other personage of high status engaged in ritualistic activities.

Other shapes include double-chambered bridge and spout vessels similar to contemporaneous North Coast ware in form, but painted in Chancay black-on-white style. Also represented are wide-mouthed jars and vessels with animals modeled on the rims. Not a single stirrup pot, a form characteristic of North Coast pottery, has been found at Chancay culture sites. Placement of ribbon-like handles low on the body

12. Possibly, the flaring neck was a direct result of Inca influence, and the handles were used for attachment of straps as an aid in carrying as were those of the Inca (Sawyer 1966:64).

of jars, use of *adornos*, and paneling of designs in quadrants is suggestive of Inca influence.

Technical Aspects of Chancay Pottery Manufacture

Production of pottery is dependent upon availability of suitable clay. The quality of clay in the Central Andes varied from locale to locale, but the western slopes of the Andes and the coast of Peru abounded in clays suited to the manufacture of pottery. Most clays from the coastal area contained a high proportion of igneous rock from the Andes. That of the South Coast derived largely from marine tertiary formations. Clay from the desert coast contained feldspar, which decomposes into kaolin plus various iron compounds. It is these iron compounds that determine the color of the clay body after firing. Clay used in the Late Intermediate Period and Late Horizon on the Central Coast was true terra-cotta—sandy and porous (Russum and Stroup 1958: 41).[13]

To render the raw clay usable, impurities must be removed. This can be accomplished by first drying, then crushing and grinding the clay. In some remote areas of Peru clay is ground between two stones (Linné 1925:27). If too much organic material is left in the clay it becomes porous and cracks in the processes of drying and firing. The clay must then be made plastic so that it will hold the desired shape when mixed with the proper amount of water. The plasticity of clay when wet depends upon the formation of lamellae or leaf-shaped particles. If the clay contained much free quartz sand, then finely crushed gravel containing feldspar, mica, and quartz was added. Addition of these tempering materials also served to render the clay less subject to cracking while drying, making it better able to withstand the sudden temperature changes of the firing methods used. A coarse grain in the paste may also have served to stop cracks from expanding.

Except for the North Coast, where molds were extensively used, most pre-Columbian pottery in Peru was manufactured by the coiling process, although some very small pieces were produced by direct shaping of the clay lump. Vessels were usually built from the bottom up, the bottom section supported by a basket, leaves, bowl or stone slab that could be rotated fairly rapidly. The Old World potter's wheel was unknown.* Sides were raised by adding cylindrical strips, either row by row or spirally. These coils were shaped and united by pinching and smoothing or pressing with a paddle while an anvil was applied to the inner surface. Often it is impossible to ascertain the presence of joinings. Tools used for daubing out the seams were pieces of shell, gourds, bone fragments, or bits of tortoise shell. Lugs, handles, and other additions were stuck on by pressing and squeezing.

There is much evidence for the use of molds at Chancay and Chancay related sites (Lumbreras 1974:192). Molds found at those locations suggest mold-made parts were combined with handmade components.[14] Thus, the swollen neck and flange of a globular pot might have been mold-formed while the body of the vessel constructed by hand.

13. A comparative study of available clays might help to explain regional differences.

* Terence Grieder argues for limited use of a "shaft-centered" potter's wheel at Pashash (Grieder, *The Art and Archaeology of Pashash*, Austin: University of Texas Press, 1978, p. 96). —A.C.-C.

14. It is possible that pots were assembled from several separate mold-made components. It has been suggested that mass production of pottery among the coastal cultures during the Late Intermediate Period and Late Horizon, especially among the Chimú, reflected a growing influence and increasing democratization of society (Donnan 1969).

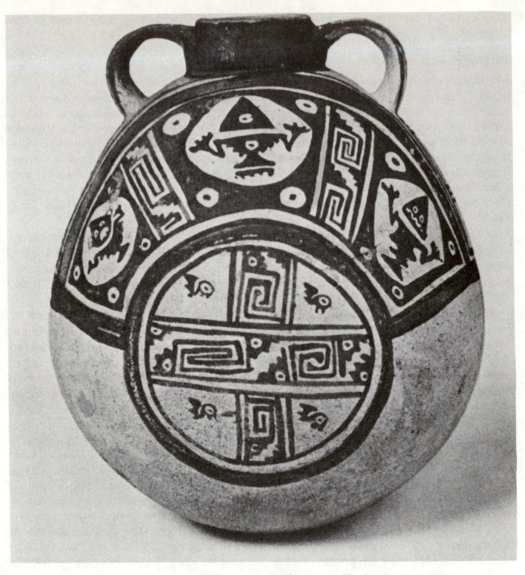

Figure 7. Vessel in sub-Chancay style. Cajamarca. (Dockstader 1967:156.)

Slip was prepared from fine clay or pigment chosen for its color properties. White slip was produced from kaolin rich clay, and black from burnt animal matter, soot from cooking pots, or ground mineral pigment. Ground slate, oxides of iron or manganese would have provided a dark brown tone. It is also possible that an ink obtained from squid or cuttle fish could have been used to provide a sepia color (Linné 1925:134-35). Clay slip first had to be ground and then washed, the finer material held in suspension, then poured off and then allowed to settle. There is no evidence that dispersants such as lye or gums used in Central America as an aid to deflocculation were in use in Peru (Bennett and Bird 1960:185). In addition to imparting the desired color and forming a base for painted decorations, the white clay wash applied to Chancay pots served to make the clay less porous and more waterproof. A similar function was served by burnishing unslipped ware among the Chimú.

Application of slip is a complex process, as the slip and the clay body must react similarly during drying and firing. It is also possible that several firings were involved in the production of Chancay pottery; the ware may have been slipped after the first firing and then fired again. The white slip of Chancay vessels scales easily, and the black paint is not stable and tends to dissolve in water, suggesting that these pots were not intended for cooking purposes but rather to fulfill less prosaic needs.

Kilns in the sense of enclosed ovens may have been used in production of Chancay pottery, but none has been discovered. While it has been suggested that every pre-Columbian Peruvian ceramic technique may be duplicated in open fire baking (*ibid*:187), it is also possible that temporary kilns were employed, the vessels stacked in pyramidial fashion and surrounded with firewood and covered with some non-inflammable material such as fresh bark (Linné 1925:113-25).[15] This conically shaped mass would have had air holes at the base and an aperture at the top to generate a strong draft during firing. At 400 degrees Centigrade, the molecular water is driven out of the clay, and it loses its plasticity permanently. Temperatures of from 400 to 800 degrees produce porous pots. It is possible that temporary kilns may have produced temperatures of up to 900 degrees Centigrade, high enough to have produced the relatively hard-fired ware of the Chancay culture (cf. Shepard 1968:83). Similar temporary kilns may have been built up of potsherds and fired with charcoal or dung. Abundant presence of air would have caused all or most of the carbon to have burned away, resulting in a clay body of from cream to red in color, depending upon the amount of ferric oxide present.

In spite of the apparently large volume of pottery produced, individual pieces were not considered expendable as evidenced by the painstaking care with which breaks were repaired. Broken Chancay-type pottery was preserved by the crack-lacing method of mending. First a row of small holes was drilled on either side of a crack. These holes were conical in shape with the wider opening on the outside. The surfaces of the break were drawn tightly together and fine twigs were threaded through the holes and then laced up like the lacings on a shoe. Finally the holes were filled in with resin. This method of preservation was widely observed in Peru. Pieces so treated were apparently considered worthy of burial.

Conclusions

The most popular ware produced during the Late Intermediate Period and Late Horizon in the Chancay and Chillón valleys was made in the black-on-white style. The distinctiveness of this style had earlier been considered evidence of the isolation experienced by the Chancay culture. Further investigation indicates that this isolation was relative and that influences from both the Chimú and Inca cultures reached these valleys with some consistency. These influences, however, were remodeled to fit a distinct and self-possessed style. It is suggested that outside influences blended with the old local black-white-red patterns to produce the Chancay variants. Sub-Chancay, with its double-chambered, mold-made forms, is most clearly Chimú influenced. Late Chancay—the black-on-white style—on the other hand, despite use of molds and Inca derived lugs and *adornos*, owed less to outsiders and most to local impulse. The stylistic enclave represented by black-on-white pottery in the Chancay valley was probably reflected politically. It is likely that here resistance to Chimú and Inca domination was most successful.

15. The bromeliad, Tillandsia, may have been used as fuel in dry locations such as Chancay (Rowe 1966a: 297).

Bibliography

Bennett, Wendell C.
 1946 "The Andean Highlands: An Introduction." *In* Julian H. Steward, ed. *Handbook of South American Indians*, vol. 1. Washington, D.C.: Smithsonian Institution.
 1946a "The Archaeology of the Central Andes." *In* Julian H. Steward, ed. *Handbook of South American Indians*, vol. 1. Washington, D.C.: Smithsonian Institution.
 1954 *Ancient Arts of the Andes*. New York: The Museum of Modern Art.
 _____ and Junius B. Bird
 1960 *Andean Culture History*. Garden City: The Natural History Press.

Bird, Junius B.
 1962 "Art and Life in Old Peru." *Curator*, 5.

Bordaz, Jacques
 1958 "Review of Samuel K. Lothrop and Joy Mahler, A Chancay-Style Grave at Zapallan, Peru." *American Antiquity*, 24:200-01.

Bushnell, Geoffrey H. S.
 1965 *Ancient Arts of the Americas*. New York: Praeger.

d'Harcourt, Raoul
 1950 *Primitive Art of the Americas*. New York: Tudor.

Donnan, Christopher
 n.d. Ancient Peruvian Art: Advent of the Industrialist Approach. A lecture delivered at the Los Angeles County Museum of Art, April 23, 1969.

Kroeber, Alfred L.
 1926 The Uhle Pottery Collections from Chancay. *University of California Publications in American Archaeology and Ethnology*, 21 (7):265-304. Berkeley.
 1951 "Great Art Styles of Ancient South America." *In* Sol Tax, ed. *The Civilizations of Ancient America: Selected Papers of the XXIXth International Congress of Americanists*. Chicago.
 _____ and William Duncan Strong
 1925 The Uhle Pottery Collections from Ancón. *University of California Publications in American Archaeology and Ethnology*, 21 (4). Berkeley.

Kubler, George
 1962 *The Art and Architecture of Ancient America*. Baltimore: Penguin.

Lanning, Edward P.
 1967 *Peru Before the Incas*. Englewood Cliffs: Prentice-Hall.

Larco Hoyle, Rafael
 1966 *Peru*. James Hogarth, trans. Cleveland: World Publishing Co.

Linné, Sigvald
 1925 "The Technique of South American Ceramics." *Vetanskaps-Och Vitterhets*, 29 (5). Götesborg.
 1953 "Prehistoric Peruvian Painting." *Ethnos*, 18:110-23. Stockholm.

Lothrop, Samuel K. and Joy Mahler
 1957 "A Chancay-Style Grave at Zappallan, Peru." *Papers of the Peabody Museum of American Archaeology and Ethnology*, 50 (1). Cambridge.

Lumbreras, Luis G.
 1974 *The Peoples and Cultures of Ancient Peru*. Washington, D.C.: Smithsonian Institution.

Mason, J. Alden
 1961 *The Ancient Civilizations of Peru*. Baltimore: Penguin.

Means, Philip Ainsworth
 1931 *Ancient Civilizations of the Andes*. New York: Gordian.

Newman, Marshall T.
 1947 "Indian Skeletal Material from the Central Coast of Peru." *Papers of the Peabody Museum of American Archaeology and Ethnology*, 27 (4). Cambridge.

Proulx, Donald
 1967 "Review of Rafael Larco Hoyle, *Peru*." *American Antiquity*, 34 (4):555-56.

Rowe, John Howland
 1966 "Stages and Periods in Archaeological Interpretation." *In* John Howland Rowe and Dorothy Menzel, eds. *Peruvian Archaeology: Selected Readings*. Palo Alto: Peek Publications.
 1966a "Urban Settlements in Ancient Peru." *In* John Howland Rowe and Dorothy Menzel, eds. *Peruvian Archaeology: Selected Readings*. Palo Alto: Peek Publications.

Russum, Olin and Marian C. Stroup
 1958 *The Wurtzburger Collection of Pre-Columbian Art*. Baltimore: The Baltimore Museum of Art.

Sawyer, Alan R.
 1966 *Ancient Peruvian Ceramics: The Nathan Cummings Collection.* New York: The Metropolitan Museum of Art.

Shepard, Anna O.
 1968 *Ceramics for the Archaeologist.* Washington, D.C.: Carnegie Institution.

Stumer, Louis
 1954 "The Chillón Valley of Peru: Excavation and Reconnaisance." *Archaeology,* 7 (3 and 4):171-78, 222-28.

Uhle, Max
 1910 Über die Frühkulturen in der Umgebung von Lima, Verlandlungen des XVI Internationalen Amerikansten-Kongresses. Vienna: A. Hartleben.

Willey, Gordon R.
 1943 "Excavations in the Chancay Valley." *Columbia Studies in Archaeology and Ethnology,* 1 (3).

Yacovleff, Eugenio
 1932 "Las Falcónidas en el Arte y en las Creéncias de los Antiguos Peruanos." *Revista del Museo Nacional,* 1: 35-111. Lima.

Ecology, Art, and Myth:
A Natural Approach to Symbolism

Judith Davidson
Anthropology Department
University of California, Los Angeles

Iconography is a fascinating aspect of art historical research. At the very least it allows the researcher to identify the patterns of belief developed by ancient non-literate peoples. Occasionally, it allows more.

The *Spondylus princeps* shell as both a real item and as an artistic motif has enjoyed an extremely long history in South America's Andean area, beginning some 4,000 years ago. This report analyzes *Spondylus* iconography in the light of the shell's biological reality. The resultant interpretation is then tested against ethnohistorical and ethnographic data. The results indicate a very real basis for the shell's veneration and depiction in Andean art.

THE IMPACT OF THE NATURAL ENVIRONMENT on cultural patterning has been little utilized as an analytical tool for the interpretation of New World motifs. This paper uses the representation of a marine mollusk in Andean iconography to illustrate that by actively following the delicate interrelationships between biological and cultural cycles, new meaning can be drawn from iconographic motifs.

Throughout Andean prehistory, beginning with the pre-Ceramic Period (Feldman 1977:14), the marine bivalve *Spondylus sp.* has figured prominently in Andean economics (Murra 1975:255-269) and religion (Davidson 1979). In addition, it functioned as a status indicator in elite burials and residential structures (Andrews 1974:245; Conrad 1974:49). Even today, in the highlands, the image of this mollusk continues to play an essential role in traditional rituals (Davidson, in press). The rationale behind this continuing need for spondylids will be shown to be a function of the belief that the shellfish can enhance communication with supernatural beings directly responsible for human fertility.

I will explain why this mollusk has retained its symbolic import through 4,000 years of Andean cultural history first by discussing significant aspects of its natural history and morphology that were apparently known to pre-Hispanic Peruvians. I will then demonstrate the manner in which ideology conforms to ecology in myth and ritual. Finally, I will illustrate how an analytical system based on natural modeling can aid in the elucidation of artistic motifs.

The Spondylus in the Natural Environment

Several aspects of the life history and morphology of this mollusk had profound implications for ideological patterning. One of these is its seasonal toxicity. Because it spends its entire adult life cemented to the ocean floor, the *Spondylus* feeds on micro-organisms brought to it by marine currents (Dakin 1928:338). At two times of the year (from August to September and from April to May), streams of water swept into the mollusk's inner tissues can contain dinoflagellates possessing substances toxic for human consumption (Kamiya and Hashimoto 1978:303-306). These two time periods are considered to be extremely dangerous in the Andean ritual calendar. July to August marks the end of the dry season, and April to May marks the end of the wet season. It is at these exact times when bivalve offerings are performed by contemporary practitioners (Davidson, n.d.); furthermore, it is these time periods that are mentioned in the ethnohistoric documents as the times when *Spondylus* shells were sacrificed to weather deities to guarantee crop and livestock fertility (*ibid*). At these times, the marine environment itself appears threatening: during a dinoflagellate bloom the ocean surface can glow with an inner fire, an effect produced by these luminescent organisms. *Spondylus* eaten then have been implicated as a cause of human death (Tufts 1978:403), as well as agents responsible for sensory and psychotropic distortions (R. Abbot and B. Halsted, personal communication).

The outstanding morphological features of this mollusk are the brilliant color of its shell, the long thorny spines that cover the outside of the shell (Figure 1), and the sensory organs (Figure 2). The shell of *Spondylus princeps*, the species most commonly recovered from Peruvian sites, can range in color from white to orange, red, or purple (Olsson 1961:150). The hard calcareous spines serve two functions for the mollusk: protection, and communication. According to Stanley (1970:34),

> . . . spines of spondylids act as rigid spikes guarding the delicate inner tissues. It is true that parrot fish and other similarly endowed groups could nibble away the spines . . ., but such behavior would require considerable time and energy expenditure, while other more abundant and better exposed animals . . . are far easier prey.

Likewise, it is impossible to rule out the use of the bivalve spines as sensory warning devices, even if they also serve for direct physical defense. Thus it is apparent that the spines serve the mollusk in much the same way as the *Spondylus* shell itself was used in rituals. It served as a means of protection and communication.

Figure 1. A modern Spondylus pictorum *illustrating the sharp spines. Photograph courtesy of Alana Cordy-Collins.*

Figure 2. Sensory organs of a fresh specimen. (Rees 1957: 23). Photograph courtesy of Shell Transport and Trading Co., London.

While other mollusks possess rigid spines as well as beautifully colored shells, the one feature that distinguishes spondylids from other mollusks is their remarkable sensory organs: their eyes. These are the only molluskan eyes capable of forming an image (Watson 1930; Wilbur and Yonge 1966). Spondylid eyes can number up to a hundred in a single large specimen (Dakin 1928; Rees 1957:23). And although their outstanding sensory qualities are a rather recent scientific finding, indigenous peoples were certainly aware of their physical characteristics. In the fresh specimen they shine brilliantly; after a few days out of water, however, they become desiccated and dulled (Dr. Leonard Muscatine, personal communication).

Presumably, it is the unique combination of these attributes that ultimately resulted in the shell's role as a "power" object in myth and ritual.

The Spondylus in Myth and Ritual

Ancient ethnohistoric accounts and modern ethnographic records both provide evidence supporting a strong association of spondylids with religious belief systems. The point of juncture between these past and present sources lies in the way the shells are used in rituals and the belief that they can influence deities who control human fertility.

Accounts written by Spanish observers during the sixteenth and seventeenth centuries, such as Father Pablo José de Arriaga (1968:47,68,171), Father Miguel Cabello de Balboa (1951:327), Father Bernabé Cobo (1956:Lib XIII, cap. xxii), and Father Cristóbal de Molina (1947:57, 67, 150), describe the Spondylus (using the Quechua term mullu) as an essential ritual ingredient used by the Indians for the protection of their crops and herds. Not only did Cobo meticulously record the types of

333

mullu that could be sacrificed, he recorded temporal prescriptions attendant to the rites, as well as the Indians' own rationale for the sacrifice of these shells. According to Cobo, the Indians believed that these shells could only be used at the time of planting (during August and September); in addition, the shells were able to promote rain because they were "daughters of the sea, who is the mother of the water." In Inca cosmology, this "mother of the water" is identified as a female deity called Mamacocha.

There appears to be a pattern to the manner of *Spondylus* sacrifice that relates to the sex of the deity invoked. In sacrifices to feminine deities of water or earth, the shells are unburned; however, when offered to masculine deities associated with the sky, thunder, lightning, and tumultuous rain, they are burned. This pattern continues among traditional Quechua and Ayamara speakers of the high Andes with very little variation (Davidson, n.d.).

The strength of the belief in this mollusk's power to act as an intermediary between man and the forces of the environment persists in spite of the intense effort exerted by the Spanish after conquest to discourage their use by the Indians (Arriaga 1968:105). The tenacious attachment of pre-Hispanic and contemporary traditional Indians to this bivalve stems from the fact that it transmits a connotative message that could be carried by no other shell. The key to their hitherto enigmatic persistence in Andean ideology is apparent once the points of juncture between their role in the natural world and their role in the cultural world are clarified.

One of the most striking correspondences between these two systems is the spondylids' seasonal toxicity and the corresponding seasonal pattern of their sacrifice. At exactly the seasons when ocean conditions favor the development of a "red tide" in the Gulf of Guayaquil, Ecuador, these shells are sacrificed to fertility and weather deities in Peru. The act of sacrifice itself is referred to by contemporary ritualists as the "feeding of the gods" (Bastien 1978:142-148). This form of sacrifice seems to be based on ancient legends recorded by Father Avila from the Quechua oral tradition of Huarochiri. In one of these legends, the Inca Tupuc Yapanqui implores the aid of the *huacas* in defeating his enemies. The only deity, or *huaca*, who answers his call is the weather god, Macahuisa. On defeating the enemies of the Inca by unleashing tumultuous rain, thunder, and lightning, the Inca offers Macahuisa gold, silver, textiles, women, and food. But the only reward the deity will accept is *Spondylus* shells. This section reads:

> *Yo no me alimento de estas cosas, mulluqta apamuy, digo (manda que traian mullu). Y cuando le trajeron le deseado lo devoror al instante. "Cap, cap" rechinaban sus dientos mientras masticaba.*

> (I do not eat those things, give me *mullu*, I said! And when they brought him what he wanted he devoured them instantly. "Cap-cap" sounded his teeth while chewing.)

> (Arguedas 1966:135)

Another legend from the same source relates a story of the super-god Pariacaca, the father of Macahuisa. Pariacaca is described as "devouring these shells grinding his teeth" (*ibid.*:59).

In contrast to the way *mullu* is consumed by male deities, shells given to female deities gain entry into their bodies through a totally different route. They are metaphorically incorporated within the bodies of female deities through the transforming media of earth and water. In essence, the shells are placed within the bodies of female deities through the act of offering them to water sources or placing them directly into the earth. According to Cobo, the act of offering *mullu* to water sources was essential

in order to assure adequate rainfall. The power generated by this act was believed to be obtained by the offering of *mullu* to Mamacocha, the mother of the waters.

Again, it is through the oral tradition that the belief system underlying the ritual is elucidated. In the story of Achkay, a daughter named *Mullu* is eaten by her own supernatural mother (Carrión 1955:80). In effect, the practice of placing shells into the earth or into bodies of water duplicates the result of this tale. Their sacrifice returns the daughter, *mullu*, into the body of her mother.

Thus, the continuing belief in the power of spondylids to influence environmental conditions is apparently related to their ability to influence weather and fertility deities who desire them as food. The belief that supernatural beings desired spondylids is undoubtedly derived from the observation that at specific times of the year these mollusks contain a substance powerful enough to cause human death and suffering, as well as providing nourishment the rest of the year, thus themselves wielding the god-like powers of life and death.

These mollusks therefore became the proper food of Peruvian gods. Yet, this mollusk is not found in the cold Peruvian coastal waters. As shown in Figure 3, its range is restricted to the warm coastal waters that flow from the Gulf of California to the Gulf of Guayaquil, Ecuador (Abbot 1974; Keen 1971; Olsson 1961). Can it be that the ancient Peruvians were familiar with the natural history and features of the morphology of fresh specimens whose closest source is the Gulf of Guayquil, Ecuador? The evidence that clearly indicates that these features were known to pre-Hispanic Peruvians is documented in the visual record.

The Spondylus as an Iconographic Motif

The most direct evidence indicating the breadth of Peruvian pre-Hispanic knowledge of this mollusk is derived from artistic motifs created by artisans of the mother culture of Peru, Chavín. Two physical attributes of the *Spondylus* with deep ideological import were their incredible sensory organs and the physical effects of their consumption on the human body during specific seasons of the year. As mentioned above, as well as death, consumption of spondylids could produce sensory distortions and psychic disturbances (R. Abbot and B. Halsted, personal communications). These two attributes were rendered into artistic motifs in Chavín stone carvings and textile design. As shown in Figure 4 and 5, spondylids were portrayed with a prominent eye. However, the association of motifs on the textile fragment (Figure 5) clearly shows that part of Chavín scientific knowledge encompassed characteristics of Ecuadorian fauna observable only in the fresh specimen. The central supernatural figure is shown with a *Spondylus* appended to its back; in its hand it holds a stalk of San Pedro, the hallucinogenic cactus used in contemporary North Coast Peruvian shamanistic rites (Sharon 1978:39-44). The association of the mollusk, the San Pedro cactus, and a supernatural figure signifies that not only were Chavín artisans cognizant of the sensory organs and the physiological effects of the consumption of spondylids, but additionally they indicate the religious importance of these motifs.

It has been suggested that the spread of Chavín religion was accomplished through the transmission of images portrayed on small portable objects (Cordy-Collins 1977:360). Textile motifs served as a form of catechism for the spread of the Chavín religious message. It is therefore apparent that the cognitive message transmitted by this image is that an elemental component of Chavín religion was the communication with supernaturals made possible through the use of spondylids.

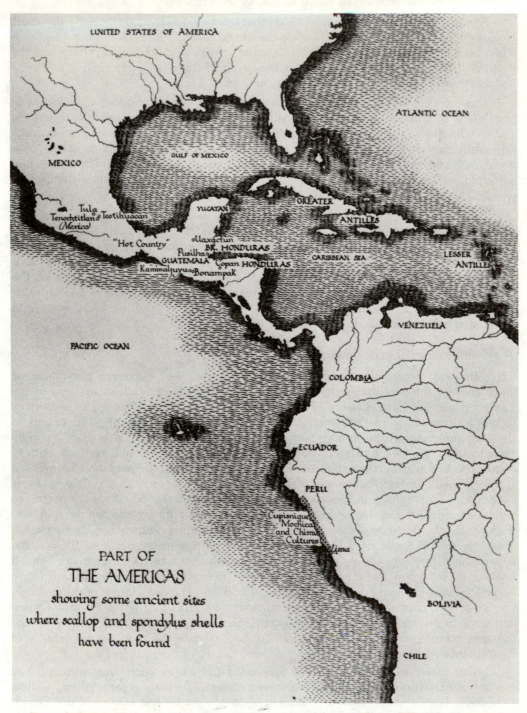

Figure 3. Geographical range of the natural habitat of Spondylus sp. (Digby 1957: 115). Photograph courtesy of Shell Transport and Trading Co., London.

336

Figure 4. A Spondylus at Chavín de Huantar depicted with a prominent eye on the upper right of the "Great Image." (Cordy-Collins 1978: Figure 2. Re-drawn).

Figure 5. An anthropomorphic figure shown with a Spondylus appended to its back. Re-drawn from an original drawing by Alana Cordy-Collins taken from a Chavín textile dated to Phase D (950 B.C.), recovered from the area of Carhua (South Coast, Peru) (Cordy-Collins 1978; Figure 13).

Considering the prominence of spondylids in Chavín religion it is not surprising to find that they continued to be represented 2,000 years later in Chimú iconography. Chimú artisans used the image of the *Spondylus* to decorate ceramics and gold and silver objects. In ceramic form, spondylids can be identified by two diagnostic criteria: the spines placed on the sides of vessels (Figure 6); and the stipples applied to vessel bodies (Figure 7) (Davidson 1980:44-45). The Chimú spout and bridge vessel shown in Figures 8 and 9 features two symbolically related themes. The image of the *Spondylus* is portrayed on the spouted chamber by the use of spines and stipples; the non-spouted chamber portrays an anthropomorphic figure whose body is covered with small ears of corn. This vessel clearly indicates the agricultural bounty made possible through spondylid sacrifice to supernatural beings.

Another vessel whose iconographic message can only be deciphered through the understanding of the relationship between culture and biology is shown in Figure 10. The Chimú spout and bridge bottle also features an anthropomorphic figure on one chamber and the image of a *Spondylus* on the other. However, in this case a lizard is shown with the anthropomorphic figure. The relationship between the lizard and the *Spondylus* seems quite perplexing. An examination of the cultural significance of lizards to the contemporary people of the Peruvian North Coast, however, reveals that the rationale underlying their iconographic association was that they were both used for the same purpose: fertility. Lizards are consumed as food by contemporary peoples of the North Coast. However, they are not consumed only because they are an excellent source of protein. There is a belief that the fruits of the algarroba tree, upon which the cañane lizards exclusively feed, contain a powerful aphrodisiac. Since this fruit is quite bitter, it is not eaten directly; the tree's reputed beneficial qualities are obtained by eating the lizard (Helms 1977:63).

338

Figure 6. Variation in the representation of spondylid spines placed on the sides of ceramic vessels (David-son 1980: 84 Figure 4).

Figure 7. Variation in the representation of spondylid spines shown as stipples on ceramic vessels (Davidson 1980: 83 Figure 3).

339

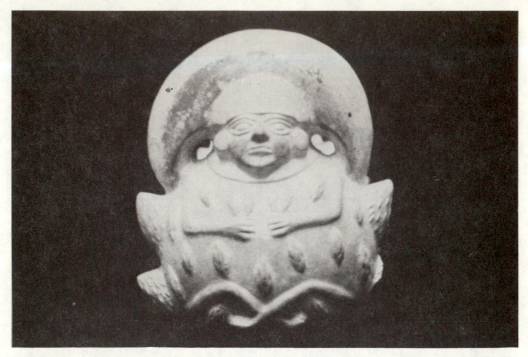

Figure 8. Chimú spout and bridge vessel (ca. A.D. 1000) Bruning Museum, Peru #MB-1060a. 14 cm. Front view showing the anthropomorphic figure with small ears of corn appended to its body.

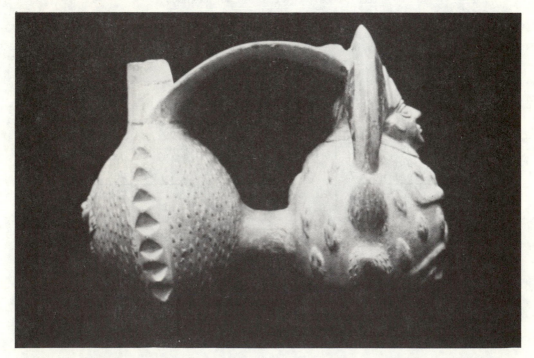

Figure 9. Sideview of vessel illustrated in Figure 8, showing the spouted vessel represented as a Spondylus.

340

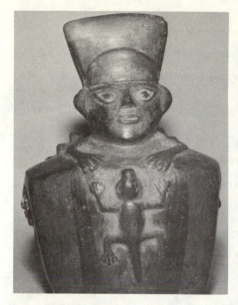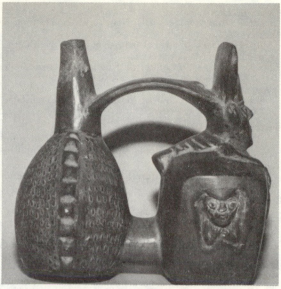

Figure 10. Front and side view of Chimú spout and bridge painted vessel (ca. A.D. 1000) illustrating the close relationship between supernatural figures, lizards, and the Spondylus. Photograph courtesy of the Los Angeles County Natural History Museum #477-53-4.

These examples illustrate that by following an analytical system that uses natural modeling as an iconographic tool, associations that previously appeared enigmatic can be clarified.

Conclusions, Interpretations, and Reflections

The continuing practice of using the image of spondylids in Andean rituals stems from the belief that they enhance communication with supernaturals. Through their use, mankind is able to influence forces of the environment in order to maximize agricultural productivity, thereby assuring the food necessary for his own survival. This ancient belief system derived from the direct modeling of ideology on ecology. In this case, features of this mollusk's natural history and morphology were used as templates for belief systems enacted through myth and ritual. The brilliant color of its shell, the protective spines, prominent eyes, and seasonal toxicity transformed the bivalve into a ''symbol vehicle whose ritual use abridges what would be a lengthy statement'' (Turner 1967:184). As such, its image serves as a medium of connotative communication whose message is read by following the effect of the biological environment on the formation of ideational systems.

This paper demonstrates that by focusing attention on the relationship between the natural history of biological motifs and their cultural significance, visual images gain new meaning. As noted by Gerardo Reichel-Dolmatoff (1971:xv), ''the tremendous force contained within the biome exerts a specific pressure that molds the expression of ideational systems.''

Guided by this orientation, I have attempted to show that the impact of this mollusk on Andean ideology influenced the pattern of myth, ritual, and art. It is precisely because ancient Peruvians were aware of the natural history and morphology of spondylids that they placed such an extraordinary religious value on them. They became the ''food of gods,'' and thereby are used as instruments guaranteeing human survival.

Bibliography

Abbot, R. Tucker
 1974 *American Seashells.* New York: Van Nostrand Reinhold Co.

Andrews, A.P.
 1974 "The U-Shaped Structures at Chan Chan, Peru." *Journal of Field Archaeology* 1 (3-4): 241-264.

Arguedas, José María (translator)
 1966 *Dioses Y Hombres de Huarochiri.* Narración Quechua recognida por Francisco de Avila M.N. Lima (Reedición, Siglo XXI, México, 1975).

Arriaga, Pablo José
 1968 *The Extirpation of Idolatry in Peru.* Translated by L. Clark Keating. Kentucky: University of
 (1621) Kentucky Press.

Bastien, Joseph W.
 1978 *Mountain of the Condor: Metaphor and Ritual in an Andean Ayllu.* American Ethnological Society Monograph 64. St. Paul: West Publishing Company.

Cabello Balboa, Miguel
 1951 *Miscelanea Antárctica.* Universidad Nacional Mayor de San Marcos. Lima: Instituto de
 (1586) Etnología.

Carríon Cachot, Rebeca
 1955 "El Culto Al Agua En El Antiguo Perú." Separata de la *Revista del Museo Nacional de Antropología* II(I) Lima.

Cobo, Bernabé
 1956 *Historia de Nuevo Mundo.* Madrid: Biblioteca de autores Españoles. T91-92.
 (1653)

Conrad, Geoffrey W.
 1974 "Burial Platforms and Related Structures on the North Coast of Peru: Some Social and Political Implications." Ph.D. dissertation. Harvard University.

Cordy-Collins, Alana
 1977 "Chavín Art: Its Shamanistic/Hallucinogenic Origins." *In* Alana Cordy-Collins and Jean Stern, eds. *Pre-Columbian Art History: Selected Readings.* Palo Alto: Peek Publications.

 1978 "The Dual Divinity Concept in Chavín Art." *El Dorado: A Newsletter-Bulletin on South American Archaeology.* III (2): 1-31.

Dakin, William John
 1928 "The Anatomy and Physiology of *Spondylus* with Particular Reference to the Lamellibranch Nervous System." *Proceedings of the Royal Society of London.* Series B 103:337-354.

Davidson, Judith R.
 in press "The Spondylus Shell in Chimú Cosmology." Lima: Revista del Museo Nacional XLV.

 1980 "The *Spondylus* Shell in Chimú Iconography." MA thesis, California State University, Northridge.

 n.d. "The *Spondylus* Shell: An Image of Ecological Regulation." Paper submitted to the *Journal*
 (1980) *of Latin American Lore*, March 1980.

de Molina, Cristóbal
 1947 *Ritos Y Fabulas de los Incas.* Buenos Aires: Editorial Futuro.

Digby, Adrian
 1957 "An Excursion Into the Americas." *In* Ian Cox, ed. *The Scallop: Studies of a Shell and Its Influence on Humankind.* London: Shell Transport and Trading Co.

Feldman, Robert A.
 1977 "Life in Ancient Peru." *Field Museum of Natural History.* Bulletin 48(6): 12-17.

Helms, Mary W.
 1977 "Iguanas, and Crocodilians in Tropical American Mythology and Iconography, With Special Reference to Panama." *Journal of Latin American Lore.* 3(1):51-132.

Kamiya, H. and Y. Hashimoto
 1978 "Occurrence of Saxitoxin and Related Toxins in Palauan Bivalves." *Toxicon* 16; 303-306.

Keen, Myra
 1971 *Sea Shells of Tropical West America: Marine Mollusks From Baja California to Peru.* Stanford: University of Stanford Press.

 1970 "Relation of Shell Form to Live Habits of the Bivalvis (Mollusca)." *Memoir* 125. Geological Society of America.

Murra, John V.
 1975 "El Tráfico de *Mullu* en la Costa Del Pacifico." *In* *Formaciones Económicas Y Políticas del Mundo Andino.* Pp. 275-313. Lima: Instituto de Estudios Peruanos.

Olsson, A.A.
 1961 *Mollusks of the Eastern Pacific, Particularly From the Southern Half of the Panamic-Pacific Fauna Province (Panama to Peru).* Ithica: Paleontological Research Institution.

Rees, William J.
 1957 "The Living Scallop." *In* Ian Cox, ed. *The Scallop: Studies of a Shell and Its Influence On Humankind.* London: Shell Transport and Trading Co. Pp. 15-33.

Reichel-Dolmatoff, Gerado
 1971 *Amazonian Cosmos: The Sexual and Religious Symbolism of the Tukano Indians.* Chicago: University of Chicago Press.
Sharon, Douglas
 1978 *Wizard of the Four Winds: A Shaman's Story.* New York: The Free Press.
Stanley, Steven M.
 1970 "Relation of Shell Form to Live Habits of the Bivalvis (Mollusca)." Memoir 125, Geological Society of America.
Tufts, Norman R.
 1978 "Molluscan Transvectors of Paralytic Shellfish Poisoning." *In* Dennis L. Taylor and Howard H. Seliger, eds. *Toxic Dinoflagellate Blooms.* New York: Elsivier/North Holland.
Turner, Victor
 1967 *The Forest of Symbols: Aspects of Ndembu Ritual.* Ithaca and London: Cornell University Press.
Watson, Hugh
 1930 "On the Central Nervous System of *Spondylus* and What Happens to a Headless Mollusc's Brain." *Proceedings of the Malacological Society of London.* XIX (1); 31-37.
Wilbur, Karl M. and C.M. Yonge, eds.
 1966 *Physiology of Mollusca.* New York and London: Academic Press.

Acknowledgements

I would like to express my appreciation to Johannes Wilbert for his suggestion that I explore the *Spondylus* as a "natural symbol"; and to Alana Cordy-Collins for bringing to my attention the Chavín textile motif.